Contracultura

Contracultura

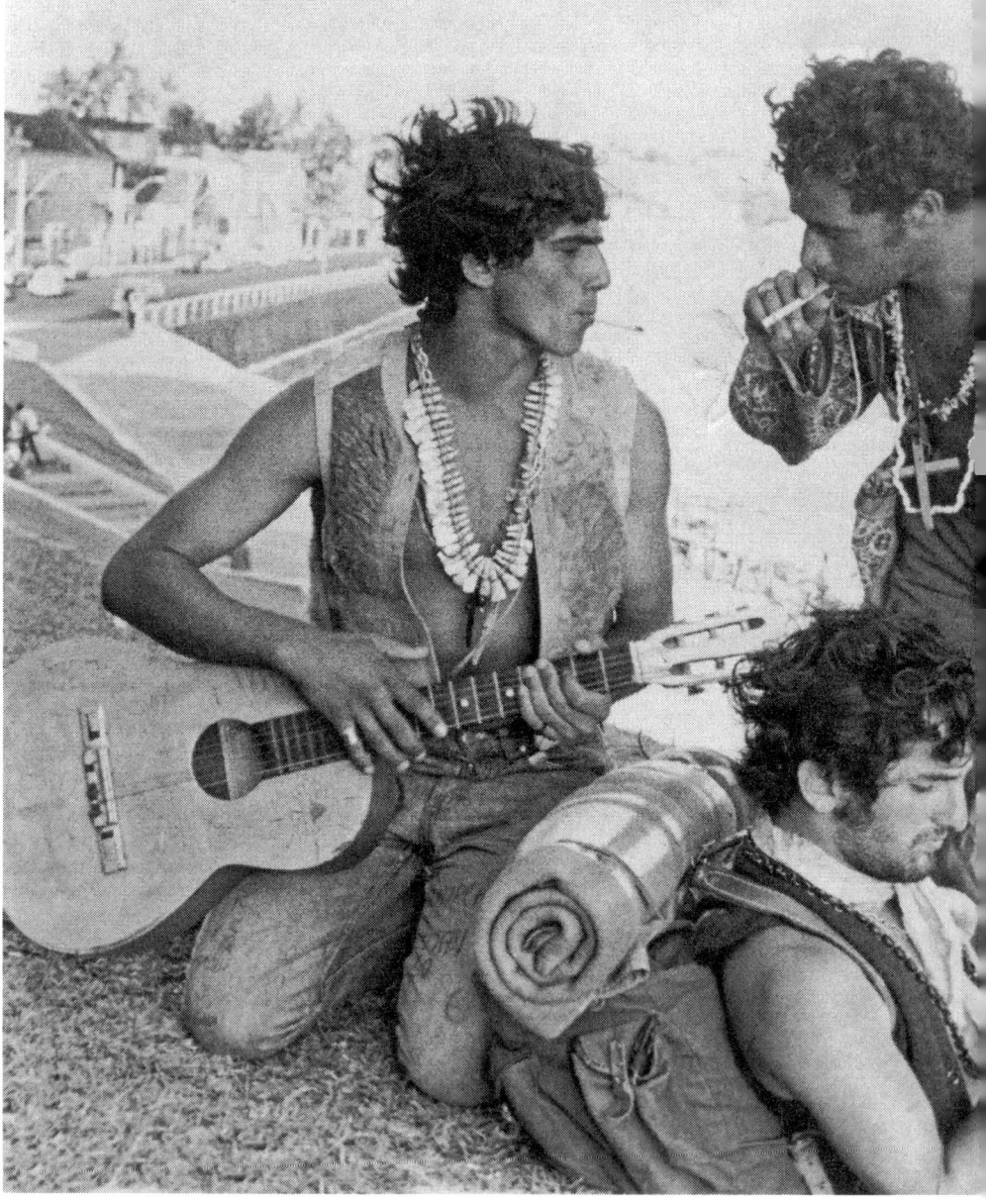

Alternative Arts and Social Transformation in Authoritarian Brazil ≈ CHRISTOPHER DUNN

The University of North Carolina Press *Chapel Hill*

Open access edition funded by the National Endowment for the Humanities.

© 2016 The University of North Carolina Press
The text of this book is licensed under a Creative Commons AttributionNonCommercial-NoDerivatives 4.0 International License: https://creativecommons.org/licenses/by-nc-nd/4.0/

Designed and set in Quadraat and Quadraat Sans by Rebecca Evans

Cover art: Hippies on a Rio de Janeiro beach, 1973.
Ari Gomes/CPDoc JB.

Library of Congress Cataloging-in-Publication Data
Names: Dunn, Christopher, 1964– author.
Title: Contracultura : alternative arts and social transformation in authoritarian Brazil / Christopher Dunn.
Description: Chapel Hill : The University of North Carolina Press, [2016] | Includes bibliographical references and index.
Identifiers: LCCN 2016019440| ISBN 9781469630014 (cloth : alk. paper) | ISBN 9781469628516 (pbk : alk. paper) | ISBN 9781469628523 (ebook)
Subjects: LCSH: Counterculture—Brazil—History—20th century. | Brazil—Social conditions—20th century. | Totalitarianism and art—Brazil. | Totalitarianism and literature. | Brazil—Civilization—20th century. | Brazil—History—1964–1985.
Classification: LCC HN283.5 .D86 2016 | DDC 306/.10981—dc23 LC record available at https://lccn.loc.gov/2016019440

An earlier version of Chapter 1 was published as "*Desbunde* and Its Discontents: Counterculture and Authoritarian Modernization in Brazil, 1968–1974," *Americas* 70, no. 3 (January 2014): 429–58. Portions of Chapter 2 were published in different form as "Experience the Experimental: Avant-Garde, *Cultura Marginal*, and Counterculture in Brazil, 1968–72," *Luso-Brazilian Review* 50, no. 1 (Fall 2013): 229–52.

Para meus filhos, Luango, Isa, Joaquin e Zé

Contents

Acknowledgments xi

Introduction: Power and Joy 1

1 ⇌ Desbunde 36

2 ⇌ Experience the Experimental 72

3 ⇌ The Sweetest Barbarians 108

4 ⇌ Black Rio 146

5 ⇌ Masculinity Left to Be Desired 175

Epilogue 201

Notes 207

Bibliography 235

Index 251

Illustrations

Brazilian students, 1967 15

Hippies on the road in Brazil, 1971 42

Hippies on the beach, Rio de Janeiro, 1973 48

Cartoon by Jaguar in *O Pasquim*, 1969 60

Hippie Fair of Ipanema, 1970 66

Advertisement for Tissot watches in *O Pasquim*, 1969 69

Hélio Oiticica's *Éden*, 1969 82

Gal Costa performs "Vapor barato," October 1971 87

Poster for Ivan Cardoso's *Nosferato no Brasil*, 1971 94

Waly Salomão, 1972 98

Hippies at the Porto da Barra, Salvador, Bahia, 1969 122

Hippies buying *acarajé* from a *baiana*, 1969 124

Hippies arriving in Arembepe, Bahia, February 1972 126

Maria Bethânia at the Lavagem de Bonfim, early 1970s 138

Doces Bárbaros in concert, 1976 141

Commentary on Angela Davis by Paulo Francis, 1972 148

Tim Maia, 1972 154

Baile soul, Rio de Janeiro, 1976 161

Shoe store in Madureira, Rio de Janeiro, 1976 165

Ney Matogrosso and João Ricardo of Secos & Molhados, 1974 191

Acknowledgments

I am, first and foremost, grateful to Elaine Maisner, senior executive editor at the University of North Carolina Press, for her encouragement, insight, and patience throughout the many years it took me to research and write this book. She took an interest in my work early on and has remained steadfast in her support ever since. I also wish to thank Dino Battista, Mary Caviness, Alison Shay, and the rest of the staff of UNC Press. I am truly fortunate to have had the opportunity to work with this superb university press since the beginning of my scholarly career.

It has been a tremendous privilege to teach and conduct research at Tulane University during the past two decades. I have realized, *no meio do caminho*, that there is no better place for me to teach and pursue my intellectual passions. Michael Bernstein, provost and vice president of Academic Affairs, and Carole Haber, dean of the School of Liberal Arts, fostered a supportive environment during the time I developed this project. The School of Liberal Arts provided funding for the rights to reproduce some of the period photographs in this book. I offer many thanks to Tom Reese, executive director of the Stone Center for Latin American Studies, and to Hortensia Calvo, director of the Latin American Library, who have assisted me in ways large and small. My colleagues at Tulane University have provided friendship, intellectual stimulation, and all manner of assistance over the years. Idelber Avelar and Rebecca Atencio are beloved friends and brilliant interlocutors who have contributed to the development of this project. Thanks also to Rosanne Adderley, Elizabeth Boone, Claudia de Brito, Barbara Carter, Colin Crawford, Jean Dangler, Gaurav Desai, Jimmy Huck, T. R. Johnson, Zachary Lazar, Megwen Loveless, Valerie McGinley Marshall, Vicki Mayer, Tatjana Pavlovic, Marc Perry, Mauro Porto, Dan Sharp, Maureen Shea, Terry Spriggs, John Verano, and Edie and Justin Wolfe.

I wish to thank the National Endowment for the Humanities for a research fellowship during the 2013–14 academic year. I have the fondest memories of that period, during which time I lived with my family in Madison, Wisconsin,

the lovely hometown of my parents. My Uncle Tad and Aunt Joan provided familial warmth and cheer, which got us through a long, cold winter, polar vortex and all. I am indebted to Severino Albuquerque and Kathryn Sanchez, who welcomed me to the vibrant community of Luso-Brazilianist scholars at the University of Wisconsin, where I was a Fellow of the UW Brazil Initiative. Kathryn generously lent me her carrel on the fifth floor of Memorial Library, where I drafted most of this book.

I am forever indebted to my professors and mentors at Brown University—Anani Dzidzienyo, Thomas Skidmore, Luiz Valente, and Nelson Vieira—as well as to Peter Blasenheim, who introduced me to the history, cuisine, and music of Brazil many years ago when I was an undergraduate student at The Colorado College. J. Lorand Matory "gave me a ruler and a compass" (to quote a song by Gilberto Gil) and then pointed me in many directions. Randal Johnson, Jeffrey Lesser, Charles Perrone, and Robert Stam have provided inspiration and support over many years. I wish to thank friends and colleagues throughout Brazil, the United States, and Europe, who have contributed to this project in myriad ways: Paulina Alberto, Durval Muniz de Albuquerque Jr., Armando Almeida, Pedro Amaral, Vitória Aranha, Paulo César de Araújo, Beatriz Azevedo, Luca Bacchini, Elisabete Barbosa, Patrick Barr-Melej, Carlos Basualdo, Sophia Beal, Marcus Brasileiro, Kim Butler, Steven Butterman, Claudia Calirman, Bruno Carvalho, Frederico Coelho, Sergio Cohn, Benjamin Cowan, Silvio Humberto Passos Cunha, Jerry Dávila, Marshall Eakin, Fran Faller, Fátima and João Farkas, Martin Cezar Feijó, Marcus Freitas, John and Jan French, David George, Jaime Ginzburg, Fred and Graça Goés, Glen Goodman, James Green, Tracy Devine Guzmán, Marc Hertzman, Scott Ickes, Leon Kaminski, Victoria Langland, Silvia Lopez, Valeria Manzano, Heloísa Marcondes, Bryan McCann, Paulo Miguez, Fred Moehn, Pedro Meira Monteiro, Milton Moura, Tereza Nakagawa, Marcos Napolitano, Mariângela Nogueira, César Oiticica Filho, Ana de Oliveira, Derek Pardue, Anthony Pereira, Patricia de Santana Pinho, Joanne Pottlitzer, João José Reis, Marcelo Ridenti, Dylon Robbins, Livio Sansone, Alessandra Santos, Jocélio Teles dos Santos, Nicolau Sevcenko (1952–2014), Elena Shtromberg, Irene Small, Patricia Sobral, Liv Sovik, Deborah Sztajnberg, J. Michael Turner, Herom Vargas, Barbara Weinstein, José Miguel Wisnik, George Yúdice, and Eric Zolov. Thanks to two anonymous reviewers who offered insightful critiques and splendid recommendations.

Finally, I am deeply appreciative of those Brazilian artists and intellectuals who shared with me their recollections and thoughts about culture, politics, and everyday life during the period of authoritarian rule: Lino Almeida

(1958–2006), Armindo Bião (1950–2013), Paulinho Boca de Cantor, Heloísa Buarque de Hollanda, Rui Campos, Ivan Cardoso, Chacal, Xico Chaves, José Celso Martinez Corrêa, Neville D'Almeida, Hélio Eichbauer, Juca Ferreira, Luciano Figueiredo, Dom Filó, Fernando Gabeira, Luiz Galvão, Gilberto Gil, Gerson King, Jards Macalé, Luiz Carlos Maciel, Antonio Manuel, Antonio Luiz Martins, Ney Matogrosso, Jorge Mautner, Carlos Alberto Medeiros, Luiz Melodia, Leila Miccolis, Moraes Moreira, André Luiz Oliveira, Antonio Risério, João Jorge Rodrigues, Jorge Salomão, Waly Salomão (1943–2003), Silviano Santiago, Renato da Silveira, and Caetano Veloso. I am most grateful for the friendship of Tom Zé and Neusa Martins, who have looked after me during my visits to São Paulo.

My parents, Joe and Gwenn, and sister Susan offered their encouragement throughout the long process of researching and writing this book. Sadly, my mother did not live to see the project come to fruition, but her interest in my work always motivated me. My wife, Ladee Hubbard, offered abiding love and flashes of revelation. I have no idea if this book will be of any interest to my children, but it is to them with love that I dedicate it.

Contracultura

INTRODUCTION ~ *Power and Joy*

Joy erupted in laughter as well as mockery, in parody and circus as well as in the human body in search of the plenitude of pleasure and delight in one's own pain. . . . Those in power became, contradictorily, optimistic and sad. Those who opposed the regime were at once sacrificed and joyful.
—SILVIANO SANTIAGO, "Poder e alegria" (1988)

Authoritarian military rule in Brazil between 1964 and 1985 coincided with an astonishingly effervescent period of cultural production and social transformation. To the multiple forms of state violence, censorship, and everyday forms of repression justified in the name of "national security," Brazilians resisted in ingenious and numerous ways.[1] This book is about those young Brazilians who responded to authoritarian rule with attempts to rethink the idea of liberation during a period in which "the utopian verve" of the 1960s had come to an end throughout much of Latin America.[2] To varying degrees, these young Brazilians identified with and took inspiration from the international counterculture, or *contracultura*, as it is known in Brazil. To understand the Brazilian counterculture, one must take into account the sense of profound disillusionment with the failure of emancipatory projects of "national liberation," the rise of a right-wing military regime, and the crushing defeat of the opposition. As suggested by literary critic Silviano Santiago, cited in the epigraph above, Brazilians also cultivated a sense of joy, sometimes imbued with humor, even as people were "sacrificed" by political repression and violence. Although the regime asserted a triumphalist discourse of patriotic nationalism, which reached a peak in the early 1970s, its leaders often appeared as dour bureaucrats. Those in power were, as Santiago notes, simultaneously "optimistic and sad."

Several poems from the 1970s might help us to understand the emotions, impulses, and commitments among Brazilians who came of age under authoritarian rule. They are exemplary texts of *poesia marginal*, a poetic move-

ment known for its colloquial informality and confessional tone. According to one critic, *poesia marginal* was characterized by its antitechnicism and anti-intellectualism and the politicization of everyday life.[3] The marginal poets often (but not always) positioned themselves in opposition to the formalist and famously erudite concrete poets of São Paulo. *Poesia marginal*'s do-it-yourself ethos would inspire thousands of young Brazilians, with various degrees of literary talent, to write and self-publish in the 1970s and beyond. In some ways, *poesia marginal* was a kind of literary wing of the Brazilian counterculture. Published in the milestone anthology 26 *poetas hoje* (1975), Francisco Alvim's poem "Revolução" (Revolution) captured the sense of disillusionment among intellectuals of his generation:

> Before the revolution I was a professor
> When it came I was fired from the university
> I began to demand stances from myself and others
> (my parents were Marxists)
> I've gotten better—
> Today I don't mistreat myself
> Nor anyone else[4]

In contrast to 1960s-era belief in the power of culture and the revolutionary vocation of artists and intellectuals, Alvim's poem is about self-critique, disengagement from organized politics, and a reorientation toward personal behavior. Alvim's poem foregrounds the ambiguous and contested meaning of its title—*revolução*. The word evokes, of course, the historic aspirations of Marxists, like his parents, for whom social revolution appeared visible on the horizon in the years immediately before the coup. The generals who came to power in 1964 recognized the rhetorical power of the word "revolution" and appropriated it to justify the implementation of a repressive national security state and an economic program of authoritarian modernization. Emptied of its historic association with national liberation and social transformation, Alvim invokes it ironically—the hopeful time "before the revolution" when he was a university professor. The "revolution" was, in fact, a catastrophe: Brazil fell under the rule of a right-wing military regime, and he lost his job, along with other prominent intellectuals who were fired from their posts due to their political convictions and activities. A period of frustration ensued, as the poet submitted himself and others to ideological critique, seen in retrospect as an unhealthy compulsion driven by personal resentment. The final three lines seem to reinforce a sense of melancholic retreat, as the poet seems to say, "I'm just working on myself." In its focus on

retreat and self-healing, Alvim's poem almost suggests a kind of narcissism proper to what Walter Benjamin called the "melancholy Left"—a brooding, debilitating attachment to a loss or defeat that hinders or prevents any recovery.[5] Yet the final lines may also be read as a transcendence of Left melancholy in suggesting a process of release and reorientation. The poem suggests, in this way, a third reading of "revolution," as a process of individual liberation at a time when conditions for collective mobilization were limited. As the U.S.-backed regime violently suppressed dissent, politics were pushed increasingly into the realm of private life. It was time, as the poem suggests, to care for oneself and develop empathy for others.

While Alvim's poem recommends introspection, other poems from this period celebrate erotic release and revelry in the face of repression. In "20 anos recolhidos," the poet Chacal (Ricardo de Carvalho Duarte) dispenses with the first-person confessional voice of the sort used in Alvim's poem and adopts instead an impersonal exhortative voice that appeals to his generation, which came of age as the dictatorship entered its most violent and repressive phase. The title suggests that the poem is highly personal, as Chacal was, in fact, twenty years old when he published this poem in his first collection, *Muito prazer*, in 1971. The adjective "recolhidos" is multivalent, suggesting twenty years "recalled," as if to take stock of his life up to that point; but it could also mean twenty years "confined" or "withdrawn," a state from which the poet now liberates himself:

> the time has arrived to love desperately
> passionately
> uncontrollably
> the time has arrived to change styles
> to change clothes
> it arrived late like a train that's late
> but arrives[6]

In the face of authoritarian violence and stifling repression, Chacal calls for an erotic, Dionysian gesture of release and self-affirmation. As the regime stimulated patriotic euphoria, dissenters needed to reclaim joy in a liberating way. Chacal's poem is not about future promise but rather about acting in the here and now, as announced in the opening line, "the time has arrived." But the time for what? Chacal's poem is not a call to arms or even a call to protest. Instead, it points to new ways of being in the world based on the release of erotic energy. In referencing style and clothing as markers of the catharsis, Chacal suggests that consumption played a central role in this

emergent youth culture. The poem also calls attention to the question of periodization: the Brazilian counterculture reached its height in 1972, not in 1968, thus his metaphor of the *trem atrasado* that is late but inevitably arrives.

Writers with the *poesia marginal* movement, as noted above, also engaged with quotidian interpersonal politics. The poem "Vã filosofia" (Vain philosophy) by Leila Miccolis, a leading female voice in the *poesia marginal* movement, explored the tensions and contradictions between political ideology and everyday behavior. The revolutionary Marxist ideals that mobilized left-wing intellectuals in the 1960s were at odds with deeply ingrained cultural habits, patterns, and roles that reinforced patriarchal class society:

> You talk a lot about Marx,
> About the division of labor
> About grass-roots organizing
> But when you get up
> You don't even make the bed.

As an activist in the feminist movement, Miccolis wrote the poem as a gendered critique of the left-wing male intellectual, who rails on about the division of labor and grassroots organizing but leaves domestic chores to wives or girlfriends. The poem can also be read more broadly as a critique of class privilege enjoyed by both male and female leftists, who depended on the labor of poor domestic workers, often black women, to maintain the house. "Vã filosofia" affirms an ethos of congruency between ideals and life practice that assigns primacy to everyday behavior over lofty pronouncements about a future utopia. Her poem captures with wry humor the notion that "the personal is political," one of the key principles of second-wave feminism in the United States. In different ways, these poems convey a generational process, from disillusionment with the revolutionary project to the joyful defiance of personal liberation and, finally, to a rethinking of everyday politics.

⇌ On Counterculture

The term "counterculture" has been used in diverse historical contexts to refer to individual and collective resistance to political authority, social conventions, or established aesthetic values. It first appeared in postwar U.S. sociological literature as a counterpoint to the category of "subculture." John Milton Yinger's definition of what he called "contraculture" emphasized "conflict with the values of the total society."[7] He hypothesized that the formation of "contracultures" was a response to deprivation and frustration

among lower-class and marginalized populations.[8] While subculture maintains a more or less neutral stance toward society at large, counterculture designates a broader oppositional movement in conflict with the dominant society.[9] With emphasis on personal transformation, countercultural movements typically assign primacy to "consciousness-raising," a process of mind-expanding self-critique that embraces new ideas and perspectives. For some people, this process was aided by the consumption of mind-altering drugs, especially marijuana and hallucinogens such as LSD and psilocybin mushrooms. For others, countercultural consciousness-raising involved a radical critique of "the West"—understood in terms of European and Christian civilization—and the embrace of Asian, African, and Native American cultures and religions.

One of the conceptual problems in using the term "counterculture" relates to context and periodization. Ken Goffman and Dan Joy have argued that countercultural movements are transhistorical, near-universal phenomena, providing examples that include Abraham, Socrates, Taoists, Zen Buddhists, Sufi mystics, Provençal poets, Enlightenment rationalists, American Transcendentalists, avant-garde artists, beatniks, hippies, punks, and cyber hackers.[10] While the sweep of their historical argument is compelling, the array of examples is so heterogeneous that it renders comparisons and connections difficult to sustain. Italian critic and novelist Umberto Eco has argued that, in anthropological terms, "there are no counter-cultures, just other cultural models."[11] He notes, however, that we may speak of counterculture as a modality of critique, or what he calls "a critical definition of the dominant culture."[12]

Despite its applicability to a wide range of contexts, "counterculture" generally refers to forms of social and cultural dissent in the United States, Europe, and Latin America during the 1960s and 1970s. The counterculture flourished primarily in the United States, with its strong tradition of individualism, its obsession with youth, and its highly developed culture industry. Young radicals in Europe tended to have stronger ties to left-wing institutions devoted to class struggle through established trade unions.[13] The civil rights movement of the late 1950s and early 1960s inspired and mobilized middle-class youth, who then went on to radicalize university campuses. Political activists and visionary artists created what Jeremi Suri has called a "language of dissent," which drew on a growing population of university students who formed an "infrastructure of dissent."[14] New Left activists pivoted away from the labor movement and reoriented their struggles toward participatory democracy, racial justice, anti-imperialism,

and dissident cultural politics. Dissident movements grew in response to the escalation of American involvement in Cold War proxy wars in Vietnam and Cambodia. Seeking immediate change, these young activists privileged direct action over coalition building and gradual reform.[15] The New Left also embraced the notion that "the personal is political," opening up a range of questions pertaining to everyday social relations.

Theodore Roszak's *The Making of a Counter Culture*, published in 1969, popularized the term in the United States and Britain. Focusing on the U.S. context, Roszak argued that the counterculture was both a symptom of and a response to a sense of social alienation during a period of affluence and full employment.[16] Contrary to Yinger's hypothesis that counterculture was a reaction to deprivation, Roszak argued that it was a middle-class rebellion of "technocracy's children" in an age of economic growth and rationalization—a generational revolt among youth who rejected conventional ideas about what constituted the good life. The rationalization of human activity in industrial society produced a sense of malaise and disillusionment, particularly among youth, who began to question the political, social, and philosophical foundations of Western society. Roszak likened the counterculture to a Dionysian "invasion of the centaurs," disrupting the civilized festivities of Apollo, the guardian of orthodox culture.[17] Against the technocratic reason of industrial society, the countercultural centaurs embraced irrationality and cathartic emotion.

Roszak's analysis owed much to the work of Herbert Marcuse, the German émigré affiliated with the Frankfurt School, who was widely read in New Left circles at the time. His most influential work, *One Dimensional Man* (1964), was a critique of modern industrial society in its ability to co-opt dissent and subversion, thereby neutralizing dialectical, or "two-dimensional," transformation. The only way to resist this state was through a "total transcendence of the existing order," what Marcuse called the "Great Refusal." Manifestations of this total negation might include "dropping out," creating communal spaces, rejecting consumer society, and eschewing social conformity. Marcuse once referred to the hippies as "the only viable social revolution" in the way they "rejected the junk they're supposed to buy, rejected the war, and rejected competitive performances."[18] Revolutionary agency, according to Marcuse, shifted from the proletariat to radicalized students, civil rights and black power activists, third world insurgents, and feminists.[19]

Contemporary scholars tend to be considerably more skeptical of the counterculture as a critique of technocratic society. Thomas Frank argues

that the counterculture, far from instantiating a Marcusean "great refusal" from the margins, emerged from the ideological nerve center of "one-dimensional society." Whereas Roszak acknowledged that consumer society took advantage of generational conflict and youthful rebellion to sell products, Frank argued that consumer society actually generated this ethos of dissent. The counterculture was a product of Madison Avenue innovations in the realm of advertisement that promoted niche-product consumption as a way of expressing individualism, nonconformity, and social distinction. Advertising executives were in the vanguard of promoting a rebellion against postwar social conformity within the middle class. Business culture paralleled and even anticipated the counterculture, especially in the way that it marketed youthful dissent, what Frank calls "hip consumerism."[20] All of the anxieties and complaints about social conformity, oppression, and alienation in modern industrial society could be remedied through lifestyle consumption.

Joseph Heath and Andrew Potter are more strident in their critique of the counterculture, which they claim has done enormous damage to the patient work of political organizing and efforts to promote social justice through deviant nonconformity, hedonism, and unbridled individualism: "Doing guerrilla theater, playing in a band, making avant-garde art, taking drugs and having lots of wild sex certainly beat union organization as a way to spend the weekend."[21] In this regard, they make a distinction between social dissent (activities attached to a progressive political strategy) and social deviance (individualistic transgressions that undermine efforts to effect incremental reforms).[22] Although frequently imagined as anticapitalist, they argue, countercultural rebellions of the 1960s and 1970s were completely integrated into consumer society. Countercultural nonconformity stimulates consumption, as it is ultimately mobilized as a marker of social distinction.[23] The counterculture, in their view, is at best an innocuous distraction from the real task of organizing for social change and at worst a dangerous illusion that actively undermines progressive politics.

Critics of the counterculture offer an important corrective to an earlier tendency to interpret the rebellions of the late 1960s and early 1970s solely in terms of resistance and refusal. To be sure, from the perspective of Left orthodoxy, countercultural values and practices were hedonistic, self-centered, and impulsive. Even Roszak, a champion of the counterculture, had serious concerns about its drug-fueled irrationalism, its lack of discipline, and what he called its "commercial verminization."[24] Yet these critiques overlook the larger context of dissatisfaction among broad sectors

of international youth during the Cold War period in both capitalist and socialist societies. Ideological conflict, proxy wars, and the threat of nuclear annihilation produced anxieties that led to broader questioning of received values and social conventions. The fact that contestation found expression through consumption, especially in an advanced consumer society such as the United States, hardly comes as a surprise. If commodification relativized or undermined some of the more radical claims of the counterculture, it also ensured that it would have an extended reach.

Despite its novel appearance, the counterculture responded to struggles and debates that had long histories dating back at least to the early twentieth century. As Jeremi Suri has noted, these youth "deployed a very usable political past" in confronting patriarchy, racial injustice, and imperial aggression.[25] In advocating sexual liberation, drug consumption, and untrammeled expression, they defended the pursuit of pleasure rather than wealth and power. While it is important to recognize the limitations of the counterculture, it is also essential to understand its significance in motivating young people in many different national contexts to reconceive politics in both personal and public spheres during the Cold War period.

⇒ Latin American Countercultures

Nearly every Latin American nation witnessed local countercultural movements, which were linked to transnational processes involving circulation of texts, films, and, above all, popular music. The modern Latin American historiography for the period of the 1960s and 1970s has concentrated largely on the armed insurgencies and state-directed counterinsurgencies. The 1959 Cuban Revolution provided impetus to armed revolutionary struggle and marked a generational shift away from traditional leftist parties while maintaining the social values and aesthetics associated with previous generations. The Latin American New Left distinguished itself from traditional, or "Old Left," parties and organizations, whether communist or syndicalist, which tended to seek gradual reform while forming cautious broad-front alliances in politics. To use Greg Grandin's concise definition, the Latin American New Left was characterized by its "will to act."[26]

Eric Zolov has argued for an expanded notion of the New Left in Latin America that takes into account the cultural and social upheavals of the so-called long 1960s, which stretch from the late 1950s to the early 1970s.[27] The focus on the dichotomy between revolutionary and counterrevolutionary movements overlooked broad sectors of the Left that avoided the armed

struggle and expressed dissent by engaging in countercultural practices. Latin American youth who participated in countercultural movements shared affinities with their North American counterparts, but their sources of discontent were somewhat different. While the counterculture in the United States erupted in the context of civil rights struggles, the escalation of the Vietnam War, and discontent with modern industrial society, Latin American countercultures emerged in response to conservative moral strictures enforced by the Catholic Church and patriarchal family structures, authoritarian governments, and, in some contexts, the impact of revolutionary insurgency. Countercultural phenomena often flourished simultaneously with armed revolutionary movements, constituting twin facets of what Zolov calls a "New Left sensibility."[28]

Zolov highlights the central place of Mexico as a transnational crossroads that attracted North American youth, including Beat writers Jack Kerouac and Allen Ginsberg, as well as Latin American exiles, including Ernesto "Che" Guevara and Fidel Castro, in the 1950s. While Mexico offered an exotic refuge from postwar America for Beat writers and other alternative tourists, it provided a training ground for the revolutionaries as they prepared to launch their assault on Cuba. Mexico provided the context for Guevara's personal trajectory from a wandering and undisciplined bohemian to a committed and disciplined revolutionary.[29] In the late 1960s, Mexico became an alluring destination for North American hippies, who were attracted by the country's rich indigenous cultures, as well as by the easy availability of marijuana, peyote, and psilocybin mushrooms.[30] A countercultural movement known as La Onda emerged in Mexico City, galvanizing working- and middle-class youth in opposition to conservative and patriarchal state institutions. The counterculture was associated with *desmadre*, the social chaos that contrasts with *buenas costumbres*—something akin to "family values."[31] As Zolov explains, "La Onda became a pretext for *desmadre*, for openly defying the *buenas costumbres* of family and society through drug consumption, liberated sexual relations, and in general replacing familial dependency with independent living."[32] The anti-authoritarian politics of La Onda became a driving force behind a student movement against a state dominated by one corrupt party—the Institutional Revolutionary Party (PRI), autocratic presidential authority, restrictions on free speech, economic inequality, and police repression. Protesters sharply criticized Mexico's hosting of the 1968 Olympics, which they saw as a wasteful extravagance for a developing country with pressing social needs.[33] In October 1968, just weeks before the Olympics, the conflict between the students and the state reached a tragic

denouement with the massacre of protesters by army detachments in the Tlateloclo section of Mexico City. In the wake of the massacre, La Onda counterculture became an important vehicle for expressing disillusionment with the political system, but also for pursuing alternative lifestyles inspired by the international hippie movement.[34]

As elsewhere, Latin American countercultures were closely associated with the worldwide spread of rock music, facilitated by the expansion of radio and television networks, the growth of multinational recording companies, the availability of cheap radios, turntables, and vinyl records, and the development of print media dedicated to the genre and its cultural styles. The groundbreaking collection of essays *Rockin' Las Américas* (2004) shows that vibrant rock subcultures were emergent in urban centers throughout Latin America, from large nations such as Argentina, Brazil, and Mexico to smaller nations such as Guatemala, Cuba, and Uruguay. Latin American rock fans and performers were subject to government repression, intellectual scorn, and social opprobrium under both conservative and progressive, authoritarian and democratic regimes.[35] Critics on the Right associated rock with social subversion and sexual promiscuity, while leftists denounced the genre as a symbol of U.S. cultural imperialism, which undermined national music. Rock music was typically positioned in opposition to local musical traditions and Left-nationalist neo-folk movements such as Chilean Nueva Canción, Cuban Nueva Trova, or Brazilian Canção de Protesto, which eschewed the use of electric instruments in favor of acoustic guitars and regional instruments. These various "new song" movements mobilized a didactic language of social protest, national liberation, and anti-imperialism, while the early phase of Latin American rock 'n' roll tended to focus on themes of youth sociability, style, consumption, and sexual adventure. For example, the Brazilian Jovem Guarda, or "young guard," led by the telegenic crooner Roberto Carlos, gained mass popularity in the mid-1960s with songs about romantic dramas, fast cars, and everyday life in the city. Artists associated with MPB (Música Popular Brasileira), the designation for popular music based primarily on national or regional traditions, composed their share of love songs but also explored themes of social inequality and injustice. Tensions between local rock and acoustic protest music were related to larger Cold War–era ideological struggles over whether to pursue capitalist or socialist strategies for modernization in Latin America.[36] In this context, left-wing intellectuals and artists tended to reject rock music as "alienated" commercial entertainment imported from the United States.

Following the worldwide success of The Beatles and other British Invasion

groups, rock gained a measure of intellectual prestige as an art form with sophisticated lyrics and virtuoso musicianship. Distanced from its origins in African American dance music, rock attracted middle-class, predominantly white and male connoisseurs for whom rock was a musical genre for intellectual contemplation and cathartic revelry. By the early 1970s, the tension between rock and national musical traditions had largely dissipated, leading to greater fluidity between rockers and folk artists, as seen in the famous collaboration in 1971 between the Chilean group Los Blops and Victor Jara, the legendary singer-songwriter of Nueva Canción, who was tortured and executed two years later by army officers soon after the military coup led by Augusto Pinochet.

With the emergence of countercultural movements in the late 1960s and early 1970s, rock music (as well as new styles that combined rock with local musical traditions) increasingly embraced the language of social dissent and political protest. In Mexico, a rock movement known as La Onda Chicana rejected the imitation of foreign models and forged an original sound, albeit with English lyrics. For a brief period in the early 1970s, bands associated with La Onda Chicana enjoyed unprecedented support from multinational record companies and significant media exposure, allowing them to attract diverse, cross-class audiences.[37] La Onda Chicana reached its peak in September 1971 with the Avándaro Rock Festival, which attracted a huge audience to the Valle de Bravo near Mexico City. Reports and images from the festival portrayed scenes of triumphant *desmadre*, with widespread drug use, frenzied collective dancing, and the indecorous display of the Mexican flag. Critics on the Left and the Right were swift to condemn the festival, as well as La Onda Chicana movement. Conservatives fretted that it undermined *buenas costumbres* and promoted behavioral transgressions, while leftists denounced it as an instance of "mental colonialism" (in the words of Carlos Monsiváis) that distracted youth from political organizing.[38] The Avándaro Festival marked the apex of La Onda Chicana but also led to its demise and banishment from national memory as the government actively suppressed the rock counterculture.[39]

In some national contexts, rock music was tolerated and even embraced by left-wing revolutionaries. Vania Markarian shows, for example, that Uruguayan communists were remarkably open-minded toward the rock counterculture in their efforts to appeal to a youth constituency.[40] In the late 1960s, the official communist newspaper offered a Sunday supplement, "La Morsa" (The walrus), an homage to The Beatles' "I Am the Walrus" (1967), which featured stories about rock music, hippie style, and drug use,

alongside cartoons and psychedelic drawings. Uruguayan communists recognized the role of culture in creating the conditions for social transformation.[41] In Argentina, rock music was part of a broader revolt of urban youth during a period of political instability and violence following the ouster of Juan Perón, the populist modernizer who inspired a broad, heterogeneous movement that included both leftist revolutionaries and right-wing groups that fought over the meaning of his legacy during his long exile in Spain (1955–73). Valeria Manzano writes that rock had become "the core of antiauthoritarian politics" during the period of military rule in the late 1960s.[42] A group known as Los Gatos scored a big hit in 1967 with "La Balsa" (The raft), which beckoned youth to drop out of society and live adrift on an imaginary raft. The "long-haired boys" identified with an emergent Argentinian hippie movement thereafter came to be known as *náufragos*, or "shipwrecked sailors," who pursued a politics of personal liberation.[43] Left-wing Peronists acknowledged the cultural legitimacy and political potential of rock, but they typically dismissed local hippies as alienated youth under the sway of imperialist propaganda.[44] Both rockers and revolutionaries were subject to violent repression with the ascendancy of right-wing Peronists following Perón's return from exile and the subsequent return of military rule in 1976.

While most frequently suppressed by conservative civilian and military regimes, rock music and other countercultural manifestations were also stifled by leftist regimes. The revolutionary government of Cuba denounced rock as frivolous entertainment complicit with U.S. cultural imperialism, rendering it incompatible with the nationalist cultural policy of the state. As the socialist regime consolidated its control over mass media, English-language rock was driven underground and even prohibited for a time from the Cuban airwaves.[45] Robin Moore observes that the Cuban government associated rock with "alternative dress and lifestyles" that were incompatible with the socialist project. "To the leadership," he writes, "the implicit aesthetic of all rock, with its emphasis on transgression, physical gratification and liberation, excess and pleasure, ran contrary to the development of a disciplined and self-sacrificing socialist mentality."[46] Moore cites one interview that suggests that thousands of young men, including "hippies, long-haired ones, malcontents," were sent to farms and camps, where they engaged in manual labor and attended compulsory reeducation sessions.[47]

Socialist governments were wary not only of rock but also of countercultural movements espousing heterodox ideas about achieving collective liberation through individual liberation, which turned Marxist theory on its head. Patrick Barr-Melej has shown that the Popular Unity government

of Salvador Allende in Chile actively suppressed a movement known as Poder Joven, which was led by a charismatic leader known simply as "Silo." Developing as "an esoteric fragment" of the Chilean counterculture, the siloístas shared affinities with local hippies but eschewed recreational drug use and free love.[48] The siloístas dismissed Allende's socialist government as "reformist" and advocated self-transformation as the path toward "total revolution." Although a small group, the Poder Joven attracted the scrutiny of the Popular Unity government, which eventually arrested its leaders and accused them of corrupting young, impressionable women.[49] The persecution of Poder Joven revealed the conservative social values of the socialist government under Allende. Branded as fascist by some reporters during the Allende years, the Poder Joven would be denounced as subversive Marxists following the 1973 military coup that destroyed the Popular Unity government and ushered in a right-wing authoritarian regime under Augusto Pinochet. In the wake of the coup, siloístas were persecuted and arrested but escaped the fate of other leftists who were executed and disappeared by the Pinochet regime.[50]

The counterculture in Latin America was always open to the charge that it was imported and inauthentic. From this perspective, the counterculture would be one more idéia fora do lugar, an "out-of-place" idea, to remember Roberto Schwarz's famous formulation pertaining to the circulation of classic liberalism among elite circles in nineteenth-century Brazil at a time when the economy was dependent on slave labor.[51] Schwarz argued that these ideas, unmoored from economic and social reality, took on lives of their own as markers of social prestige—a kind of hollow cosmopolitanism. Along these lines, Carlos Monsiváis questioned the relevance of La Onda, in light of Roszak's interpretation of counterculture as a revolt against technocracy in advanced industrial societies. Monsiváis writes: "Of what great abundance can the Mexican hippies deny? Against which high technology do they protest in the name of love?"[52] Monsiváis's critique of La Onda reminds us of the need to contextualize and specify, but it misses its mark by assuming that all youth countercultures emerge in response to the same, or even similar, structural environments.

≈ The Brazilian Sixties

Several years ago, I found a period photograph in the National Archive of Rio de Janeiro that provides a suggestive portrait of late 1960s Brazilian youth. Little information accompanied the image other than that it featured a group

of university students, most likely in Rio de Janeiro, in April 1967. At the time, the military regime was implementing legal and constitutional mechanisms for institutionalizing authoritarian rule, while opposition forces, including political leaders, student groups, and a variety of armed organizations, intensified their activities. Despite the increasingly dire political climate, the students in the photo form a tableau of diverse subjectivities as they enjoy a moment of leisure. A young woman, dressed conservatively in a cotton dress and slipper flats, braids the hair of a friend, who wears similar attire. Sitting beside them, another woman sports a "mod" look, with loosely worn long hair, a black shirt, a plaid skirt, and leather boots. The young man who seeks her attention affects an emergent hippie style; he is a *cabeludo* ("long hair") with a handlebar moustache, muttonchop sideburns, leather sandals, and a groovy flowered shirt. Behind them, a young black man, shirt unbuttoned, appears to clap, as if marking the rhythm together with others who are outside of the frame. In the upper left corner of the photo, a fragment of graffiti seems to pose a question about the responsibility of humanity to combat evil. On an adjacent wall, over the hippie couple, another bit of graffiti features the international peace symbol with the famous antiwar slogan of the United States, rendered ungrammatically as "MAKE LOVE, DON'T WAR." The graffiti calls attention to the international circulation of discourses and cultural artifacts relating to the youth counterculture of the United States and how these were "translated" and made into something new in other national contexts. In late 1960s Brazil, the slogan simultaneously protested the Vietnam War and the violence of the military government, but it could also be read as a rejection of armed struggle.

Although it was part of a global phenomenon, the counterculture emerged as a response to particular conflicts and crises in Brazilian society. The young Brazilians who would participate in varying degrees and ways in the counterculture came of age during a period of rapid modernization and intense political turmoil. Many were adolescents and young adults during the presidency of Juscelino Kubitschek (1955–60), a democratic populist committed to a program of rapid modernization, conceived broadly in terms of infrastructural development, industrialization, education, and social progress. The new futuristic capital city of Brasília, with buildings designed by world-renowned modernist architect Oscar Niemeyer, was inaugurated in 1960 as the crowning achievement for a president committed to positioning his country among the ranks of developed "first world" nations. Kubitschek's deficit spending to finance his developmentalist ambitions contributed to a severe economic crisis in the early 1960s, one factor that

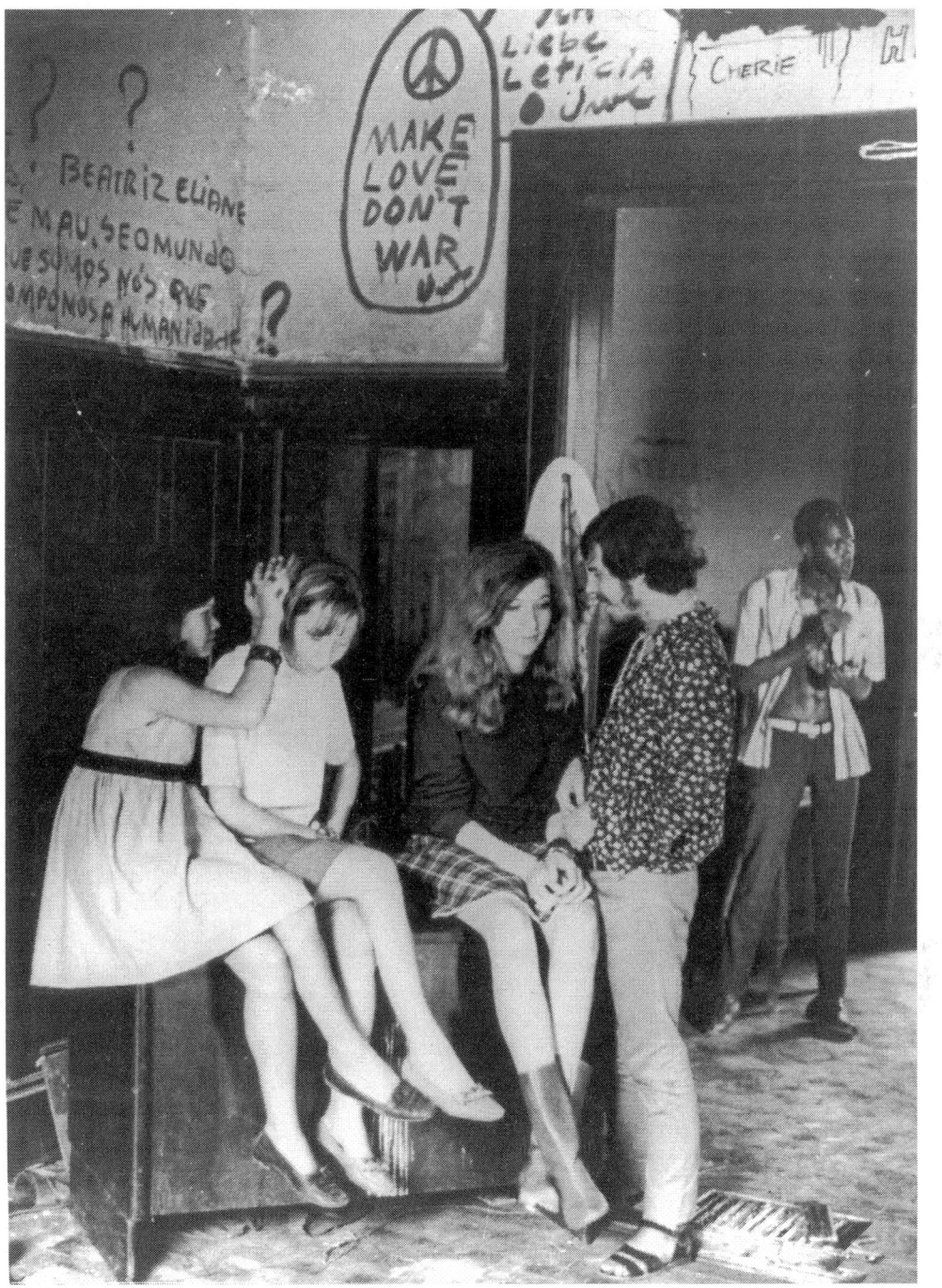

Brazilian students, 1967. Photo by Pimentel. Courtesy of the National Archive, Rio de Janeiro.

provoked the abrupt resignation of his successor, Jânio Quadros, after just seven months in office. Despite fierce opposition from the military establishment and its conservative civilian allies, Quadros's vice president, João Goulart, assumed the presidency in 1961.

During this period, an array of progressive political organizations, referred to as *esquerdas*, or the "lefts," enjoyed considerable influence among students, workers, progressive intellectuals, and urban professionals. The National Student Union (UNE) became increasingly radicalized as it advocated for a central role for university students in national politics. Through its cultural wing, the People's Center of Culture (CPC), the UNE reached out to urban and rural masses, the *povo*, in an attempt to mobilize society in support of social revolution. The Brazilian Communist Party (PCB), founded in 1922, was the dominant ideological force among the Brazilian lefts. The PCB, known as the *partidão* ("big party"), advocated an alliance of progressive national bourgeoisie, workers, and peasants against foreign capital allied with traditional landed elites. The PCB called for a popular front alliance in cooperation with the Goulart government in order to enact social transformation, starting with agrarian reform to address severe inequalities and alleviate misery in the rural areas.

The Brazilian lefts, as Marcelo Ridenti has written, embraced an ethos of "revolutionary romanticism," which combined cultural nationalism with a rejection of modern capitalism.[53] Inspired by anti-imperialist struggles throughout Africa, Asia, and Latin America, Brazilian leftists employed the language of national liberation from the tyranny of traditional elites in collusion with international capitalism. The Cuban Revolution was particularly inspiring, especially for Brazilian university students, who dreamed of closer ties to the masses. As Roberto Schwarz has written of the early 1960s: "Prerevolutionary winds were decompartmentalizing the national consciousness and filling the newspapers with talk of agrarian reform, rural disturbances, the workers' movement, the nationalization of American firms, etc. The country had become unrecognizably intelligent."[54] Radicalized youth engaged in these struggles and debates firmly believed that Brazil was on the path to socialism.[55]

For Brazilian leftists caught up in what at the time seemed like "prerevolutionary winds," the military coup of April 1, 1964, supported by the U.S. government, came as a bitter surprise. Their dismay was further compounded by the outpouring of support for the new regime among the urban middle classes, which had been alarmed by left-wing mobilization during the Goulart years. Supporters of the coup ransacked and torched the UNE

headquarters, which had tremendous symbolic value to the student Left.[56] In the months following the coup, many student leaders were arrested, while others fled the country. Just days after the coup, hundreds of supporters paraded through Rio de Janeiro in the March of the Family with God for Liberty, a name that underlines the interconnection between authoritarian politics and traditional religious and family institutions.[57] For these demonstrators, as Carlos Fico suggests, the coup was nothing less than the restoration of Christian civilization and traditional family values in the face of godless communism. Their popular endorsement bolstered the ideas, common among military circles, that the coup responded to a moral crisis in Brazilian society and that the regime had a new "civilizing mission" to accomplish.[58]

During the first phase of consolidation under the presidency of Humberto Castelo Branco, the regime aggressively suppressed established left-wing parties, such as the PCB and the Communist Party of Brazil (PCdoB), student groups such as the UNE, labor unions, peasant leagues, and other organizations involved in political organizing. Once order was restored and the threat of communist revolution was defeated, Castelo Branco hoped to call elections and return the country to civilian rule. The regime instituted a series of *atos institucionais* (institutional acts), known by numbered acronyms, that gave the regime broad powers to change the constitution, suspend political rights, remove legislators, and dismiss federal employees (AI-1), and to establish indirect elections for president (AI-2), as well as for governors and mayors of state capitals and other major cities (AI-3). All existing political parties were abolished and replaced by the pro-government Alliance for National Renovation (ARENA) and an officially sanctioned opposition, the Brazilian Democratic Movement (MDB). During the Castelo Branco years, civil society remained relatively open, with an unfettered national press and a vibrant cultural scene. Although the Left had been defeated, there were still opportunities to express dissent through organized demonstrations, labor strikes, political journalism, and anti-regime expressive culture. Many left-wing artists and intellectuals regarded the U.S.-backed coup as a surmountable obstacle and maintained an abiding belief in the revolutionary potential of protest culture to inspire and mobilize people.[59]

As opposition to military rule grew, the regime intensified its efforts to violently suppress dissent. In turn, activists began to turn away from the aboveground opposition movement and join armed clandestine organizations, such as the Ação Libertadora Nacional (ALN), founded by Carlos Marighella in 1967 as a dissident group of the PCB. In quick succession, around thirty clandestine groups of various sizes formed with the intent to

oppose and eventually overthrow the regime by force. Marcelo Ridenti has estimated that the armed Left involved around 2,465 people, mostly university students under the age of twenty-five.[60] Although relatively small in numbers, the clandestine opposition quickly gained notoriety through daring operations, including bank robberies and high-profile kidnappings in exchange for ransom.

In response to the radicalization of the opposition, the regime approved a fourth institutional act in 1967, which established a new constitution designed to concentrate power in the executive branch, restrict labor rights, and expand military justice, thereby providing a legal structure for establishing a national security state. That same year, the second military president, Artur da Costa e Silva, signed an executive decree that established a new National Security Law designed to combat political subversion or armed insurgency, especially those efforts motivated and/or funded by international communism. In addition to provisions one would expect to find in a law of this kind (for example, prohibitions against espionage, armed attacks on elected officials and government installations, and attempts to establish independent territories within the national boundaries), the 1967 decree-law effectively established a police state. It made all people and institutions responsible for national security, so that it would be incumbent on Brazilian citizens to police one another. In addition to provisions against armed insurgency, the law also prohibited oppositional discourse in the form of "antagonistic threats or pressures," "propaganda or counterpropaganda," or "false, tendentious, or distorted news" that might embarrass the regime or compromise the "prestige of Brazil." The law reveals a particular anxiety in relation to external forces or actors that might attempt to introduce "propaganda of foreign origin" contrary to national interests as defined by the regime. The threat of international communism was the primary concern, but the law was written broadly so that it could also be applied to other discourses and ideologies deemed incompatible with national security. The secret police, known as the Departamento de Ordem e Política Social (Department of Political and Social Order), or DOPS, kept extensive files on citizens it regarded as potentially subversive, including dozens of artists and intellectuals. In a study of DOPS files concerning Brazilian musicians, Marcos Napolitano found that these reports were generally "guided by a mixture of ultra-moralist, anti-democratic, and anti-communist values," yet also often "incoherent" and exaggerated.[61] In their zeal to uncover subversive behavior, regime agents often grossly misinterpreted the behavior of the people and events they spied on.

≈ 1968: The Year That Never Ended

The year 1968 has accrued heightened symbolic value as a watershed year for political, social, and cultural transformation in many countries. Student protests erupted throughout Western Europe, most notably in France, where students forged a brief alliance with labor unions against the conservative Gaullist state and nearly brought the capitalist economy to a halt. The "events of May" disrupted social identities and produced conditions for cross-class communion in a deeply compartmentalized and hierarchical society.[62] In the former Czechoslovakia, leaders instituted a series of liberal reforms designed to "humanize" socialism, before Soviet forces invaded and put an end to the Prague Spring. Students in Belgium, Italy, Poland, Spain, and Sweden also occupied universities and demonstrated in the streets.[63]

In Brazil, 1968 holds particular significance as the year of mass demonstrations against the military regime, initially sparked in April 1968 when Edson Luis, a working-class student from Pará, was shot by the state police at a student cafeteria in downtown Rio. In her evocative account of this tragic incident, Victoria Langland has shown how the death of Edson Luis galvanized the student-led opposition and mobilized broad sectors of civil society against the dictatorship. Under the slogan "neste luto começa a luta" (in mourning, the struggle begins), many student activists imagined that a mass uprising against the regime was under way.[64] In June 1968, Brazilian students led a group of artists, clergy, and other civil society leaders in the March of 100,000 through downtown Rio, a peaceful event that demonstrated broad opposition to military rule. For Brazilian leftists, 1968 would be imbued with special meaning as an exhilarating and dangerous year when it was still possible to imagine the defeat of authoritarian rule, the return to democracy, and the resumption of a revolutionary path to socialism. That such an outcome proved illusory only enhanced the symbolic importance of the year. As Langland writes, "The '1968' that swelled beyond the bounds of a temporal marker to become a broadly powerful and contested memory of massive, anti-regime student protest, was only created in the years following."[65] In the words of Brazilian journalist Zuenir Ventura, 1968 was "the year that never ended."[66]

The year 1968 also witnessed tremendous cultural effervescence in Brazil. A vibrant culture of critique and dissent had developed in the years following the military coup, with powerful manifestations in all realms of cultural production. Serious divergences erupted among artists regarding the political relevancy, aesthetic innovation, and value of entertainment, pleasure, and

joy in art. Some artists were committed to an instrumentalist vision of art as a vehicle for raising political consciousness and mobilizing people. Other artists, most conspicuously the poets and visual artists of the concretist avant-garde, which emerged in the 1950s, defended what Charles Perrone has called "the imperative of invention" and rejected overtly political art bereft of formal innovation.[67]

A series of cultural interventions in popular music, visual arts, theater, and film erupted in 1967–68, eventually coalescing under the banner of "Tropicália" (or "Tropicalismo"). Tropicália is best understood as a cultural "moment," although it briefly coalesced as an organized movement in popular music in 1968.[68] Beginning as the name for an installation by Hélio Oiticica, the term "Tropicália" was appropriated by an emerging singer-songwriter, Caetano Veloso, as a song title. Veloso was part of a larger group of young artists from the northeastern state of Bahia who had migrated to Rio de Janeiro and São Paulo in the mid-1960s to pursue careers in popular music. In late 1967, Veloso and fellow Bahian Gilberto Gil attracted an enthusiastic audience of listeners after participating in a competitive televised song festival, in which they placed fourth and second, respectively. In 1968, they launched a movement with two other Bahian artists, Gal Costa and Tom Zé; a psychedelic rock band from São Paulo, Os Mutantes; and a small cohort of avant-garde composers and arrangers. The tropicalists generally avoided obvious expressions of political protest, preferring instead satirical or allegorical commentary on everyday life in urban Brazil. They were acutely sensitive to contradictions and disjunctures in Brazilian society, which was modernizing rapidly even as severe poverty and archaic social relations persisted. At the same time, they critiqued cultural nationalism by rereading the Brazilian song tradition in light of post-Beatles rock and other forms of international pop.

The historiography of Tropicália has tended to focus on popular music, the only field in which an actual movement coalesced, often leading to the erroneous perception that tropicalist phenomena in other fields were mere appendages of the music. Frederico Coelho has argued for making a clear distinction between *tropicália*, which involved avant-garde visual artists, writers, and filmmakers, and *tropicalismo musical*, which operated in the terrain of mass culture.[69] "The memory of tropicalismo," he writes, "has swallowed the memory of tropicália."[70] This distinction allows us to better appreciate the trajectories of several distinct art forms in relation to internal debates proper to their respective fields, particularly in relation to the avant-garde tradition in Brazil. Oiticica's work, for example, was deeply rooted in the

midcentury constructivist avant-garde and its peculiar trajectory in Brazil. Since the late 1960s, critics have argued that Tropicália represented the moment of invention and innovation, while Tropicalismo denoted a subsequent moment of dilution, stereotype, and massification.[71] While such a distinction helps to sort out the disciplinary genealogies of diverse artistic practices, it also suggests a value-laden binary division between Tropicália (invention) and Tropicalismo (dilution). The tropicalist musicians themselves preferred the term "Tropicália" and produced music that was highly experimental, as well as accessible pop songs. Moreover, the separation of tropicalist music from the other fields obscures or minimizes the vital intersections, however partial or messy, between them. Oiticica himself insisted on the singular importance of the tropicalist musicians, especially Veloso and Gil, and the profound affinities he shared with them. Tropicália was a fractured and fleeting totality, encompassing several projects, rife with tensions, but still meaningful as a moment of exchange across artistic fields.

I have argued that Tropicália may be understood as an inaugural gesture of the Brazilian counterculture.[72] Although artists associated with Tropicália did not articulate their project in terms of "counterculture," their works and public statements introduced to Brazilian audiences some of the attitudes, ideas, and styles associated with the international phenomenon. Tropicalist musicians, for example, used electric instruments, appropriated elements of contemporary international rock, and sang about everyday forms of social dissent and transgression. Veloso's "É proibido proibir" (It's forbidden to forbid), for example, called for "tearing down the shelves, bookcases, statues, tableware, books," in a cathartic gesture of refusal to adhere to social conventions.[73] Although mistrusted by the PCB-dominated Left, which abhorred their use of electric instruments and their anarchic performances, the tropicalists eventually aroused suspicions among regime agents, who mistook them for protest singers. In October 1968, they were publicly denounced by a popular radio host in São Paulo for supposedly performing a parody of the national anthem during a concert in Rio, which appears to have led to their arrest two months later. Although the charge was false, it showed that the regime was particularly sensitive to any attack, however lighthearted or innocuous, on national symbols.[74]

Although mass demonstrations waned after the March of 100,000 in June, tensions between the regime and the civilian opposition continued to mount throughout 1968. Meanwhile, the armed insurgency gathered momentum in the major cities, especially Rio and São Paulo. On December 13, the regime approved a fifth institutional act, known simply as AI-5, which suspended

congress, prohibited political demonstrations, suspended habeas corpus, and established strict censorship over the press, music, theater, and film. AI-5 stripped dissenting public servants, including university professors, of their jobs and their political rights. The fifth institutional act signaled the definitive ascension of hard-line forces within the military regime, such that it is often referred to as a "coup within the coup." Prominent members of the civilian opposition fled the country or went into hiding. In late December, Veloso and Gil were arrested, imprisoned, and eventually placed under house arrest in Salvador, Bahia. In June 1969, they were sent into exile and relocated to London.

⇒ The Suffocating Miracle

AI-5 ushered in the most repressive phase of authoritarian rule, as the U.S.-backed military regime used unprecedented violence against the opposition in its efforts to safeguard the national security state. Known as the *sufoco* (suffocation) or as the *anos de chumbo* (years of lead), the period between 1969 and 1974 witnessed the triumph of the regime over opposition forces. Security agencies, mostly affiliated with branches of the military, made extensive use of torture to punish and extract information from insurgents, student leaders, and other dissidents. As the aboveground opposition was crushed, more Brazilians joined the clandestine insurgency, which was largely based in the cities. Armed organizations had some early successes, most spectacularly with the successful kidnapping in September 1969 of the American ambassador, Charles Elbrick. After four days, he was ransomed in exchange for fifteen imprisoned insurgents, who were then safely flown out of the country. Two subsequent kidnappings secured the release of more prisoners, but the regime redoubled its efforts to contain the insurgency and kill or imprison its leaders. By 1972, the armed movement had been defeated, except for a rural insurgency organized by the PCdoB in Araguaia, Pará, near the Amazon basin, which held out until 1974.

A new president, General Emílio Garrastazu Médici, presided over the most repressive phase of the dictatorship. A jovial leader with a populist touch, Médici enjoyed substantial popularity among Brazilians, despite the brutality of the regime he directed. Nationalist euphoria reached a peak in 1970 as Brazil became the first country to win three World Cup soccer championships. Some dissenters, rightly concerned that the regime would benefit from a World Cup victory, had met secretly to cheer for opposing teams.[75] The *sufoco* coincided with the so-called *milagre econômico* (economic

miracle), during which time the annual GDP of Brazil rose by an average of 11 percent each year.[76] The regime established a model of political economy based on authoritarian modernization, which emphasized capital accumulation, infrastructural and technological development, expansion of communications networks, and growth of consumer markets, while suppressing political dissent and curtailing labor demands. The regime hastened Brazil's uneven integration into a global market and an attendant expansion of an internal market for consumers of both durable goods and cultural products like television dramas, musical recordings, and publications of all sorts targeted to a mass audience.[77] The government also invested heavily in higher education, especially in engineering, law, business, and technical areas that would directly contribute to economic growth. The expansion of university enrollments followed a larger international pattern of postwar growth in higher education in the United States, Western Europe, and the Soviet Union.[78] Between 1971 and 1976, Brazilian university enrollments nearly doubled, to over a million students by mid-decade.[79] An expanding urban middle class gained new buying potential to participate in a growing market for new automobiles, household goods, and other consumer items. Most middle-class youth were integrated into the system as they sought to take advantage of new opportunities for social advancement. In the early 1970s, as Idelber Avelar has noted, "television disseminated daily messages about how great things were, federal censorship tightly controlled the written press, and an economic boom, favored by the increased extraction of surplus labor made possible by repression, contributed to keep the middle class satisfied or immobilized."[80]

It was a period when the Brazilian government "reinvented optimism," in the words of historian Carlos Fico. Médici hired public relations experts, who mobilized a long tradition of patriotic sentiment, known as *ufanismo*, which exalted Brazil's qualities as a cordial and prosperous country. The modern discourse of Brazilian optimism was forged in the 1930s during the rule of Getúlio Vargas, which used its powerful Department of the Press and Propaganda (DIP) to broadcast and circulate celebratory images and ideas pertaining to Brazil's grandeur. The Vargas government coincided with the elaboration of a national discourse that asserted Brazil's unique propensity for racial and cultural mixture, or *mestiçagem*, a discourse most closely associated with the patrician intellectual Gilberto Freyre. In the 1960s and 1970s, Freyre gained notoriety as the primary ideologue of "racial democracy," which asserted the relative absence of racism in Brazilian society, especially in comparison to the United States. Freyre was an ardent

supporter of the military regime that came to power in 1964, and his works were widely read and admired by military officials who endorsed the racial democracy thesis.[81]

Regime publicists were careful to avoid heavy-handed official propaganda typical of the Vargas-era DIP and sought to convey a sense of levity and happiness in their celebration of Brazil.[82] They even worked with commercial advertising agencies to encourage them to refrain from making references to repression in sales pitches like "free yourself from the tyranny of coffee filters" or "down with the dictatorship of prices."[83] One particularly striking example of this kind of advertisement showed a television set against a dark background, lit by a single overhead light, with a coiled leather whip in the foreground next to the message: "In the torture chamber, Philips 550 resisted everything."[84] By 1970, regime publicists had ensured that such references to coercion and violence in advertising would be curtailed.

Created in 1968, the Assessoria Especial de Relações Públicas (Special Office of Public Relations) developed campaigns that emphasized national optimism. Its consultants sought to avoid the repetition of an infamous campaign around the slogan "Brasil: ame-o ou deixe-o" (Brazil: love it or leave it), based on the Vietnam War–era slogan of the American right, which appeared on bumper stickers throughout Brazil. Created in 1969 by the special counterinsurgency unit Operação Bandeirantes (OBAN), the slogan was a menacing ultimatum that reinforced the dour and cantankerous image of the generals. To counter this image, consultants created buoyant slogans such as "Ninguém segura este país" (Nobody can hold back this country, 1970), "É tempo de construir" (It's time to build, 1971), "Você constrói o Brasil" (You build Brazil, 1972), "País que se transforma e se constrói" (A country that changes and builds, 1973), "O Brasil merece nosso amor" (Brazil deserves our love, 1973), and "Este é um país que vai pra Frente" (This is a country that is moving forward, 1976).[85] Many of these campaigns coincided with massive public works projects like the Transamazonian Highway, the Itaipu Dam, and the Rio-Niterói Bridge, which bolstered the regime's discourse of "Brasil Grande," emphasizing the grandeur, size, and potential of the country.[86] Some popular entertainers contributed to the climate of patriotic euphoria with songs that celebrated military rule. The duo Don & Ravel scored a massive hit with the song "Eu te amo, meu Brazil" (I love you, my Brasil), which was recorded by the rock band Os Incríveis in 1970. High school textbooks from this period included these lyrics to be analyzed and discussed in class.[87] The regime mobilized the rhetoric of populism, appropriated from the Left,

in order to claim its role as protector of national identity and to cast suspicion on intellectuals, especially the voices of dissent.[88]

AI-5 ushered in a period of intense political repression, producing what Zuenir Ventura famously described as a *vazio cultural* (cultural void)—a perceived dearth of creativity in comparison to the flourishing of artistic expression during the 1950s and 1960s. In an article published in the national magazine *Visão* in July 1971, Ventura observed: "In the field of architecture and urbanism, nothing comes close to the inventive grandiosity of Brasília; in the field of cinema, no movement like Cinema Novo; nothing comparable to Bossa Nova in music; the Arena Group in theater or the formalist investigations in literature by the concretists; nothing like those movements of critical self-reflection in relation to the country."[89] He pointed to several factors to explain this cultural impasse, including a rigorous regime of censorship affecting all of the arts, the exile of artists for both political and professional reasons, and the intellectual and creative impoverishment of cultural production. At the time, Ventura reported that around one hundred plays, thirty films, and sixty songs had been prohibited since 1968. Countless books had been confiscated, including works by venerable authors such as Machado de Assis, Jorge Amado, and Carlos Drummond de Andrade.[90] Visual artists tended to have more creative freedom since the regime regarded them as relatively inconsequential, but several major exhibitions were censored in the late 1960s and early 1970s.[91]

While Ventura's notion of *vazio cultural* captured the sense of malaise and disillusionment with the defeat of revolutionary aspirations in Brazil, it was also limited by a rather narrow view of what constituted culture (that is, middle- and upper-class urban artistic expression). It also idealized the achievements of the 1950s and 1960s while overlooking the unique dynamics of cultural production after AI-5. Despite a climate of intense repression, there was a remarkably vibrant alternative press, an emergent poetry movement (*poesia marginal*), experimental cinema with feature-length and short films made with Super 8 cameras (*cinema marginal*), and extraordinary innovations in popular music. Some of the most influential and critically acclaimed Brazilian albums of all time, such as Gal Costa's *-Fa-tal- Gal a todo vapor* (1971), the Novos Baianos' *Acabou Chorare* (1972), Milton Nascimento's *Clube da Esquina* (1972), Caetano Veloso's *Transa* (1972), and Raul Seixas's *Krig-ha, Bandolo!* (1973), are from this period. Despite intense political repression and censorship, Brazilian artists managed to create works of great beauty and social relevance.

Marcos Napolitano has identified four principal sectors of left-wing political and cultural resistance to military rule in Brazil—liberals, communists, countercultural groups, and a New Left composed of progressive Catholics, socialists of various stripes, and emergent social movements.[92] There was also significant exchange and overlap among the groups, especially between the counterculture and the New Left social movements and between the communists and the liberals. Tensions were particularly acute between the communists, who defended a "national-popular" cultural model, the primacy of rationality, and the tactical integration into the culture industry, and the counterculturalists, who embraced international youth culture, questioned Western reason, and occupied a position of marginality in relation to dominant culture.[93] Key artists associated with the PCB, most notably the playwrights Dias Gomes, Oduvaldo Vianna Filho, and Paulo Pontes, pursued opportunities at the highest levels of the culture industry, including jobs writing, directing, and producing humor shows and soap operas (telenovelas) for TV Globo, an ally of the regime. Napolitano notes that these communist artists sought to "occupy spaces" within the system in order to reach a mass audience.[94] Countercultural artists sought to create alternative spaces of cultural production and circulation, although some enjoyed considerable mass appeal, most notably in the realm of popular music.

⇒ Dropping Out

During the years of the sufoco, most young Brazilians plodded along, avoided the authorities, and tried to take advantage of new opportunities for social advancement. Yet a significant minority, disillusioned with politics, unwilling to join the armed struggle, and alienated by society under authoritarian rule, embraced attitudes, ideas, and practices associated with the international youth counterculture. Embracing the counterculture could mean many different forms of dissent, from pursuing a modestly "alternative" lifestyle within a middle-class structure to more radical options of "dropping out," avoiding formal employment, pursuing an itinerant hippie lifestyle, or living in a commune. Although primarily a middle-class phenomenon, the counterculture also appealed to working-class youth who sought to escape the social confines of a class society. In his documentary about a favela community in Rio de Janeiro, Babilônia 2000 (2001), Eduardo Coutinho interviewed a working-class woman named Fátima who fondly recalled her days as a hippie in the 1970s. Fátima had read Herman Hesse's Siddhartha (1922), a story of Buddhist self-discovery that was popular among countercultural

youth in the 1960s and 1970s, and had named her first son after the mystical protagonist. In one scene, Fátima stands on a bluff overlooking Rio's south zone and passionately belts out her personal version of "Me and Bobby McGee," a song made popular by her favorite singer, Janis Joplin. Although just one example, Fátima's story suggests that the hippie movement and international icons of the counterculture circulated among working-class, as well as middle- and upper-class, Brazilian youth.

The recreational use of drugs, especially marijuana and hallucinogens, expanded dramatically among urban adolescents and young adults, becoming for many a central feature of daily life. Marijuana, or *maconha* (an anagram of *cânhamo*, or "hemp"), as it is called in Brazil, was introduced to Brazil by enslaved Africans, who valued the plant for its medicinal and recreational uses.[95] The sale and use of what was known as *fumo d'angola* was first prohibited by the municipal government of Rio de Janeiro as early as 1830 but was not vigorously prosecuted until the early twentieth century, when medical authorities branded it a danger to public health. By that time, smoking marijuana was stigmatized as a leisure activity of poor, predominantly black men, typically branded as *marginais* (outlaws). In 1938, the federal government established laws against the sale and consumption of marijuana, which was in line with a racialized public health discourse that pathologized its users as dangerous and unhygienic.

With the rise of the counterculture in the 1960s, the consumption of marijuana expanded dramatically among middle-class adolescents and young adults in urban Brazil. The expansion of drug use in Brazil provoked alarm and suspicion among agents of the regime and conservative opinion makers, who feared that it was part of a subversive plot to corrupt young people and lead them astray politically. In one DOPS report about a rock festival in Rio de Janeiro, the agent asserted that "drugs are used as a political weapon in order to attract and groom youth, create psychic dependence, and make them slaves to drugs in order to blackmail them into becoming new informants and faithful agents of international communism."[96] In Belo Horizonte, the DOPS created a dedicated unit to crack down on drug use, the Brigada de Vício (Vice Brigade), which was based on the assumption that drug use led to political subversion.[97] The purported association between drug use and political subversion circulated widely in international anticommunist circles and informed the military regime and its right-wing supporters.[98]

Contrary to these paranoid fantasies, accounts of recreational drug use in Brazil during this period suggest that it correlated with political demobili-

zation. In a classic ethnography on drug consumption and social behavior among a group of middle- and upper-class cariocas (as natives of Rio de Janeiro are known) from the city's south zone (zona sul), Gilberto Velho noted that his informants began regular use of marijuana around 1969.[99] He divided his informants into two categories—the young adult *nobres* (nobles), who associated drugs with mind-expansion, and the adolescent *anjos* (angels), who used drugs for pleasure, typically while surfing. For the former group recreational drug consumption was directly related to personal journeys of self-realization following the political trauma of the 1960s. The authoritarian turn ushered in by AI-5 emboldened the most radical opposition militants in their armed struggle but also had the effect of demobilizing people who had earlier participated in the protest movement. As young people turned away from political activities out of disillusionment and fear for personal safety, they reconsidered freedom in terms of individual life experience.[100] One woman related her quest for personal happiness after a period of discord and conflict driven by political activism: "I learned how to enjoy [*curtir*] things, people, my life, and value myself without having to always prove that I am good, dedicated, and serious."[101] With all of his informants, Velho found that drug use, especially smoking marijuana, was important for liberating the senses, facilitating self-knowledge, and relieving stress. Some members of the group, especially those who had spent time abroad, also used LSD and cocaine. His informants typically reported that marijuana had helped them to relax, engage productively in introspection, and access corporeal sensations with more intensity. The use of LSD as a resource and sacrament was potentially even more enriching but carried the risk of provoking a "bad trip," which induced unpleasant hallucinations and paranoia.[102] Several of his informants who were pursuing artistic endeavors used drugs to stimulate creativity. The therapeutic and inspirational value of drugs recalls similar claims in the United States—that drugs promoted "better living through chemistry," a promotional slogan for Dow Chemicals that was parodied by LSD enthusiasts in a popular poster.[103]

Antonio Risério has asserted that the consumption of marijuana brought together privileged and marginalized youth "in an exchange of life experiences and languages," which would contribute to overcoming what he calls "the shield of whiteness."[104] While it is reasonable to suppose that youth of different social classes came together in *rodas de fumo* (smoking circles), it is not clear that marijuana consumption undermined white privilege. Gilberto Velho's middle-class informants, for example, generally took a rather dim view of the Brazilian masses and idealized Europe as more civilized. One

informant admitted that he was "a bit of a racist," asserting that a national project involving Portuguese and blacks was "bound to fail."[105] Velho also observed that the white middle-class adolescents of Ipanema generally avoided contact with a mixed-race, working-class group of hippies.[106] He suggested that drug consumption in the early 1970s was, for his informants, a sign of distinction on par with having a university education, traveling to Europe, and being familiar with current artistic trends. For this group of *nobres*, which he called an "aristocracizing vanguard," leisure, consumption, and artistic creation took precedence over work, especially the kind of bureaucratic work considered to be *careta*, or boring. While pursuing a lifestyle oriented toward creativity and reflection was a sign of social distinction, it could also lead to financial troubles. Members of this group were careful not to slide into the chaotic, drug-fueled lifestyle of some hippies, who had lost social status.[107]

On one hand, the counterculture represented a generational revolt against conservative social and political values. Velho found that the parents of many of his informants were *udenistas*, or supporters of the National Democratic Union (UDN), a conservative, law-and-order party with substantial support from the urban middle class during the postwar period.[108] On the other hand, his informants expressed profound disillusionment with the PCB, severely criticized the regimes of China and the USSR, and blamed clandestine groups for provoking the regime and exacerbating violence. They became progressively less interested in politics as they became more involved in other forms of behavior regarded as "deviant," such as consuming marijuana and LSD.[109] With its focus on personal liberation, the counterculture could be regarded as politically ambiguous, potentially appealing to Brazilians of all political stripes. None other than Gilberto Freyre, one of Brazil's most famous conservative thinkers and an apologist for authoritarian rule, once affirmed a deep affinity for hippies for their rejection of "excessive convention."[110]

Many young Brazilians sought freedom from traditional family structures to live among friends or with romantic partners, which would have a profound impact on attitudes and behaviors relating to sexuality. Brazilian men had traditionally enjoyed sexual license, but middle-class women were expected to remain chaste and leave the family home only after marriage. Like their contemporaries elsewhere in the United States, Western Europe, and Latin America, thousands of Brazilian women migrated to urban centers, ran away to avoid the constraints of traditional family life, or simply moved out of their parents' homes to live with friends. "Leaving home," as

Valeria Manzano has observed in the context of urban Argentina, "was a metaphor for young women's life experiences and for public perceptions about them."[111] The rise of communal living among young Brazilians of both sexes further advanced the trend toward increased sexual freedom, aided by the increasing availability of contraceptives, which authorities regarded as a threat to social order.[112] In recalling this period, the psychoanalyst and journalist Maria Rita Kehl has observed that politics shifted from public to private spheres among middle-class Brazilians of her generation: "[It was a] generation that left the family home, not to study in another city or join the clandestine armed struggle, but simply to live another way, refusing a consumerist attitude, adopting a kind of aesthetics of poverty and avoiding (at least this is what we sought) any work that would contribute to the strengthening of capitalism."[113] These "micropolitical" or "molecular" transformations, according to Félix Guattari and Suely Rolnik, were essential for initiating and sustaining larger processes of social transformation.[114]

A distinctly Brazilian neologism, *desbunde*, and its adjective, *desbundado*, were added to the urban lexicon to refer to a range of countercultural practices, from psychedelic revelry to quiet withdrawal from family and society to pursue a life less devoted to work and consumption and more oriented toward creative leisure. With etymological origins in *bunda* (buttocks), the most widely used Africanism in the Brazilian lexicon, *desbunde* began as an epithet used by guerrillas against former comrades who opted to leave the armed struggle. Turning Grandin's phrase on its head, *desbunde* might be understood in the Brazilian context as the "will to not act"—a deliberate choice to reject the armed struggle and disengage from society. As it became more broadly associated with the hippie movement, *desbunde* accrued additional associations with heightened emotional, sensorial, and social experiences.

Agents of the regime and local police authorities predictably took a rather dim view of countercultural youth, particularly hippies, whom they regarded at best as unwanted vagrants, and at worst as dangerous subversives. Many left-wing intellectuals also dismissed the counterculture, which they perceived as an insidious import from the United States that distracted and weakened the opposition to the military regime. Writing for *Opinião* in 1973, Luciano Martins criticized a culture of "horoscopes, drugs, and magic," which he regarded as part of the same "obscurantist syndrome" afflicting middle and upper classes, including members of the intelligentsia.[115] He later expanded this critique in a long essay, "Geração AI-5" (1979), which examines the generation that came of age around the time the regime enacted

the fifth institutional act. Martins employed the concept of alienation, a standard analytical category of the Marxian toolbox, to describe the behavior of urban youth from affluent families of Rio's south zone. Lacking mechanisms for expressing themselves and conditions for analyzing authoritarian violence, they were unable to formulate political objectives and became estranged from the social world.[116] In his view, counterculture was at once an expression and an instrument of alienation that prevented Brazilian youth from critically engaging society. In the absence of opportunities for collective expression and resistance, the counterculture merely offered "recipes for personal liberation" based on an array of "idiosyncratic behaviors."[117]

Martins identified three main tendencies of the counterculture that had alienating effects: drug use, the disarticulation of discourse, and psychoanalytic fads. Drugs produced physical dependency that suppressed the will of the subject. Taking drugs was, for Martins, a form of evasion, a means by which disaffected youth avoided confronting social and political realities with logic and reason.[118] Contrasting the political discourse that had mobilized resistance during the first phase of military rule in the mid-1960s, he argued that the language of the counterculture amounted to little more than an obscure lingo, a kind of hippie Esperanto, with minimal capacity to engage the wider society.[119] For Martins, the indeterminacy and imprecision of these words suggested an insular, detached social milieu devoid of historical consciousness. He was also wary of what he called *modismo psicoanalítico*, the vogue for psychoanalysis among Rio's middle and upper classes. Noting the dramatic expansion of the market for psychotherapy, he criticized Brazilian psychoanalysts for failing to distinguish people with psychological pathologies from those who had emotional problems due to the social and political context. The AI-5 generation, Martins concluded, suffered from a kind of narcissism focused on personal therapeutic solutions with little regard for the conflict between society and individual. In embracing a project of personal liberation and sensorial gratification based on enjoyment and detachment from the political context, one was reduced to being nothing more than a *bobo alegre* (happy fool), blissfully alienated from reality.[120]

As elsewhere in Latin America, the Brazilian counterculture emerged in dialogue with New Left, hippie, and underground movements in the United States and, to a lesser extent, Western Europe. An active alternative press, discussed in Chapter 1, provided a steady stream of information about the artistic, philosophical, and social trends connected to the counterculture. Roszak's *The Making of a Counter Culture* was translated into Portuguese and published in 1972 as *A contracultura* by the progressive Catholic press Edi-

tora Vozes.[121] The latest rock albums by American and British rock groups were readily available in major Brazilian cities as domestic releases by multinational recording companies, such as Philips, RCA, and Warner. Alternative and mainstream print media devoted extensive coverage to the recordings and concerts of these groups. In 1973, music journalist Roberto Muggiati published Rock, o grito e o mito (Rock, the scream and the myth), which introduced Brazilian readers to the history of rock, from rhythm 'n' blues to the latest experiments in rock subgenres such as psychedelic, acid, progressive, and jazz fusion. Muggiati's book was important for informing rock enthusiasts in Brazil about the African American origins of rock (a fact that was obscured throughout Latin America), its global circulation as youth music, its complex association with consumer society, and its relation to countercultural movements.

While Brazilian youth traveled to other countries in Latin America, they had relatively little knowledge of analogous countercultural scenes, even in the neighboring countries of the southern cone. For example, very few references to the vibrant rock cultures of Argentina and Uruguay appeared in the alternative press in Brazil. Judging from police reports and newspaper reports, Argentinian, Uruguayan, and Chilean hippies frequented the cities and beaches of Brazil, but relatively few Brazilian hippies traveled to the southern cone. Political violence and the rise of authoritarian regimes in neighboring countries likely deterred alternative travelers from Brazil, who would have been more likely to find spaces of relative freedom in the remote beaches and mountains of their own country. The long-standing prestige of U.S. and Western European (especially British, French, German, and Italian) cultures among Brazilian artists and intellectuals was transferable, even to countercultural movements that purported to reject Western civilization.

The Brazilian counterculture emerged as one of several responses to authoritarian modernization, which emphasized capital accumulation, infrastructural and technological development, expansion of communications networks, investment in higher education, and growth of consumer markets, while suppressing political dissent, curtailing labor demands, and establishing and enforcing a regime of heavy-handed national security. Claudio Novaes Pinto Coelho has argued that the counterculture in Brazil may be understood as the lado avesso (flip side) of authoritarian modernization, which emphasized the "rationalization of social life," managed by technocrats and enforced by repressive agents of the state.[122] Lucy Dias makes a similar point in asserting that "the counterculture opened fire on a kind of death within life produced by a society dominated by technocratic

totalitarianism."[123] In this regard, it may be understood as a manifestation of resistance and dissent. Yet the counterculture was also deeply enmeshed in the expanding consumer society fostered by the regime, appealing to young people who embraced it as personal style.

By the mid-1970s, the hippie counterculture of the *desbunde* began to wane as Brazil entered a new phase of authoritarian rule. The economic miracle had come to an abrupt halt with the petroleum crisis of 1973, and the regime experienced its first major political challenge as the mainstream opposition coalition scored victories over the official pro-regime civilian party in the 1974 congressional elections.[124] The generals retained a firm grip on power, and the security apparatus continued to harass, detain, torture, and murder opponents of the regime. By that time, the armed opposition movement had been defeated and its leaders were dead, imprisoned, or in exile. Following the defeat of the armed movement, surviving and emergent opposition groups rejected revolutionary violence, seeking instead an incremental restoration of democratic rights.

Maria Paula Nascimento Araújo argues that the revolutionary utopian project of the 1960s, founded on the universality of class struggle, ceded to a "fragmented utopia" of new social movements: "The utopia of the 1960s and 1970s incorporated into the project of transforming society the idea of changing everyday life: modify the affective and sexual relations between men and women, family relationships between parents and children, create new relations between man and nature, release desire, explore the possibilities of the unconscious. Create in short, a new sociability and a new sensibility. During the 1960s and a good part of the 1970s, this feeling inspired the specific movements and political minorities that constituted the groups and organizations of the dissident left."[125] Countercultural sensibilities would inform a range of social and cultural movements among the alternative Left oriented toward "new subjectivities." By the end of the decade, autonomous feminist, gay, and black movements had emerged, eventually forming shifting, tactical alliances with a new labor movement, later constituted as the Worker's Party. In all of these movements, there were individuals and even factions that identified with the countercultural experiences of the early 1970s in their efforts to expand the scope of political action in the years leading up to Brazil's democratic transition.

This book is divided into five chapters. Focusing on Rio de Janeiro, the epicenter of the countercultural scene in Brazil, Chapter 1 explores multiple dimensions of *desbunde*, including the Brazilian hippie movement, the alter-

native press, and key artists and intellectuals who articulated its values. This chapter also examines the tensions between the counterculture's disengagement from capitalist society and the emergence of a consumer market with its own advertising language, which sought to appeal to a broader section of urban middle-class youth. Chapter 2 explores the connections between the artistic avant-garde and the counterculture. A small but influential group of artists, sometimes identified as "marginal" or "underground," coalesced in the aftermath of Tropicália. *Cultura marginal* may be located at the intersection of two seemingly contrary cultural phenomena: On one hand, it had deep affinities with the emergent counterculture. On the other hand, *cultura marginal* was indebted to the midcentury constructivist avant-garde and its peculiar permutations in the 1960s. Chapter 3 will focus on the northeastern state of Bahia, particularly its capital, Salvador, which emerged as something of a mecca for Brazilian and other South American youth who identified with the counterculture. An important center for Afro-Brazilian culture, Bahia was imagined as a place of non-Western spirituality and cultural alterity, much in the way that Mexico and India, respectively, were seen by North American and European hippies. I will explore the significance of the Brazilian counterculture for a local discourse of regional identity, sometimes referred to as *baianidade*, which is central to the way the state has been promoted to national and international visitors.

The last two chapters will explore connections between the Brazilian counterculture and new social and political movements that emerged in the late 1970s, when civil society activism against the regime was revived. Chapter 4 will examine the specifically black urban counterculture associated with the so-called Black Rio movement. Black Rio was a cultural phenomenon that brought together predominantly black, working-class youth from Rio's north zone for dance parties featuring soul and funk music from the United States. Chapter 5 explores social and cultural practices that challenged traditional conventions of gender and sexuality in Brazilian society. In the late 1970s, emergent feminist and gay movements succeeded in expanding the range of leftist political debates to include discussions around gender roles, sexual desire, corporeal pleasure, and other issues previously regarded as personal or private and therefore outside the realm of the political.

When it erupted in the late 1960s and early 1970s, the Brazilian counterculture alarmed the military regime and its conservative supporters, as well as many Brazilians who defended traditional behaviors and values. Those affiliated with the left-wing opposition tended to see the counterculture as a lamentable and irresponsible abdication of political struggle. The turn away

from the politics of national liberation toward individual quests for personal self-realization involved displays of self-indulgence and narcissism, but it also set in motion transformational processes and movements in Brazilian society that sought to expand the boundaries and redesign the contours of politics.

1 ≈ Desbunde

> The slightest suspicion that I am fulfilling a destiny causes me anguish. I have a kind of nostalgia for the quotidian.
> —CAETANO VELOSO, *Rolling Stone*, May 2, 1972

"For my generation," writes Alex Polari, "our option was precisely this: either flip out [*pirar*], trip out on drugs, or join the armed struggle. Heroism vs. alienation, as we who joined the armed struggle saw it; conformity [*caretice*] vs. liberation, as they saw it."[1] Born in 1951, Polari was a teen during a period of cultural effervescence and political struggle in the mid- to late 1960s but reached adulthood during a period of severe repression between late 1968 and 1974, when public protest and left-wing cultural expression were suppressed and censored. Polari chose the "heroic" option as a member of the Vanguarda Popular Revolucionária (VPR), one of the many groups that engaged in armed struggle against the regime. As recounted in his memoirs published in 1982, he also expressed a deep affinity for those who "flipped out" and embraced attitudes and practices associated with the counterculture.

For Polari, the divide between the armed movement and the counterculture would impose limitations on both: "Our country had this defect. Politics never claimed counterculture's message of liberation and formal audacity in relation to life and discourse, nor did the counterculture become rigorously political; it articulated a platform of desire, of healthy, chaotic aspirations for liberty that would join forces with concrete struggles, even though they were limited to the middle class."[2] Brazilian youth who identified with the counterculture were committed to an idea of "liberation," but this idea was not in line with established left-wing narratives of revolutionary national liberation.

In similar fashion, psychotherapist and cultural critic Suely Rolnik has described a tension between an "activist camp," which engaged in "macro-

political" struggles for power, and a "countercultural camp," which engaged in "micropolitical" activities oriented toward subjective, interpersonal experience. She was imprisoned by the regime for her countercultural lifestyle, but she also had affinities with the activists who resisted military rule. Rolnik has observed that "there was a gulf between these two forms of resistance within one and the same generation. Thus, to be in-between the two meant not being comfortable anywhere: a micro-political malaise in the activist camp and a macro-political malaise in the countercultural camp."[3] In her view, the great political challenge for those who opposed authoritarian rule was to overcome the abyss between the micropolitics of the counterculture and the macropolitics of the left-wing opposition.

The large majority of Brazilian youth who came of age under military rule neither picked up arms against the regime nor flipped out to pursue an alternative vision of liberation. Most young Brazilians plodded along, hewed to social conventions, tried to take advantage of opportunities offered by an expanding economy, and avoided trouble with the authorities. During this time, the military regime invested heavily in higher education, especially in law, economics, science, engineering, medicine, and business administration and other areas oriented toward capitalist production and consumption.[4] Middle-class kids were far more likely to pursue new opportunities for professional advancement than to join a guerrilla movement or to live on a commune. Another former guerrilla, Alfredo Sirkis, has referred to those who pursued a life of comfort and stability within the system as a "third segment."[5] Yet even this "third segment" was complex and multifaceted. It included people who led lives of relative security, yet who sympathized with the armed struggle and even harbored guerrillas. Some might be regarded as "situational hippies"—people who abhorred the regime, chafed at social conventions, and consumed drugs, especially on weekends or during vacations, but also maintained steady employment, constructed middle-class lives, and remained undetected by the police. Others avoided steady employment, especially in jobs considered boring or conventional, and became semidependent on support from their parents. For this segment of young adults, engaging the counterculture involved grappling with existential questions of how to construct fulfilling lives under authoritarian rule, which often entailed soft resistance against societal conventions, legal strictures, and family expectations. It also entailed forms of lifestyle consumption that were seen as alternative but also commensurate with the growing spending power of the urban middle class in the early 1970s.

⇒ Defining Desbunde

Despite the fact that most young Brazilians were neither guerrillas nor hippies, this binary opposition continues to have deep cultural resonance in Brazil. In recalling the political and cultural struggles of the period of authoritarian rule in Brazil, Antonio Risério has written that his generation confronted a choice "between the machine gun and LSD."[6] The visionary theater director José Celso Martinez Correia (known as Zé Celso) has claimed: "My generation used the body. Some joined the armed struggle and risked bodily harm. Others joined the *desbunde*."[7] The neologism *desbunde* was invented by guerrillas as an epithet directed at those who left the armed struggle, which likely reinforced the guerrilla/hippie binary in the generational memory. A comrade who *desbundou* was considered a traitor to the revolutionary cause and in some cases was summarily executed by former comrades.[8] By the early 1970s, the term had acquired additional meanings to refer to countercultural attitudes and practices such as drug consumption, refusal of conventional employment, chronic itinerancy, and residency in alternative communities or communes. Sirkis was expelled from the armed movement MR-8 (Movimento Revolucionário 8 de Outubro) for, among other transgressions, "hanging out with *desbundados* who smoke[d] marijuana."[9] Although often used as a synonym for the hippie movement, *desbunde* could also refer to a broader range of behaviors among people who did not necessarily identify as hippies.

The word *desbunde* is richly evocative in the way it combines the prefix "des," which conveys undoing or dismantling, with "bunde," a corruption of *bunda* (from the word *mbunda* in the Kimbundu language of Angola), meaning "buttocks." As Zé Celso suggested, *desbunde* implies corporeal experience in seeking freedom of movement and hedonistic pleasure. References to the *bunda* are often gendered. In relation to women, the word *bunda* typically has positive valence in Brazilian culture, among others, as an embodied sign of sexual desirability and fertility. The *bunda* is also associated with the mastery of bodily movement as epitomized by female samba dancers, or *passistas*, who wear sequined bikinis designed to showcase the polyrhythmic undulations of their backsides. These clichéd associations are persistent and ubiquitous in Brazilian media. In relation to men, however, *bunda* often has negative connotations, as in epithets like *bundão* ("fat ass") and *bunda mole* ("soft ass"), which respectively suggest sloth and cowardice. In its original usage, *desbunde* implied counterrevolutionary behavior unfit for the rigors of armed insurgency. James Green has observed that *desbunde* has an "unusual

semisexual connotation" with "a possible association with homosexual relations."[10] The revolutionary Left considered homosexuality to be bourgeois and degenerate behavior that was incommensurate with revolutionary masculinity. Even those who risked their lives by joining the armed struggle had to remain inside what Green suggestively calls "revolutionary closets."[11]

Even for left-wing artists and intellectuals who did not join the armed struggle, the term *desbunde* was generally used to refer to drug-addled, inconsequential hippies. Frederico Coelho identifies *desbunde* as a "pejorative term" mistakenly applied to experimental artists like Waly Salomão and Hélio Oiticica (discussed in Chapter 2) who identified themselves as "marginal" or "underground."[12] The anti-intellectualism of the *desbunde*, he argues, was unacceptable to these artists, who were committed to erudition and formal rigor.[13] Yet in other ways, the *desbunde* corresponded to their own vanguardist projects of fusing art and everyday life. As Silviano Santiago has explained, "Desbunde cannot be defined as if it were a concept, much less a rule for behavior. Instead, it is a spectacle in which an artistic attitude toward life and an existential attitude toward art are joined together."[14] It is often associated with the playful pursuit of pleasure known as *curtição* (and corresponding verb *curtir*), another term that will appear with some frequency in this study, which Santiago defined as "the sensibility of a generation."[15]

In a compilation of Brazilian lexical borrowings and neologisms derived from Bantu languages of central-west Africa, Nei Lopes notes that *desbundar* has several current meanings that depart from its origin as an epithet: 1) the loss of self-control; 2) the revelation of one's true face after attempts at dissimulation; and 3) the causation of wonder and astonishment.[16] The first definition is the most commonly used and recognized, although the other two are significant for ways in which they suggest the revelation of authentic identity and heightened emotional or sensorial experience. The word *careta*, traditionally used to signify "mask," began to circulate as the antonym of *desbunde* to denote anything that was conventional, conformist, or, in American parlance, "square." While the *desbundado/a* revealed his/her authentic self, the *careta* wore a mask to keep up appearances. People who abstained from drugs were also known as *careta*, including some countercultural icons such as Caetano Veloso, who was known as "Caretano," a moniker he proudly affirmed.[17] *Desbunde* provides an interesting contrast to *desmadre* ("unmothering"), a word associated with the Mexican counterculture (known as La Onda), which, as Eric Zolov has noted, "expresses a notion of social chaos."[18] In the Brazilian context, *desbunde* has accrued over time an irreverent and humorous resonance, suggesting a gleeful gesture

of refusal, ludic pleasure, and personal adventure, free from commitments and responsibilities.

Desbunde conveys something like "losing one's ass," "sliding through life on one's ass," or, in the lingo of the U.S. counterculture, "dropping out." One writer who came of age during this period has observed that "the *desbundado* wasn't concerned with changing the political regime, but wanted to be left alone in peace, smoking dope and listening to the Rolling Stones. Before changing the system of power, he sought the transformation of the interior self and daily life."[19] *Desbunde* captured a particular sensibility among youth who were radically disillusioned with political and social life under military rule and sought alternative paths to personal freedom. While *desbunde* never constituted a movement per se, people who embraced it sensed that they were part of a larger, collective phenomenon. The singer Ney Matogrosso (discussed in Chapter 5) has recalled this feeling when he left a stable job to pursue an alternative lifestyle in the late 1960s: "I knew at the time that I was participating in something, something was clearly happening, a *desbunde*, because a lot of people were living what I was living."[20] As Matogrosso suggests, the *desbunde* had a significant impact on broad sectors of urban youth, who simply disengaged from family and society to pursue other life adventures.

≈ Desbunde on the Road

In the song "God" (1970), John Lennon professed that "the dream was over," a statement about his disillusionment with the mythologies and symbols of his generation, including The Beatles, which captured a more general sense of retreat from political projects. Exiled to London in 1969, Gilberto Gil responded to Lennon's song with "O sonho acabou" (The dream is over), after witnessing the Glastonbury Fair on the summer solstice of 1971. Gil has noted that the song registered the "end of a cycle in pop music," which had begun for him around 1966 when he first heard The Beatles.[21] While the song makes an obvious reference to Lennon's "God," he employs the neologistic gerunds *demanhando* and *desolvindo* to suggest the passing of one "dream" and the beginning of something else: "The dream is over today when the sky / gave way to morning, the sun coming, coming, coming." The song was featured on Gil's album *Expresso 2222*, which was released in 1972, by which time the political opposition had been largely defeated and the revolutionary "dream" of the 1960s had been destroyed. At the time, countercultural energies were ascendant among Brazilian youth, a hippie movement was in full

swing, and alternative communities were emerging in both rural and urban areas. Gil's riff on Lennon's requiem draws attention to the fact that the Brazilian counterculture, far from waning, was on the rise in the early 1970s.

First reports of the hippie movement began to circulate in Brazil in 1967–68, coinciding with the tropicalist movement. When Caetano Veloso and Dedé Gedelha were married in November 1967, the press trumpeted the event as a "hippie wedding." In February 1968, the national magazine *Realidade* introduced a mass readership of Brazilians to the movement in an article titled "Façam o amor, não a guerra" (Make love, not war), about the hippies of San Francisco and the Summer of Love in 1967. As a recognizable mass phenomenon, the hippie movement emerged in Brazil in early 1969, soon after the authoritarian turn in military politics occasioned by AI-5 and the denouement of the tropicalist movement. Over the next several years, thousands of *mochileiros* (backpackers) or *andarilhos* (wanderers) hit the road to explore Brazil, other parts of Latin America, and other continents. There were established routes for these kinds of adventures, which primarily attracted youth from the more affluent southern and central regions of the country. A popular trip for alternative travelers was to explore the northeastern backland by descending the São Francisco River from its headwaters in northern Minas Gerais, through towns such as Pirapora, Xique-xique, and Petrolina, to the coastal towns separating Sergipe and Alagoas. To explore the Andean region of South America, travelers took the so-called *trem da morte* (train of death), a slow-moving train that departed from Corumbá, in the state of Mato Grosso do Sul, and traveled to Santa Cruz de la Sierra in Bolivia. From there, passengers could continue on to the Andean highlands to visit destinations such as Machu Picchu. Wealthier or more adventurous Brazilians joined thousands of Europeans and North Americans on the famous "hippie trail" that extended from Europe to South Asia.

Another song from Gil's 1972 album made reference to the allure of Asia for young Westerners seeking alternative spiritualities and life practices. Written in Ibiza, Spain, then a popular destination for international hippies, "Oriente" evokes the sound of an Indian raga, opening with the exhortation: "Orient yourself, man / by the constellation of the Southern Cross." The phrase "orient yourself" is multivalent, suggesting that self-discovery, or personal orientation, may be found in the "Orient." The song was also issued as a 45-rpm single on the flip side of "O sonho acabou," which was included as a promotional insert in a special edition of the countercultural magazine *Bondinho*. The lyrics of "Oriente" are constructed as advice to a friend who is at a crossroads in life and is coping with an existential crisis.

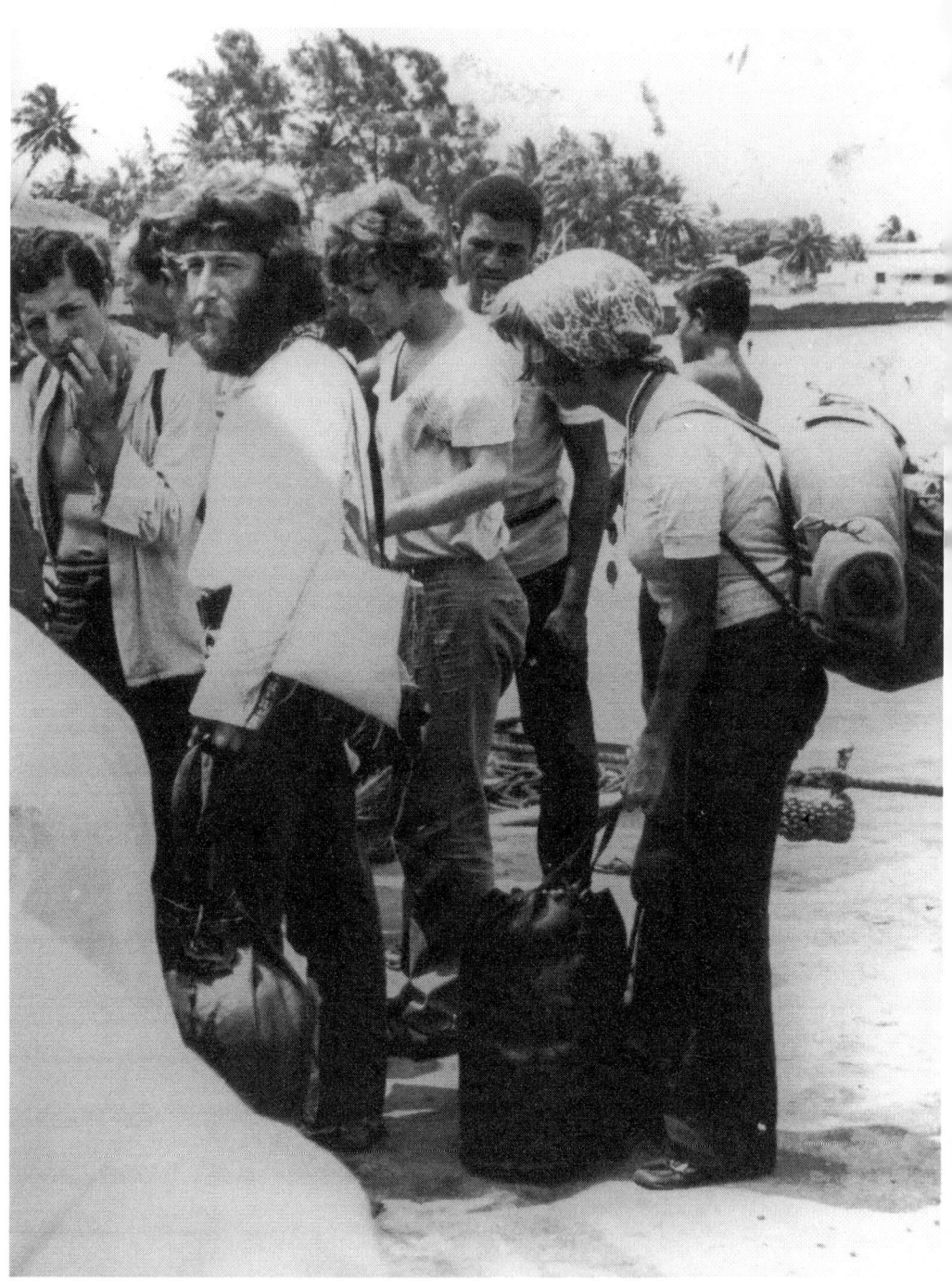

Hippies on the road in Brazil, 1971. Photo by Vigota. Courtesy of the National Archive, Rio de Janeiro.

In the first stanza, he instructs self-sufficiency and circumspection in the lines "the spider lives by the webs it spins" and "everything merits consideration." The second stanza recommends a distant journey on a shoestring budget to the other side of the planet: "Consider the possibility of going to Japan in the cargo hold of a Lloyd steamer." The final stanza, however, suggests the limits of this journey around the world, as he urges his friend to use the time to "determine where to pursue a graduate degree," which seems like rather mundane advice from a spiritual counselor. As noted in the Introduction, the Brazilian counterculture coincided with the dramatic expansion of the university system, and, increasingly, young Brazilians, like the young man portrayed in "Oriente," contemplated advanced degrees. Gil's song alluded to the fact that these travels were not typically lifelong adventures, but rather a prelude to settling down and pursuing a career.

Giving up everything and hitting the road was a rite of passage for youth who identified with the counterculture, as captured in the song "Tudo que você podia ser" (All that you could be), written by Lô Borges and Márcio Borges and recorded in 1972 by Milton Nascimento for the milestone album *Clube da Esquina*: "You dreamed about sun and rain / that it would soon be better / you wanted to be the great hero of the road / all that you wanted to be." The song relates the expectations and fears of a young Brazilian in the early 1970s who leaves home with the dream of becoming a "hero of the road," a free spirit, exposed to the natural elements and the vicissitudes of life. In this adventure, one could fail and come up with nothing, but one could also have life experiences and attain a level of self-realization that would have been impossible for those who stayed at home.

Writing for the first edition of the underground journal *Presença* (October 1971), Joel Macedo exhorted youth to get out and explore the world: "The road is open. For everyone. It's no longer necessary to be a millionaire to go around the world. Some years ago, the hippies started and now an entire generation is traveling on a shoestring with a backpack and little money. The road is a language. Just as important as music, meditation, or any other language that our generation has been exploring." He offered information, suggestions, and advice for travelers seeking to travel to the United States, Europe, South America, Kathmandu, and Istanbul. Macedo also dispensed advice specifically for young alternative travelers from the cities who might arouse suspicion: "Your long, disheveled hair, your beard, your clothes, will certainly create problems!"[22] Hippie communes and other alternative communities emerged along the coast, most famously in Arembepe, a fishing village north of Salvador, Bahia, as well as in the mountainous interior, such as

in Visconde de Mauá, Rio de Janeiro; São Thomé das Letras, Minas Gerais; Lençóis, Bahia; and Pirenópolis, Goiás. Members of a commune outside of Nova Friburgo, located in the mountains of Rio de Janeiro state, were cast in *Geração Bendita* (1971), a feature film by Carlos Bini that dramatized the fraught relations between hippies and the residents and authorities of a conservative provincial city. Some of the preferred destinations for itinerant hippies offered seasonal attractions, such as the Festival de Inverno (Winter Festival) of Ouro Preto, Minas Gerais, which was held in July between 1967 and 1979. Organized by the Federal University of Minas Gerais in Belo Horizonte, the annual arts festival attracted thousands of tourists from throughout Brazil. By the early 1970s, the Festival de Inverno had become, according to one report, "a giant magnet that attracted the entire *hipolândia nacional* [national hippieland]," which eventually led to police surveillance and repression.[23]

For some children of privilege, countercultural exploration provided a way to free themselves of stifling family ties, parental expectations, and financial dependency. Lucy Dias interviewed one former hippie whose father was a professor and honorary president of the Escola Superior de Guerra (ESG), the elite military college in Rio de Janeiro, which trained the top officials of the military establishment.[24] In the late 1960s, he entered law school with the intention of eventually going on to pursue a diplomatic career. During a vacation in Bahia during the summer of 1970, he visited the hippie commune in Arembepe, where he first experimented with marijuana. He began to question his own class privilege as well as the abrogation of personal liberties by the regime that his father served. After finishing his law degree, he sold his car and traveled to India with a friend, where he lived for an extended period on about sixty dollars per month. As their money ran out, the two traveled to Indonesia and then on to Australia, where he found work loading frozen shrimp. This experience with manual labor, which he would have never known had he remained in Brazil as the scion of an elite family, further expanded his horizons and instilled in him a sense of self-sufficiency.

While the repressive apparatus of the U.S.-backed military regime was focused primarily on crushing the various revolutionary armed factions, it also cracked down on hippies. Everyday life for hippies could be perilous and stressful due to police harassment. On the road, hippies (or those who merely adopted the hippie style) were targeted by federal police at highway checkpoints or during bus inspections. Archives from the Department of Order and Social Politics, known by its acronym DOPS, reveal that regime

authorities were concerned about the hippies. One DOPS file from February 1970, for example, reported that the secretary of security, working through various police districts, arrested "vagrant elements, who call themselves 'hippies' and wander through the city without documents, living in promiscuity in encampments set up on the beaches of Rio."[25] As in other countries, hippies in Brazil tended to avoid conventional labor that would require reporting to a workplace at a set time to perform tasks under supervision—the type of work they eschewed as *careta*. Instead, hippies survived on shoestring budgets, performing odd jobs, trafficking in drugs, or selling handcrafted jewelry and leather goods. The DOPS file went on to report that police action was designed to prevent a planned gathering in Barra da Tijuca (then an emergent beach community west of the south zone of Rio) of young people from various countries who had come for carnival. Some of those arrested had criminal backgrounds, but the majority were "descendants of traditional families." Among the arrested was a group of Argentines who had come to Brazil with the expressed intention of "smoking dope in peace and discuss[ing] future meetings in other countries." The same report described an attempt by the secretary of security to prohibit an arts-and-crafts fair, founded in 1969, in the Praça General Osório of Ipanema, alleging "disruption of public order." The Association of Visual Artists of Guanabara issued a manifesto against the repressive action and was able to convince municipal authorities to issue licenses to artists and craft makers to show their work on Sundays, a weekly open-air fair that eventually grew into a popular tourist attraction, the Feira Hippie de Ipanema (discussed below). In March 1970, the weekly magazine *Veja* reported that the federal police had ordered all states to arrest hippies based on the assumption that "love hides prostitution, peace is a subversive slogan, and flowers have the aroma of drugs." In the cities, hippies with no discernible occupation could be arrested for *vadiagem*, or vagrancy, a judicial legacy of the colonial period. As the *Veja* report noted, "What is for them 'resistance to consumer society' squares perfectly with the Brazilian juridical concept of *vadiagem*."[26]

A year later, in February 1971, the police barred hippies from attending an open-air music festival, inspired by Woodstock, in Guarapari, a beach town in the state of Espirito Santo, about 300 miles to the north of Rio de Janeiro. One federal police agent, interviewed by a journalist from *Veja* sent to report on the festival, explained: "For us, hippies are dirty, foul-smelling people, carrying around bric-a-brac, who could interfere in the show. They cannot participate in the festival, not even in the audience."[27] The failure of the Festival de Guarapari provides a stark contrast to analogous events

elsewhere. For example, the Woodstock festival of August 1969 had attracted 400,000 people to a dairy farm in upstate New York. A defining moment of U.S. cultural history, Woodstock would become an enduring symbol of the hippie counterculture. The Festival de Avándaro, remembered as the "Mexican Woodstock," attracted some 200,000 people in September 1971 and, as Eric Zolov observes, "clearly marked the commercial apex of La Onda Chicana."[28] In Argentina, the Buenos Aires Rock Festival (BAROCK) attracted 6,000 people each of the five days of its inaugural year in 1970, and attendance tripled in two successive annual editions. In 1973, 20,000 Argentines attended the Festival of Liberation, featuring the most prominent groups of rock nacional, to celebrate the victory of Peronist candidate Héctor Cámpora.[29] The Festival de Gaurapari, in contrast, was a miserable failure, due to poor organization but also to the climate of repression. Only 4,000 people attended the festival, planned for an audience of 40,000.

Conservative voices in civil society also denounced the hippie movement as an affront to traditional values and a threat to society. Antonio Carlos Pacheco e Silva, professor of psychiatry at the University of São Paulo and past president of the Brazilian Association of Psychiatry (1967), was particularly strident in his condemnation of the social transformations among urban youth. With his book *Hippies, drogas, sexo, poluição* (Hippies, drugs, sex, pollution), published in 1973, Silva sounded the alarm on behalf of the medical community. Drawing from international sources, Silva warned that the hippie movement had "swept the world, contaminating a considerable portion of youth."[30] He denounced hippies for their rejection of "established values," their habitual use of drugs, and their tendency to congregate in "monstrous agglomerations," such as the Woodstock festival. Silva went on to ridicule hippie music (mistakenly and oddly characterized as "dodecophonic"), their "most eccentric dances," their sartorial style, and their poor hygiene.[31] His disdainful description of Brazilian hippies could have appeared in conservative publications anywhere in the United States, Western Europe, and elsewhere in Latin America. It resonated with Ronald Reagan's famous quip from 1967 when he was governor of California, which described a hippie as someone "who dresses like Tarzan, has hair like Jane, and smells like Cheetah."[32]

The regime associated the hippies with social dissent and political subversion. Official reports suggesting a link between the hippie movement and international communism would continue well into the 1970s, even after the armed insurgency had been defeated. One general asserted: "The hippie movement was created in Moscow and if parents don't carefully guide the

youth, communism will end up dominating Brazil."[33] A DOPS agent filed a report in March 1973 with the following warning: "Recently there has been a lot of movement throughout several Brazilian states of *andarilhos* and Hipies [sic], often indistinguishable one from the other, who seek to demonstrate a way of life, an entire philosophy that consists, in their way of thinking, of the search for total freedom, without any commitments to a permanent job and specifically affirming an identity that is essentially nomad. In many instances these elements have been detained for questioning, revealing that behind the apparent simplicity, used as a ruse or cover, there was a more dangerous element with pre-determined activities and missions, many of which go against National Security given their subversive character and tendencies."[34] The author of the report went on to insinuate that some hippies were collaborating with a mysterious "Russian element" in the Amazonian region. The DOPS agent concluded his report with the recommendation that police closely monitor the activities of hippies and *andarilhos* throughout national territory, noting that they posed a threat to government interests. The appeal of hitting the road and "sleeping in a sleeping bag," as celebrated in "O sonho acabou," also came with perils, especially for those youth identified by authorities as hippies.

≈ Spaces of the Carioca Counterculture

While many Brazilian hippies adopted itinerant lifestyles, most settled for extended periods in the major cities. Rio de Janeiro was the epicenter of the Brazilian counterculture in the early 1970s. With its renowned natural setting, featuring broad swaths of beach enveloped by mountains, and its historic status as the major national center of cultural production, Rio was attractive to hippies in ways that were not so different for residents and tourists. It was a place where one could hang out at the beach or hike through remnants of the Atlantic Rainforest during the day and, with money or contacts, catch the latest musical or theatrical act at night. Countercultural circles tended to congregate in particular areas within the city, especially on the south zone beaches. The beaches provided spaces of relative security and seclusion where friends could smoke marijuana without being detected by authorities. If the police approached, incriminating evidence could be quickly buried in sand. Although most hippies in Brazil were white, I also found several period photos of multiracial groups of hippies, such as the one shown below.

The modernist poet Carlos Drummond de Andrade, then in his early sev-

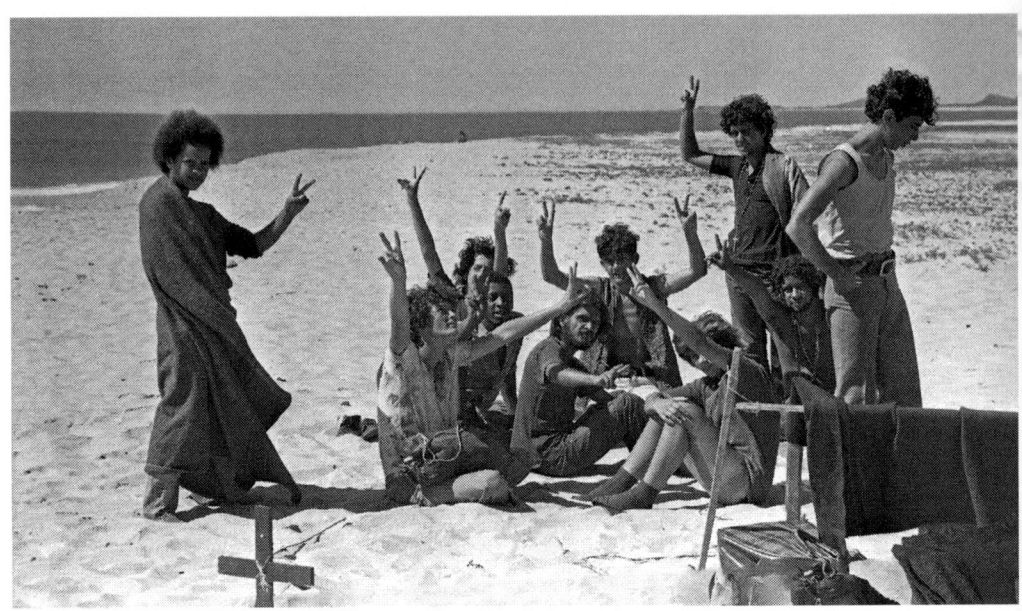

Hippies on the beach, Rio de Janeiro, 1973. Ari Gomes/CPDoc JB.

enties, observed the hippie scene with a mixture of fascination and amusement in a collection of chronicles and poems titled *O Poder Ultra-Jovem* (Super youth power), published in 1972. In one chronicle, "Verão: aqui e agora" (Summer: here and now), he historicizes the use of south zone beaches for summertime leisure as a legacy of the Vargas period: "Since the 1930 Revolution, which brought many innovations, summer became a cyclical phenomenon, observable between the Leme beach and Niemeyer Ave. In the rest of the city, it was only hot."[35] In other words, summer was a cultural product of modernization as well as social segmentation, as it primarily manifested itself in middle- to upper-class neighborhoods, starting in Leme and passing through Copacabana and Ipanema to Avenida Niemeyer at the far southern end of Leblon. Elsewhere in the city, he wryly notes, "it was only hot." Drummond noted that summer had begun expanding to other city neighborhoods and villages around the state, most notably in the newly developed upscale neighborhood of Barra da Tijuca in the far west zone of the city. In the poem "Cariocas," Drummond describes this process of transformation as new social groups arrive to experience the south zone summer and old habitués flee to other spots, marked by *postos*, or lifeguard stands, along the beaches. Written in the early 1970s, the poem makes reference to two south zone beaches that had become favorite meeting points for

countercultural youth: "Ipanema is invaded / hippie and festive, arriving at Leblon." Since the 1950s, Ipanema beach has accommodated various social scenes organized spatially around "points" (the English-language-loaned word is used in this context) identified by geographic markers like street names, hotels, or lifeguard posts. Ipanema's first fashionable point was at Arpoador, at the far north end of the beach, which attracted surfers. In the mid-1960s, the beach in front of the Rua Montenegro (later renamed for the poet and composer Vinícius de Moraes) became the fashionable point, especially among intellectuals.

In the summer of 1970, the point moved a half block back toward Arpoador, as engineers began another dredging project to build a modular pier to provide a support structure for the installation of submarine sewage pipes extending miles out into the Atlantic Ocean. The pier had an impact on the waves, creating excellent conditions for surfers. A predominantly adolescent social scene revolving around surfing and smoking marijuana formed part of the larger countercultural orbit of Rio's south zone. The sand dredged from the seabed was deposited on the beach, forming large sand dunes that obscured the view from the street to the sunbathing area.[36] One habitué of the pier described it as an idyllic oasis: "The dictatorship remained severe. Yet on that stretch of beach people lived in a democratic climate. They breathed, or tried to breathe, freely."[37] The beach was where young people went to see and be seen, debate politics and culture, exchange information about upcoming events, and obtain promising leads on where to safely purchase drugs.[38] Another longtime denizen of Ipanema remembers the pier as a place where people engaged in long conversations about "astrology, macrobiotics, orientalism, alternative communities, the 'new age,' the LP by Cream, the play Hair or the latest delivery of cannabis."[39] This area of relative seclusion attracted a group of artists identified with the counterculture, especially Gal Costa, who had emerged as the leading musical icon of the post-tropicalist Brazilian counterculture. She frequented the dunes so much that they came to be known as the *dunas da Gal*.[40] The poet and songwriter Waly Salomão described the Ipanema Pier as a "liberated territory" where "one could stay and not be bothered by the authorities." It was there that he composed his countercultural anthem "Vapor barato" (discussed in Chapter 2), which was featured in Gal Costa's famous 1971 show "Gal a todo vapor [Gal full steam ahead]."[41]

Gay men occupied space on Ipanema beach adjacent to the *dunas da Gal*. James Green has noted that the "heterogeneous young crowd of hippies, artists, intellectuals, and musicians exhibited a tolerant attitude toward

homosexuality."[42] However, some of the adolescent surfers who were part of a larger countercultural scene occasionally harassed groups of older gay men, even as they tolerated and engaged in homosexual play within their own milieu.[43] The Ipanema Pier and adjacent dunes also provided a space for heterosexual men to express themselves in ways coded as "feminine," mostly through the use of female or unisex beachwear. Luiz Carlos Maciel, a key intellectual of the counterculture discussed below, has written about one afternoon at the pier when he wore his wife's panties, instead of swim trunks, in order to express his "solidarity with the behavioral revolution."[44]

The Ipanema Pier lasted for three summers between 1970 and 1973, a period that corresponded to the most repressive phase of military rule and to the height of the counterculture in Brazil. When its structure was dismantled, surfers returned to Arpoador and the artists and intellectuals moved down to the Posto 9, the lifeguard post that has since remained a favorite point for youth. The south zone beaches would continue to provide key spaces of sociability and freedom to hippies, artists, intellectuals, and others who embraced to varying degrees the ideas of the counterculture, despite the restrictive atmosphere under military rule. Other spaces in Ipanema attracted specific segments of the countercultural community of Rio. Since the 1950s, the bar and restaurant Jangadeiros, located on the Rua Visconde de Pirajá facing the west side of the Praça General Osório, had been a favorite watering hole for artists and intellectuals of the south zone. In the late 1960s and early 1970s, Jangadeiros became the place to meet for drinks after a long day at the Ipanema Pier. In 1975, the Livraria Muro, a small bookstore catering to a leftist, countercultural, and vanguardist clientele, opened in a large shopping gallery next to Jangadeiros; it would become a favored performance space for the *poesia marginal* movement.[45] The adolescent surfing milieu congregated in and around the Lanchonete Balada, a juice bar located on Rua Teixeira do Melo on the south end of the Praça General Osório. The surfers and their girlfriends were known for smoking marijuana in front of the juice bar and engaging in ostentatious displays of affection.[46]

Venues for theater and live music also served as meeting places where young people would gather. Founded in 1968 under the direction of Rubens Corrêa and Ivan Albuquerque, the Teatro Ipanema became the most important venue for staging new works by young playwrights, most notably José Vicente, and for launching the careers of emerging actors, such as José Wilker and Isabel Ribeiro. First staged in 1971, Vicente's play *Hoje é o dia do rock* (Today is the day of rock) proposed theater as communal ritual, much in the manner of Zé Celso's Teatro Oficina. The oldest theater in Rio,

Teatro João Caetano, was located on the Praça Tiradentes near the city center, thereby attracting more diverse audiences from both the north and the south zones that came to see top MPB (Música Popular Brasileira) performers of the time. The most important venue for live music was the Teatro Tereza Rachel, known as the "Terezão," located on Rua Siqueira Campos in Copacabana. The most important concerts of the period, such as Gal Costa's famous show "Gal a todo vapor," took place at the Terezão. Right around the corner from the Terezão, on the Rua Barata Ribeiro, was Rio's most famous record store, Modern Sound, which also became a meeting place for young Brazilians in search of the latest rock imports from the United States and Europe.[47]

A countercultural scene also developed in the city center around the Museu de Arte Moderna, which featured a large patio garden designed by acclaimed landscape architect Roberto Burle Marx. In the early 1970s, the patio became a popular meeting place for the so-called *hippies do museu*, young people from Rio's working-class north zone (*zona norte*) who were not always welcome in the countercultural spaces of Ipanema.[48] Hippies and artists also began moving to Santa Teresa, a centrally located neighborhood first settled in the eighteenth century on a large hill with easy access to the city center between the south zone and the north zone. Santa Teresa is famous for its decaying mansions, narrow winding streets, and trolley cars that take passengers across to the city center, passing over a converted colonial-era aqueduct. A relatively quiet neighborhood surrounded by the Tijuca rainforest, Santa Teresa was another space within the city with relatively little police presence that provided refuge for artists, intellectuals, and hippies.

In the mid-1970s, another countercultural scene developed around the Escola de Artes Visuais (EAV), a multidisciplinary art school housed in a large Italianate mansion originally built for an opera star in the 1920s in the Parque Lage, a lush tropical park in Jardim Botânico, a neighborhood named for the city's famous botanical garden. Under the direction of Rubens Gerchman, the school offered open courses in painting, sculpture, photography, filmmaking, and design, as well as in philosophy, art history, and psychoanalysis.[49] Nearly forty artists, including leading figures in the Brazilian art scene such as Lina Bo Bardi, Mario Pedrosa, and Helio Eichbauer, offered workshops to more than 2,000 students throughout the latter half of the decade. At night, the internal patio of EAV was often converted into a performance space for musicians such as Caetano Veloso, Luiz Melodia, Jards Macalé, and Jorge Mautner and poets associated with *poesia marginal*. For the latter half of the decade, EAV served as a space of

creativity and relative protection from official repression.[50] At a time when the military government invested heavily in the control of urban territory, these alternative spaces provided opportunities for people to congregate, socialize, and create.

⇒ Bard of the *Desbunde*

In Paulo Lins's blockbuster novel, *Cidade de Deus* (1997), set in a poor neighborhood on Rio's periphery ravaged by violence between rival drug gangs, the most sympathetic protagonist, Bené, dreams of leaving behind his lucrative but stressful life as a trafficker to settle on a farm with his girlfriend, smoke marijuana all day, and listen to Raul Seixas. An iconoclastic rocker from Salvador, Seixas did more than any other artist to promote the ideas and attitudes of the counterculture to a mass audience. Combining elements of new-age mysticism, individual nonconformism, political dissent, and irreverent humor, he attracted a middle-class audience of young rockers but also appealed to working-class youth and *favelados*, as suggested by the references to him in *Cidade de Deus*. In the cinematic rendering of the novel, Seixas's "Metamorfose ambulante," a defiant anthem about perpetual change, provides the sound track to Bené's transformation as he plots a new life away from the favela. Seixas sings in praise of uncertainty, inconsistency, and ambivalence: "I prefer to be / this moving metamorphosis / than to hold that old opinion about everything." In contrast to the protest culture of the 1960s, which demanded political conviction and ideological coherence, "Metamorfose ambulante" reclaimed the right to discard cherished ideals, adapt to new circumstances, and live in permanent flux. For Bené, the song represents a utopian quest to find personal peace, a quest that is tragically thwarted when he is shot on the eve of his departure from the favela. That it was featured in *Cidade de Deus* nearly twenty-five years after it was recorded suggests that Seixas's song continues to resonate with Brazilian youth of all social classes.

Raul Seixas had a penchant for melodramatic ballads, known in Brazil as *música brega* or *música cafona*, which contributed to his mass appeal. His songs are easy to play for an amateur musician with an acoustic guitar and a chorus of friends. A sui generis blend of 1950s rock 'n' roll, American country music, and traditional northeastern genres like the *baião* and *repente*, his music seemed to bypass entirely the British Invasion rock of the 1960s, psychedelia, and even Tropicália. For much of the 1970s, Seixas composed with lyricist Paulo Coelho, who would later achieve renown as a best-selling

author of mystical, inspirational novels. Seixas fashioned himself as "a cosmic messiah of the Brazilian counterculture," as he told one magazine.[51]

In 1973, he released his first solo album, *Krig Há Bandolo!*, a title that referenced Hal Foster's popular comic strip in which Tarzan used the war cry "kreegah bundolo" to warn of approaching enemies. Launching the album at the Teatro Tereza Rachel in 1973, Seixas distributed a manifesto to the audience in the form of a comic book, or *gibi*. Written with Paulo Coelho with illustrations by Adalgisa Rios, the *gibi*/manifesto "A Fundação Krig-Ha" portrayed in words and images a world dominated by what they called the "monstro sist." (an abbreviation of *sistema*), or "monster system," which crushed individuals and prevented the blossoming of imagination. Although not precisely defined, the "monstro sist." referred to consumer capitalism and authoritarianism, which in different ways disciplined and constrained individuals.[52] While the manifesto does not refer explicitly to the military regime, it made reference to the triumphalism of its agents and supporters: "The hardest thing about our time is that the fools possess conviction and those who possess imagination and rationality are filled with doubt and indecision." To resist the "monster system," Seixas and Coelho recommended irony as "one of the few forms through which imagination can be expressed right now." Indeed, many of the songs on his 1973 album employ humor and irony to critique Brazilian society.

Seixas's first hit song, "Ouro de tolo" (Fool's gold), was a scathing indictment of social conformity and complacency under military rule at the height of the "economic miracle."[53] In first-person voice, Seixas describes himself as a "respectable citizen" who has achieved success as an artist, earns a handsome salary, drives a new car, lives in Ipanema, and goes to the zoo with his family on Sundays. Instead of bringing happiness, however, his status and comfort leave him feeling empty and frustrated. His achievements seem trifling and hollow, leading him to conclude that all humans are ridiculous and limited. The promise of economic growth and modernization, which had seduced broad segments of Brazil's urban middle class, amounted to nothing more than "fool's gold." In the final lines of "Ouro de tolo," the artist looks to the horizon, past the fenced-in yards of the city, where he spies the "sonic shadow of a flying saucer." The mediocrity of human life, he suggests, can only be redeemed with the help of extraterrestrials. In the early 1970s, UFO sightings were a popular topic of conversation among Brazilians, especially those interested in new-age religions.[54] For Raul Seixas and Paulo Coelho, flying saucers had special significance to the origin myth of their creative partnership. They met each other for the first time in 1972 on the

beach of Barra da Tijuca when they both witnessed a low-flying UFO, which they took to be a sign that they were to embark on a mission together.[55]

Inspired by the esoteric British occultist Aleister Crowley (1875–1947), Seixas and Coelho founded the Sociedade Alternativa (Alternative Society) as a platform for their music and ideas. Of particular importance was the Liber AL vel Legis (The book of the law), published in 1904, which is the central text of Thelema, a quasi-religious philosophical doctrine created by Crowley. His mysticism notwithstanding, Crowley's teachings are essentially Nietzschean in their renunciation of Christianity and their bold assertion of human will. Combining elements of satanic ritual, new-age libertarianism, and Dionysian anarchy, Sociedade Alternativa propagated radical individual freedom. Seixas and Coelho composed a rousing rock anthem, "Sociedade alternativa," featured on Seixas's second solo album, Gita (1974), which referenced the central dictum of Crowley's teaching: "There is no law beyond do what thou wilt." Despite its message of total freedom, the lyrics to "Sociedade alternativa" are anodyne and whimsical, not militant or revolutionary: "If you and I want / to bathe with a hat / or wait for Santa Claus / or talk about Carlos Gardel." When questioned by the regime officials, Seixas and Coelho tried to convince them that the "alternative society" was meant as a personal option, not as an attack on "the system," but their movement aroused suspicion and they were detained by DOPS agents and jailed. Although not officially exiled, Seixas and Coelho left for the United States in 1974 after a failed attempt to establish an alternative community in rural Bahia. By 1975, they were back in Brazil in time for the Hollywood Rock Festival, where they performed "Sociedade alternativa" and read another manifesto taken directly from Crowley's teachings.

Seixas's most explicit homage to the Brazilian counterculture came several years later in the song "Maluco beleza" (Crazy beauty) from the album O dia em que a terra parou (1977). The word maluco, traditionally used to described someone or something that is "crazy," became a slang word for a "freak" who refused to live according to social conventions. The valorization of irrationality, often described as a form of delirium, or loucura, was a constant theme in songs and poems associated with the counterculture, which bristled at the rationality of both the regime and the orthodox Left.[56] The music of "Maluco Beleza" was based on the 1965 hit "Aline" by French crooner Christophe (Daniel Bevilacqua), which displayed Seixa's penchant for repurposing melodramatic romantic ballads, known in Brazil as música cafona.[57] The original recording, in which Christophe makes an impassioned cry for a woman who has left him, becomes, in Seixas's version, a defense

of madness—*maluquez*: "As you make great efforts to be a regular guy / and follow all of the rules / I'm over here learning to be crazy / a total freak in this real madness." For Seixas, learning how to forsake social conventions in order to embrace madness requires courage and effort, especially within a context of authoritarian modernization and the rationalization of social life. Seixas implies that Brazilian society under a technocratic military regime actually constitutes the *loucura real*, or "real madness," against which the *maluco* resists.

More than any other artist of his generation, Raul Seixas cultivated an image as a subversive rebel, Dionysian guru, and prophetic visionary.[58] He is in some respects akin to other rock heroes, like Jim Morrison and Janis Joplin, whose lives came to tragic ends, although in the case of Seixas, his final demise in 1989 came after a long slide toward fatal alcoholism. His mid-1970s work with Paulo Coelho synthesized in song form the central ideas of the countercultural *desbunde*, especially its apology for radical individualism, and brought them to a mass audience far beyond the middle-class university circles. Oscillating between disillusioned cynicism and new-age utopianism, mind-blown irrationality and lucid criticism, Raul Seixas captured the ambiguities and contradictions of the *desbunde*.

⇒ Luiz Carlos Maciel and the Alternative Press

Countercultural attitudes, ideas, and styles had a particularly notable impact on print media in the late 1960s and early 1970s. The full-color, glossy weekly magazine *Realidade* (1966–76) introduced to Brazilian readers the kind of "new journalism" championed by Norman Mailer, Tom Wolfe, and Truman Capote, who dispensed with objective reporting in favor of highly subjective narratives with literary flourishes. Published by the Editora Abril, *Realidade* covered topical issues of interest to youth, such as the student movement, feminism, birth control pills, homosexuality, the hippie movement, and new fashion trends. In the wake of AI-5, *Realidade* and other print media outlets identified with the opposition were severely hampered by censorship. Newspapers that took an oppositional stance toward the regime, such as *Correio da Manhã* and *Última Hora*, were driven out of business, while the pro-regime Globo conglomerate expanded dramatically after its founding in 1965.[59]

In the shadows of the mainstream press, a vibrant *imprensa alternativa*, or alternative press, emerged in the major Brazilian capitals, providing outlets for political satire, humor, social critique, cultural commentary, and liter-

ary expression. By the mid-1970s, there was a vast array of alternative press journals, from small literary outlets to weekly papers with national distribution. It is difficult to define precisely what makes a publication "alternative." On one hand, it can refer to publications outside of the mainstream industry with small print runs and limited distribution, which could include low-budget mimeographs as well as full-color art publications. On the other hand, it can refer to content not typically found in mainstream newspapers or magazines. Some large-scale publications with national distribution, such as *O Pasquim* and *Bondinho*, were considered alternative on the basis of content, just as there were small press publications like church bulletins and community papers that were not. One of the first alternative press publications, *O Sol*, which focused on emergent trends in youth culture, was published in 1967–68 as a supplement to *Jornal dos Sports*, a mainstream sports paper.

There were basically two types of alternative press publications. The first type included left-wing publications with origins in the national-popular mobilization of the 1960s that articulated political opposition to the regime.[60] These publications can be further divided into papers, such as *Opinião* and *Movimento*, founded in 1972 and 1975, respectively, that represented the leftist political establishment connected to the PCB (the Brazilian Communist Party), and papers founded in the late 1970s connected to new social movements. The latter were generally critical of the orthodox Left associated with the PCB and sought to amplify the scope of political discourse to include questions of personal identity and political subjectivity in everyday life.[61] They focused on movements around feminism (*Brasil Mulher, Nós Mulheres, Mulherio*), gay rights (*Gente Gay, Lampião da Esquina*), and black consciousness (*Jornegro, Versus*). This second type focused on cultural trends, social change, and lifestyle consumption. These publications may be further divided into publications known as *jornais de costumes*, dedicated to popular culture, celebrities, fashion, and lifestyle, and others focused more on artistic and poetic experimentation. There was, of course, significant overlap in focus and content among these various types, as the more "political" venues also featured cultural criticism and the more "cultural" publications often advanced political views.

In 1969, a group of journalists and cartoonists convened in a bar in downtown Rio de Janeiro to establish a weekly paper, *O Pasquim*, which was independent of the large media companies. The founders were already part of the journalistic establishment in Rio, having worked for *Última Hora, Correio*

da Manhã, and *Jornal dos Sports*, as well as small satiric publications such as *Pif-Paf* and *Carapuça*. They were inspired by Sérgio Porto, a master satirist who, under the pseudonym Stanislaw Ponte Preta, contributed a regular column to *Última Hora* called "Festival de besteiras que assolam o país" (Festival of idiocy that sweeps the country), which lampooned the regime in its early years after the 1964 coup.[62] The cartoonist Jaguar (Sérgio Jaguaribe) has referred to Porto as "the father of *O Pasquim*."[63]

Under the direction of its first editor in chief, Tarso de Castro, *O Pasquim* achieved early success, selling all 20,000 copies of the first issue, published on June 26, 1969. Although Castro was a *gaúcho* from Rio Grande do Sul, he presided over a paper that was resolutely carioca in its attitude, style, and content. By the time it reached its twenty-seventh issue, it had a weekly print run of 200,000.[64] Combining political and social satire with cultural commentary and long, unedited interviews with pop artists, movie stars, and other celebrities, *O Pasquim* found a substantial niche among the urban middle class of Rio during the period of most intense repression and censorship. Its spiritual home, so to speak, was Ipanema. The cartoonist Ziraldo (Ziraldo Alves Pinto), a founder of the paper, has recalled: "At that time, Ipanema seemed to be Brazil's paradise. Everyone thought that the corner of Rua Montenegro and the beach was amazing and cool. So *Pasquim* became the mouthpiece for that *modus vivendi*."[65] The paper championed the hard-drinking, chain-smoking bohemian intellectual life of Rio's south zone. *O Pasquim* was criticized for promoting *imperialismo ipanemense*, an imperialistic attitude toward the rest of Brazil, which annoyed in particular the intellectuals of São Paulo. Writing for *O Pasquim* in 1972, paulista journalist Mino Carta characterized Ipanema as a "typical neighborhood" that would "even be nice, if it weren't so pretentious and provincial." In the same issue, the editors of *O Pasquim* retorted: "That's right, Mino, folks here think that Brazil is an intellectual appendix of Ipanema."[66]

Between 1969 and 1974, *O Pasquim* was one of the few major outlets for anti-regime critique, albeit in the form of satire, and was one of only a handful of papers that were subject to *censura prévia*, in which material had to be vetted and approved by censors before publication.[67] During the first phase of publication, which one critic has called the journal's "Dionysian period," *O Pasquim* established a reputation for caustic satire often disguised as self-deprecation.[68] This early period also featured some of the journal's most famous interviews with musical celebrities such as Caetano Veloso, Gilberto Gil (during London exile), Maria Bethânia, Gal Costa, Jorge Ben, and Tom

Jobim and movie stars like Leila Diniz and Helena Ignez. The editorial staff was united in its opposition to the regime but often disagreed over social and cultural issues.

In some ways, O Pasquim was a transgressive paper, which delighted in lampooning the generals and satirizing the absurdities of life under authoritarian rule. The first issue featured a letter by cartoonist Millôr Fernandes addressed to his colleagues in which he quipped, "Remember what I told you: as humorists we are important enough to be arrested, but not enough to be released."[69] The masthead of one issue from 1970 openly parodied the infamous pro-regime slogan: "Pasquim—love it or leave it."[70] Another cartoonist, Henfil (Henrique de Souza Filho), gained notoriety during the repressive Médici years by creating a series of sketches, "The Cemetery of the Living Dead," in which he symbolically buried public figures who collaborated or sympathized with the regime. Through this series, he denounced some of the most famous and powerful celebrities of the time, such as soccer star Pelé, and the coach of the victorious World Cup team, Zagalo; musicians Wilson Simonal and Sergio Mendes; TV hosts Flávio Cavalcanti and Hebe Camargo; conservative Catholic bishops Dom Vicente Scherer and Dom Geraldo Sigaud; writers Nelson Rodrigues, Rachel de Queiroz, and Josué Montello; and actors Jece Valadão and Bibi Ferreira, among others. O Pasquim ridiculed traditional propriety and scandalized conservative readers with risqué cartoons and frank discussions about sex. The paper gained tremendous notoriety when in November 1969 it featured a long interview with Leila Diniz (discussed in Chapter 5), who brazenly declared her sexual independence, much to the consternation of the regime.

Yet O Pasquim was also reactionary in the ways that it trafficked in male chauvinist humor, with occasional forays into gay bashing. It was published by a group of white, heterosexual, middle-class men who had been active as journalists since the 1950s. The humorists/cartoonists Millôr Fernandes, Ziraldo, and Jaguar were typically the most caustic in their attacks on hippies, feminists, and gays. To a large extent they were products of the hopeful time and place of Rio de Janeiro before the coup—the world that created bossa nova and the mythology of Ipanema as a cosmopolitan beachside idyll. Even as they satirized the authoritarian moralism of the regime and its supporters, they reinforced the conservative political culture of their social milieu, especially with regard to gender and sexuality.[71] For the humorists of O Pasquim, sexual liberation was about the relaxation of conservative mores governing middle-class women and the gleeful indulgence of a naughty male gaze. They ridiculed feminism with sexual double entendre: "Pasquim—a

journal on the side of women. And also on top and on the bottom."⁷² When Betty Friedan visited Rio de Janeiro in 1970, she granted an interview to *O Pasquim*, during which the writers belittled the activist and her struggle. As shown in Chapter 5, they also policed the boundaries of heterosexual masculinity by reinforcing the *macho/bicha* (macho/queer) dichotomy and ridiculing gays. A 1971 essay by Millôr Fernandes best captured the sarcastic attitude toward identity movements found in the pages of *O Pasquim*. With the title "Handicapped Black Homosexuals vs. Sexagenarian Lesbian Jews," the essay is an exercise in reductio ad absurdum, as Fernandes imagined a fragmented world of conflicts among discrete interest groups that form fleeting and arbitrary alliances.⁷³

On the other side was Luiz Carlos Maciel, a former theater director who had turned to journalism in the late 1960s after one of his plays was censored.⁷⁴ As a fellow *gaúcho*, he found common cause with Tarso de Castro in the internal squabbles with the carioca humorists. An ardent champion and defender of the tropicalists in 1968, Maciel became a leading proponent of the Brazilian counterculture. In 1969, he and his wife started an urban commune in Botafogo where friends and acquaintances could meet, smoke marijuana, trip on LSD, play music, and paint. Their guests often stayed for weeks at a time, but Maciel and his wife used it more as a social space, while maintaining an apartment in Leblon. After the dissolution of the urban commune, they lived for a period on a remote beach south of Rio de Janeiro, but his experience with alternative living in the manner of hippies was limited and sporadic.⁷⁵

Maciel's interest in the counterculture was, above all, intellectual. He was a student of the Western philosophical tradition, with a particular interest in the legacies of Marx and Freud and the work of Herbert Marcuse, Norman O. Brown, Wilhelm Reich, and others. He has described himself as an existentialist inspired foremost by Jean Paul Sartre, who taught him an early appreciation for seeking personal freedom and taking responsibility for it.⁷⁶ Maciel was also fascinated with the philosophical and religious traditions of East and South Asia as well as various shamanic traditions of indigenous peoples of the Americas. In the years he wrote for *O Pasquim*, from 1969 to 1972, his three main objectives were to propagate the debates and cultural manifestations of the international counterculture, introduce aspects of Asian and Native American shamanic thought, and chronicle the reception and circulation of these ideas in Brazil. His writing was not geared toward specialists, nor did it resemble the mind-blown prose of "gonzo journalism" popularized in the United States by Hunter S. Thompson. Instead,

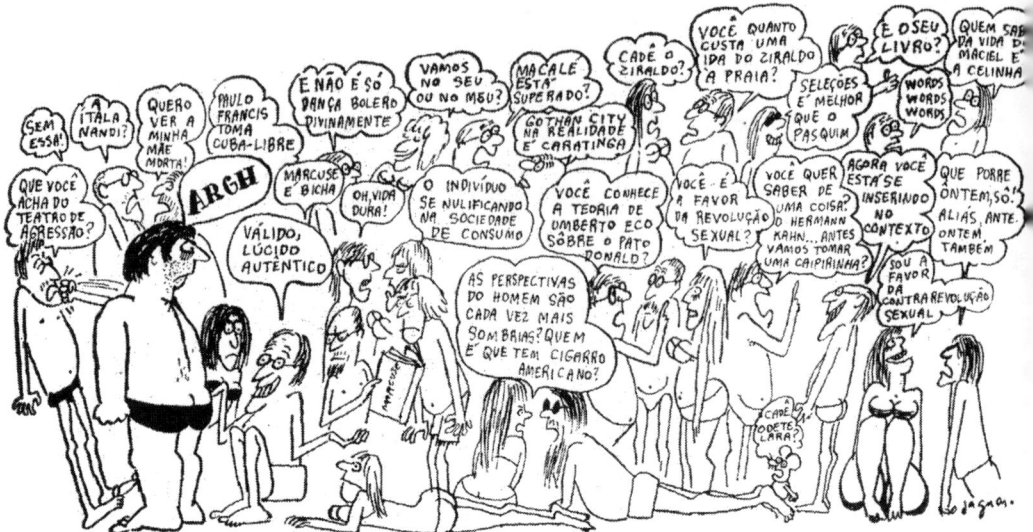

Cartoon by Jaguar in *O Pasquim*, 1969. Courtesy of Sérgio Jaguaribe.

Maciel patiently cultivated a general audience of readers who yearned for more information about the counterculture. He was often described erroneously as "the guru of Brazilian counterculture," but his role was more that of cultural mediator and translator. Having lived and studied theater in the United States in the early 1960s, Maciel was well versed in American literature, culture, and politics. In one essay, he described himself as a "compiler" of foreign texts that provided Brazilians with the necessary information to establish a "critical relationship" with the counterculture. He argued that through *antropofagia*, the well-known modernist trope for cannibalizing other cultures, Brazilians could forge a unique counterculture.[77]

The tenor of Maciel's countercultural writing oscillates between ironic humor and new-age conviction, as suggested by early texts for *O Pasquim* in which he sought to take stock of the "new sensibility" as it took shape and circulated in conversations at the beach and in bars of the south zone. Published in November 1969, at the beginning of the summer, his essay "Cultura de Verão" (Summer culture) offered advice to "visitors from the hinterland" on how to fit into the beach scene of Ipanema.[78] The essay was accompanied by Jaguar's cartoon illustration showing a crowd of beachgoers in heated conversations captured in speech bubbles with random questions and interjections like "Are you in favor of the sexual revolution?" "Do you know Umberto Eco's theory about Donald Duck?" "The individual nullifies

himself in consumer society." "Marcuse is a fag." "Shall we go to your place or mine?" One conversation featured a bearded hippie lounging in the sand who asks a young bikini-clad woman: "The future prospects for man are increasingly somber? Does anyone have an American cigarette?" In the foreground, a pudgy guy who looks out of place scowls at a skinny intellectual who prattles on about what is "valid, lucid, authentic." At the same time, he throws a punch at another guy who asks his opinion about *teatro de agressão* (guerrilla theater).

Like Jaguar's cartoon, Maciel's essay reinforced the image of Rio's south zone as a center of cultural and intellectual life but also lampooned it as superficially festive. Oozing with mock paternalism and intellectual snobbery, Maciel's first bit of advice was to instruct his neophyte readers to never use the words "valid," "lucid," or "authentic" or the term "placed in context"—all obvious references to the lexicon of political revolution and cultural nationalism from the 1960s. He instructed his readers to pointedly eschew psychoanalysis, then emergent among the urban middle class, recommending hallucinogenic drugs as an alternative form of therapy. He further recommended that his readers learn how to "talk about drugs with utmost familiarity," referring to marijuana in a blasé manner "as if it were Coca-Cola." Since it was important to be able to drop references to social theorists and movements of the time, though not necessarily with any depth, he offered a simple rule of thumb: if a source had already been translated into Portuguese and had circulated in Rio's south zone, it was already passé. The key to impressing friends and acquaintances was to drop references to foreign authors who were still unavailable in translation: "Marcuse was still a good topic last summer, but careful, he no longer impresses. Better to say that you are more a Norman O. Brown type; he hasn't been translated so few people know about him." Finally, he told his readers that *teatro de agressão* was no longer in vogue, Godard was passé, and "the only thing left was the underground."

Two months later, in early January 1970, Maciel issued the "Manifesto Hippie," which contrasted sharply with the blithe sarcasm of "Cultura de Verão." Whereas his early essay poked fun at the superficiality of countercultural style and discourse, reducing it to a highly self-conscious performance, the manifesto attempted to synthesize the aesthetic values and existential experience of this "new sensibility" introduced by the hippies. In his manifesto, Maciel created a two-column list, inspired by Norman Mailer's "The Hip and the Square" (1959), which attempted to schematize this new sensibility.[79] He proposed a list of binaries, abbreviated below, to instruct his

readers in how to distinguish the "new sensibility" from the cultural icons and values of the recent past:

Cool Jazz	Free Jazz
Anguish	Peace
Whiskey	Marijuana
The Beatles	Jimi Hendrix
Volkswagen	Jeep
Hygiene	Beauty
Night	Morning
Aggressive	Calm
Talk	Sound and color
Atheist	Mystic
Somber	Joyful
Lenin	Che Guevara
Psychoanalyzed	Turned on
Bar	Beach
Martinho da Vila	Gilberto Gil
Politics	Pleasure
Bossa nova	Rock
Discourse	Groove [curtição]
Family and friends	Tribe
Security	Adventure

The left column cites references associated with the nightlife of late-1950s Rio de Janeiro (bossa nova, bar, whiskey) and the political crisis of the Left during the 1960s (talk, anguish, somber, discourse), together with more traditional references to social conventions (family and friends, security, hygiene). In some cases, even references that for many would have epitomized contemporary pop culture, such as The Beatles, were dismissed as belonging to the past. The new sensibility, corresponding to what Mailer called "hip," was attuned to sensorial experience, nature, spirituality, and communal living, together with references to artistic celebrities like Jimi Hendrix and Gilberto Gil. These two texts are emblematic of Maciel's countercultural journalism, which focused heavily on the circulation and reception of international discourses, trends, and icons while remaining attentive to the specificity of local trajectories and conflicts within the Brazilian context. Maciel's texts suggest that the Brazilian counterculture was a movement of multivalent gestures, combining despair with revelry, surface-level style with conviction of purpose, and radical disillusionment with novel forms of utopianism.

In May 1970, at the suggestion of Tarso de Castro, Maciel launched a column called "Underground," which provided him with a platform to propagate countercultural ideas and experiences to a large and devoted readership of young Brazilians who wrote to him about their anxieties and aspirations.[80] Most of his articles for "Underground" were about countercultural celebrities, lifestyle trends, and political struggles in the United States and, to a lesser extent, Europe. "Underground" featured pieces by Yippie leaders Abbie Hoffman and Jerry Rubin, black power leaders Stokely Carmichael and Eldridge Cleaver, and advocates for psychedelic drugs Aldous Huxley, Timothy Leary, and Ken Kesey. Maciel wrote on a range of topics, including the Gay Liberation Front, the Black Panthers, feminism, and the antiwar movement. He reported on the visit to Brazil of the New York–based experimental theater group Living Theater and the notorious arrest of their directors in Ouro Preto.[81] He wrote extensively about popular music, focusing on Brazilian artists associated with counterculture, such as Caetano Veloso, Gilberto Gil, Gal Costa, and the Novos Baianos, as well as American and British artists such as Bob Dylan, Ritchie Havens, Janis Joplin, Jim Morrison, John Lennon, and George Harrison. Maciel was particularly fascinated with Jimi Hendrix and his impact on the counterculture. In a long essay following the artist's death, he wrote that Hendrix's music represented "a new existential experience that demands . . . a profound change in the listeners' way of living, in the values that orient their behavior, and in their own nervous systems."[82]

During this initial phase, *O Pasquim* challenged the limits of the regime's patience with an increasingly popular vehicle for anti-authoritarian humor. In November 1970, the editorial offices of *O Pasquim* were raided and several of its contributors, including Maciel, were jailed, along with Tarso de Castro in response to an irreverent cover described in Chapter 4. They were not subjected to the same kinds of physical and psychological violence inflicted on members of the armed opposition, but this marked the end of the ebullient "Dionysian period." The arrested staff were eventually released, but *O Pasquim* was subject to censorship for the next five years. Tarso de Castro left the journal, and the music critic Sérgio Cabral assumed leadership. Maciel continued to publish "Underground" through 1972, when he turned it over to musician-writer Jorge Mautner and embarked on new editorial projects.

Upon being released from prison in 1971, Maciel cofounded, with Torquato Neto, Rogério Duarte, and Tite de Lemos, the short-lived but highly influential literary and cultural broadsheet *Flor do Mal* (an homage to Baudelaire's *Les Fleurs du Mal*, 1857), the first of several Brazilian journals published

in Rio de Janeiro, São Paulo, and Salvador that explicitly identified with the counterculture. Its design and layout were low budget and idiosyncratic, featuring texts printed in handwritten cursive, experimental graphics, photo collages, and found objects. Unlike O Pasquim, Flor do Mal covered little in the way of politics, mass culture, celebrities, or current events, nor did it demonstrate any interest in humor and satire. The writing in Flor do Mal was experimental and confessional, directed at a small intellectual milieu of Rio's south zone, with little regard for reaching a mass audience. It was soon followed by a series of countercultural publications, including Presença, also from Rio, Verbo Encantado, from Salvador, and Bondinho, a full-color glossy magazine published in São Paulo. All carried essays, reviews, and advertisements relating mostly to popular music in the United States and Britain.

In late 1971, Maciel was invited by a British expatriate, Mick Killingbeck, to serve as editor of a Brazilian edition of Rolling Stone, which featured translated articles from overseas together with original reportage on the Brazilian popular music scene.[83] Cover stories included articles on American and British artists such as The Beatles, Bob Dylan, Janis Joplin, Joan Baez, Alice Cooper, Mick Jagger, David Bowie, Jane Fonda, Elvis Presley, and Jim Morrison, as well as Brazilian artists like Caetano Veloso, Gal Costa, Chico Buarque, Rita Lee, Tom Jobim, Luiz Gonzaga, and Hermeto Pascoal. It also occasionally featured cover stories about topical social phenomena like the hippie communes of California, Angela Davis and black power, and the emergent gay liberation movement. Lasting from November 1971 to January 1973, the Brazilian edition of Rolling Stone produced thirty-six issues and attracted an estimated readership of 30,000. Killingbeck and his partners failed to pay royalties to the American publication, which thereafter ceased to send articles and original photos. For a time, the Brazilian version of Rolling Stone operated as a pirata, or "pirated" magazine, but eventually ceased publication.[84]

Throughout the 1970s, Maciel continued to contribute to short-lived alternative papers, but the peak moment of countercultural journalism in Brazil passed with his departure from O Pasquim and the early demise of Rolling Stone. These foundational journals and magazines would inspire a tremendous surge in the alternative press, including two papers with large circulation focusing primarily on politics, Opinião and Movimento, which were important vehicles for the left-wing opposition. During the same period, dozens of short-lived literary and cultural journals filled a void left by Flor do Mal, providing venues, however precarious and ephemeral, for the circulation of experimental writing. The alternative press movement was, together

with the recording industry, the most important vehicle for the circulation of countercultural ideas, attitudes, and styles in Brazil.

⇒ Hippie de Butique: Consuming the Counterculture

Theodore Roszak argued that the counterculture was a product of affluence and overindulgence, not privation and suffering. He also noted how dissent itself had become commodified, an insight later taken up by Thomas Frank and others: "Teen-agers alone control a stupendous amount of money and enjoy much leisure; so, inevitably, they have been turned into a self-conscious market. . . . With the result that whatever the young have fashioned from themselves has rapidly been rendered grist for the commercial mill and cynically merchandised by assorted hucksters—*including* the new ethos of dissent, a fact that creates an agonizing disorientation for the dissenting young (and their critics)."[85] Although Brazil was certainly not a society of comparable abundance in the early 1970s, its expanding economy spurred the growth of a consumer culture oriented toward urban youth. Products and styles associated with the counterculture were fashionable, serving as signs of one's modern, worldly, and progressive sensibility in a poor, marginalized country ruled by dictators. In addition to the thousands of young Brazilians who adopted alternative, ambulant lifestyles, many also adopted the counterculture as a style. The so-called *hippie de butique* (boutique hippie), the middle- or upper-class kid who adopted the hippie fashion but maintained a lifestyle of comfort and privilege, entered the scene. Since Tropicália, Brazilian cultural and fashion industries had sought to capitalize on an emergent hippie chic. The French fabric company Rhodia created an entire line of exuberantly colored floral and geometric prints inspired by the tropicalist movement.[86] In 1969, the São Paulo–based fashion designer Regina Boni opened the boutique Ao Dromedário Elegante (To the Elegant Dromedary), which defined the tropicalist-hippie style of urban Brazil. In Rio, a store in Ipanema called Hippie Center was devoted entirely to hippie-inspired fashion.[87] Artistic celebrities further popularized styles associated with the international counterculture. In her first interview after the end of Tropicália, Gal Costa spoke adoringly of the hippies: "I'm not able to find beauty in conventional things. I think it's pretty when I see a person with colorful, crazy, youthful clothes. To me, hippies are beautiful."[88]

Victoria Langland has shown that in the late 1960s, female models posing as armed radicals and hippies were two increasingly common images associ-

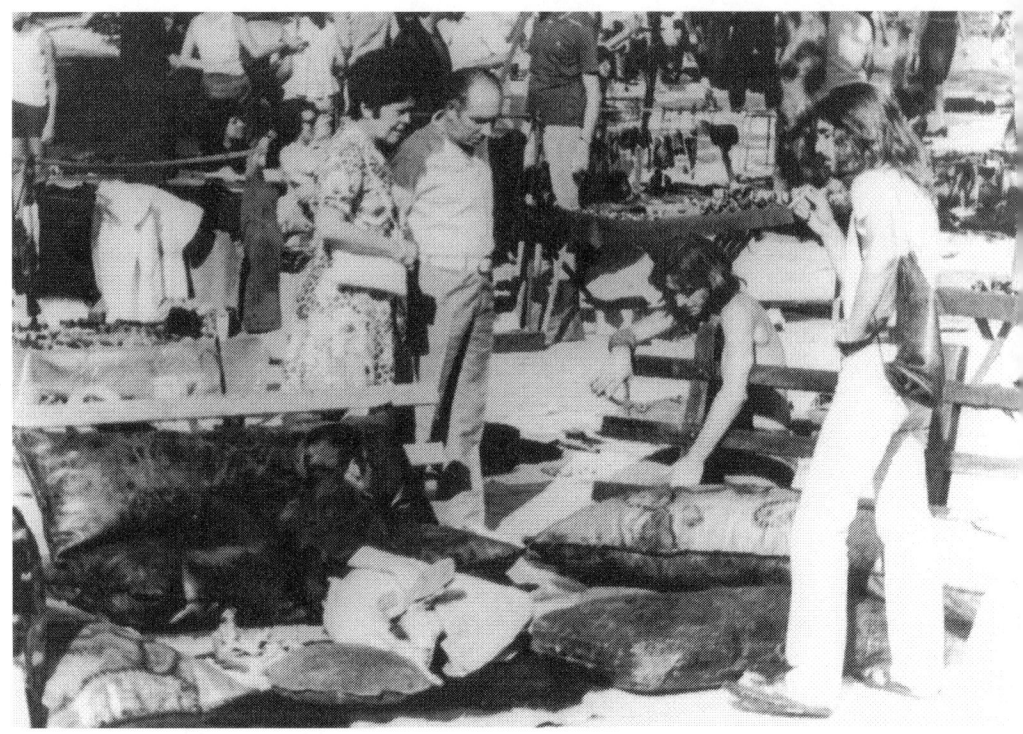

Hippie Fair of Ipanema, 1970. Photo by O. Alli. Courtesy of the National Archive, Rio de Janeiro.

ated with fashion and popular culture.[89] As elsewhere in the West, including urban Latin America, blue jeans were worn by both men and women, signaling a new informality and sexual openness in everyday fashion.[90] The popularity of American jeans made by Lee and Levi Strauss generated a market for contraband imports, yet Brazilian companies soon produced local brands that were attuned to current fashions.[91] *O Pasquim* frequently ran an advertisement for Ôi, a national brand of jeans described as *prafrentex* (forward looking, up-to-date), featuring a drawn illustration of several curvy female buttocks with impossibly small waists. Suggesting an association between female sexuality, sartorial style, and bold character, the advertisement proclaimed that Ôi jeans "are almost a philosophy."[92]

Seeking to resist the attractions of consumer society, some youth refused to shop at malls and even avoided boutiques. They sewed their own clothes and purchased accessories at fairs.[93] The 1970s witnessed a boom in *artesenato*, the return to individual or cooperative craftsmanship that eschewed industrial manufacturing and embraced handmade production. Young people

flocked to the Feira Hippie de Ipanema and similar fairs in other cities to buy handcrafted leather belts, sandals, pants, jackets, handbags, satchels, beanbags, and cushions, as well as handmade jewelry, furniture, musical instruments, and home decorations. These open-air fairs appealed to crowds of young people with countercultural sensibilities, but also attracted older people with conventional tastes who were curious about hippie style.

Located in the Praça General Osório, on the north end of the famous beachside neighborhood, the Feira Hippie de Ipanema got its start with a group of young artists who encountered difficulties in showing and selling their work in south zone galleries. They congregated at the bar Jangadeiros, where they hatched a plan to start exhibiting their work on the wide swath of sidewalk adjacent to the square on the Avenida Visconde de Pirajá, Ipanema's main commercial thoroughfare. A community of artists and artisans congregated on Saturdays and Sundays on the perimeter of the square, soon occupying its interior spaces. Many of the earliest sellers were young itinerant travelers from the urban working or lower-middle classes who sought adventures on the road and eschewed conventional work. In February 1970, the Feira Hippie was invaded and shut down by the police for operating without licenses after authorities had received complaints from local businesses. After a local association of artists protested the invasion, the Feira Hippie was allowed to reopen on Sundays only.[94] The city began to issue permits and charge fees, and the vendors erected temporary stalls, or *barracas*, which are still a central feature of the Feira Hippie. In the early 1970s, the Feira Hippie soon became a fashionable meeting point for middle- and upper-class south zone youth. While many of the artisans lived as hippies on the margins of society, their clientele were quite often upscale residents. Whatever tensions may have existed between those who lived as hippies in the informal economy and those weekend hippies, the early 1970s is still remembered as something of a golden age of the Feira Hippie, when artists came to merely exhibit, artisans adhered to rigorous standards of rustic, anti-industrial production, and affluent consumers from the south zone came to spend money.

At the same time, advertisements from Brazilian journals and newspapers marketed toward a young middle-class audience reveal ample evidence of what Thomas Frank calls "hip consumerism."[95] In many cases, the signs and symbols of the hippie counterculture were used to pitch a product as playfully rebellious but not dangerously subversive. Advertisements provide ambiguous evidence of a cultural trend, since they represent informed conjecture of what might attract a target audience without guarantee that they

will resonate with potential consumers. The proliferation of advertisements that deploy countercultural ideas, themes, and images suggest that there was a substantial audience of potential consumers who responded to the language of dissent and transgression while pursuing conventional middle- and upper-class lives.

By 1968, local businesses were regularly appropriating the language and iconography of the international counterculture in advertising campaigns, even in the mainstream press. *O Estado de São Paulo*, for example, published a couple of advertisements for a local paulista department store, Clipper, which referenced sixties-era performance art in promoting a *liquidação happening* (happening sale) with *descontos bárbaros* (barbarous discounts).[96] A couple of months later, the same paper ran an advertisement for the supermarket chain Pão de Açucar, which announced that it was lowering all of its prices. The illustration featured three long-haired hippies (one wearing a shirt that proclaimed "I'm hippie") holding a trio of placards, as if at a political demonstration, that read "special offers are easy . . . but lowering all prices . . . only at Pão de Açucar!"[97] The Swiss company Tissot used the iconography of public dissent even more explicitly in marketing a round wristwatch, the Sideral, which played on the double meaning of *quadrado* (square) by implying that the shape of the old watches was out of fashion. In the illustration, an agitated hippie brandishes a protest sign with the slogan "Down with square watches."[98] The pitch also sought to link the watch with youthfulness, novelty, and space-age ultramodernity. "Down with the old junk! Up with the Sideral, the only one with a case made of fiberglass, the raw material of space crafts." Finally, the advertisement trumpeted the authenticity, ruggedness, and convenience of the watch for everyday life: "Down with imitations. . . . Up with the Tissot Sideral, impermeable, automatic, with a calendar!" The pitch ends with an appeal to Brazilian youth who would appreciate the Swiss pedigree of the watch and an endorsement of the stores that carried it: "A Swiss watch of the best quality with a special price for young people! And warm praise for the up-to-date [*prafrentex*] watch stores affiliated with Tissot, which are selling the Sideral throughout Brazil with that thing . . . very friendly terms for sale!"

Countercultural pitches were also used to promote educational services and employment opportunities. The most common advertisements of this sort were for preparatory courses for the *vestibular*, a national qualifying exam for admission into a university. In 1968, the regime instituted a massive educational reform designed to dramatically expand the public and private university systems.[99] There was suddenly a huge market of urban youth in

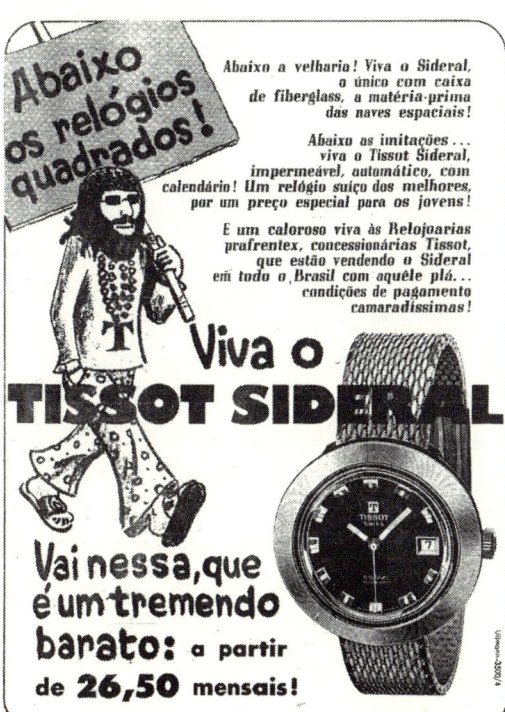

Advertisement for Tissot watches in *O Pasquim* 73 (November 11–17, 1969).

need of preparatory courses. Visual metaphors of mobility and adventure appear in an advertisement for the Curso Módulo, a preparatory course for the vestibular, this time drawing on a well-known international point of reference for countercultural adventure—the 1969 film *Easy Rider*, directed by Dennis Hopper. A photo shows a long-haired, leather-clad gang of men and women posed seductively around a couple of motorcycles under the exhortation "Atenção Easy Riders!"[100] One of the more striking uses of countercultural references appeared in an advertisement for Capi Vestibulares in São Paulo, which developed an entire pitch based on the image of the drug-addicted youth in search of a fix. A cartoon rendering of a bearded hippie smoking a pipe, framed simultaneously as a laid-back toker and a self-satisfied intellectual, provides a visual cue to the sales pitch: "We are addicted." Subsequent lines explain: "Yes, addicted (for eleven years) to turning *vestibulandos* into university students. . . . To this end we intoxicate our students with handouts, texts, cinema, simulated dialogues, all with teachers who are righteously doped up on vestibular exams."[101]

The careerist sales pitch to striving but hip middle-class youth did not stop with the adolescent vestibulandos, eager to gain a place in the univer-

sity, nor was it confined to the center-south industrial cities. An advertisement from 1972 in Salvador's A Tarde, for example, carried an announcement for a desk clerk pitched to attract hipsters in search of real money: "No more of this business of being broke, dude. Come work for us." A crudely drawn, slightly pudgy hippie with a goatee and muttonchop sideburns, wearing a tunic, quadrangle sunglasses, and a peace medallion, stands beside the appeal to "Check out this tip to secure some smooth cash, grooving with a cool job: if you are between 25 and 35 years old, intelligent, and know how to relate easily to people, come by."[102] A similar advertisement from O Pasquim was a bit more cryptic, stating only that it was not an office job, but promising that it would be "uma tremenda curtição" (a tremendous groove). The leading pitch reminded youth who were attracted to alternative lifestyles that "curtição só dá pé com grana no bolso" (you gotta have some cash to enjoy life).[103]

Countercultural style and language were also used to reach young professionals who were completely integrated into the capitalist system at the highest levels, as seen in an advertisement for a Grupo Financeiro Independência, an investment bank, looking for young entrepreneurs in need of capital to start new businesses.[104] Juxtaposing the "underground generation" with the "underwriting generation," the advertisement suggests that young industrialists who had made use of Independência's venture capital were just as hip as the underground dropouts. "The underwriting generation has emerged in Brazil. It's the same age as the underground generation. It uses slang, wears long hair and beards, rides motorcycles. But it's on another trip. It thinks that the biggest curtição is money." The pitch to potential clients also appeals to their modern sensibility: "No more of this business of setting up an industrial empire with the money [grana] of old people." In Brazil's booming economy of 1972, it was old-fashioned to rely on the family fortune to start a business when such cool and easy money could be borrowed by people with "youthful thinking, youthful entrepreneurial mentality, to grow together with a youthful Brazil." Companies selling business attire for young executives also employed the language of dissent. Sudamtex, a multinational producer of polyester fabric used to make suits, instructed potential customers: "Be a rebel, even wearing a suit and tie."[105]

Although a small sample, these advertisements suggest ways that the hippie movement, countercultural dissent, and notions of nonconformity were integrated into youth consumption, professional development, and capitalist growth during the period of the "economic miracle" in the early 1970s. The language of subversion and transgression proved to be, as in the United States, useful for reaching young consumers. Of course, people

who actually dropped out and pursued an alternative lifestyle complained of counterculture's commodification, as Maria Rita Kehl has noted: "The market responded to our attempts to change the world, sold our dreams, transformed our resistance into another commodity to mystify the idiots."[106] Readers of Herbert Marcuse, by then available in translation, or Maciel's discussion of his work in the pages of *O Pasquim* would have been attentive to the workings of consumer capitalism in creating superfluous needs in order to sell products.[107] As Thomas Frank has observed, representations of the counterculture found in most advertising were "notoriously unconvincing" to people who actually took part in the movement, for the simple reason that they did not constitute the target audience for these campaigns.[108] Some young people who were attracted to the counterculture were striving to enter college, enter the professional class, and gain access to consumer goods.

The *desbunde* counterculture created a context for disaffected adolescents and young adults to disengage from society under a stifling dictatorship, especially during the first half of the 1970s. Although they were more concerned with armed opposition groups, agents of the regime believed that the counterculture, especially the hippie movement, could pose a threat to social order and national security. Meanwhile, leftist critics regarded it as alienated and politically vacuous. Yet even former guerrillas embraced alternative or countercultural practices and discourses after leaving the clandestine movement, while in prison, or in exile. For Vera Sílvia Malgalhães, a member of the MR-8 who participated in the 1969 kidnapping of the American ambassador (discussed in Chapter 5), the armed struggle and the counterculture "were all part of the same process" of liberation.[109] Alex Polari, the urban guerrilla cited at the beginning of this chapter, was arrested in 1971, repeatedly endured torture, and remained imprisoned in São Paulo until 1980. During the *abertura* of the early 1980s, he discovered Santo Daime, a syncretic religion based on indigenous shamanic practices that is dedicated to healing and spiritual transcendence through the consumption of the psychoactive plant ayahuasca. He later founded his own temple dedicated to Santo Daime in Visconde de Mauá, a mountainous community long favored by hippies.[110] The new sensibility, forged through countercultural experiences during the most repressive phase of military rule, would inform and inspire struggles in the waning years of the dictatorship, when there was a much greater range of opportunities to resist authoritarian rule beyond either "flipping out" or picking up arms.

2 ⇒ Experience the Experimental

> Occupy space, my friend, I tell you: cracks: go through them.
> —TORQUATO NETO, Polém, September–October 1974

"Today, the phenomenon of the avant-garde in Brazil is no longer the concern of a group coming from an isolated elite, but a far-reaching cultural issue of great amplitude tending toward collective solutions."[1] This well-known declaration by Hélio Oiticica (1937–80), one of Brazil's most inventive and influential artists of the last half century, framed his manifesto-like essay for the 1967 Nova Objetividade (New Objectivity) exhibit at the Museum of Modern Art in Rio de Janeiro, which sought to account for the current state of the avant-garde in Brazil. Oiticica had been a central figure in neo-concretism in the late 1950s and early 1960s. Like other avant-garde movements, neo-concretism was generally perceived not as a "broad cultural issue" but rather as a specific intervention for a rarified audience of artists and critics.

By 1968, a confluence of interventions in several artistic fields emerged under the banner of Tropicália, a term invented by Oiticica for an installation he presented at the Nova Objetividade exhibit. Caetano Veloso had appropriated the term "Tropicália" for the song-manifesto of his first solo album, released in January, and months later it appeared again in the title of a concept album, *Tropicália, ou Panis et Circencis*, involving a group of musicians identified as tropicalists. Astonished with the unexpected resonance of his work, Oiticica would write to British art critic Guy Brett: "One thing, crazy but in a sense very important to me, is that my idea of 'Tropicália' ... became the most talked about thing here." He went on to explain parenthetically that "Tropicália is a word here, today, that most often means 'psychedelic' or 'hippie,' and I think that it will soon be all over the world to characterize a 'Brazilian thing.'" In the same letter, Oiticica described the music of Caetano Veloso, an artist for whom he "had already felt many affinities."[2] In a subsequent essay written in English, Oiticica credits the tropicalists for provoking "the most extraordinary revolution in Brazilian pop music" while

creating a "synthesis" of artistic interventions in several fields.[3] By the time Veloso and Gil were exiled to London in October 1969, Oiticica was residing there following his first international exhibit at the Whitechapel Gallery earlier in the year.

In the early 1970s, artists who were aligned to varying degrees and in different ways with Tropicália developed new projects identified as *cultura marginal* or *marginália*. These artists have been called "post-tropicalist," but it would be a mistake to imagine that their work developed directly and solely from the tropicalist experience.[4] Although not necessarily synonymous, related terms for *cultura marginal* included the English-language term "underground," its Portuguese-language equivalent *subterrâneo*, and its homophonic transliteration *udigrudi*, which was used especially in the realm of cinema. While conditions of production and distribution played a significant role in how *cultura marginal* was positioned and understood, questions of aesthetic practice and cultural politics were even more significant. *Cultura marginal* was indebted to the constructivist avant-garde but also had deep affinities with the counterculture. The poet, lyricist, and producer Waly Salomão emerged in the early 1970s as a central figure of *cultura marginal* in Rio de Janeiro. A native of Jequié, a small town in the interior of Bahia, he burst on the scene as a songwriter and concert producer for Gal Costa and as the author of Me segura qu'eu vou dar um troço (Hold me back cause I'm gonna throw a fit), a kaleidoscopic prose poem, written largely in the first person, documenting life on the streets and in the prisons of Rio de Janeiro during the dictatorship. Like Oiticica, Salomão developed his projects in several realms and registers using spectacular erudition together with references to popular culture, urban marginality, and everyday life.

As noted in the Introduction, Zuenir Ventura had used the term *vazio cultural* to describe the relative dearth of vital artistic production in comparison with the period before 1968. Ventura argued that this impasse in cultural production had created a set of binary oppositions in terms of artistic strategies—"industrialism and marginalism; the avant-garde and consumption; logical expression and more intuitive, emotional expression."[5] A closer look at specific works and events of this period, however, reveals that these oppositions frequently dissolved in practice. Artists with substantial mainstream appeal within the culture industry could adopt postures, attitudes, and repertoires that were readily identified as "marginal," while outsider artists with precarious access to the media were able to intervene sporadically in mass culture. In similar fashion, artists who embraced and defended vanguardist projects were also given, perhaps out of necessity, to

producing work for popular consumption. This dynamic brought together, for example, Hélio Oiticica, Waly Salomão, and Gal Costa, the former tropicalist who was perhaps the most visible icon of the Brazilian counterculture in the early 1970s. The poet Torquato Neto, who wrote the lyrics to key tropicalist songs, established himself as a combative cultural journalist with regular columns in Última Hora and Plug in which he wrote about artists of cultura marginal, defended their stances, and attacked their critics. Emergent singer-songwriters, such as Jards Macalé and Luiz Melodia, formed creative partnerships with Salomão and Neto to produce songs that were in turn performed and recorded by Gal Costa. In the early 1970s, as Brazil suffered through its most repressive phase of military rule, cultura marginal functioned as a conduit and fulcrum mediating between the avant-garde tradition in Brazil and a more generalized youth counterculture.

"We Are the Proposers"

The story of cultura marginal has rather unlikely origins in a midcentury constructivist avant-garde and its peculiar permutations in the 1960s. Just as Abstract Expressionism was consolidating its dominant position in the United States, Brazil witnessed the emergence of an entirely distinct form of abstract, nonfigurative art that celebrated rationality, functionality, and technological progress and that coalesced under the banner of concretism in the early 1950s. The young Brazilian concretists, based in São Paulo, took inspiration from a variety of historic constructivist vanguards, most notably from the work of Kasimir Malevich and the Russian Suprematists and from Piet Mondrian and the Dutch neo-plasticism of De Stijl. A more direct influence on the Brazilians was Max Bill, the Swiss architect and sculptor who founded and directed the Ulm School of Design in Germany, whose work was the subject of a major retrospective exhibit at the Museum of Modern Art in São Paulo in 1950 and later received the grand prize at the first São Paulo Biennial of 1951.

Much concretist art from this period was geometric abstraction devoid of all external representation or symbolism. It contrasted starkly with modernist painting, which was concerned foremost with representing "Brazilianness," with the intent either to advance social critique, as in much of the work of Candido Portinari, or to celebrate images of tropical sensuality, exemplified by the mulata portraits of Di Cavalcanti. We find a parallel challenge in the realm of art music, as young composers led by German emigré Hans Joachim Koelreutter rejected the nationalist modernism of

Villa-Lobos and his followers and embraced the dodecaphonic technique of Arnold Schoenberg and later the serial compositions of John Cage. The most influential concretist project developed in the field of poetry around a group based in São Paulo composed of Augusto and Haroldo de Campos and Décio Pignatari. The concrete poets eliminated verse in their efforts to produce functional *objetos-palavras* (object-words) and *poemas-produtos* (poem-products) informed by techniques of contemporary graphic design and mass communication. They proposed, in the words of Haroldo de Campos, "a poetics of construction, rationalist and objective, against a poetics of expression, subjective and irrationalist."[6] Concrete art and poetry coincided with manifestations in other cultural fields that shared its constructivist and internationalist concerns, the most celebrated example being the ultramodern capital Brasília, constructed between 1956 and 1960.[7] Emerging in 1958, bossa nova might be understood as a kind of constructivist popular music in the way that it distilled samba to its most essential rhythmic elements, although it maintained a lyrical poetics of subjective expression that was contrary to concrete poetry.

Against orthodox concretism, a neo-concretist group formed in Rio de Janeiro around the poet-critic Ferreira Gullar and included artists Lygia Clark, Hélio Oiticica, Willys de Castro, and Lygia Pape, among others. Although still dedicated to the constructivist project, the neo-concretists rejected, in the words of Gullar, "concrete art taken to a dangerous rationalist extreme." In the "Manifesto Neoconcreto" (1959), Gullar delineated the group's principal difference with the paulista concretists: "The neo-concrete, born of the need to convey the complex reality of modern man within a new visual language, negates the validity of scientific and positivist attitudes in art and rearticulates the problem of expression, incorporating new 'verbal' dimensions created by non-figurative constructive art."[8] Unlike the paulista concretists, the carioca neo-concretists evidenced little interest in reaching a mass audience through graphic and industrial design. On one level, neo-concretism was less politically engaged than concretism since it maintained a detached attitude in relation to the modernizing developmentalist project.[9] On another, the neo-concretist project insinuated an alternative politics based on participation through sensorial experience. While still working with a language of abstraction, the neo-concretists sought to reincorporate elements of emotion and affect that assigned primacy to the sensorial experience of the spectator-participant who would participate actively in the production of meaning. The concretists had replaced the word "create," linked to a romantic sensibility, with the word "invent," associated

with the scientific rationality of orthodox concretism.¹⁰ In turn, we might say that the neo-concretists replaced "invent" with the term "propose" to describe their highly speculative and contingent artistic practice.

Lygia Clark articulated the most concise and fervent explanation of this idea in a mini-manifesto written in 1968, "Nós somos os propositores" (We are the proposers): "We are the proposers: we buried 'the work of art' as such and call out to you so that thought may live through your action."¹¹ What is distinctive about Clark's language, which is true to the neo-concretist avant-garde, is the notion of artistic practice as a "proposal" that is contingent and speculative and depends on spectator participation. These proposals were, as Clark suggests, timely and ephemeral, concerned foremost with the here and now. Clark's statement reveals an obvious debt to early twentieth-century avant-garde movements that attacked the institutional status of art. While the Russian constructivists called for art to regain its productive value, Dada drew attention to what Hal Foster calls art's "uselessness value" and its dependence on institutions that have the power to define what constitutes art.¹² This institutional critique, as Peter Bürger has argued, would ultimately lead to the most radical and elusive goal of the historic avant-garde: "Art was not to be simply destroyed, but transferred to the praxis of life where it would be transformed, albeit in a changed form."¹³

Clark and Oiticica were interested in transcending the limitations of pictorial space produced by the frame and releasing painting into space. Oiticica achieved this effect with remarkable force in *Grande Núcleo* (1960), part of his spatial relief series. Oiticica saw this line of work as both an extension of and break with Mondrian's experiments with color and space in a two-dimensional space. This liberation of color and form into space opened up a key element in his subsequent work: the participation of the viewer. Clark found her own way of addressing this issue with her *Bichos*, a series of sculptures made of metal planes articulated by hinges to be manipulated by the spectator-turned-participant. With the *Bichos*, emphasis was on tactile experience, or what Merleau-Ponty called the "haptic gaze," a form of seeing through touch.¹⁴ Later in the decade, Clark further explored sensorial experience with the series *Objetos Relacionais*, which included proposals involving masks, gloves, and goggles that seek to induce visual and tactile experiences in which the participant gains heightened awareness of his/her own body, its relationship to other bodies and objects, and its role in the constitution of self.

The neo-concretist group disbanded in 1961. The movement's principal theorist, Ferreira Gullar, abandoned the avant-garde project and joined the

CPC (Centros Populares de Cultura), which advocated direct communication with the masses based on discursive clarity and social protest. He would later question the very relevance of "vanguardist formalism," which he dismissed as distant from Brazil's reality.[15] The artists and theorists of the CPC were committed to "participation" in artistic practice, which entailed agitprop events, political consciousness-raising, and direct communication with the masses. Whatever tensions had existed between the paulista concretists and the carioca neo-concretists were minimal in relation to the deeper rifts between those artists of diverse fields who were devoted primarily to formal experimentation and those who believed that the primary function of art was to mobilize people politically. This debate took on greater urgency with the ascension of military rule in 1964 and the hardening of the U.S.-backed regime during the second half of the decade. Gullar's renunciation of the avant-garde prompted Oiticica to radicalize some key concepts of neo-concretism in relation to popular culture.[16]

≈ The Participatory Turn

The constructivist avant-garde continued to be the primary point of reference for both Clark and Oiticica as they forged new directions that put greater demands on the spectator-participant. At a time when left-wing artists typically conceived of participation in terms based on political content that could be delivered to a mass audience, they conceived of participation in terms of process. The passive spectator would be encouraged, if not obliged, to be an active participant in the creation of the work. The participatory turn in Oiticica's work occurred in 1964, when he accepted an invitation from two other artists to visit the Morro da Mangueira, one of Rio's oldest favelas and home to one of its most acclaimed samba schools.[17] Waly Salomão has asserted that Oiticica's work with Mangueira constituted a "radical rupture with the ethnocentric view of his social group and subversion of the dominant cultural circles of that time."[18] It was not, however, unusual for middle-class revelers and patrons to venture up to the morro during the carnival season to take part in rehearsals and parade with the samba schools, nor was Oiticica alone in forging sustained ties with the favelas. In the early 1960s, left-wing musicians, filmmakers, and theater directors, especially those associated with the CPC, sought direct connections with these poor communities and took particular interest in the velha guarda samba musicians from Mangueira, whom they saw as bearers of authentic cultural traditions. Oiticica was not interested in the questions of "authen-

ticity" defined in terms of cultural nationalism or the popular "roots." He appears to have had little or no contact with venerable samba musicians then being "rediscovered" by artists, critics, and producers.[19] The popular culture of the favelas was for him temporally coeval with Brazilian modernity, not a vestige of a traditional past.

Among his new proposals were the *parangolés*, a series of multilayered capes of different colors, forms, and sizes, some with defiant inscriptions like "Incorporo a revolta" (I embody revolt) and "Da adversidade vivemos" (Of adversity we live). The polyvalent word *parangolé* originated in the favelas of Rio as a slang term for "something happening," as in the interrogative greeting "Qual é o parangolé?" (What's happening?).[20] Oiticica conceived the *parangolés* in relation to his earlier neo-concretist explorations of structure-color in space but situated them within a new paradigm centered on the participant. When he invited some of his friends from Mangueira to perform with the *parangolés* at the opening of the collective exhibit Opinião 65 at the Museum of Modern Art in Rio de Janeiro, they were expelled from the museum. Oiticica and his friends from Mangueira left the building to exhibit the *parangolés* in the exterior patio of the museum. Although it was unplanned, the event is now remembered as a key moment in contemporary Brazilian art that generated a kind of institutional critique of the museum as a space and of the work of art as an object of passive contemplation.[21]

Cultural production from this period is filled with art works, films, and songs that focus on issues of violence, criminality, and marginality in Brazilian society. Oiticica was particularly drawn to romanticized notions of marginality, which he incorporated into his work.[22] He was a personal friend of a notorious urban outlaw known as Cara de Cavalo ("Horseface"), who was murdered by a death squad in 1964.[23] In 1968, he created a red banner with the black silhouette of a dead body and the inscription "Seja marginal, seja herói" (Be marginal, be a hero), which gained notoriety when it was displayed at a concert featuring the tropicalists at the nightclub Sucata in late October 1968. When a DOPS agent present at the club demanded the removal of the banner, Veloso denounced his act of censorship from the stage, a protest that likely contributed to his arrest and incarceration two months later.[24]

For Oiticica, marginality was a social reality but also an ethical position in a context of political violence and social exclusion. In the program of conservative modernization promoted by the military regime, poverty was itself criminalized, as large segments of the population were excluded from the formal economy. The rapid expansion of Brazilian cities in the postwar

era had contributed to the rise of urban poverty and violence, further exacerbated by authoritarian removal policies implemented by local authorities. In the mid-1960s, the state government of Rio initiated a wide-scale demolition of urban favelas to make room for middle-class developments. Writing to Lygia Clark in 1968, Oiticica stated: "Today I am on the margins of the marginal [*marginal ao marginal*], not the marginal with petit bourgeois aspirations, which happens to most, but really on the margins: on the margin of everything, which gives me a surprising freedom of action."[25]

☞ Tropicália/Éden

With *Tropicália*, Oiticica initiated a new phase in his environmental and participative work. Conceived and constructed for the 1967 Nova Objetividade exhibit, *Tropicália* was a total environment, or *ambiente*, consisting of two simple structures with cloth siding called *penetráveis* ("penetrables") surrounded by tropical plants, dirt paths, and live parrots displayed in cages. The two *penetráveis* evoked what he called the "organic architecture" of the favelas, although they were not designed as reproductions of shanties, which were typically made of wooden planks or even bricks and mortar. The larger penetrable was a spiraling structure that led the participant through a dark passage to a functioning television set, thereby registering the presence of the then-new technologies of mass communication in the poor urban communities. "It is the image which then devours the participant, because it is more active than his sensorial activity." Oiticica called it "the most anthropophagic work in Brazilian art" as a way to address "the problem of the image"—the excess of mass-mediated images in modern society and its impact on contemporary artistic trends, most notably pop art.[26] In this passage, Oiticica referenced Oswald de Andrade's *antropofagia* not as a triumphant, anticolonial devouring of metropolitan culture and power, but rather as a mechanism of domination and erasure.[27]

The tropicalist moment reveals a productive tension between the tradition of constructivism (in its concretist and neo-concretist manifestations) and an emergent aesthetic clearly influenced by American pop art. Whereas the constructivism of Oiticica and Clark sought to overcome the image and assert sensorial, participative experiences, Brazilian neo-figurativism reveled in worn-out or banal images of everyday life, often with reference to the role of mass media. The carnivalesque theater of Teatro Oficina, compositions by Caetano Veloso, and paintings by Rubens Gerchman embraced an imagetic aesthetics of kitsch. When he was first introduced to American

pop art at the 1967 São Paulo Biennial, Veloso observed that "it confirmed a trend we were exploring in tropicalismo: that is, to take an object—a vulgar, even a culturally repulsive object—and remove it from its context, displace it."[28] Oiticica recognized the value of satirizing "good taste" through the use of banal cultural references. He warned, however, that the celebration of *cafonice* (bad taste) paved the way for conservative *saudosismo* (nostalgia) and *velhaguardismo* (the glorification of the old guard).[29] Oiticica was also wary of pop-kitsch tropicalism as a spectacular explosion of images for mass consumption. In an essay about his work *Tropicália*, he declared that "there are elements there that cannot be consumed by bourgeois voracity: direct life experience [*elemento vivencial direto*], which goes beyond the problem of the image."[30]

Despite his misgivings about pop-kitsch tropicalism, Oiticica championed Veloso and Gil for their experimental approaches to music, performance, and everyday behavior. He even created *parangolés* in homage to Veloso and Gil, respectively titled *Caetelesvelásia* and *Gileasa*, both from 1968. Writing that year, Oiticica observed: "It is the musical process that takes Caetano and his group through each stage, to successive visual transformations, to environmental creation, to the necessity of propagating what they think and want to the four winds—and this is nothing more than the need to create experimental conditions necessary for these very transformations. But all of that brings them to the central concept of this experimental attitude, which is acting on people's behavior directly, not in a pure process of desublimating relaxation, but rather in a creative structuring, an invitation to transform and not to submit to conformity."[31] Oiticica's assessment of the tropicalists complimented the efforts of the concrete poets, most notably Augusto de Campos, who championed them in the press and other public forums. Oiticica's dialogue with artists working in other fields, especially popular music, would intensify in the following Nova Objetividade exhibit and a major retrospective at the Whitechapel Gallery in London in 1969.

Writing to Guy Brett, Oiticica discussed ideas for "constructing an environment for life itself based on the premise that creative energy is inherent in everyone."[32] These ideas would directly inform his next major work, created for his first international retrospective curated by Brett in 1969 at the Whitechapel Gallery in London. The exhibit, known as the Whitechapel Experiment, featured a new environment, *Éden*, which Oiticica characterized as "an experimental campus, a kind of indigenous community [*taba*], where all human experiences are permitted. . . . It's a kind of mythic place for sensations, for actions, for the making of things and for the building of

each one's inner cosmos—for this reason, 'open' proposals and even raw materials to 'make things' are provided to the participants."[33] Waly Salomão has described Éden as an "immanent paradise" created on earth, suggesting that people must assume the responsibility of creating their own spaces of pleasure and creativity.[34] Photos from the Whitechapel exhibit show Londoners, some with kids in tow, lounging in nests and walking through the penetrables. Éden effectively "domesticized" public space by offering an inviting environment where people could relax and play for extended periods of time.[35] Oiticica's reading of key texts for the international counterculture, including Herbert Marcuse's *Eros and Civilization*, Edgar Morin's *California Journal*, and Marshall McLuhan's *Understanding Media*, informed the work.[36] In Marcusian terms, he conceived Éden as a utopian space of "desalienation" and "desublimation."[37] While in London, Oiticica also interacted with experimental artists and alternative communities, most significantly the Exploding Galaxy collective founded by David Medalla. Oiticica later wrote that he felt a "spiritual connection and mutual affinity" with Exploding Galaxy based on parallel interests in "public, sensorial experiences, spectator participation, etc."[38] When he first arrived in London in January 1969 he lived in the Exploding Galaxy communal house, and members of the group helped him to assemble his built environments for the Whitechapel Experiment.

While *Tropicália* was structured as a space to walk though, Éden was a multisensorial environment in which individuals could circulate as well as linger in spaces that were both communal and secluded.[39] Participants were invited to take off their shoes, traipse through the pools of water, play in sand, rest in little nests of straw, seek refuge in enclosed spaces, and linger in the environment for extended periods of time. Some of the structures made reference to Afro-Brazilian culture, such as a "water penetrable" designated Iemanjá (the Yoruba deity of the sea), or a booth named for Tia Ciata, the legendary host of samba parties in early twentieth-century Rio. Other structures referenced aspects of the counterculture, such as "Cannabiana," a reference to cannabis, and the Caetano-Gil tent, in which participants could listen to their music. For Oiticica, relaxing in the Caetano-Gil tent was the core experience of the Éden environment: "In this black tent an idea of the world aspires toward its beginning: the world that it created through and around leisure, not as an escape, but as the apex of human desire."[40] In March 1969, Oiticica wrote to Veloso, who was then under house arrest in Salvador, describing Éden and its reception in London: "Your presence was permanent throughout this month of exhibition: your voice, your marvelous music constantly, permanently in the black tent of Éden, which became

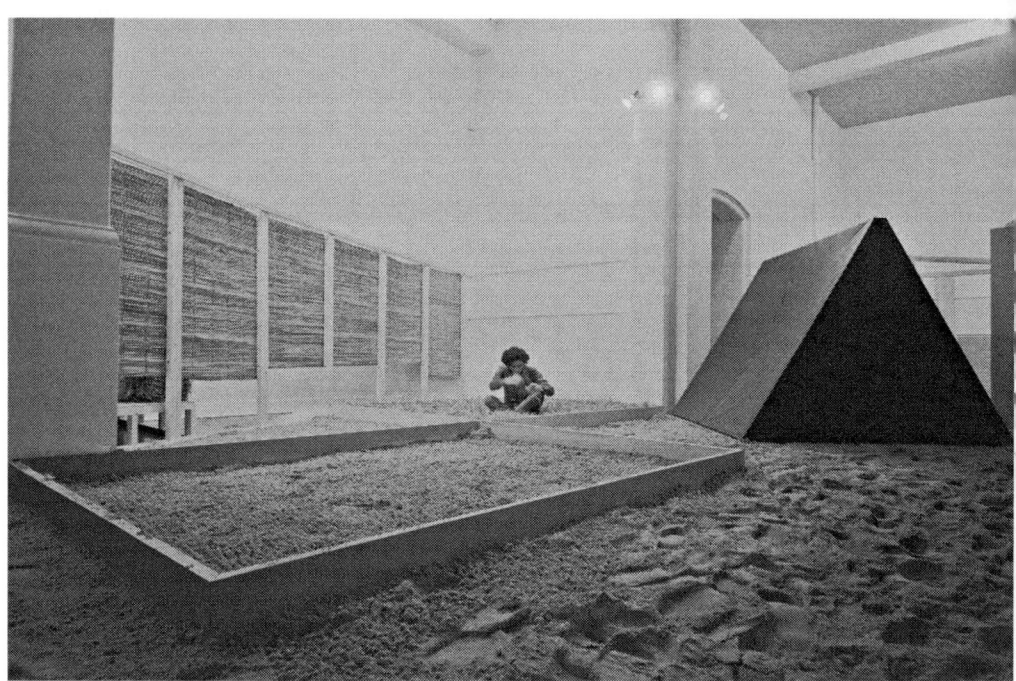

Hélio Oiticica's *Éden*, 1969. Whitechapel Gallery, London. Courtesy of Projeto HO.

the center of the experience."[41] Oiticica's use of the tent in this context is suggestive in the way that it refers to the ambulant lifestyle of the hippie counterculture and also in the way that it references leisure as a creative, liberating practice.

The catalog featured a detailed diagram of the environment, "The Eden Plan," which Oiticica described as "an exercise for the creleisure and circulations." Oiticica formulated the idea of "creleisure," or in Portuguese *crelazer*, which carries the dual semantic charge *criar do lazer, crer no lazer* (create through leisure, believe in leisure) as the organizing concept of *Éden*.[42] In an article written in English for *Art and Artists*, Oiticica explained the concept of "creleisure," using a series of related neologisms such as "crefeel," "cresleep," and "credream" that suggested a seamless integration of creative activity and everyday life.[43] For Oiticica, the concept of *crelazer* that was central to *Éden* also applied to other contexts and situations outside of the institutional setting of a gallery or museum. In a letter to music critic and producer Nelson Motta, Oiticica employed the concept of *crelazer* to describe the behavior of revelers at the Isle of Wight Festival during the performance of Bob Dylan. Oiticica observed "a creative attitude that in a certain sense

one could identify with what I call 'crelazer.' Anything that you could imagine was happening: everyone with blankets, sleeping bags, dressed in all kinds of clothes or naked . . . the whole 'hippie' scene of Piccadilly, Arts Lab, Portobello Road was there."[44] This passage suggests that Oiticica associated Éden with a whole range of life experiences and dispositions then associated with the international counterculture. Oiticica conceived of Éden as a "germinating structure" or "germinating community" that would develop into a utopian communitarian project, which he called the Barracão.[45]

Following the Whitechapel Experiment, Oiticica returned to Brazil, where he remained for most of 1970 before moving to New York. In an interview about his experience in London, Oiticica spoke at some length about the value and meaning of participation: "For me, spectator participation and the introduction of sensorial elements were important for introducing a new form of behavior (that is much more directed at daily life), and not for creating a new form of art."[46] Participation was, for Oiticica, no longer a formal or structural dimension of his work but rather a permanent disposition oriented toward everyday life. Upon returning to Brazil, he told one journalist that his time in London had deeply impacted his work in much the same way that his experience in Mangueira had shaped his earlier projects: "I integrate myself fully into the environments in which I live, thus, first the people of the favelas then the hippies of London taught me a lot of things."[47]

≈ Gal -Fa-Tal-

Soon after Hélio Oiticica returned to Rio, he began collaborating with an artistic milieu that emerged around Gal Costa during a time in which she developed new projects with visual artists, poets, and musicians associated with cultural marginal. In June 1970, Costa initiated a two-week run at the Boate Sucata, a nightclub in the Lagoa neighborhood in Rio, and invited Oiticica to serve as artistic director. Having just returned from his successful exhibit at Whitechapel, this project allowed Oiticica to experiment with environmental art outside of a gallery space within the context of a popular music event. Eschewing conventional scenography, Oiticica created instead a total environment (ambientação) for her performances at the Boate Sucata.[48] Entering the venue, the audience passed through, as if in a ritual of deconditioning, a dense forest of plastic filaments into a space organized into compartments by gauzelike screens hanging from the ceiling to the floor. The musicians, the rock band Os Bubbles (later renamed A Bolha) with the percussionist Naná Vasconcelos, were instructed to wear everyday clothes

instead of stage costumes, which further reinforced the idea of an "environment" instead of a "show." Once inside, audience members accommodated themselves on cushions and pillows, which created an environment that was reminiscent of *Éden*. On the first night of the two-week run at the Sucata, much of the environment was ripped down by the audience, which suggested that the audience disliked the visual sense of distance and alienation from their idol but also enacted the principle of spectator participation.[49] The following year, after moving to New York, Oiticica created another environment for Gilberto Gil's first performance in the United States, produced by the Theater of Latin America (TOLA) in St. Clements Church. For this environment, Oiticica built two large wooden frames similar to the twin base structures for "Cannabiana" and "Lololiana" in *Éden*, and filled them with gravel. As Gil walked over the gravel from a stool to a chair placed in opposing corners of the square frames, his steps produced audible grating sounds, an effect designed by Oiticica.[50] Gil performed two solo sets, one in each frame, under lighting also designed by Oiticica to produce a dramatic play of light, color, and shadow.[51]

Despite his aversion to readily consumed images, Oiticica also created the album cover for Gal Costa's LP *Legal* (1970). The cover featured a black-and-white photo of the singer cropped to show only her right half. A photo collage, arranged as long wavy hair flowing down from her head and face, features well-known cultural figures from Brazil and abroad (Caetano Veloso, Gilberto Gil, Jards Macalé, Waly Salomão, James Dean), images of experimental art (Lygia Clark's *Máscara Sensorial*, Lygia Pape's *Ovo*, Oiticica's own *Bólide Bacia 1*), and scenes from Whitechapel High Street in London. He chose photos that conveyed a "poetic, virtual reference, nothing of things 'connected to Gal,' but rather images without limit," as he described it to Lygia Clark.[52] The overall effect of the cover art was to situate Gal Costa in relation to Oiticica's circle of experimental artists. He wrote enthusiastically to Lygia Clark about the project, noting that it brought him some "experience and money" while offering a platform for inserting his own visual synthesis of the cultural moment, its relation to Gal Costa, and its vital link to experimental culture in Brazil.[53]

Lygia Clark maintained more distance from the world of popular culture and mass media. She was adamant about distinguishing herself from the tropicalists, noting that the neo-concretists had never cultivated an audience outside of a small group of artists and critics. While in exile in London, Caetano Veloso traveled to Paris, where he visited Clark in the company of his wife, Dedé, Gal Costa, and poet José Carlos Capinan. Veloso has recalled

that Clark improvised a simple installation in her living room for her guests. She laid out a blanket on the floor, as if to prepare an indoor picnic. As a centerpiece, she placed a Coca-Cola bottle with a single plastic rose, declaring that it was an homage to the tropicalists: "I am paying you this romantic homage in order to receive you, because a plastic rose in a Coca-Cola bottle is like Pop art that's romantic, like the things you tropicalists do, even though they are very powerful and interesting. I don't identify at all with that sort of thing because I am classical, and am only interested in classical things, that is, timeless things, because everything romantic depends on information from a certain period."[54] For Clark, the tropicalists were more akin to pop art with its focus on artifice, mass media, and consumer culture, as suggested by her gift of a plastic rose in a Coca-Cola bottle. Tropicália was, in this sense, an immanent critique that accounted for historical context and ideological underpinnings of any object or phenomenon. Clark claimed for herself a universal sensibility oriented toward the transcendence of history, culture, and context. In contrast with the tropicalists (and even with Oiticica), there was little in her work that referenced contemporary Brazil.

Following the Sucata shows, Oiticica departed for New York, but Gal Costa continued to work with artists from his circle of friends as she prepared for a "Gal a todo vapor," a series of performances in October 1971 at the Teatro Tereza Rachel under the direction of Waly Salomão and Luciano Figueiredo. The set design combined visual elements, avant-garde aesthetics, and subtle political critique. The stage, painted purple, was emblazoned with the suggestive neologism "violeto," a word invented by Waly Salomão. Its semantic charge is ambiguous, simultaneously evoking the color violet, *violeta*, and the context of political repression, aptly described as *violento*. The hyphenated capital letters -FA-TAL- appeared on the stage floor and backdrop. Salomão separated the word "fatal" into two phonemes, drawing attention to the rhyme tal/Gal ("a certain Gal"), while retaining the complete word with all of its various meanings in Portuguese (deadly, fateful, inevitable). The use of ambiguous but highly allusive "word-objects," the fragmentation of words, and the strategic deployment of graphic space revealed a debt to concrete poetry, while the total environment of the venue suggested the influence of Oiticica.

In addition to the unconventional staging, the concerts also marked a departure from ways in which Costa had been presented as an artist. During the first part of the show, Gal performed solo in a stripped-down *voz e violão* (voice and guitar) presentation, typically reserved for artists who had achieved some competence with the instrument. Gal was a novice on the

guitar, lending the opening numbers a certain air of amateurish informality, as if she were playing for a group of friends. Her vocal style and repertoire moved seamlessly from bossa nova to hard rock to traditional sambas and rural song forms from the Brazilian northeast. Gal's repertoire, developed in consultation with Salomão, was notable for its eclecticism. It included none of the standards of bossa nova or her recent hits from the Tropicália period. Instead, it featured two songs from traditional Bahian folklore, classic sambas from Geraldo Pereira ("Falsa baiana") and Ismael Silva ("Antonico"), and a *baião* ("Assum preto") by Luiz Gonzaga, who was then experiencing a late-career revival after some twenty years out of the limelight. In addition to four songs by Caetano Veloso, the show also featured new compositions by emergent artists such as Jards Macalé and Luiz Melodia.

"Gal a todo vapor" opened with an a cappella version of "Fruta gogoia," an anonymously authored song from Bahian folklore, which established her credentials as a *baiana*, albeit middle class and white. As we will see in Chapter 3, young Brazilians were then just beginning to flock en masse to the state of Bahia, especially its capital, Salvador, in search of "authentic" cultural experiences. Picking up an acoustic guitar, she next performed a fragment of "Charles Anjo 45," Jorge Ben's homage to the redeemed outlaw from the favela, leading into Caetano Veloso's "Como 2 e 2," which expressed the sensation of disaffection and disorientation among those who opposed the regime: "A desert all around us, all is right / all is right like two and two make five." At least one journalist interpreted the entire performance as a manifestation of generational despair, reporting that "Gal Costa is at the Teatro Tereza Rachel in Rio in a show in which she sings with some bitterness that the hippie dream is over, that underground culture failed. . . . But the great mass of the audience was made up of crazy youth with exotic clothes, enormous hair, necklaces, rings."[55]

This sense of disillusionment was dramatized at the end of Gal's opening acoustic set when she performed "Vapor barato," a countercultural anthem written by Waly Salomão and Jards Macalé. Narrated in first-person voice, "Vapor barato," a slang term for marijuana, relates the existential drama of a *desbundado* who is leaving behind a partner to "embark on that old ship" on some unspecified journey. While the term "vapor barato" is never actually cited in the song, a cloud of marijuana smoke seems to hang over it, a simple five-chord blues lament for a wayward hippie dressed in red pants and a military coat, with rings on every finger. As we have seen, Salomão often took a dim view of hippies in his literary work, but he was capable of creating an empathetic portrait of them in his songwriting: "Yes I'm so

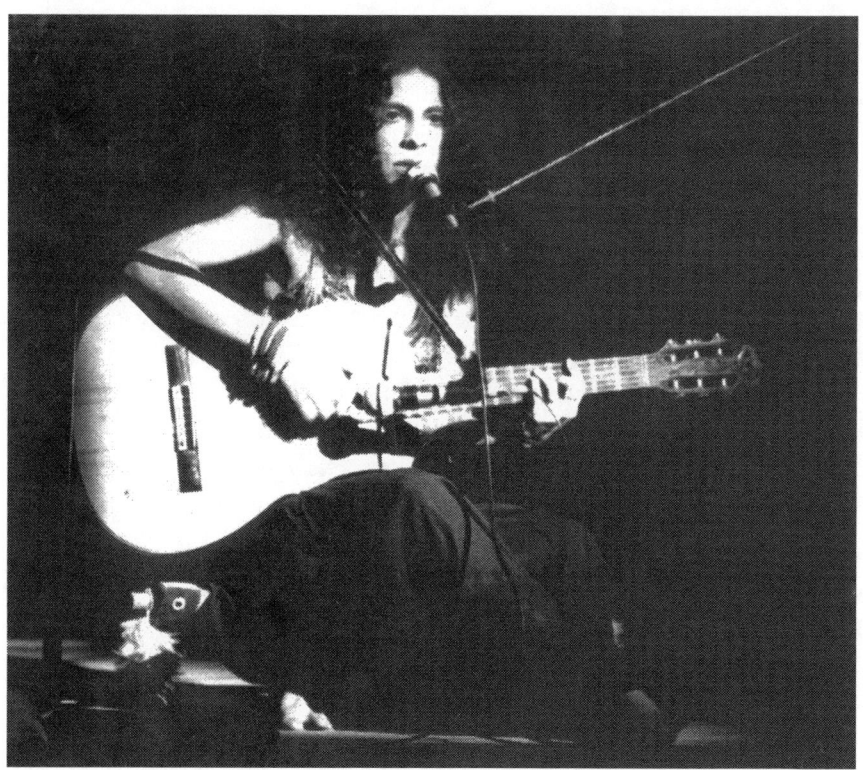

Gal Costa performs "Vapor barato," Teatro Tereza Rachel, Rio de Janeiro, October 1971. Courtesy of the National Archive, Rio de Janeiro.

tired / but not of saying / that I don't believe you anymore." Writing for *Última Hora*, Torquato Neto reported that the single of "Vapor barato," recorded by Gal Costa in 1971, sold 10,000 copies in just fifteen days, which suggests that the song resonated with young audiences.[56] "Vapor barato" captured the sense of fatigue and disillusion felt by urban youth who opposed the regime. It is an interesting companion to Chico Buarque's much more famous and certainly more exuberant samba, "Apesar de você" (In spite of you), which was recorded around the same time: "In spite of you, tomorrow will be another day." Both songs frame questions of public discord in personal terms—a fallout between two lovers—yet while Buarque's song, directed at the authoritarian state, suggests a day of revenge and redemption, Salomão's song conveys a sense of disenchantment, in relation not only to a person, but also to the ideals of the counterculture. At eight minutes and thirty-eight seconds, "Vapor barato" was the longest piece in Gal's repertoire, serving as a leitmotif for the entire performance. Halfway through the song, Gal's

electric band, led by guitar virtuoso Lanny Gordin, entered with a blues vamp, marking a passage from a mournful acoustic set to a raucous, rock-inflected jam session.

Gal's show featured members of the Novos Baianos, a group formed in Salvador that had relocated to São Paulo before ending up in Rio de Janeiro. Led by lyricist Luiz Galvão and guitarist-vocalist Moraes Moreira, the Novos Baianos wore long hair, dressed like hippies, and made frequent references to the consumption of marijuana and psychedelics in their songs. The group is best known for a pair of albums written and recorded in the early 1970s when the group lived communally with family and friends, first in an apartment in Botafogo (a neighborhood of Rio) and later on a farm on the outskirts of the city in Jacarepaguá. Their second album, *Acabou Chorare* (1972), featured an enchanting mix of hard rock, *choro* (an instrumental music using samba rhythms), and bossa nova to create what some critics rank as the best Brazilian album of all time. At the time, they received guidance and inspiration from João Gilberto, the master of bossa nova, who took an interest in their music. At a time when left-wing artists shunned symbols of national identity for their association with the hyperbolic patriotism of the regime, the group embraced samba and were so devoted to soccer that they formed their own team, Novos Baianos Futebol Clube, which was the title of their third album. In this way, the Novos Baianos sought to reclaim cherished Brazilian cultural practices that had been appropriated by regime propagandists.[57] Gal performed the Novos Baianos song "Dê um rolê" (Roll with it), a blues rock number featuring Gal's soaring vocals and Gordin's Hendrix-inspired guitar runs. The song's title referred to a defensive movement in capoeira in which a player evades an attack by rolling away and mounting a counterattack.[58] Written by Moraes Moreira and Luiz Galvão, the song expressed a defiant attitude of *curtição* and love in the face of violence and fear: "Don't be afraid, people, if I say that life is good / when they beat on each other, roll with it and you will hear . . . I am, I am love from head to toe." Performed right after Salomão's lament, "Dê um rolê" gave expression to the festive, Dionysian dimensions of the counterculture.

The show also introduced Luiz Melodia, a young Afro-Brazilian singer-songwriter from the Morro de São Carlos, whom Salomão had befriended in the period following his release from Carandiru prison. Melodia was from a working-class family immersed in the musical traditions of the adjacent neighborhood of Estácio, often cited as the birthplace of modern samba. He shared with Salomão a jazzy ballad written for a former girlfriend, with a bilingual title, "My black, meu nêgo," a popular term of endearment (that

is, "my guy") that indicated Melodia's affinity for African American music. The lyrics conform to an age-old genre in which an anguished male protagonist declares his love for an inexperienced girl and tries to convince her of his sincerity in an effort to bed her. The final stanza ends with the plea, "Try to understand everything about sex / I'll lend you a book if you like / acquaint yourself with it to avoid deception." The song acquired a second, more oblique meaning through the intervention of Salomão, who suggested the substitution of "My black, meu nêgo" with "Perola negra" (Black pearl) as an homage to a mutual friend, Edilson, a local transvestite from the Morro de São Carlos. Melodia agreed to the change, thereby infusing the song with a powerful ambiguity as a love song originally written for a woman, yet altered at the suggestion of a friend to refer to a local transvestite. This ambiguity was further enhanced by Gal Costa's debut of the song in 1971 at a time when she was widely regarded, mostly by men, as a countercultural muse and sex symbol.[59]

The "Gal a todo vapor" show was a milestone in the cultural history of the dictatorship, establishing Gal Costa as the most prominent voice of the Brazilian counterculture and Salomão as a popular lyricist, producer, and cultural mediator in Rio de Janeiro. Within months of the performances, the recordings were released as a double LP, -Fa-tal- Gal a todo vapor, now a canonical album of Brazilian popular music from the golden age of the LP. These shows also provided opportunities for experimental artists such as Waly Salomão to reach a substantial audience.

≈ Occupy Space

The group of artists identified with *cultura marginal* also gained access to a large general audience through the cultural journalism of Torquato Neto. A native of Teresina in the far northeastern state of Pauí, Neto had moved to Salvador in the early 1960s, where he met the Bahian group. Although not a musician, he was a gifted poet who wrote the lyrics for some of the most important tropicalist songs, such as "Geléia geral," "Mamãe, coragem," and "Marginália II." Following the abrupt end to the tropicalist musical movement, Neto focused more on cultural journalism, while continuing to write poetry and personal narratives that largely concerned his fragile psychological state, which required several stints in a local sanatorium. André Bueno has characterized Neto as "a romantic, radical, bohemian, nihilist dissident with intense emotions who never separated art from life, life from work, language and body, taking everything to the limit."[60] One of his later songs,

"Let's Play That," which was featured on the first solo album of Jards Macalé, best captured Neto's discordant disposition, particularly in relation to mainstream society. The song parodied Carlos Drummond de Andrade's well-known modernist classic, "Poema de Sete Faces" (Seven-side poem, 1930), a personal statement of self-awareness as a maladjusted and marginalized observer of the world: "When I was born, a twisted angel / one of those who live in the shadow / said: Go on Carlos! Be gauche in life." The twisted angel of Drummond's poem becomes a crazed angel with airplane wings in Neto's parody: "When I was born / a crazy angel really crazy / came to read my palm / it wasn't a baroque angel / it was a really crazy twisted angel / with airplane wings." Neto's angel is not a baroque cherub of the sort found in colonial churches of Brazil, but rather an angel of modernity with airplane wings that brings to mind Walter Benjamin's "angel of history," who is blown into the future by a storm called "progress," leaving behind the wreckage of catastrophe. In this context, the poet must stake out a position of perpetual critique and skepticism, or, as his angel tells him, "go on dude, sing out of tune in the chorus of the contented," an incitement to disrupt order and undermine contented conformism.[61]

From mid-August 1971 to mid-March 1972, Torquato Neto maintained a daily column in the Última Hora under the title "Geléia Geral," the name of his tropicalist song-manifesto featured on the 1968 collective album Tropicália, ou Panis et Circensis. A key trope of the concrete avant-garde, geléia geral first appeared in the mid-1960s to characterize the formless chaos of Brazilian culture. In a discussion with Décio Pignatari, the modernist poet Cassiano Ricardo had stated that the "bow cannot remain tense forever." In using the Nietzschean metaphor of the "tense bow" to denote vanguardist rigor, he implied that the concrete poets were too rigid in their positions and would eventually have to relax.[62] Pignatari retorted, "In the Brazilian geléia geral someone has to exercise the function of spine and bone."[63] Neto's appropriation of the trope in the song "Geléia Geral" was ambiguous since it both celebrated and satirized aspects of modern Brazilian culture.[64] Neto's column was also amorphous and unstructured, like the geléia geral, yet was aligned with the Brazilian avant-garde tradition.

On one level, Neto's column was an information clearinghouse for the cultural life of Rio's south zone, with announcements about upcoming concerts, record releases, book publications, theater performances, and film releases, as well as brief reviews. He championed the alternative press, particularly Presença, Flor do Mal, and Verbo Encantado, a journal from Salvador (discussed in Chapter 3). Written in telegraphic prose that recalls the

experimental writing of Oiticica, Salomão, and other artists aligned with *cultura marginal*, "Geléia Geral" reads like an insider's tips for young people. As Frederico Coelho has noted, Neto's column represented "a new way of doing daily journalism that mixed news and literary texts with personal confessions, intellectual debates, cultural information, existential doubts, and outbursts over a range of problems that in Torquato's view affected and asphyxiated cultural production in the country."[65] "Geléia Geral" also functioned as an alternative advice column for young readers finding their way through life. Neto was fond of didactic rhymes of the sort popularized by Chacrinha, the clownish host of a popular televised variety show who was famous for his slogan "Quem não se comunica se trumbica" (Those who don't communicate, aggravate). Some of Neto's slogans included "segure, mas não se dependure" (hold on, but don't hang on) and "quem não se concentra se arrebenta" (if you don't concentrate you are sure to break).

Torquato Neto wrote extensively about popular music, the area where he had established a name in the late 1960s. He regularly announced the arrival of the latest imports from the United States and Britain by the likes of Bob Dylan, Frank Zappa, Aretha Franklin, Joni Mitchell, Carole King, Neil Young, Joe Cocker, George Harrison, the Rolling Stones, The Who, and John Lennon Plastic Ono Band. Neto lavished praise on the former tropicalists and emergent artists identified with the counterculture, such as the Novos Baianos, Jards Macalé, and Luiz Melodia. He also gave extensive coverage to the resurgence of Luiz Gonzaga, the master of the northeastern dance genre *baião*, who had achieved national success in the 1940s. In March 1972, Jorge Salomão (Waly's younger brother) produced a show at the Teatro Tereza Rachel, "Luiz Gonzaga volta pra curtir" (Luiz Gonzaga come backs to revel), a title that quoted the theme of one of Waly's songs (discussed below), which sought to introduce Gonzaga to a young audience. Neto was a fervent advocate for artists from his own milieu, loosely identified with countercultural or marginal circles. Neto derided artists and works of the cultural mainstream with the same fervor that he defended and championed underground, countercultural, or marginal artists. He excoriated the record companies for sustaining an "asphyxiating" music scene and expressed contempt for Dom & Ravel, a duo known for their hyperpatriotic *marcha* "Eu te amo meu Brasil" (I love you, my Brazil), following the 1970 World Cup victory.[66] Yet Neto was not opposed to artists who had achieved mass success; his pages are filled with gushing praise for Roberto Carlos's *Detalhes*, the chart-topping album of romantic pop songs from 1971.

Neto's most heated polemic concerned a group of filmmakers formerly

identified with the Cinema Novo movement of the 1960s who had begun making high-budget films with sponsorship from Embrafilme, the state company established by the military government in 1969 to promote national cinema. He railed against filmmakers such as Nelson Pereira dos Santos, Carlos Diegues, Arnaldo Jabor, and Gustavo Dahl for forsaking the low-budget, high-concept ideals of Cinema Novo for state-sponsored superproductions, often historical sagas about Brazilian history. For an emergent group of underground filmmakers, according to Robert Stam, "Cinema Novo had become *embourgeoisé*, respectable, paternalistic, overly cautious both in terms of its thematics and in its cinematic language."[67] Neto contrasted what Rogério Sganzerla had called "Cinema Novo Rico" (nouveau riche cinema) with low-budget and highly improvisational *cinema de invenção* (cinema of invention).[68] Neto championed underground filmmakers Rogério Sganzerla and Júlio Bressane, affiliated with the independent production company Belair; the horror film director José Mojica Marins (known as "Zé do Caixão," or "Coffin Joe"); and Ivan Cardoso, who was then experimenting with Super 8 cameras to make a series of low-budget short films he called "Quotidianas Kodaks."[69] Cardoso's work with Super 8 cameras was part of a larger trend among Latin American artists who embraced this technology, as evidenced in contemporary parallels, such as the *superochero* movement in Mexico.[70]

The most important film of the Quotidanas Kodaks series was *Nosferato no Brasil* (1971), a playful parody of F. W. Murnau's masterpiece of German expressionism, the vampire film *Nosferatu* (1922). Vampires appeared with some frequency in alternative Brazilian arts, usually as highly sensual, pansexual figures, as in Jorge Mautner's song "Vampiro," narrated in the first-person voice of a vampire who is "inebriated with passion" in his desire for other bodies, both female and male. "I go about sucking the blood of boys and the girls that I find," he sings.[71] Whereas Murnau's bald vampire is frightening and repulsive, Cardoso's hippie vampire, played by a long-haired Torquato Neto, is delicate and handsome. A signboard informs the viewer that the first part of Cardoso's film, silent and in black and white, is set in nineteenth-century Budapest, although it has obviously been shot in a park in Rio de Janeiro. A second signboard informs viewers: "Onde se vê dia, veja-se noite" (Wherever you see daytime, view it as nighttime). In this way, Cardoso humorously called attention to the low-budget production that made nocturnal filming impossible, while also inviting the viewer to take a more active cognitive role in watching the film.[72] In Budapest, Nosferato's efforts to seduce women are constantly thwarted, and he resorts to using

brute force to subdue his victims. He is eventually vanquished by a sword-wielding and cross-brandishing prince.

At this point, the film switches to color and adds a sound track of instrumental bossa nova. A hand reaches out with a razor blade to slice into a black plastic disk mounted on a wall as bloodlike liquid pours down over a signboard that announces "Nosferato in Brazil," followed by another shot of "Rio 1971" drawn into the sand. The sound track transitions to lounge bossa nova as a revived Nosferato walks the beaches, hills, and streets of Rio de Janeiro, observing the tropical foliage, civic monuments, and billboards. Nosferato seeks victims among the hippie girls of Rio's south zone to the sound of Bob Dylan's "If Dogs Ran Free," Roberto Carlos's "Detalhes," and the Rolling Stones' "In Another Land." We see Nosferato on the beach, clad in nothing but swim trunks and a black cape, as he sips a green coconut and scans the beach under a dazzlingly bright sun. His luck with women improves dramatically as he learns to seduce his victims. Instead of fleeing, a bikini-clad woman, played by journalist Scarlett Moon de Chevalier, flirts openly with him on the boardwalk of Copacabana. His victims turn into vampires who seduce men into Nosferato's lair, where they are consumed in bloody bacchanalia. A bearded hippie is lured into an orgy with several female vamps that ends in his bloody demise, all under the lustful watch of the Brazilian Nosferato. A signboard reads, "Sem sangue não se faz história" (Without blood, history is not made), and then the film cuts to Nosferato and his vamps, sated with blood, who lounge around watching TV and reading magazines to the psychedelic sound of the Rolling Stones' "2000 Light Years from Home." In the last scene, Nosferato waves from an airplane window as he prepares to return to Europe for the summer. Stan Getz's bossa nova instrumental version of Dylan's "Blowin' in the Wind" provides a suave, delightfully cheesy sound track. *Nosferato no Brasil* epitomized the Super 8 movement in Brazil by humorously and inexpensively reimagining a canonical film within the context of contemporary Rio de Janeiro. Haroldo de Campos characterized the film as "the vampire's fang (made of plastic) on the sclerotic jugular of 'serious' cinema."[73]

Torquato Neto regarded Super 8 films as democratizing technology, in that almost anyone could use the camera to make what he called *cinema de invenção*. He sought to reclaim the ethos of mid-sixties Cinema Novo captured in Glauber Rocha's maxim that all one needed to make a film was "a camera in hand and an idea in the head." In similar fashion, Neto urged his readers to try their hands at filmmaking: "Invent. A camera in hand and Brazil in the eye: document that, my friend. We're not on the outside where

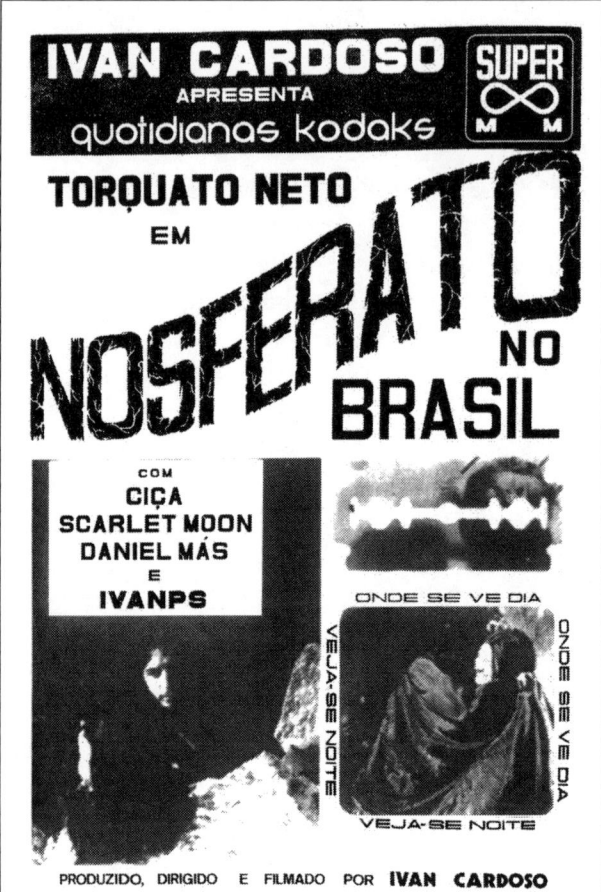

Poster for Ivan Cardoso's *Nosferato no Brasil*, 1971. Courtesy of Luciano Figueiredo and Oscar Ramos.

it's the same thing: *underground*, subterrânea. Reality has its cracks, look for them, take photos, make films, and enjoy. . . . Organize archives of Brazilian images from these times, everyone saving their own little films until one big film is ready."[74]

Neto's advice to his readers was closely aligned with the kind of artistic practices developed by Hélio Oiticica, from the ethos of participation to the impulse to document and archive everyday life. As Neto suggests, this open disposition to invent was particularly urgent in "these times," a period of intense repression, censorship, and, in his words, "asphyxiation." As an exercise in everyday resistance to authoritarian rule, social conformity, and cultural mediocrity, Neto advised his readers to "occupy space [*ocupar espaço*]," a slogan he first advanced in late October 1971: "Summer is coming, very hot. Open the windows. Look kindly on your own eyes. And let's occupy

space. That's it: occupy space."[75] A multivalent term, "occupy space" could literally mean to inhabit and transform public space, in the way, for example, hippies and surfers laid claim to the dunes around Ipanema Pier as a kind of "liberated territory," to remember Waly Salomão's characterization. In contrast to some of the PCB-affiliated artists (discussed in the Introduction), for whom "occupying space" meant employment in the state bureaucracy or in the culture industry, Neto understood it as a permanent disposition oriented toward everyday creativity and improvisation. Neto instructed his readers: "First step is to control space. There is lots of space and only you know what to do with yours. First, occupy. Next, figure it out."[76] The phrase also functioned as a metaphor for creative, intellectual, and social activities that in some way resisted the stifling atmosphere under authoritarian rule: "Occupy space, create situations. . . . Occupy space: scare away conventional attitudes [caretice]: take the place: tighten the bow: feet on the ground: day after day."[77] To "occupy space" and "tighten the bow" on a daily basis was for Neto and his artistic allies a strategy for "creating conditions" (to remember Salomão's phrase) for invention and critique.

⇌ Creating Conditions

Throughout his career, Oiticica wrote consistently and extensively about his own work, its relation to a wider field of artistic production, and the avant-garde tradition, philosophy, and commentary about all realms of creativity. Starting in the late 1960s, his writing became more experimental and more personal as it documented and dissected aspects of his everyday life in London, Rio, and finally New York, where writing became his principal activity.[78] Having received a Guggenheim Fellowship, Oiticica moved to New York in 1970 and would remain there until 1978. For most of this time, he lived in precarious conditions with no steady income after the fellowship ended. Yet New York was also a liberating space for him to explore his sexuality as a gay man, which had been considerably more difficult in Brazil. While in New York, he wrote constantly to his friends and fellow artists, including Caetano Veloso, Gilberto Gil, Jards Macalé, Torquato Neto, Rogério Duarte, Augusto de Campos, and Haroldo de Campos, among others. A voracious reader, Oiticica constantly requested books, articles, LP records, and other materials from his friends in Brazil, sometimes sending extensive lists of items he wanted.[79] His dialogue with the concrete poets intensified during the early 1970s as they shared common artistic, philosophical, and literary references and a deep commitment to the avant-garde tradition. The

first of a series of recorded conversations, which he called "Heliotapes," featured Haroldo de Campos, who read a fragment of his prose poem *Galáxias*, a work-in-progress that was eventually published in 1984.

Oiticica wrote effusively about the Brazilian artists, writers, filmmakers, and musicians associated with *cultura marginal* but also revealed antipathy toward other figures identified with the Brazilian counterculture and the underground press.[80] He was unimpressed with the New York art world and gravitated instead to the scene connected to the underground filmmaker and performance artist Jack Smith and the transvestite actor Mario Montez, who performed in "Agrippina é Roma-Manhattan" (1972), a short film he made with Neville d'Almeida. His relationship with Smith and Montez would have a decisive impact on his own development of a queer aesthetic in subsequent projects like *Cosmococas* and *Quase-cinemas*.[81] In his writing from this period, Oiticica railed against the "aestheticism" of current trends in international art like Pop Art, Op Art, and even happenings, which he pointedly disavowed.[82] During this period, Waly Salomão was Oiticica's most important interlocutor, primarily through an exchange of letters throughout the early 1970s. Oiticica wrote extensive observations about the local art scene, rock concerts, film screenings, theater productions, and his adventures in the gay underground of New York, which he called "bonecolândia babilônica" (babylonian land of dolls).

Salomão wrote letters and sent packages of newspaper clippings from the carioca press with stories and photos about local crime, sports, culture, and gossip. These "prose-packages," which he called "Groovy Promotion," would later be integrated into a larger book project that Salomão had started in January 1970 after he was arrested for marijuana possession in São Paulo. After a short stint in the infamous Carandiru prison, he returned to Rio, where he continued work on the project.[83] After Oiticica's departure for New York, Salomão continued sending texts from the project for him to review and critique. Fragments of the text first appeared in *Flor do Mal* and *Presença*, the two leading underground cultural journals of the time. Under the pen name Waly Sailormoon, he published *Me segura qu'eu vou dar um troço* in 1972. His publisher, Editora José Alvaro, arranged for the book to be distributed at newspaper stands. The cover featured a black-and-white photo by Ivan Cardoso of the author standing between writer José Simão and Rúbia, a friend from the Morro de São Carlos, on the promenade of Copacabana beach. Salomão holds a beach umbrella with a small placard announcing the sale of soft drinks, while the other two hold a black banner with the letters "–FA—TAL," originally produced for Gal Costa's 1971 show. The commercialism of

the cover is both ironic in "selling" the book like a bottle of Pepsi and savvy in associating it with Gal Costa's wildly successful show and double LP.

Me segura is part prison notebook, part theater, part movie script, and part personal narrative, interrupted by news flashes, commercials, police interrogations, and prophecies. Antonio Candido characterized the text as "anti-literary literature" that "mixes protest, contempt, testimony, outcry, report—all in a language generally based on free association, chaotic enumeration formed by colloquial phrases, 'hippie' slang, obscenities, truncated sentences, violent ellipses, and abrupt transitions, resulting in lively narration based on the personal experience of the author."[84] In one of the final sections of the book, "Um minuto de comercial" (A commercial break), the author himself offers several descriptions of the book that allude to its multiple registers: "*Me segura qu'eu vou dar um troço* is a modern book; that is, it was made to satisfy a demand to consume personalities, the narration of personal experiences—experiences of a symptomatic, not insular, singularity." With both irony and candor, Salomão declares his ambitions for a book that had little commercial potential yet was also attuned to emergent literary trends oriented toward personal, everyday experience. Most important, *Me segura* was an experimental exercise that, in Salomão's words, represented "the first step in the struggle for the creation of conditions."[85] Like Torquato Neto's mantra, "occupy space," Salomão's proposal to "create conditions" called for the relentless pursuit of artistic production free from restrictions.[86]

Much of *Me segura* is narrated in a first-person voice, yet it is a polyphonic voice, inhabiting several different subjectivities. His own subjectivity as a poet is superdramatized, larger-than-life, occupying a quasi-mythic plane, as announced in the opening line of the first section, "Apontamentos do PAV 2," which establishes the Carandiru prison as the site of enunciation— "SÍRIO desponta de dia" (Syrian/Sirius appears at dawn)— a phrase that connects his personal identity as an Arab-Brazilian of Syrian descent to Sirius, the brightest star in the night sky. This self-aggrandizing may be understood as a compensatory gesture for a prisoner for whom writing was a way to resist feeling like a victim.[87] Elsewhere he suggests that a supernatural entity—the "poet-warrior" Sailormoon—has descended into his body like an *orixá* of Candomblé, the Afro-Brazilian religion of spirit possession.[88]

The first part of the book, "Apontamentos do PAV 2," is a chronicle of his experience in prison, written in brief, telegraphic flashes. It is framed as a Dantesque descent into hell with a pop music sound track featuring Roberto Carlos, Gilberto Gil, Caetano Veloso, Ray Charles's "Georgia,"

Experience the Experimental 97

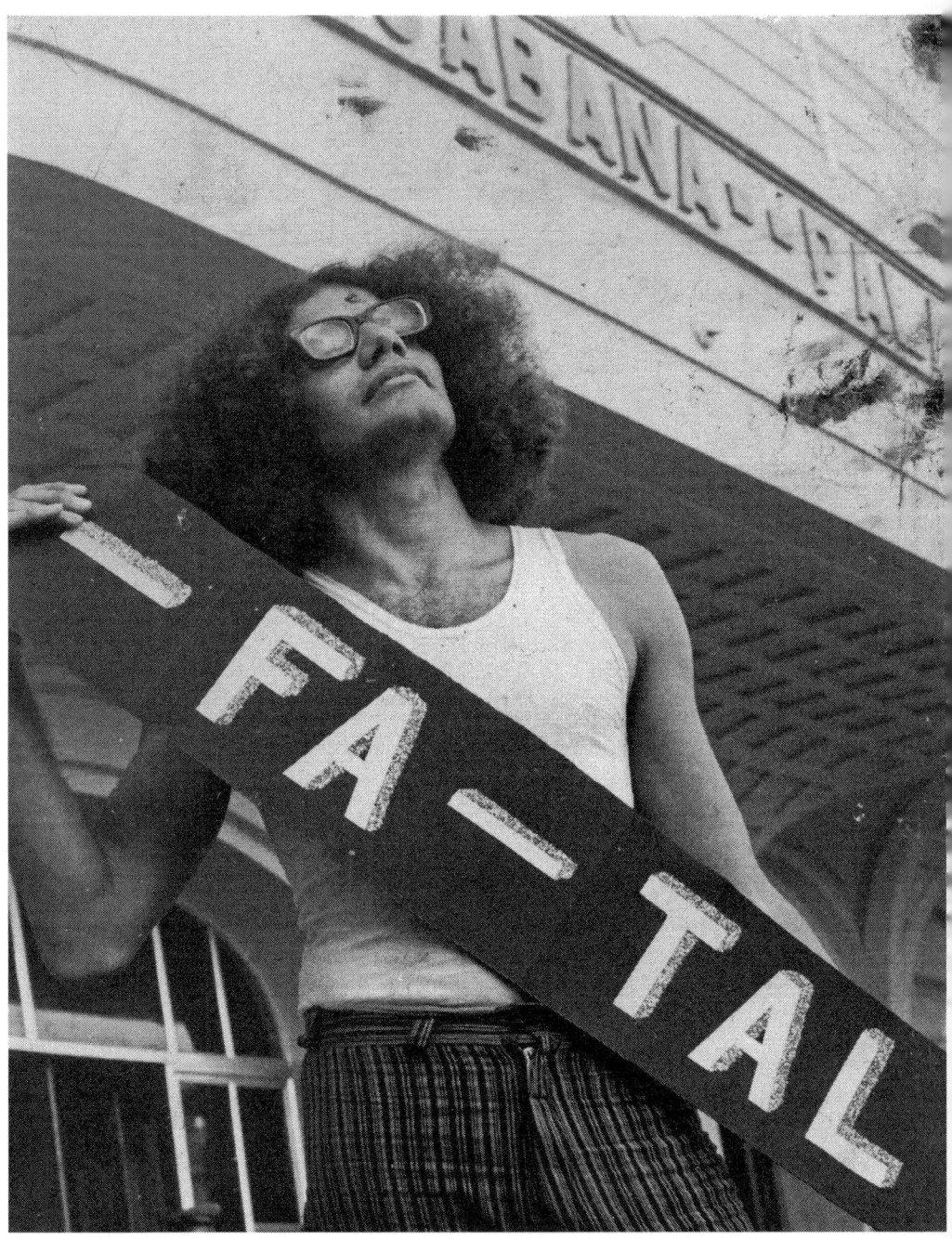

Waly Salomão, 1972. Photo by Ivan Cardoso. Courtesy of the National Archive, Rio de Janeiro.

and Jorge Ben's "Charles Anjo 45." Salomão also provides commentary on his fellow inmates, who have been detained for a range of transgressions, some political, some criminal, and others apparently arbitrary: "The poet's descent into hell. I'm listening to Roberto Carlos, Ray Charles, Georgia, Gil and Caet, Charles anjo 45. The nice carioca who lent his car to a friend, arrested at the entrance to the favela. The middle-class guy who sends letters to his fiancée as if he were recovering from an accident in a hospital in Argentina. The cleanliness and ideals of cell 506. The mental case who lost his pants to a samba dancer. The candy asses."[89] Although described as a hellish experience, Salomão's brief stint in prison also appears to have been a catalyst to write.[90]

Like Oiticica, Waly Salomão took refuge in the favelas of Rio de Janeiro. He wrote most of *Me segura* in the Morro de São Carlos, one of the oldest favelas in Rio, located on the near north side adjacent to Estácio, a neighborhood famous for its role in the emergence of samba music in the early twentieth century. For Salomão, this community provided a space of freedom and security since the police would not enter the area.[91] This insight came from personal experience: the policewoman who arrested him for marijuana possession was an undercover agent posing as a hippie in a sting operation that would have been impossible in the favela. The incident that landed him in jail may have inspired a lingering antipathy toward hippies, which erupts occasionally in his text, as on the first page of a section titled "-FATAL—Luz Atlântica Embalo 71," in which he writes: "We have in common, the police and I, loathing hate for national hippies, for hippieland caravans *on the road*. miserable trips cheap dope [*vapor barato*]."[92] As this is a literary polyphonic text with multiple voices and discourses, it is not clear that the "I" in this statement can be easily conflated with the author, but other texts from the period suggest that Salomão was adamant about rejecting any association between his poetic work and the counterculture, especially the hippie scene or *desbunde*. Along with Torquato Neto, Salomão was at the time engaged in a polemic with filmmakers who criticized *cultura marginal* as alienated and inconsequential. Within this context, it was of key importance for Salomão to draw sharp distinctions between his own literary project and the hippie counterculture, which he criticized for being anti-intellectual, drug-addled, and Americanized. In a text published in *Verbo Encantado*, he declared that the "discussions about counterculture, underground today in Brazil are conformist." Salomão also made a point to pay tribute to the concrete poets of São Paulo—"Viva Haroldo and Augusto de Campos. Death to

ignorance"—a gesture that affirmed his identification with the concretist avant-garde.[93]

With Oiticica, Salomão was determined to establish a position of permanent experimentation, as suggested in one passage from *Me segura:* "To create without being tied down to things here in Brazil—language of national leisure—but sending international letters. FROM BRAZIL. go forward with everything that came from me. Death to existent languages. death to demanding languages. experiment freely. life strategy: mobility along the rio são paulo bahia AXIS. trips inside and outside of BR."[94] The metaphor of mobility functions here in spatial terms, suggesting his desire to hit the road and experience a variety of places within and beyond the nation, but also a will to move within linguistic and discursive registers. He reveals an affinity with North American Beat poets, with their privileging of spatial mobility as a metaphor for poetic adventure. The Beats are clearly a point of reference for Salomão. At one point in *Me segura* he parodies the somber opening lines of Ginsberg's *Howl*—"I saw the best minds of my generation destroyed by madness"—transposing them to the context of authoritarian Brazil using a mixture of Portuguese and English in almost telegraphic phrases: "The best talents of my generation. *Jail and mental hospital.* I can't be grounded with so much misfortune of others."[95] *Me segura* occasionally erupts in a tone of explicit denunciation, calling attention to the dire political context and reaffirming the primacy of artistic practice in resisting the dictatorship: "We are in ruins. For our brothers and to the people of America we are cursed [*malditos*]. bitter times are in store for our country. somber days lie ahead for Latin America. one must constantly hit hard where it hurts. today this shameful crime leaves us ashamed."[96]

In an article published in 1973, which cited *Me segura* as an illustrative example of new literary trends, Silviano Santiago argued that the posttropicalist generation generally despised literature, associated with solitary reflection, and was attracted more to popular music and other forms of art oriented toward nonverbal communication. He argued that these texts should be approached in terms of ludic pleasure, or *curtição*.[97] While it is certainly possible to engage Salomão's text in this way, it does not necessarily lend itself to *curtição* in the manner of *poesia marginal*, which tended to eschew the kind of erudition and oblique intertextuality found in *Me segura*. Instead, as Roberto Zular has argued, *Me segura* is closer to Oiticica's anti-art, in which "the reader is called to participate in the process of production, which also engages the writer and maintains constructive aspects."[98] These "constructive aspects" would include exposing the reader to the process of

writing, the context of enunciation, the geography of the narration, and the connection between writing and the body.[99] Salamão references this artistic strategy in the context of his detention by the police, when he explains: "Art is an extension of the body. I explained all of this to the police."[100] His lived experience as a prisoner became the very condition of possibility for artistic creation. For Salomão, being is not confined to the physical body, but is rather "extended" through artistic creation.

In one of his "Heliotapes" recorded in 1971, before the book's publication, Oiticica commented on texts from Me segura that addressed "the problem of creating conditions" for perpetual experimentation and critical reflection. For Oiticica, this was a question that artists had to confront in their daily lives: "To create conditions is to accept an existential position, it is to accept a position of difference in relation to the everyday."[101] Oiticica likened Me segura to Brancusi's overcoming or absorbing the pedestal in sculpture.[102] In particular, he cited one of the last sections of Me segura, "Um minuto de comercial" (A commercial break), in which Salomão proclaims "the end" of the text several times, yet keeps adding narrative, dialogue, and aphorisms. In Oiticica's reading, "the end" functions structurally as the pedestal (or the frame in painting) that is overcome and surpassed by the text itself, which is repeatedly revised based on new perspectives. Oiticica interpreted these successive textual fragments "as if they were compartments of the everyday, as if they were garbage you threw away . . . as if they were the library of the everyday, no, a library of subjective existence [euxistênciateca], no because the thing is a creation in itself."[103] His neologism euxistênciateca is highly suggestive but ultimately unsatisfactory because it suggests a catalog of personal experiences that is outside of the work, not intrinsic to it. The final product, whether an object or text, is ultimately less important than the daily process of creation in which closure—"the end"—is perpetually ruptured by new ideas and projects. For Oiticica, "Um minuto de comercial" provided an insight into his own writing process, a daily creative exercise that never crystalized into a finished product.[104]

Salomão conveyed a similar idea in "Revendo amigos" (Revisiting friends), one of many songs he composed with Jards Macalé.[105] An upbeat acoustic rock song featured on Macalé's first solo recording (1973), "Revendo amigos" is famous for its tagline "volto para curtir," the perpetual return to creative revelry in the face of uncertainty, turmoil, and loss. In one stanza, he confronts Rio de Janeiro, which is alternately "careta" (boring or conventional) and "porreta" (a Bahian colloquialism for something great). Constantly in motion, he might get stranded like the unfortunate Portuguese sailors on

the *Nau Catarineta*, who drifted aimlessly for months after being attacked by French corsairs in the sixteenth century: "I show up one day, take off the next / If I get lost on the Catarineta Ship / I go, I kill, I die, and come back to revel." Even after his daily struggle ends in death, the artist returns incessantly to carouse and create in another instance of exceeding "the end." In both "Revendo amigos" and *Me segura*, the refusal to reach a definitive conclusion creates a perpetual state of becoming. To "create conditions" means that the process must overcome the product.

⇌ Navilouca

During the period when Salomão, Figueiredo, and Oiticica were working with Gal Costa, they were also in the initial stages of an editorial project that brought together poets, filmmakers, visual artists, and musicians identified with the concretist avant-garde, Tropicália, *cultura marginal*, and the counterculture. Inspired by his reading of Foucault's *Madness and Civilization*, Salomão named the project Navilouca, a reference to the *stultifera navis*, ships of the late medieval and Renaissance periods that ferried around Europe the deranged people who had been expelled and banished from their communities. A vibrant alternative press had emerged in response to the censorship of mainstream media, but its journals often folded after a few issues. In contrast, *Navilouca* was conceived as a one-off manifesto, announcing on the cover that it was the "primeira edição única." The editors of *Navilouca*, Waly Salomão and Torquato Neto, conceived of the project as a way to overcome provincial rivalries and divisions within Brazilian arts, especially in relation to the acrimonious split between the paulista concretists and the carioca neo-concretists in the late 1950s.[106] Luciano Figueiredo and Oscar Ramos oversaw the graphic design and layout of the publication. It was, as Figueiredo has noted, an "artisanal editorial adventure" more akin to a limited edition art book than to an underground magazine.[107] *Navilouca* synthesized and documented a range of artistic practices that connected in various ways and degrees to the constructivist avant-garde, *cultura marginal*, and the counterculture in Rio de Janeiro of the early 1970s.

A large-format publication (27 x 36 cm), *Navilouca* had a full-color glossy cover featuring color photographs of all of the contributors. Most of its ninety-two pages were printed in black and white, with the occasional use of magenta letters and graphics. The project was stunning in its heterogeneity as it brought together a diverse group of artists, including concrete

poets (Augusto and Haroldo de Campos and Décio Pignatari), artists associated with the neo-concrete movement (Hélio Oiticica and Lygia Clark), former tropicalists (Caetano Veloso, Torquato Neto, and Rogério Duarte), and artists identified with *cultura marginal* (Waly Salomão, Jorge Salomão, Luciano Figueiredo, Ivan Cardoso, Oscar Ramos, Luiz Otávio Pimentel, Duda Machado, Chacal, and Stephen Berg).[108] Each of the artists was invited to contribute texts, ideograms, photos, film stills, collages, cartoons, or anything else that could be represented on a page. The entire project was assembled long before it was published. As early as January 1972, Torquato Neto announced in his column: "Get ready: *Navilouca* will appear shortly. A heavy venture. Have a little patience."[109] Publication was delayed for lack of money, and in November of that year Torquato Neto took his own life. Despite his exhortation to "occupy space" and never admit defeat in the face of adversity, the poet himself succumbed to despair after a long struggle with mental illness.[110] The project was put on hold until 1974, when Caetano Veloso was able to secure funding from André Midani, then the president of Philips Records (the owner of Phonogram) in Brazil, to pay for the printing costs.[111] *Navilouca* was never commercially distributed; most of the copies were given away to friends.

Navilouca gathered together in one omnibus publication diverse poetic, graphic, and discursive currents that connected the avant-garde tradition in Brazil to *cultura marginal* and its diffuse articulation through the counterculture. Luciano Figueiredo has described it as a "great manifesto," but it contrasted sharply with earlier vanguardist manifestos in its sheer heterogeneity of aesthetic and social concerns and obsessions, which undermined any programmatic intention. As Figueiredo explains: "It was a project imagined as a condensed form of expressive processes that could produce 'clandestine earthquakes,' as Harold de Campos said, overcome the cultural conflicts of the Left, and propose a repertoire of ideas that were more receptive to all that was happening in the rest of the world, like the youth movement, *underground*, which renovated cultural environments in a powerful way."[112] The participants did not identify rivals or seek adherents, reveling instead in riotous polyphony. Elaborate visual and poetic experiments found a place next to cartoons, fake advertisements, and concert photos. Long treatises on participatory art were followed by a series of film stills from *chanchadas* (Brazilian popular comedies from the 1950s), horror films by Zé do Caixão, and *cinema marginal* productions like Júlio Bressane's *Família do Barulho* and Rogério Sganzerla's *Sem essa, aranha*. Ivan Cardoso contributed a

promotional photo of bikini-clad bombshells from his soft-core short *Chuva de Brotos* (1972), together with a poster for *Nosferato no Brasil* created by Luciano Figueiredo and Oscar Ramos.

The concrete poets took the opportunity to reaffirm the ongoing vitality of poetics of invention from the late nineteenth century through the modernism of the 1920s and on to the midcentury concretist avant-garde. In "Sonoterapia," Augusto de Campos paid tribute to the ostracized heroes of this tradition: "na géleia geral da nossa história / sousândrade kilkerry Oswald vaiados / estão comendo as pedras da vitória" (in the general jelly of our history / sousândrade kilkerry oswald were jeered / they're eating the stones of victory). A photo from the early 1970s of Augusto and Haroldo de Campos and Décio Pignatari holding an open book with a photo of the trio in the 1950s further emphasized the idea of the continuity and perpetual renovation of the concretist project. The final page featured a black-and-white photo of Sousândrade, the nineteenth-century symbolist poet lionized by the concrete poets.

Other textual and visual contributions dispensed with vanguardist pretensions and embraced the values of the counterculture, as in "Regras do jogo: Jogo de criação" (Rules of the game: Game of creation) by Jorge Salomão:

> I, fragments of a sensibility that produces rhythm
> I, who came to the world to partake in this crazy mass with my crazy
> dance in the destruction of values that torture the human soul.
> I, child of the sun
> I, strong, beautiful, brother of the setting sun
> I, dancing, in these spare-spaces stages of life

In his use of a strong, declarative first-person voice and his celebration of Dionysian revelry and destruction, Salomão's poem was more in line with *poesia marginal*, which had emerged in opposition to the concretist avant-garde. The young poet Chacal, a leading figure in the *poesia marginal* movement, also contributed to *Navilouca*, although his material was published as a separate insert.[113] Chacal's contribution to *Navilouca* was remarkable for its experimentation with concrete and visual poetry, which was quite different from the rest of his published work.

Twelve pages of *Navilouca* were entirely dedicated to the work of Waly Salomão, the principal instigator of the project. Salomão's text is divided into several distinct sections, beginning with a manifesto with the Spanish-language title "Planteamiento de Cuestiones," which outlined the problems

facing experimental artists at the time, his own position as a writer, and possible strategies for creating and maintaining conditions for artistic production. He positions himself as an embattled warrior, occasionally using the Arabic term *fedayin* (that is, *fedayeen*) as a mode of self-identification. The key trope of his text is *forçar a barra*, something like "to push the envelope" or "break boundaries" through constant innovation:

> BREAK BOUNDARIES:
> I am possessed with TERRIBLE ENERGY that translators call HATE—
> —absence of parents: reject the judeo-christian tradition—absence of cultural parents—absence of family ties—
> Nothing holds me down—
> Produce without expecting anything in exchange:
> The Myth of Sisyphus.
> Produce the best of me pari passu with the loss of hope of recomPension Paradise.
>
> END OF THE FEVER
> OF
> PRIZES AND PENSIONS
> OF A
> POET WITHOUT
> LLAAUURREEAATES

For Salomão, the radical rejection of cultural traditions, family ties, and literary recognition creates the conditions for total artistic freedom. Literary creation becomes an existential question of daily struggle and resistance oriented toward process and not the result.[114]

Lygia Clark contributed a text to *Navilouca* with a photo of her donning one of her *Luvas sensoriais* (1968), a series of "sensorial gloves" used in proposals designed to accentuate the tactile sense. After moving to Paris in 1968, her work focused on group workshops conducted with students at the Sorbonne, marking an "extradisciplinary" shift from art to psychotherapy based on collective multisensorial experience.[115] Clark was the only female contributor to *Navilouca*, which tended to celebrate male genius, as in Augusto de Campos's poetic genealogy of the Brazilian avant-garde, or the male gaze, as in Cardoso's stills from campy sexploitation films. While Clark did not foreground her identity as a female artist, her participation in *Navilouca* was unique in meditating on her own body as a locus of eroticism, sensuality, and selflessness. Her text combines critical commentary, explanations of her own work, fantastic visions, dream recollections, and luminous epipha-

nies. She devoted the first part of her text to establishing her distance from "body art," which in her view involved narcissistic spectacles of artists who display their pathologies as works of art. In contrast, Clark strived to obscure or even obliterate her own position as a catalyst for multisensorial proposals, seeking instead to "dissolve in the collective." She expressed an intense desire to transcend a fixed identity and experience selfhood as "fragmented" and "elastic." In this way, sex was not about surrendering oneself to a male partner. Instead, intercourse involved an "appropriation of the penis as an integral part of my body, feeling myself through the other as if I were copulating with myself." Some of the images Clark conjures would not have been out of place in a 1970s feminist literary journal: "Dream: I saw myself naked, enormous, I was the landscape, the continent, the world. Around my pubis tiny men built a dam. A containment dam or a big lake for everyone to dive into." While the other long texts featured in Navilouca focused on the history of the avant-garde, current conditions for experimentation, or individual trajectories and ambitions, Clark introduced a discussion about the body as a locus for overcoming the abyss between self and other, dreams and reality, life and death, male and female.

As the Navilouca project was in production, Oiticica was living in New York, but he maintained a constant and extensive correspondence with the editors, especially Salomão. He sent photographs of new projects in New York and Rhode Island from the early 1970s, including his Babylonests and Ninhos, created as integrated living-work spaces in his lower Manhattan loft. Oiticica also sent a manifesto, "Experimentar o experimental," written in March 1972, in which he traced his own artistic trajectory since 1959, from his neo-concrete núcleos and bólides through the participative turn represented by the parangolés and ambientes. Much of the text is dedicated to critiquing Brazilian visual arts, especially painting and sculpture, the gallery system, and puerile rivalries among artists. It echoes some of the ideas outlined in text written for the Nova Objetividade exhibit yet makes no mention of the avant-garde. If, in 1967, the idea of the avant-garde in Brazil was for Oiticica a "far-reaching cultural issue of great amplitude," by the early 1970s the term had largely dropped out of his writings. In the context of authoritarian rule with so many artists in exile, the call to programmatic action, guided by a "general constructive will," no longer retained the ethical and aesthetic valences it had had in the late 1960s. The idea of avant-garde ceded to a more diffuse, less rigid, but equally vital imperative: the experimental. The shift from the avant-garde to "the experimental" was already implicit in Oiticica's work since the end of neo-concretism and his embrace of "anti-art" con-

ceived in terms of open "proposals" and "environments." He had explained the meaning of "the experimental" in the essay "Brasil diarréia," a metaphor similar to *geléia geral*, but with aggressive, scatological connotations: "There is no such thing as 'experimental art,' only the experimental, which not only assumes the idea of modernity and the avant-garde, but also the radical transformation in the area of present value-concepts: it is something which proposes transformations in the behavior-context, which swallows and dissolves the convivial collusion [*convi-conivência*]."[116] One of hundreds of Oitician neologisms, "convi-conivência" demystified the stereotype of Brazilian conviviality and denounced those who were complicit in perpetuating it through folkloric images of national culture. Aside from the experimental, he concluded, everything else was mere "dilution and diarrhea." With a nod to the international counterculture, he quotes Yoko Ono: "To create is not the job of the artist. The job is to change the value of things." He concludes the manifesto on a hopeful and insurgent note, calling attention to the potentially endless possibilities of "the experimental" in Brazilian cultural life, even at a time of severe political repression:

> the loose ends of the experimental are energies that spring forth
> creating a number of possibilities
> in brazil there are loose ends in a field of possibilities: why not
> explore them

His language is speculative and utopian, speaking of "possibilities" for new proposals and actions. While the manifesto did not directly inspire political resistance to the regime, it figures as an important call for affirming the primacy of the "experimental" energies at a time when the regime used the power of the state to enforce conformity and obedience.

3 ⇝ The Sweetest Barbarians

> It would hardly seem an exaggeration to call what we see arising among the young a "counter culture." Meaning: a culture so radically disaffiliated from the mainstream assumptions of our society that it scarcely looks to many like a culture at all, but takes on the alarming appearance of a barbaric intrusion.
> —THEODORE ROSZAK, *The Making of a Counter Culture* (1969)

In early October 1971, readers of *Veja* magazine learned about a remarkable boom in tourism to Salvador, the coastal capital of the state of Bahia.[1] The front cover of the weekly featured a close-up color photo of an Afro-Brazilian man in a straw hat with the heading "O Brasil Baiano" (The Bahian Brazil). The lead story, titled "A redescoberta do Brasil" (The rediscovery of Brazil), portrayed Bahia as the "real" Brazil far from the hustle and bustle of Rio de Janeiro and São Paulo. *Veja* reported a 17.6 percent increase in tourism to Salvador for that year, noting that the city had forged an image as "a marvelously enchanted place, where the sky, sea, coconut palms, colonial-era townhouses [*sobrados*], spices, and personalities were combined to inspire in people a state of mind usually known as happiness."[2] The story depicted Salvador as a spatial and temporal sanctuary protected from the modernizing forces transforming Brazil. Visitors from the south regarded Bahia as a place to recover authentic experience and simplicity, a common motivation for modern tourists.[3]

Bahia's status as a place of enchantment was closely associated with Afro-Brazilian culture, especially Candomblé, an Afro-Brazilian religion of divination and spirit possession with origins among the Yoruba- and Fon-speaking peoples of West Africa, who had been brought to northeastern Brazil as slaves. The Yoruba pantheon of deities, or *orixás*, had gained iconic status in the city. According to the *Veja* report, the "careful preservation of the mysteries of the African religion, with its *orixás*, beliefs, divinations, is the principal reason for the magic that envelops Salvador."[4] Visitors to Bahia in the late

1960s and early 1970s would have found a modern city filled with references to the orixás in names for hotels, stores, salons, gas stations, and auto repair shops.[5] One of the most fashionable nightclubs for Salvador's youth, Xangô, took its name from the orixá of fire and thunder.[6] The city's premier space for contemporary art, Galeria Oxumaré, was named for the orixá of natural cycles and seasons.[7] References to Candomblé could also be found in powerful institutions of finance, such as the magnificent wood panel sculptures of the orixás created by Carybé (Héctor Julio Páride Bernabó) and installed in the downtown office of the Banco da Bahia in 1968. The city's first shopping mall, the Orixá Center, opened in 1973 in Politeama, a neighborhood just off of Avenida Sete de Setembro, the city's main commercial thoroughfare. In 1972, Salvador's leading folklore ensemble, Viva Bahia, premiered the show "Odoiá Bahia," inspired by Candomblé dances and themes. Combining electric guitars and traditional drumming, the show was a "folk-pop spectacle" that both delighted audiences and disturbed members of the Candomblé community due to its brash stylizations of religious rituals.[8] By that time, Salvador was a city of over a million inhabitants with an expanding economy and urban infrastructure, which belied its reputation, on display in the Veja feature, as a quaint city preserved in a time when it served as Brazil's first colonial-era capital.

While the national press had for decades featured stories about Bahia, this article was novel in explicitly associating the city with the counterculture. Contact and communion with cultural others was, of course, a common desire among countercultural youth in many contexts. At that time, North American hippies traveled to Mexico often in search of hallucinogens traditionally used in indigenous religions.[9] Thousands of Europeans and North Americans embarked on the "hippie trail," an overland route from Western Europe to South Asia, and the Veja report was eager to draw parallels: "At a time when the appeal of mysticism has become unexpectedly attractive to the modern man, when Europeans and Americans avidly explore India, attracted by the oriental concept of the world, the religion of African origin offers a primitive and fantastic world that Brazilians also wish to know. The mystic atmosphere of Bahia seems to be the most palpable attraction for its young visitors—and it's possible that this is the reason for the constant presence of hippies and freaks [bichos] in Salvador and surrounding areas, camping, for example, on the shores of Abaeté Lake or even on beaches outside of the city."[10] While the Veja report made a simple analogy, some writers in the underground press went so far as to claim an actual affinity between Bahia and India, or more broadly, "the Orient." Writing for Flor do Mal, one

of Brazil's earliest alternative journals, Franklin Machado claimed that the "mystery" and "mysticism" of African culture made Bahia the "geographic and cultural Orient of Brazil."[11] It is not clear why African culture would make Bahia "Oriental" other than to distinguish it as non-Western. Machado also suggested an affinity between the counterculture and Candomblé, given the history of persecution against the religion. He asserted that "Candomblé in Brazil was born 'underground'" due to the intolerance of Christianity and Western civilization. Machado's piece concluded with a list of addresses of Bahia's most famous temples for those interested in exploring the religion. In the early 1970s, Candomblé became fashionable among middle-class Brazilians from the south who had no previous experience with the religion.[12] Candomblé offered an alternative cosmology, liturgy, and ritual that attracted these visitors in search of new cultural and spiritual experiences.

In February 1972, *Veja* published another cover story about Bahia with renewed attention to its unique appeal for alternative travelers, referred to as *alegres invasores*, or "joyful invaders." The second article focused on the beaches and fishing communities, such as Itapoã and Arembepe, where the hippies had settled. A young traveler from the southernmost state of Rio Grande do Sul described Bahia as a kind of countercultural mecca, a place of heightened sensorial experience and enjoyment, or in hippie parlance, *curtição*: "We are pilgrims of *curtição*. There is a little bit of Jesus Christ in every hippie. And for us mystics, no other place in the country offers more peace and so many opportunities for meditation than Bahia."[13] The article also lamented the presence of *bichos marginais*, hippies who took advantage of low security at beaches, campsites, and other public areas to engage in petty theft, but regarded these incidents as minor: "In spite of these little problems, however, it is forever established the image that Bahia is a marvelous land, a paradise of tranquility and happiness, with all of this seasoned by a permanent colonial atmosphere and by the mysticism of the saints and *orixás*."[14] Unintended irony accompanied the reference to Bahia's "permanent colonial atmosphere." The journalist was referring to the city's colonial-era architecture and the narrow cobblestone streets of its historic center but inadvertently called attention to the stagnant social relations that maintained a racially stratified society with a nearly exclusively white elite, a relatively small multiracial middle class, and a large and predominantly black working class.

The "joyful invaders" were mostly Brazilians from southern cities who typically traveled in groups on a shoestring budget. Some identified openly as hippies, often with no plans to return home, and others were on extended

summer vacations and returned to their lives as students or workers soon after carnival season in February. These visitors arrived by land in cars and buses, not in planes or on cruise ships, and they set up campgrounds along the coastal neighborhoods of the city instead of staying in hotels. One student from São Paulo, identified as the leader of a group of hitchhikers that took ten days to arrive, declared to *Veja*: "I decided to come to Bahia simply because the whole world is going there."[15] The article provided a "conservative estimate" of 100,000 visitors to the city during the summer of 1972, a significant influx of tourists for a city then with about a million inhabitants.

References to Bahia as a space of freedom and relaxation in dictatorial Brazil circulated by word of mouth and in the alternative press. In 1971, *O Pasquim*, Brazil's most widely distributed alternative journal, published a long conversation about "the people of Bahia" featuring Bahian filmmaker Glauber Rocha, editor in chief Tarso de Castro, and journalist Luiz Carlos Maciel, whose regular column "Underground" was dedicated to international and Brazilian countercultures. Maciel, originally from Rio Grande do Sul, exalted the colors of Bahia as the "most bright and brilliant of any place I know" and its people as "the most relaxed in Brazil."[16] Castro, for his part, described Bahia as a "free territory" of love and tranquility in authoritarian Brazil: "Bahia is as marvelous for a meditator, as it is unpleasant for a dictator." It is revealing that Glauber Rocha, the only Bahian of the group, sounded a critical note, declaring that in Salvador "blacks are exploited just like in South Africa." Rocha went on to denounce the "hypocritical guile [*malemolência hipócrita*] that spurs cultural tourism of the worst kind."[17] Rocha's critique of Bahia was, however, a minority voice obscured by a chorus of opinion makers who promoted Bahia to a young audience with countercultural sensibilities.

Salvador's growing reputation as a festive and relaxing space for young people would figure, as Glauber Rocha noted, into strategies to market the city to potential tourists. Local authorities had promoted Salvador as a tourist destination for those attracted to local culture, architectural patrimony, and splendid beaches since the 1930s.[18] In 1952, local authorities issued the first travel guide solely dedicated to Salvador and a year later established the city's first official tourist bureau.[19] Efforts to attract tourists intensified after 1963, when BR-116, the highway from Rio to Bahia, was finally paved.[20] In 1968, the state government established a new agency, Bahiatursa, to oversee the construction of hotels and the development of transportation infrastructure and to advertise Bahia as an attractive destination. The development of tourism was a priority for Salvador's mayor, Antonio Carlos Magalhães,

a rising star in the ARENA (Aliança Renovadora Nacional), the conservative party that functioned as the civilian wing of the military regime. Magalhães persecuted political dissenters but also displayed a populist touch that made him an endearing figure to many Bahians. The most draconian of all military presidents, Emílio Garrastazu Médici, appointed him state governor in 1971. Magalhães invested heavily in the construction of tourism infrastructure, the preservation of historic patrimony, and the promotion of local culture.[21] During this period, several major international hospitality chains, Hilton and Meridian among them, and large national groups like Othon and Luxor opened large hotels along the Atlantic coast of Salvador.[22] These projects were in line with a broader initiative of the regime in Brasília to foster development through tourism.

In their efforts to attract tourists, authorities promoted baianidade, or "Bahianness," a discourse of regional identity and self-fashioning that celebrates black culture, racial mixture, cordiality, festive exuberance, and an easygoing lifestyle.[23] Early iterations of baianidade coincided with the forging of a modern national identity discourse in the 1930s and became aligned with state-directed efforts to attract tourists by the 1940s. Antonio Risério has argued that Bahian culture is the result of economic stagnation, geographic isolation, and "ethnodemographic stability" (the state having received relatively few immigrants) from the early nineteenth century up through the mid-twentieth century. Bahian culture, which he described as *luso-banto-iorubana*, emerged from the contributions of and interactions among Portuguese, "Bantu" (that is, mostly Kimbundu and Kikongo speakers from central-west Africa), and Yoruba speakers from present-day Nigeria and Benin. In his view, Bahian culture developed organically in relation to ethnic composition, geography, and economic history.[24] Osmundo Araújo Pinho, in contrast, has argued that "the idea of Bahia" is little more than a "festive and self-emulating" ideology, projected through official and commercial channels, that obscures racialized forms of inequality, exclusion, and violence in a city that is predominantly black but ruled largely by whites.[25] Patricia de Santana Pinho has articulated a more nuanced critique of baianidade, calling it "a myth spread by the dominant sectors of society" but also arguing that it is not simply imposed from the top. The discourse of baianidade depends, in her view, on acceptance from broad swaths of society, including "those at the bottom."[26] Like many discourses of collective identity, baianidade developed in a complex, multidirectional fashion, involving both locals and outsiders.

In the early 1970s, Bahiatursa issued a promotional brochure that synthe-

sized the major themes of official baianidade promoted by the Magalhães government: "The black soul of the city always inspired irresistible fascination and attraction. It wasn't only the landscape. It wasn't only the architecture. It wasn't only the sea or the land. It was the people and the lifestyle of Bahia.... The free sensuality not entirely influenced by western culture. The heritage of black African life, among others. The *democracia mulata* of big tolerant hearts."[27] Working through Bahiatursa, the government promoted Bahia as an alternative space of non-Western culture, tolerance, and inclusion. In the context of diminished political freedoms, Bahia offered visitors a "mulatto democracy." While regime authorities in Bahia were certainly no more lenient toward political dissent, they were successful in promoting an image of Bahia as a space of freedom and pleasure.

This chapter examines the regional dynamics of the Brazilian counterculture, focusing on the unique importance of Bahia, especially its capital city, Salvador, and surrounding coast areas for Brazilian youth during the period of the most intense repression under military rule. It documents the influx of hippies to Bahia, their problems with local authorities, and their establishment of a permanent settlement in Arembepe, a town north of Salvador. It will consider how the state sought to repress and expel unemployed hippies, disparaged as *vagabundos* (vagabonds or bums), yet also promoted Bahia as an alluring destination for young alternative travelers. The surprising affinities and connections between an alternative or "underground" journal and a state-sponsored tourist brochure published by Bahiatursa are emblematic of this ambivalence. Finally, it will examine the role of popular music in forging the link between Bahia and the Brazilian counterculture, focusing on the former tropicalists who toured the country in 1976 as the Doces Bárbaros (Sweet Barbarians), a name that recalls the "joyful invaders" who flocked to Salvador earlier in the decade.

≈ Candomblé, Popular Music, and Baianidade

The countercultural fascination with Bahia in the 1970s is part of a longer story about the evolution of baianidade as a discourse of regional identity related to a broader historical process of recognizing and celebrating African contributions to Brazilian culture.[28] In their quest to develop a national cultural project, modernist artists and intellectuals of the 1920s and 1930s frequently turned to Afro-Brazilian culture as a source of vernacular authenticity. In his landmark study, *Casa Grande e Senzala* (1933), Gilberto Freyre placed black and brown people at the center of a story about the rise of a

unique Portuguese-speaking civilization in the tropics. Although a native of Pernambuco, Freyre lavished special praise on Bahia as "the most harmoniously *mestiço*" and "the most Brazilian expressly Brazilian" of all cities. Bahia was, in his view, the "mother of Brazilian democracy," which he understood in terms of racial and cultural hybridity.[29] The rise of baianidade coincided with the consolidation of a modern nation-state under Getúlio Vargas (1930–45) and the emergence of narratives of national culture that celebrated African contributions to Brazil's *mestiço* identity. As a discourse about cultural tradition and harmonious social relations, baianidade was not a threat to Brazilian nationalism in the way that, for example, the bellicose regionalism of São Paulo, bolstered by economic wealth, military power, and a discourse of white superiority, had been.[30] By midcentury, baianidade was a regional discourse that presented itself as an ideal paradigm for Brazilian nationality based on racial and cultural inclusivity.

Afro-Bahians played a central role in forging a regionalist discourse that elevated local symbols of black culture, especially Candomblé, the dance/martial art capoeira, and the cycle of Afro-Catholic festivals such as the Festa de Santa Bárbara, the Festa do Senhor dos Navegantes, the Festa de Yemanjá, and the Lavagem de Bonfim. Mutually beneficial alliances involving priests, scholars, artists, and politicians contributed to Candomblé's rise to symbolic prominence.[31] Juracy Magalhães, the Vargas-appointed governor of Bahia, displayed a particular fondness for Afro-Bahian culture, and his government implemented a licensing system to regulate, rather than persecute, Candomblé.[32] Afro-Bahian religious leaders were remarkably successful in convincing anthropologists, both local and foreign, of the distinct grandeur and purity of Yoruba- and Fon-based, or *nagô-jeje*, religious traditions. Indeed, the paradox of baianidade is that it simultaneously exalts "pure" Africanity and "mixed" Brazilianness as its core values. Candomblé leaders would also play an important role in articulating the prestige and centrality of Bahia within a larger Afro-Atlantic context. Mãe Aninha, a priestess of Ilê Axê Opô Afonjá, one of Salvador's most venerated Candomblé temples, famously characterized Bahia as *Roma Negra*, the Afro-Atlantic analogue to the center of Catholicism.[33] This metaphor would circulate in international circles through the work of anthropologists like Ruth Landes and Swiss-French avant-garde poet, novelist, and travel writer Blaise Cendrars.[34]

The forging of a modern Bahian regional discourse coincided with a golden age in Brazilian popular music, which reached a mass audience with the dramatic expansion of radio stations and transmission networks throughout the country.[35] During this time, popular music contributed to

the projection of Bahia as a place of magic, seduction, and culinary delights. References to *orixás* in Brazilian popular music played a role in the expansion of Candomblé into new communities in the center-south cities.[36] No singer-songwriter did more than Dorival Caymmi to promote an alluring image of Bahia to audiences throughout Brazil during the twentieth century. A native of Salvador, he moved to Rio de Janeiro as a young man and soon achieved national success with the song "O que é que a baiana tem?" (What does the Bahian woman have?), made famous by Carmen Miranda in the film *Banana da Terra* (1938). He gained international acclaim with "Você já foi a Bahia?" (Have you been to Bahia?), which was featured in the Disney cartoon *The Three Caballeros* (1944). Caymmi's songs about Bahia, which constitute the majority of his oeuvre, conjure images of a timeless city of *baianas* (Afro-Bahian women, traditionally devotees of Candomblé, who sell *acarajé*, West African bean cakes fried in palm oil), sultry *mulatas*, capoeira fighters, and fishermen devoted to Yemanjá, the maternal *orixá* of the sea. Caymmi was the most important composer of a subgenre of modern Brazilian songs devoted to the spirit world of Candomblé, which played a critical role in familiarizing listening audiences, however superficially, with Afro-Bahian religious life. In the late 1950s, Caymmi's compositions would also figure prominently in the early recordings of bossa nova, a modern rereading of samba in dialogue with cool jazz.

The discovery of oil deposits off the coast of Bahia in 1953 spurred the development of a regional petrochemical industry, which intensified the state's economic integration into national and global economies. Intellectual elites with direct access to media outlets redoubled efforts to promote regional cultural identity. Newspaper editor and author Odorico Tavares was particularly instrumental in elaborating what Scott Ickes has called the "aesthetics of baianidade," which foregrounded Afro-Bahian culture, especially Candomblé.[37] Meanwhile, the Federal University of Bahia, under the leadership of Edgar Santos, invested in the arts and humanities, creating new schools of music, theater, and dance, as well as the Centro de Estudos Afro-Orientais (1959), the first center of its kind in Brazil.[38] These academic programs contributed to a remarkable surge in cultural production focused largely on the social conditions and cultural practices of the Bahian people, especially those of African descent. In the realm of cinema, for example, Afro-Bahian cultural and religious practices figured prominently in films of the so-called *ciclo baiano*, such as Trigueirinho Neto's *Bahia de Todos os Santos* (1960), Anselmo Duarte's *Pagador de Promessas* (1962), Glauber Rocha's *Barravento* (1962), and Robert Pires's *A Grande Feira* (1962).[39] These films constituted

what Robert Stam has called the "Bahian Renaissance," which he defines as the "cinematic rediscovery of the cultural riches of Salvador, Bahia."[40]

This moment coincided with the second generation of bossa nova, which pivoted away from the bourgeois world of Rio's south zone in an effort to engage the social problems and cultural life of the Brazilian northeast, in relation to both the hinterland *sertanejo* and coastal blacks. "Maria Moita" (1963), a song about a poor Bahian woman composed by Carlos Lyra and Vinicius de Moraes, evoked a cruel patriarchal world while calling for the intervention of Xangô (the *orixá* of thunder, fire, and justice) to put an end to the abuse of power, whether based on gender or on class. In 1966, Vinícius de Moraes and guitar virtuoso Baden Powell recorded *Os Afro-sambas*, a canonical album largely dedicated to songs about the *orixás*, such as "Canto de Ossanha," "Canto de Yemanjá," and "Lamento de Exú." These compositions placed Afro-Brazilian sacred music in dialogue with the harmonies of bossa nova and modern jazz. This same year, Gilberto Gil recorded "Eu vim da Bahia" (I came from Bahia), a song that romanticized Salvador as a city where poor people found sustenance in the spiritual powers of the *orixás* and Catholic saints; a place "where we don't have food to eat / but we don't starve / because in Bahia we have Mother Yemanjá / and Senhor do Bonfim on the other side."

With the advent of Tropicália, Gil and Veloso would begin to promote a more modern and urban image of Salvador. Whereas most popular music about Bahia represented black culture as timeless folklore, tropicalist songs tended to situate Afro-Bahian culture in contemporary urban life. Gil's "Domingo no Parque" (Sunday in the park), which was awarded second place in the 1967 Festival of Brazilian Popular Music, employed a narrative technique akin to modern cinematographic jump cuts to tell the story of a tempestuous love triangle that reaches a violent denouement during a Sunday outing at an amusement park.[41] Set to the rhythm of capoeira, Gil's televised performance of the song offered a compelling synthesis of elements coded as "traditional" and "modern"—he was flanked on one side by a percussionist playing a *berimbau* (the one-string-bowed instrument used in capoeira music) and on the other by Os Mutantes, a psychedelic rock band from São Paulo. At the same festival, Veloso performed "Alegria, alegria" (Joy, joy), which also featured electric instrumentation. During a televised interview backstage, Veloso observed that his friends in Bahia loved the song, against the expectations of his critics in Rio, who would presumably have more modern musical tastes. He quipped: "In Rio they wrote 'Caetano is going to sing with electric guitars, when he returns to Bahia he's going

to get a whipping with a berimbau.' They didn't know that the Bahians are beyond that."[42] The tropicalists were eager to dispel the folkloric image of Bahia, seeking instead to emphasize its modernity, despite its peripheral position in relation to the culture industry. Although they pursued their careers in São Paulo and Rio, the tropicalists played a key role in disseminating Bahian culture to a young urban audience in the south.

Bahia Underground

By the time Veloso and Gil were arrested and exiled to London in 1969, the Novos Baianos had formed in Salvador. While clearly influenced by the tropicalists, the Novos Baianos were devoted to the tradition of samba and explored ways to fuse it with hard rock. As noted in Chapter 2, the Novos Baianos became a fixture of Rio's countercultural scene that formed around Gal Costa in the early 1970s. Before moving south, the group was at the center of an emergent countercultural scene in Salvador, which was fast becoming the premier destination for Brazilian hippies. The title of their first album, *Desembarque dos bichos depois do dilúvio universal* (Disembarkation of the beasts after the universal deluge) (1969), suggests the dawning of a new era and radical departure from the past following a cataclysmic event. Their first single, "Ferro na Boneca," captured the spirit of adventure associated with the hippie counterculture: "It's not a road / it's a trip / so so alive like death / it has no south or north / or ticket fare." The "trip" evoked here is an existential (and possibly drug-fueled) journey, without roads, directions, or fares to pay. An even more explicit homage to countercultural youth appears in "Colégio de Aplicação," which takes its name from the laboratory school affiliated with the Federal University of Bahia, which was considered the most progressive school in the city. Songwriter Luiz Galvão imagined the students as a *nova raça*, or "new race," emerging from the school buildings under a haze of smoke, presumably from marijuana: "In the blue sky, blue smoke / a new race / from the buildings to the plazas / a new race." While the notion of a "new race" evokes the discourse of *mestiçagem*, in which new "races" would emerge from the mixture of Europeans, Africans, and Indians, Galvão uses the term to suggest a "new consciousness" among youth who were different from their parents in essential ways. In contrast to the moral certainties and political imperatives that had inspired youth throughout most of the 1960s, Galvão's lyrics suggest a kind of relativism based on personal experience: "A generation in search of neither good nor evil / each step is the reason." Life is not about achieving a destination or goal, the song

suggests, but rather about experiencing the present to the fullest and finding meaning in each step along the way.[43]

Artistic, journalistic, and official evocations of Salvador as a place of freedom and release obscured the fact that Bahian society in the late 1960s and early 1970s was profoundly conservative, hierarchical, and hostile toward the cultural and social transformations of the age. The exuberant joy on display in the music of Novos Baianos coexisted with a sense of revolt and despair among others in their cultural milieu. André Luiz Oliveira's film *Meteorango Kid: O herói intergalático* (Meteorango Kid: The intergalactic hero) (1969) explored the social alienation of hippie youth in Salvador. *Meteorango Kid* was an early example of *cinema marginal*, which involved low-budget cinematic productions that eschewed the high art pretensions and revolutionary politics of Cinema Novo. Instead, *cinema marginal* films employed a lowbrow, "trashy" aesthetic to tell stories of urban outlaws, delinquents, and misfits. Robert Stam describes these films, also known as *udigrudi*, a Brazilian corruption for "underground," as "generally violent, irreverent, iconoclastic" works that "keep the spirit of anarchic revolt alive" in the face of repression.[44] *Cinema marginal* registered the pervasive sense of disillusionment and impotence among middle-class youth during the most repressive phase of authoritarian rule.[45] Oliveira's film won several awards at the 1969 Festival of Brazilian Cinema of Brasília but was subsequently censored by the regime.[46] It garnered critical praise and popular success when it was first screened to a general audience in Rio de Janeiro, followed by other capitals.[47] Stam characterizes *Meteorango Kid* as a "filme de curtição" (a film to groove on), calling it "a sensual hymn, or better, a cine-samba, to the counterculture."[48] Despite its playful and dreamlike qualities, the film is quite anguished, occasionally taking nightmarish turns in its exploration of revolt and alienation among Brazilian youth.

Meteorango Kid depicts twenty-four hours in the life of Lula Cabelo Bom (Lula Nice Hair), a handsome young university student from a bourgeois family in Salvador. For this role, Oliveira cast Antonio Luiz Martins, also known as Lula, a young visual artist with no acting experience. At the time, Martins was the only guy in Salvador with shoulder-length hair and, as Oliveira recalls, he "didn't have acting technique, didn't argue over the obvious, didn't think the script was crazy, always wanted to contribute more, didn't have a schedule, didn't have a house, didn't have a family in Salvador; he was free in the world and had charisma."[49] In contrast to the character Lula, who leads a life of lazy comfort in a bourgeois family, the actor Lula

lived precariously in the historic center, Pelourinho, which was at the time a dilapidated and impoverished neighborhood.[50]

The film opens with Lula hanging from a cross under the blazing sun on a remote tropical beach while a dissonant and heavily distorted electric guitar drones away in the background. Lula is portrayed as a Christlike martyr for marginalized youth in dictatorial Brazil, but he is also a raffish antihero who expresses his profound alienation from family and society with a kind of blithe nihilism interrupted by action-packed, marijuana-induced flights of fancy inspired by comic book heroes such as Tarzan and Batman, international cinema, and pop music. The film employs what Stam calls "a kind of mass-media Esperanto—the cultural language that simultaneously channeled and co-opted the social aggressive impulses of late sixties youth."[51] The narrative shifts seamlessly between Lula's "real" life and his fantasy world, such that the distinction between the two is not always obvious.

Lula's slouchy posture, long, stringy hair, scruffy dress, and lax hygiene mark him as a hippie, at the time a novel type in Salvador. He is, however, utterly devoid of the romantic idealism and wanderlust typically associated with hippies. He saunters through the city like a gloomy *flâneur*, stopping to peer into shop windows, ogle at girls, and watch impassively as police agents cuff and haul people away. A sound track of American rock (Janis Joplin's "Oh Sweet Mary") and tropicalist music (Veloso's "É proibido proibir") plays in the background. His presence alternately disturbs, disgusts, and fascinates the people he encounters. On a city bus, he sidles up to a young woman, who is evidently repelled by his body odor and distressed by his attempts to rub up against her. A group of teenage girls seated in the back of the bus trade comments about his slovenly manners and long hair in a manner that suggests both desire and repulsion as he stares at them and ostentatiously picks his nose. The scene ends with Lula flicking the dried mucus at them as the girls scream in disgust.

Lula is a *vagabundo* who wakes up late, wanders the city aimlessly, and harbors idle fantasies about making it as a movie star. In one dream sequence, he is cheered by adoring fans at the premier of one of his films as two young women shower him with caresses and wash his hair and body in a fountain while they promote beauty products. Politically alienated, he is completely disengaged from the heated debates that animate his classmates at the university. He wanders into a chaotic student assembly and is approached by several peers, who plead with him to get involved and take a stand, although it is not clear what they are debating. As his friends fight over the bullhorn,

Lula reads a comic book. Later in the day, he encounters on the street his friends Caveirinha and Zé Veneno, who are with another guy, a political activist, who tries to ask Caveirinha about Lula's political affiliations to determine whether he is "Chinese or Soviet," the two major lineages of global communism in the 1960s. Caveirinha responds with a barrage of sarcasm, describing Lula as "a happy right-winger, radical leftist, Marxist-Leninist, liberal, and now unidentified!" The activist stalks away as the others erupt in derisive laughter and comment on "how boring" the guy was.

To the background sound of the Novos Baianos, the three friends proceed to Caveirinha's sparsely decorated apartment in a low-rent, high-density building. This pivotal scene begins with an extended shot of Caveirinha seated shirtless on his single mattress as he rolls a joint. The song ends, and for the first time in the film there is total silence as Caveirinha expertly prepares the joint with a seriousness of purpose that contrasts with his usually playful, slightly crazed demeanor. Finally, after several minutes of silent work, the joint is ready, and, to the sound of Richard Strauss's "Sunrise" fanfare to *Also sprach Zarathustra*, Caveirinha lights up. The dramatic fanfare had recently been employed in Stanley Kubrick's *2001: A Space Odyssey* for the opening Dawn of Man sequence, which heralds the invention of technology in the form of a bone used as a tool and weapon. In contrast, Oliveira employed the fanfare in an ironic fashion to commemorate the initiation of a marijuana-smoking circle, the ultimate leisure activity for countercultural youth.

Stoned on pot, Lula drifts into a fantasy world as the film cuts to the formal dining room of his parents' home. Seated next to his parents, Lula sips coffee, as a family friend drops by to chatter cloyingly about her recent trip to Europe. Lula turns suddenly to his father, pulls out a joint, and offers it to him: "Would you like a bit of weed?" Lula's mother screams as his father furiously beats his wayward son, who flees to his bedroom, transforms into Batman, and returns to the dining room to slay his parents. Lula wakes from his daydream to find that Zé Veneno has succumbed to marijuana-induced anxiety and frets about his life and future. Instead of soothing their friend, Caveirinha and Lula begin to ridicule him as they pretend to search for and capture "his future" as if it were an escaped mouse. Zé Veneno wants to leave, but his two friends prevent him from reaching the door. Lula hands Zé Veneno a gun and dares him to shoot. When he refuses, Lula takes the gun back, taunts both of them, and ultimately shoots Caveirinha. Although the final denouement is one of Lula's fantasies, the scene is disturbing, as

the communal rite of sharing a joint, romanticized by the counterculture as a ritual of camaraderie, devolves into violence, albeit imaginary.

After more adventures, Lula attends the wake of a university student who had been active in politics. Lula had humiliated the young man while out on a double date by undermining his masculinity. Even at such a solemn occasion, Lula maintains an irreverent attitude as he leans over the casket, takes long drags from a cigarette, and drops ashes on the face of the deceased. He then contrives to leave the wake with the sister of the dead student so that he can seduce her at the home of the girl's grandmother. At every turn, Lula transgresses social conventions and subverts prevailing ethical and moral values like the shape-shifting "hero with no character" of Mário de Andrade's modernist novel *Macunaíma* (1928). Whereas Macunaíma is on a quest to recover a sacred talisman, Lula's adventures are aimless and devoid of purpose.

Night falls, and Lula returns home. In the background, we hear Caetano Veloso's "Empty Boat," a mournful song with lyrics in English that he composed in early 1969 while under house arrest in Salvador before his exile to London. Veloso's lament about emptiness and disorientation contrasts with the visual sequence as Lula is greeted by a large gathering of family and friends, all elegantly dressed, who have come to celebrate his birthday. Lula slumps in a chair, annoyed and bewildered, as friends and relatives slap him heartily on the back and his mother smothers him with hugs and kisses. The celebrants are completely impervious to Lula's estrangement, which further aggravates his misery. The final scene finds Lula back on the cross where the film began, but he descends in a reverse action shot and then climbs a coconut tree as if to abandon his self-imposed martyrdom and satisfy his thirst.[52] The final epitaph reinforces Lula's nihilism: "What will become of me and of my life? Does it matter?"

≈ Tourists, Hippies, and *Vagabundos*

Meteorango Kid was one of the earliest films to portray hippies, a new social type that appeared on the streets of Salvador with increasing frequency in the late 1960s and early 1970s. Many were middle-class white kids from wealthier cities in the south and as such could pass for tourists, a category of people that local authorities and businesses were eager to attract. Yet these young travelers were not conventional vacationers who arrived by bus, cruise ship, or plane and stayed in hotels. Instead, they typically drove or

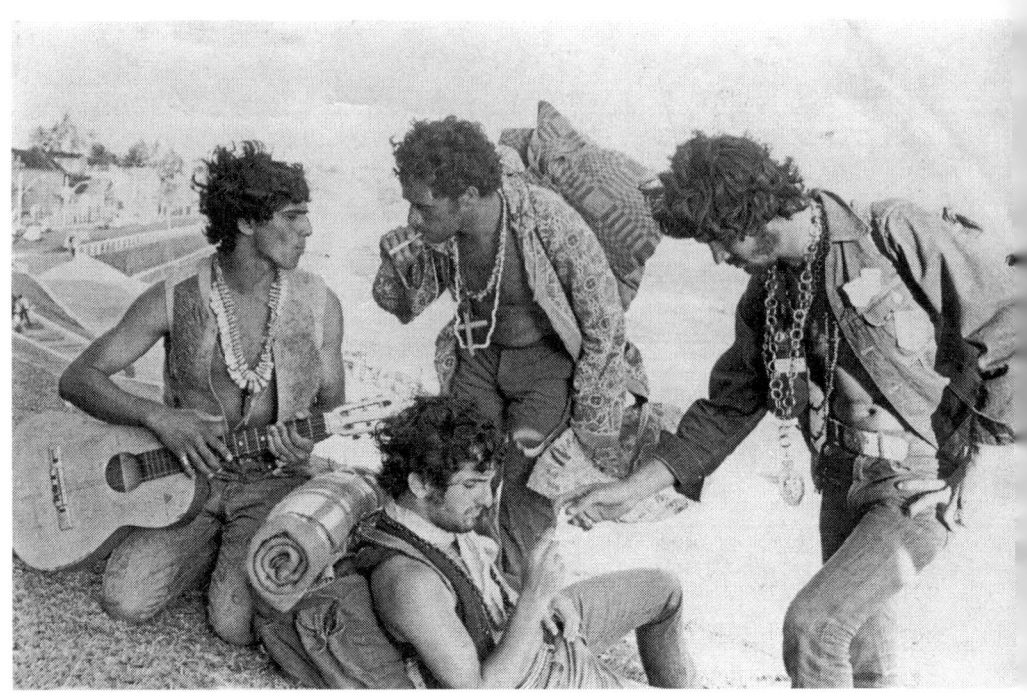

Hippies at the Porto da Barra, Salvador, Bahia, 1969. Agência A *Tarde*.

hitchhiked to Bahia, slept in tents, and pursued an itinerant way of life, often surviving on little or no money. Disparaged for their unconventional appearance and lifestyle, these visitors, including a substantial number of foreigners, also inspired curiosity. According to Luiz Galvão, the songwriter of the Novos Baianos, congregations of hippies around the beach at Porto da Barra became a popular attraction for middle-class families as they went sightseeing around the city on weekends.[53] Jack Epstein, the author of a budget travel guide to Latin America designed for young North Americans with countercultural sensibilities, offered a revealing vignette: "Once in Salvador, Brazil, as I walked down the street with my backpack, I was stopped by a man. He looked at me seriously and told me that he only wanted to satisfy his curiosity: was I a tourist or a hippie?"[54] This casual encounter, framed by the man's earnest bewilderment, suggests that for many Bahians being a tourist and a hippie were mutually exclusive.

Press reports suggest that the influx of hippies began in 1969. Salvador's leading daily newspaper, *A Tarde*, published a story about a group that arrived in October 1969 and built a shelter behind the Farol da Barra, a landmark lighthouse built on a seventeenth-century fortification. A photo from this

report showed a group of young men in hippie garb, with backpacks, sleeping mats, and a guitar, sharing a smoke by the beach. The article quoted Gal Costa, who declared that the hippies were "beautiful and marvelous."[55] The very next day, however, A Tarde ran a front-page story with a mug shot of a group of hippies that had been arrested on the Avenida Sete de Setembro. A photo of four men and two women, some dressed in hippie fashion, accompanied the story. The eyes of two of the young men have been blacked out and another covers his face, suggesting that they were minors. The first line of the story revealed much about the general perception of hippies in the Bahian capital: "A group of *vagabundos* calling themselves hippies was arrested."[56] It also suggested that those who had been arrested preferred to be identified as hippies to distinguish themselves from unemployed vagrants.[57] In Brazil, the epithet *vagabundo* is typically used to refer to someone who avoids conventional work, not someone who is excluded from the labor market. As hippies they were part of a colorful international youth movement; as *vagabundos* they were unproductive social pariahs.

Several days later, A Tarde ran a story about another group of hippies that had settled around the Farol da Barra, alerting readers to these visitors, who "day and night, under the effects of drugs, gave themselves over to libidinous acts, besides bathing nude at the beach."[58] Members of this group were planning a festival to convene hippies from throughout Brazil and other South American countries. The police expelled this group from the Farol da Barra, and the secretary of security quashed plans for the festival, an event that it had previously authorized. In the meantime, hundreds of hippies had embarked on the long journey to Salvador, mostly as hitchhikers in search of sympathetic motorists.[59] Local authorities regarded these new arrivals as a nuisance and possibly even a threat to public security, leading to a concerted effort to remove hippie encampments from the city beaches and make arrests on charges of loitering or drug possession. Police targeted male *cabeludos* ("long hairs") for their dress and hair, often shaving their heads once in custody.[60] One police chief, Delegado Gutemberg de Oliveira, was notorious for his violence against *cabeludos* and was eventually arrested by the federal police in connection with the death of a hippie from Brasília.[61]

Some local observers expressed sympathy for the hippies. When A Tarde reported the removal of the small hippie encampment at the Farol da Barra in November 1969, the story highlighted the voices of local intellectuals who offered high-minded justifications for dissent and self-affirmation among youth of all epochs throughout history. A lawyer interviewed for the article argued that the prohibition of the planned gathering was illegal since the

Hippies buying *acarajé* from a *baiana*, 1969. Photo by Paulo Neves. Courtesy of the National Archive, Rio de Janeiro.

Brazilian constitution guaranteed the right to assemble, as long as congregants were unarmed and orderly: "It doesn't seem that the motto 'peace and love' promoted by the hippies represents any threat to public order in any civilized country."[62] The lawyer also criticized the prohibition on grounds that it would interfere with efforts to build tourism to Salvador. The hippie festival, he argued, "would be of undeniable promotional value for the city of Salvador, regarded as the capital of tourism," because "the meeting would attract an incalculable number of visitors, not only Brazilians, but also South Americans." Local authorities, however, apparently perceived a threat to public order in allowing large numbers of hippies to congregate. Although the festival had been cancelled, authorities tolerated the hippie encampment at the Farol da Barra throughout most of the summer. Luiz Galvão has recalled that the police usually waited until the end of summer in March to arrest and evict the *cabeludos* in order to maintain an image of freedom for the tourists.[63] Soon after carnival, police made an early morning raid on the camp and arrested fourteen people, including several foreigners.[64]

An incident report from the Delegacia de Jogos e Costumes indicated that all hippies were, as a matter of policy, turned over to the federal police.[65]

Many hippies simply avoided the city center and beaches, preferring instead neighborhoods like Itapoã, then a relatively remote community of fishermen and vacationers. Hippie camps sprang up around the Lagoa de Abaeté, a freshwater lake fed by natural springs nestled among white sand dunes adjacent to Itapoã. A *Tarde* published a sympathetic portrait of a group from Rio Grande do Sul called the "familia girassol" (sunflower family), which, after a period at the Farol da Barra, moved up the coast to Itapoã and opened an atelier for producing handcrafted jewelry: "Using the most rustic work tools, such as hammers, nails, pieces of wood, chisels, and leather, they produce the most original objects while earning a living honestly. At the atelier, the guys and gals enjoy the greatest freedom possible and maintain good relations with the surrounding residents."[66]

By the summer of 1970, just months after the first major influx of hippies in Salvador, a permanent commune, the aldeia hippie, was established on the northern outskirts of Arembepe, a fishing village about sixty kilometers north of Salvador. Hippies were attracted to Arembepe for its natural beauty, inexpensive cost of living, and relative freedom from police persecution. Conrad Kottak, a North American anthropologist who first visited the village in 1962 and returned periodically over the next several years, interpreted the arrival of hippies as part of a larger "assault on paradise" as forces of modernization brought changes to Arembepe.[67] He initially resented the hippies, who seemed "like intruders in the tropical paradise" where he had conducted research since the early 1960s.[68] The "hippie invasion" coincided with the construction nearby of an industrial plant producing titanium dioxide, which severely damaged the local environment, especially the Capivara River. Tibrás, the German-Brazilian company that built the plant, paid for 80 percent of the cost of paving the road from Salvador.[69] Kottak came to see hippies as "rivals" but also acknowledged commonalities he shared with them as an outsider attracted to the natural beauty and everyday life of the village: "Ethnographers are like professional hippies; the hippies were like amateur anthropologists."[70] Although Kottak would eventually overcome his initial disdain, he viewed the hippies as a "multinational intrusion" analogous to the Tibrás plant, or, as he put it bluntly: "The more notorious side of Arembepe's transformation involves industrial pollution and hippies."[71]

While Kottak regarded the "hippie invasion" as part and parcel of modern "pollution," the hippies who settled in Arembepe typically understood their quest as one of "purification." Despite the forces of modernization trans-

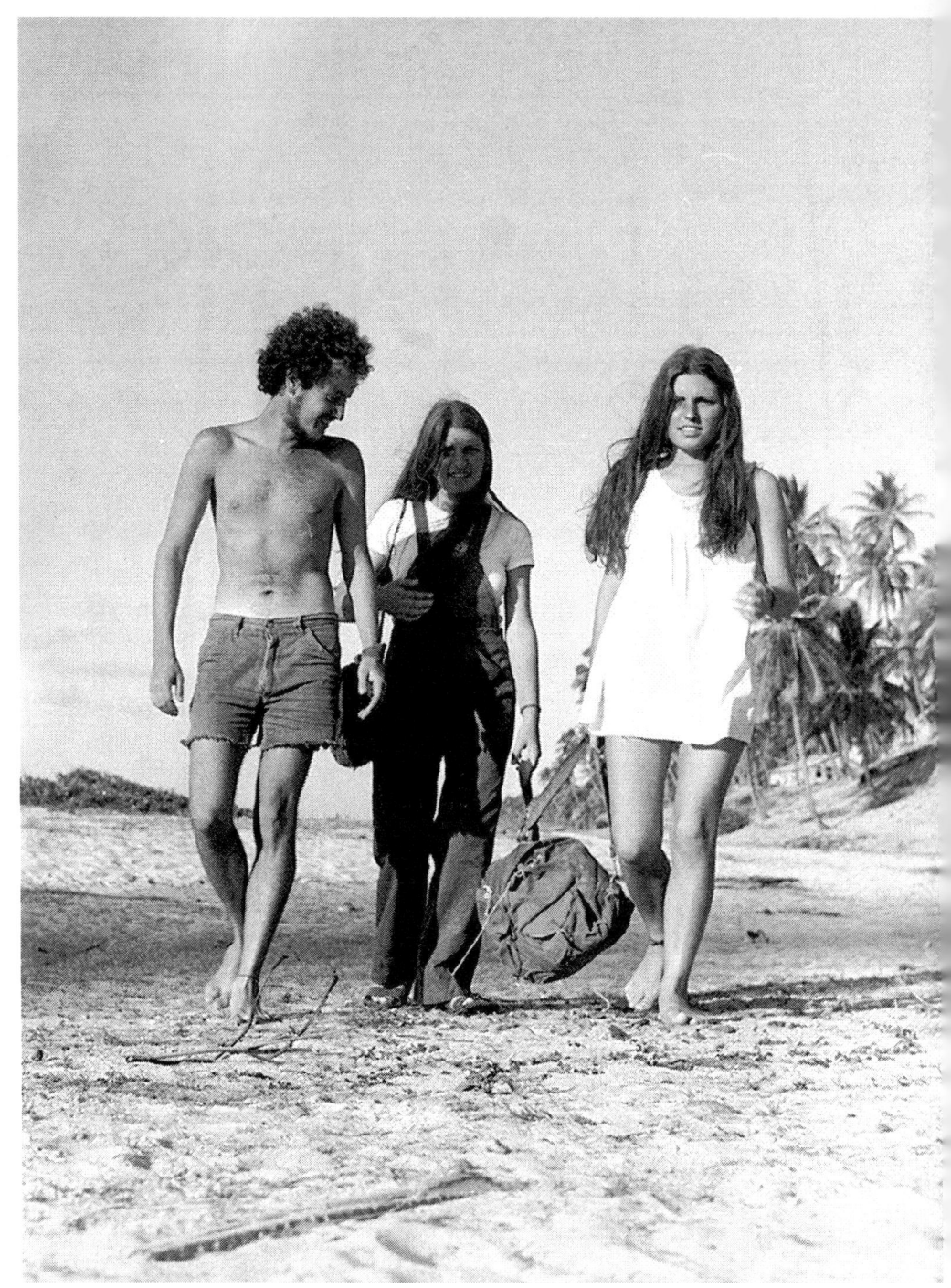

Hippies arriving in Arembepe, Bahia, February 1972. Agência A *Tarde*.

forming the area, Arembepe remained a bucolic tropical haven for young visitors to the area. *Bondinho*, a nationally circulating magazine oriented heavily toward countercultural topics, featured a long text about the village, mixing reportage, interviews, and free-association musings: "Arembepe in Tupi means that which surrounds or wraps around us. In recent times, maybe in the last two years, it has come to signify a certain kind of life, a search, *desbunde*, a new beginning. . . . It has become a Mecca, that city of pilgrimage and purification."[72] The village even attracted international countercultural icons, such as Mick Jagger and Janis Joplin, who stayed in the Casa do Sol Nascente (House of the Rising Sun), the largest cabana of the aldeia hippie, reserved for short-term visitors.[73] Arembepe had become, according to the *Bondinho* piece, "an unplanned Woodstock." A writer for the short-lived Brazilian edition of *Rolling Stone* echoed this theme, calling the village "Ondestouque" (Wavestock), suggesting a permanent hippie festival by the sea.[74] For several summers, Arembepe was a point of convergence for Brazilian artists, who drew creative inspiration from the natural surroundings.[75]

For these visitors, the bucolic life of Arembepe offered refuge from police harassment in the cities and an encounter with premodern lifeways that were different from the urban environments they had been raised in. The *Bondinho* piece quoted one inhabitant for whom village life represented a different culture, in many ways superior to his own: "I went in search of other ways to live in other cultures because my own offers nothing. Take, for example, the fishermen here. The connection they have to the sea is incredible, there's a force, a natural wisdom that comes from a direct connection with life. I was reborn here, I'm learning about the things of life. . . . I'm up with the sun, collect firewood, make porridge, clean the house, then do whatever I want—right now, for example, I'm reading about Zen Buddhism, oriental philosophy, get it? I make crafts, leather bags, to get some money."[76] Not all hippies adapted so well to life in the aldeia. Several accounts from the Bahian press remark on the poor living conditions of the young visitors from the city who knew nothing about fishing or building living structures out of local materials.[77] While some of the middle-class hippies lived comfortably, receiving monthly allowances from their parents, others survived on the verge of starvation and in dire need of medical attention.[78] As part of a mobile community, the hippies circulated between Arembepe, Itapoã, the Porto da Barra, and points between, where they sought markets to sell crafts, perform services, and, in some cases, traffic drugs.

The "hippie invasion," which was part of a larger boom in tourism to Arembepe after 1970, also brought new opportunities for locals to make

a living other than through fishing, which was a difficult and sometimes dangerous occupation. *Veja* interviewed a former fisherman who made a comfortable living with a bar catering to both locals and tourists. The article claimed that "all five hundred inhabitants of the village regard the tourists as a divine blessing embodied in colorful characters with strange clothes and odd speech, who call each other 'bicho' and don't hesitate to go swimming in the ocean nude." Not surprisingly, the *Veja* article ignored the considerable cost of tourism, which contributed, along with the petrochemical industry, to increasing social stratification within the village.[79]

Kottak also noted an increase in Afro-Bahian cultural practices historically associated with Salvador and the *recôncavo* (the region around All Saints' Bay) that were not common before the construction of a paved highway and the arrival of heavy industry and hippies. Vendors of *acarajé*, a culinary symbol of baianidade, had set up stands in town squares, and some villagers had begun to worship *orixás* under the guidance of a Candomblé priestess. The village had been entirely Catholic when he first arrived in the early 1960s. Some fishermen believed that the magical powers of the *orixás* aided them in locating prize catches, and every successful outing seemed to validate the power of Candomblé. Kottak hypothesized that Candomblé was a religion that offered solutions to life problems with work, finances, and interpersonal relations and that it attracted a local clientele that was coping with the stress of profound social and cultural transformations brought on by modernizing forces.[80] The influx of hippies and the growth of Candomblé in Arembepe were distinct phenomena, but they were part of a larger process of modernization, which brought symbols of baianidade from Salvador to coastal settlements previously isolated from the urban life of the capital.

The countercultural scene in Bahia, from beachfront settlements in Salvador up to Arembepe, reached a peak in the summer of 1972, eventually alarming local authorities. In January, two young men from elite families in Rio were arrested in Itapoã with a kilo and a half of marijuana and substantial quantities of LSD brought up from Argentina. *A Tarde* reported that an additional group of thirty-two people, identified variously as "hippies," "addicts," and "university students," were also arrested for consumption.[81] This article made a point of lamenting that most of the hippies were university students "de boa aparência" (of good appearance), a well-known term in Brazil to describe someone who is white and middle class, but who has been led astray by a leisure activity historically associated with poor blacks.[82] This time the authorities did not wait until the end of summer. On the eve of carnival, the secretary of public security launched a campaign, dubbed

Operação Limpeza, designed to "clean" the city of youths with no discernible occupation, focusing on points of congregation in Barra and other beachfront neighborhoods.[83] The police reported that Barra had become "a den of marijuana, LSD and cocaine." The stated objective of Operação Limpeza was "to moralize the ocean front, break up the points of drug dealing, and arrest potheads, hustlers, and hippies."[84] By the end of this operation in March 1972, a kilo of marijuana had been confiscated and nearly 100 people had been arrested, including several hapless tourists who had been mistaken for hippies.[85]

The police tolerated the hippie settlement of Arembepe for several months longer, but one report suggested that local authorities regarded this community as a national security concern and even considered soliciting the aid of a local army detachment to disperse the hippies.[86] In August 1972, after months of rumors of an impending crackdown, the police launched Operação Arembepe in an early morning raid on the aldeia hippie. A local paper trumpeted "the end of the good life" for the hippies as authorities raided their encampment: "In their mud huts with thatched roofs they found everything: marijuana, seeds for growing the herb, handicrafts, men, women, children, the sound, the pure air, the sea, the sand and the freedom of 'peace and love.'"[87] The police arrested twenty-one Brazilians, four Argentines, three Uruguayans, two Dutch, a Colombian, an American, and a Moroccan.

When Kottak returned to Arembepe in 1973, after several years away, he found only a dozen inhabitants of the aldeia hippie. He returned again in 1980 and found that some of the hippies had left the commune and had been integrated into the community, in some cases through cohabitation with locals. Yet the aldeia hippie survived, and Arembepe remained a point of reference for the international counterculture such that Epstein's travel guide, published in 1977, could still report that Arembepe was "the in beach for freaks."[88] As of 2016, the aldeia hippie persists as a small community of permanent and itinerant residents who make a modest living selling crafts, mostly inexpensive handmade jewelry, or work in Arembepe, which has grown substantially in the last several decades.

In Salvador, the mass influx of hippies and other youth who embraced the counterculture began to decline after the summer of 1972. It remained a popular destination for alternative tourists on modest budgets, but these travelers became less conspicuous as they formed a part of a larger influx of visitors to the city throughout the 1970s. Most tourists came for reasons that earlier travelers had found attractive—the beaches, the colonial architecture,

and the Afro-Bahian festive secular and sacred cultural events. Bahia's association with the Brazilian counterculture would continue throughout the decade and even figured into state-sponsored efforts to promote tourism.

⇒ From Verbo Encantado to Viver Bahia

As discussed in Chapter 1, a vibrant alternative press emerged in the major Brazilian capitals, providing outlets for political satire, humor, social critique, cultural commentary, and experimental writing during a time of strict censorship over the mainstream press. The first alternative paper in Salvador, Verbo Encantado, circulated weekly from October 1971 through July 1972, producing a total of twenty-two editions. It was edited by Armindo Bião, a theater director, and published by Álvaro Guimarães, a film director and journalist. For an underground journal, it had a remarkably wide distribution, with 10,000 copies sold at newsstands through a local distributor and then later as a supplement to the Tribuna da Bahia.[89] It also had limited distribution in Rio de Janeiro, São Paulo, and a few small cities around Salvador. Its title parodied the biblical idea (John 1:14) of the verbo encarnado, the "word made flesh," signifying the transmission of divine messages through the body of Christ. Verbo Encantado promised, instead, the "enchanted word," suggesting its purpose as a kind of bible for those in search of Bahia's magic. Verbo Encantado was not subjected to censorship, even though it published essays, letters, notes, and illustrations with obvious allusions to drug use and sexual liberation.

Verbo Encantado had no discernible editorial line, standard layout, design, or content focus. To a first-time reader it could appear chaotic and noisy with its hodgepodge of essays, vignettes, hand-drawn cartoons, amateur photos, album reviews, and insider recommendations for leisure activities in Salvador. Álvaro Guimarães described it as "an almanque, a journal designed and written when you are not thinking, when you are enchanted and creating fantasies."[90] It seemed like a montage of several different alternative papers of that period. Like the famous alternative weekly O Pasquim, Verbo Encantado was a jornal de costumes—a paper dedicated to local social life, cultural events, and fashion trends. Unlike O Pasquim, which was notorious for its political satire, Verbo Encantado rarely made references to the military regime.[91] It was largely disengaged from politics defined in terms of state power and left-wing opposition. In this regard, it was similar to the Rio-based journals Flor do Mal and Presença, both launched in 1971, which featured experimental prose and poetry, cultural commentary, and idiosyncratic interviews.[92]

Some pages of *Verbo Encantado* displayed the intellectual pretensions of the literary supplements of mainstream papers, featuring essays about national and international literature (for example, Edgar Allan Poe, Jack Kerouac, and Allen Ginsberg) and cinema (Buñuel, Godard). With its consistent coverage of popular music, *Verbo Encantado* also resembled the Brazilian edition of *Rolling Stone*, published in Rio in the early 1970s. It occasionally featured male beefcake photos and made occasional references to same-sex desire, which figured in more explicitly gay publications that emerged in Rio and São Paulo later in the decade.[93] Every issue featured stories about local soccer stars, media personalities, socialites, and other light topics for a general audience that would have fit into any conventional Brazilian newspaper. In terms of form and content, *Verbo Encantado* was the most heterogeneous alternative publication in Brazil. Its motto, "cada qual com seu cada qual" (to each his/her own), expressed the basic ethos of its editorial staff, which strived to maintain editorial freedom even if the final result alienated some readers.[94]

The only defining characteristic of *Verbo Encantado* was its steadfast focus on Bahian cultural life, typically described in celebratory fashion, such that the journal often read like an insider's guide to the city.[95] Nearly every issue featured a story about a particular neighborhood, street, or landmark of Salvador, including well-known destinations for city residents and tourists such as the Farol da Barra, the Mercado Modelo, Rua Chile, Rio Vermelho, Itapoã, and Arembepe, but also working-class and poor neighborhoods such as Maciel, an impoverished red-light district in the historic center; Ribeira, a working-class neighborhood on the bay; and Periperi, a distant suburb. The journal also ran detailed stories about Bahia's famous religious processions and street festivals that took place in the summer months leading up to carnival.

Every issue featured a text, often a prose poem written in telegraphic style, that dispensed advice to outsiders about how to best enjoy Bahia in ways that were clearly designed to appeal to countercultural youth. One text from late 1971, for example, instructed readers in how to experience the summer of Bahia in full communion with nature: "Make the sky your one and only ceiling . . . open the windows . . . don't go out with umbrellas because rain is part of summer. . . . It's not necessary to smoke beforehand, but read VERBO afterward . . . turn your ears over to the natural sound of waves, to the freshness of breeze . . . talk with your neighbor at the beach . . . listen to Mendelssohn and Bob Dylan . . . careful with straight-laced [*caretas*] visitors . . . sleep naked . . . don't forget that the summer will end."[96] The assumed readership was middle-class, university-educated youth who

listened to classical music and the latest popular music from the United States, smoked marijuana, sought casual interaction with locals, and, above all, wanted to commune with Bahia's tropical nature. Some stories in *Verbo Encantado* echoed the reports published in *Veja* discussed at the beginning of this chapter. One article about escaping "the machine" of modern life in a big city asks rhetorically: "Why Bahia? The response was everywhere . . . tranquility, calm . . . in the romantic encounter with a land that is mystic, mestiça . . . and still authentic."[97]

Verbo Encantado was structured loosely around recurring sections, interspersed among featured essays, interviews, and biographical profiles written by a cadre of regular staff writers and guest contributors. The various sections provide insight into the vast scope of the journal. One section, "Soltando o verbo" (Releasing the word), was dedicated to religious, spiritual, and esoteric commentary, including essays about Candomblé, Eastern religions, shamanism, spiritism, and astrology. "Trips Internacionais" was designed as an international affairs section featuring essays with titles like "The Saga of Palestinians," "What's Up with Mao?," and "Purges in Poland." Conspicuously absent was any comparable section about domestic politics, as the editors avoided any confrontation with regime censors. The section "SóSom" (OnlySound) was dedicated to popular music, featuring album and concert reviews about local artists, especially the former tropicalists, and international rock celebrities such as Mick Jagger, Jim Morrison, Frank Zappa, Bob Dylan, and John Lennon. This section also published adoring features about Afro-Bahian sambistas like Batatinha and Zé Pretinho, as well as local carnival groups such as the samba school Juventude do Garcia and the *afoxé* Filhos de Gandhi, an all-male Afro-Bahian parading organization. One notes an obvious preference for Bahian musicians and rock artists from the United States and Britain and occasional expressions of disdain for artists based in Rio and São Paulo. One issue featured a reproduction of a poster of Caetano Veloso, still in exile in London, for a concert at Queen Elizabeth Hall. The two-page spread appeared several weeks after the concert.[98] The publication of the poster, which hailed Veloso as "Brazil's leading contemporary folk/rock artist," was clearly not meant to sell tickets to the concert but rather to trumpet the international success of a local celebrity.

To supplement receipts from newsstand sales, *Verbo Encantado* featured small advertisements, mostly from local retail, that provide insight into the target audience of the journal. Few advertisements seemed to have been designed for a general audience, preferring instead young, middle-class consumers seeking clothes, records, and other boutique items that would

appeal to a countercultural sensibility. Several advertisements were contained in small boxes with hand-drawn letters and illustrations promoting small boutiques that specialized in hippie or "underground" sartorial styles designed for youth of modest spending power. One store, called Bahia News, cultivated a more affluent clientele with money to spend on imported products from the United States and Europe. Its advertisements promised a 10 percent discount on everything for customers who brought in the advertisement from *Verbo Encantado*, "excepting (of course) for Lee blue jeans and whiskey," two consumer items that marked, on one hand, countercultural style, and, on the other, bourgeois taste for imported liquor.[99] Each edition of *Verbo Encantado* also contained a section called "Trekinhos," featuring announcements for upcoming cultural events mixed in with paid advertisements ingeniously disguised as insider's tips for a wide range of products, services, shops, and restaurants.[100]

Despite revenue from sales and advertisements, *Verbo Encantado* came to an abrupt halt in July 1972, having accumulated considerable debt that would take its editors years to liquidate. To earn money, Armindo Bião and other members of the editorial staff went to work for *Viver Bahia*, a tourist magazine published by Bahiatursa from November 1973 through June 1980.[101] This new publication was oriented exclusively toward the cultural life of Bahia and the surrounding region with special attention to the annual rhythm of religious festivals. It was an heir to tourist guides going back to the 1950s that romanticized Candomblé, popular festivals, culinary delights, colonial-era architecture, and local folk vocations such as fishermen, market vendors, and, of course, the *baianas de acarajé*. What distinguished *Viver Bahia* from these earlier guides was its direct connection to government-sponsored development initiatives oriented toward tourism. It served as a clearinghouse for information about hotels, restaurants, bars, nightclubs, boutiques, craft fairs, museums, cinemas, and theaters, while keeping a regular calendar of events, performances, exhibitions, and Candomblé festivals. Candomblé communities were generally supportive of efforts to instruct visitors in how they could visit a temple or attend a festival, but there was also a growing concern over the promotion of Candomblé as a folkloric tourist attraction. One column, for example, warned readers about agencies that charged money to take tourists to folklore shows that were billed as legitimate Candomblé ceremonies.[102] When a group of Candomblé leaders convened to establish the Federação Baiana dos Cultos Afro-Brasileiros (Bahian Federation of Afro-Brazilian Cults) in March 1974, one of their primary motivations was to defend their religion from commercialization.[103]

Viver Bahia targeted a wide audience of diverse ages and spending potential, providing contact information and recommendations for visitors who stayed in fancy hotels and ate in fine restaurants, as well as for those in search of a campground and an open-air market. Its preferred audience was conventional tourists with money to spend. The only advertisement in *Viver Bahia* was for the state government of Antonio Carlos Magalhães and the Banco do Estado da Bahia, which offered financing, payable in up to twenty-four months, to come for a vacation. In an explicit appeal to the affluent tourist, the advertisement concluded: "Bahia is even more beautiful when you have money in your pocket."[104]

In other ways, *Viver Bahia* had much in common with *Verbo Encantado*. It represented the city as a magical place of ludic pleasure and mysticism where one could have an encounter with an alternative, non-Western culture while still enjoying the advantages of modern consumer culture. For the editors of *Viver Bahia*, and by extension the state government that sponsored the publication, to "live Bahia" meant an encounter with black culture and tropical nature. The use of evocative, impressionistic language expressed in a clipped, telegraphic style was very similar to some of the poetic musings found in *Verbo Encantado*. The first issue, for example, instructed visitors to "live without haste, with force. Serene, the possibility of a revelation . . . Black Bahia. Sensual, that aroma, that way of being, a risk. Clarity. Arriving, you will know it. The enchantment here is nearly fatal. You can count on us."[105] Bahia is dangerously seductive, it suggested, but *Viver Bahia* will help visitors make sense of it while they are having a good time. Like *Verbo Encantado*, it featured place-based stories, highlighting the unique attractions of specific neighborhoods, beaches, and points of interest, as well as information about local cultural practices and traditions (for example, trio elétrico, afoxé, Candomblé, carnival, capoeira, and Catholic festivals and processions), designed to provide historical context and local insight for tourists. Staff writers saw themselves as guides to authentic experience.

On occasion, *Viver Bahia* revealed its editorial origins in *Verbo Encantado*, as in a story from July 1974 about the Porto da Barra. The original epicenter of hippie life in Bahia was transforming with the construction of new hotels and a small shopping center, yet it remained a fashionable place for young locals and visitors alike to congregate at the end of the day to watch the sun set over All Saints' Bay and Itaparica Island: "The *desbundados* of Bahia meet at the Porto at 5pm for the sunset and to find out what's happening at night. Every hippie who comes puts down his or her backpack. And there everything may be obtained, from wild clothes to a part in a theater pro-

duction."[106] Summer issues featured hand-drawn cartoon illustrations of bearded hippies, sometimes wearing swimwear with peace signs, lounging on the beach. For an official tourist guide, it was remarkably eager to appeal to hippies, even as the police continued to arrest and expel them.

The early experience of alternative journalism in Salvador reveals how artists and intellectuals associated with the counterculture were invested in the promotion of Bahia as a destination for alternative travelers in ways that overlapped with or directly contributed to official efforts to bolster tourism. The transition from *Verbo Encantado* to *Viver Bahia* suggests ways in which the counterculture, stigmatized for its association with social deviance and marginality, also found a measure of acceptance within Bahian society, especially when linked to leisure and tourism.

⇒ Doces Bárbaros

In January 1972, Caetano Veloso and Gilberto Gil were allowed to return to Brazil, and they quickly revived their careers, now with the luster of persecuted artists who had been exiled to "swinging London" and had triumphantly returned. Their return coincided with what is now remembered as *verão do desbunde*, the "hippie summer" of Bahia, somewhat akin to the 1967 "summer of love" in San Francisco. The epicenter of the Brazilian counterculture briefly shifted from Rio to Bahia as hordes of young Brazilians, many identified with the counterculture, arrived in the city. To celebrate Veloso's return, a carnival club, Os Tapajós, created the Caetanave, a specially designed *trio elétrico* (a moving soundstage on top of a converted truck) that resembled a futuristic spaceship.[107] With the arrival of carnival season in January, Torquato Neto advised his readers in Rio to head for Salvador: "The carnival in Bahia in 1972 is for people who don't like to miss out on what's essential. Check it out for sure. Let's groove on this big bash: rain, sweat, and beer: don't forget: hit the road, dude. It's that way."[108] His readers would have recognized his reference to "rain, sweat, and beer" from Caetano Veloso's popular carnival hit from 1969, "Chuva, suor e cerveja," which had already become something of a classic in the repertoire of carnival music in Salvador. Reporting from Rio just before the beginning of carnival in February, Neto observed that the sand dunes of Ipanema beach, the most popular meeting place for countercultural youth, were empty on a cloudless summer day since "everyone was already in Bahia."[109]

In recalling the Bahian carnival of 1972 decades later, Veloso highlighted the sense of ludic, corporeal freedom among revelers: "I was struck by the

combination of hippies and traditional revelers and with the number of people who were openly gay. The hippies and the gays mixed naturally with the mass of revelers: the hippies seemed right at home in a world of fanciful costumes and the gays could be confused with transvestites, a carnival tradition. Many of the locals played a dual role as revelers and hippies or as traditional transvestites and modern gays. Others were tourists from Rio, São Paulo, Minas, or Rio Grande do Sul or even from abroad. With the blurred distinction among hippies, gays, and traditional revelers, one had a sense of tremendous freedom, an impression of triumphant pansexuality."[110] Rio-based artists and intellectuals of the Brazilian counterculture decamped to Salvador, later writing about their experiences for alternative press outlets, which further contributed to the aura of the city as a space of revelry and mysticism.

An emblematic figure in this regard was Jorge Mautner, the experimental novelist, pop philosopher, and singer-songwriter who had first met Veloso and Gil in London. The son of Jewish refugees from Nazi Germany, Mautner was well versed in the European philosophical tradition (with a particular devotion to Nietzsche and pre-Socratic philosophy), played the violin and bandolin, and composed whimsical songs imbued with guileless humor and pathos.[111] Of the artists and intellectuals of his generation, Mautner was the most invested in a utopian vision for Brazil, a mixed-race tropical nation of the Americas that gained its vitality from black culture, which he characterized as "Dionysian, healthy, ironic, evolved to survive in the most hostile world, in the most oppressive situations, tempered by patience and stoicism."[112] In some ways, Mautner's thinking resonated with Gilberto Freyre's *mestiço* nationalism, but he was committed to democratic socialism and an anthropophagic cosmopolitanism that celebrated the kinds of Afro-Diasporic cultural collisions that Freyre detested, as we will see in Chapter 4. After spending the summer of 1972 with Veloso and Gil in Salvador, he gave a long interview to *Bondinho*, a São Paulo–based alternative cultural magazine, which exalted Bahia as a space of Dionysian release and irrationality. Like many artists and intellectuals of his generation, Mautner conceived of Afro-Bahian culture (and African cultures in general) as uninhibited and liberated: "It's a tribal culture, it's an instinctive culture that hasn't been destroyed by the industrialized world." Mautner perceived deep affinities between counterculture and black culture, claiming that "underground culture is basically African."[113]

The *grupo baiano*, or "Bahian group" (Bethânia, Costa, Gil, Veloso), further reinforced this connection between the counterculture, what Mautner called

"underground," and black culture, especially Candomblé. While explicit references to *orixás* appeared only occasionally in their recorded music from the period, Candomblé was a primary point of reference, especially for Maria Bethânia, who was an avowed devotee of the religion. They participated in public festivals, such as the Lavagem de Bonfim, the ritual washing of the Bonfim Church, a traditional Afro-Catholic religious procession. They were particularly close to Mãe Menininha, the most renowned Candomblé priestess of the twentieth century, whose long tenure as priestess of the temple Ilê Iyá Omin Axé Iyá Massê, known as the Terreiro do Gantois, began in late February 1922, coinciding precisely with the Modern Art Week in São Paulo, which launched the Brazilian modernist movement. Menininha gained national visibility during the rule of Getúlio Vargas in the 1930s and 1940s, consolidated her place as Brazil's most famous Candomblé priestess in the 1950s, and continued to thrive under the military dictatorship. She passed away in 1986, a year after the formal restoration of democratic rule. The fiftieth anniversary of Mãe Menininha's leadership of the Terreiro do Gantois coincided with the carnival of 1972, when Salvador had become the center of countercultural convergence. Menininha's Candomblé temple in Gantois became a fashionable place to visit for the throngs of young tourists who came to the city.

For her semicentennial celebration in 1972, Dorival Caymmi composed "Oração de Mãe Menininha" (Oration for Mãe Menininha), which was recorded in 1973 as a duet by Gal Costa and Maria Bethânia. It was released amid a boom in popular songs about the *orixás* by leading Brazilian artists of the time, such as Clara Nunes, João Bosco, Martinho da Vila, and Jorge Ben. Caymmi's tribute to "this daughter of Oxum" (the *orixá* of fresh water) became a national hit and further enhanced Menininha's fame, especially among Brazilian youth with no prior connection to the religion.[114] Gal Costa, Maria Bethânia, Gilberto Gil, and Caetano Veloso all began visiting Menininha around the time of the recording and eventually completed ritual obligations to the *orixás* under her care. Gilberto Gil has noted that she belonged to a long tradition of eminent priestesses going back to the nineteenth century, but she held the unique status of being the "first pop priestess" of Candomblé.[115] Later in the decade, she would appear in print and televised advertisements to both sell products and promote state government publicity campaigns.[116]

The counterculture-Candomblé nexus was dramatized with greatest impact when Bethânia, Costa, Gil, and Veloso reunited in 1976 as the Doces Bárbaros (Sweet Barbarians) for a national tour.[117] The tour yielded a double

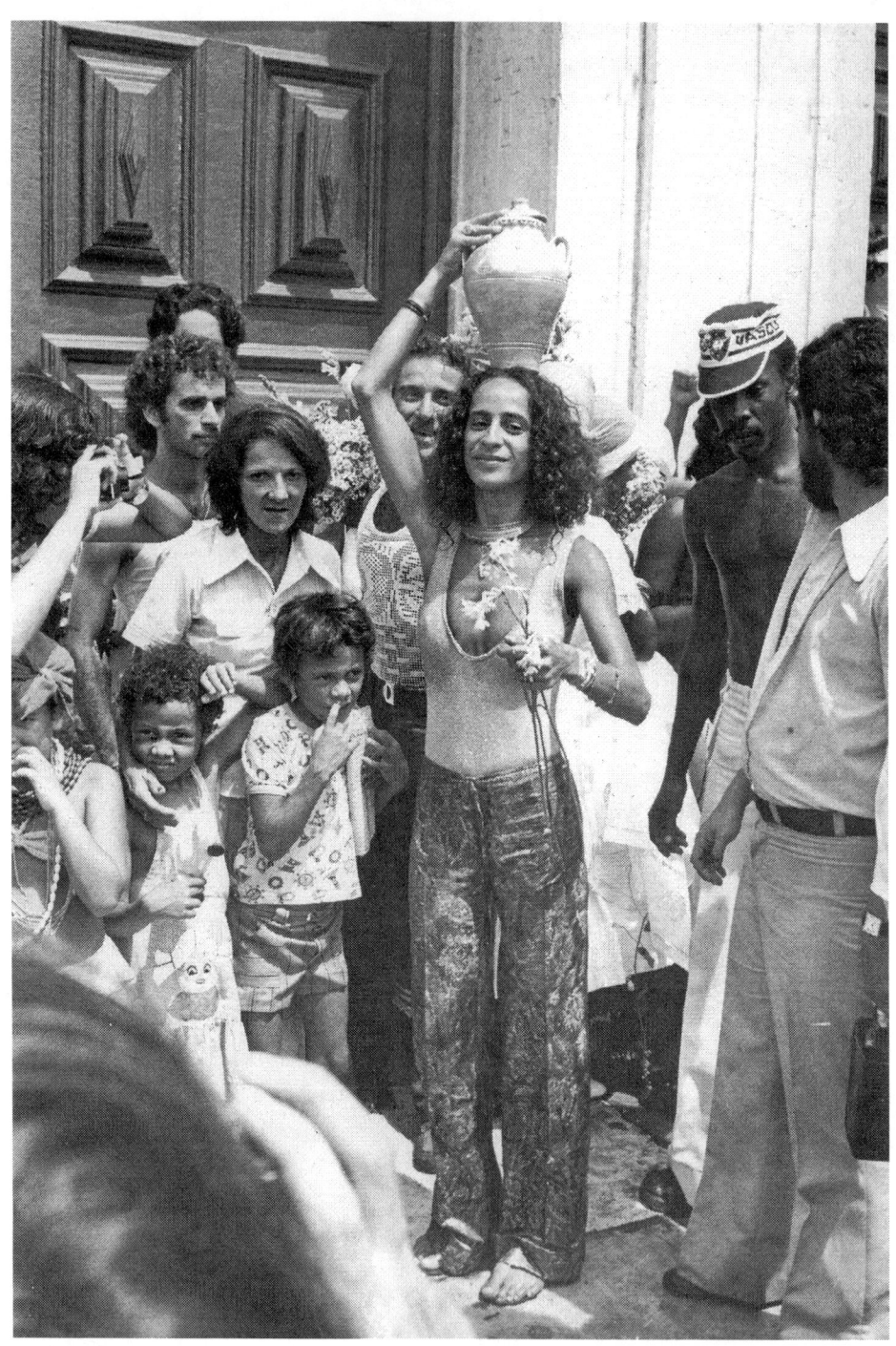

Maria Bethânia at the Lavagem de Bonfim, early 1970s. Agência A *Tarde*.

live album and a feature-length documentary by Jom Tob Azulay, which was released in 1978.[118] By that time, the military regime, now under Ernesto Geisel, had initiated a gradual political opening, known as *distenção*, yet continued to violently suppress critics. The group conveyed a message of freedom with a hint of defiance directed at the regime, as in Veloso's composition "O seu amor," which parodied the Médici-era slogan "Brasil: ame-o ou deixe-o" (Brazil: love it or leave it) by supplanting patriotic obedience with personal devotion to authentic sentiment: "Your love / love it and leave it / free to love."

The name Doces Bárbaros was richly allusive and suggestive. The term *bárbaro* in Brazilian Portuguese had accrued meaning as a term of approval to call something wonderful and exciting. It brought to mind key references from Brazilian modernism, most notably Oswald de Andrade's exaltation of popular expressive culture as *bárbaro e nosso* (barbarian and ours) in his "Manifesto da Poesia Pau-Brasil" (1924). Since the Tropicália era, Veloso and Gil were familiar with Oswald de Andrade's reference to the *bárbaro tecnizado* in the "Manifesto Antropófago" (1928). The "technicized barbarian" was for Andrade an ideal type of Brazilian who maintains "primitive" cultural practices and cosmologies, while making use of modern technologies. In similar fashion, the Doces Bárbaros sought to convey the dynamic tension between tradition and modernity in Bahian culture.[119] The name also appropriated ironically a pejorative term created by Rio-based journalists affiliated with *O Pasquim*, who had ridiculed the *grupo baiano* as an invading horde of *baiunos* (that is, Bahian Huns).[120] The epithet drew on negative stereotypes about Bahian and, more generally, northeastern migrants to São Paulo, Rio, and other center-south cities. Finally, the name inevitably evoked the throngs of hippies that invaded cities throughout Brazil. The association between hippies and barbarians had been a standard trope since the late 1960s, as evidenced in the epigraph to this chapter. We might recall the characterization of hippies who went to Bahia as "joyful invaders" in the *Veja* article from 1972. Veloso has stated that the Doces Bárbaros took inspiration from the Novos Baianos, the music group most identified with the hippie movement in Brazil.[121]

The group's affinity with the hippie counterculture was not lost on police agents, who kept the group under surveillance when they arrived for a concert in Florianópolis. On the morning of the group's first concert there, detectives raided their hotel rooms and found small amounts of marijuana with the belongings of Gilberto Gil and the group's drummer, Chiquinho Azevedo. Sensationalizing headlines from a local newspaper, featured in

Azulay's film, announced Gil's arrest and also revealed that Gal and Bethânia had been found in possession of *pó de pemba*, a natural chalk powder used to adorn the bodies of Candomblé initiates. Readers in Florianópolis, a predominantly white city with little connection to Candomblé, might have imagined that this substance, which is readily available in any shop for religious goods in Salvador, was an illicit drug akin to cocaine. Although erroneous and prejudiced, the mention of *pó de pemba* in this context reinforced the association between Candomblé and the counterculture during the Doces Bárbaros tour.

Azulay's documentary started off as a concert film about the reunion of the *grupo baiano* after they had all established successful solo careers but evolved into a larger story about youth culture, drug consumption, and repression under military rule. Gil's arrest for marijuana possession provided a unique opportunity for Azulay to explore the conflict between the counterculture and the authoritarian state in Brazil. Footage of his trial shows Gil in a powder blue cardigan with floral accents and a shocking pink beret, which he removes to reveal braids tied together with small white ribbons. In contrast, the dour officials are dressed as typical "squares" in ill-fitting brown and gray polyester suits. The bald and bespectacled prosecutor, Eloi Gonçalves, adopted the strident language of authoritarian moralism, as discussed in Chapter 1, which regarded marijuana consumption as a grave threat to the youth of Brazil. He urged the judge to separate the famous artist from a common citizen "who had been caught with the evil herb [*herva maldita*] which causes so much unhappiness in thousands of Brazilian homes." Gonçalves continued: "It wasn't the artist Gilberto Gil, but rather, the criminal Gilberto Moreira Passos Gil, who instead of disseminating his brilliant music, propagated, perhaps unconsciously, the use of drugs that today are so combated." The prosecutor recommended a stiff sentence to "serve as an example to the youth" who idolized Gil. Adopting the language of public health, Gil's defense attorney argued that drug use was a universal problem that should be combated through treatment. Gil was not a criminal but rather an addict who needed detoxification and psychotherapy: "He is not an outlaw [*marginal*], but rather someone with physical and psychological dependencies." The second approach, which was ultimately adopted by the judge, was much preferable, but it also flew in the face of Gil's own statements to the press, which extolled the mental, physical, and spiritual health benefits of marijuana.

In one unintentionally humorous scene, the presiding judge dictates his findings to a court reporter who pecks away noisily at a mechanical type-

Doces Bárbaros in concert, 1976. Acervo CPDoc JB.

writer. The judge begins by referring to Gil's statements to the media soon after his arrest, in which the artist openly declared that "he liked marijuana and its use didn't harm him or lead him to harm others." Gil further declared that "marijuana use helped him sensorially with mystic introspection." The slow bureaucratic task of dictating, typing, stopping to make corrections, and adding punctuation further dramatized the yawning gap between official Brazil and the liberated, mystical disposition of Gil. Throughout the session, Gil sat impassively in front of the judge, with an inquisitive, slightly amused expression, occasionally staring at Azulay's camera to suppress a smile. He must have known that it would make a brilliant addition to the film, especially as the court scene was followed by a separate interview with Gil in which he talked extensively about personal responsibility, respect for privacy, and global changes in how societies were dealing with the ques-

The Sweetest Barbarians 141

tion of drug use. Gil and Azevedo were sent for treatment at a psychiatric hospital but were soon released, and the tour resumed. The incident drew more publicity to the tour and provided Gil with a national media platform to defend marijuana consumption, extol its benefits, and call for its decriminalization.[122]

The Doces Bárbaros presented themselves as cultural mediators who would represent and "translate" Bahian culture, especially Candomblé, to a predominantly white, middle-class audience. The show featured several songs about orixá mythology, including "São João/Xangô Menino," a celebration of religious syncretism that casts Xangô, the deity of thunder and fire, as the divine eminence that presides over the annual winter festivals for St. John throughout Brazil's northeast, especially in the rural areas. The group wore outfits created by a designer from Arembepe that fused hippie sartorial styles with the colors and symbols of specific orixás.[123] The opening theme song of the show, "Os mais doces bárbaros" (The sweetest barbarians), likened their traveling performance to a barbarian invasion bringing a message of love and joy, expressed in terms of both countercultural revelry and the redemptive spiritual power of Candomblé. The invaders arrive "with love in their hearts," bearing "the sword of Ogum, the blessing of Olorum, and the lightening flash of Yansã." The song also makes an oblique reference to the context of repression and resistance in the line "those who are not fools know well / fish in an aquarium swim," implying that even those who are confined must act. Life is in constant motion, regardless of constraints.[124] In a barrage of disparate references, the refrain combines hippie lingo with references to Afro-Bahian culture, space travel, nature, and carnival processions: "Good vibes, groovy plans, lovely songs / afoxés, spaceships, birds, and parades."[125] The refrain synthesizes in telegraphic fashion the central ideas of the Doces Bárbaros project, which revolved around themes of mobility, tradition, renewal, and gleeful defiance. The Doces Bárbaros also made innovative use of the 12/8 tempo polyrhythms of orixá sacred music in "As Ayabás," a song composed by Veloso in homage to female orixás—Yansã, Obá, Euá, and Oxum. Candomblé rhythms had been recorded since the 1930s and performed in staged folklore shows but had rarely been performed during Brazilian popular music concerts. All four performers took turns singing praise songs in Portuguese, backed only by the traditional drums, or atabaques, used in Candomblé festivals. Bethânia's performance was particularly dramatic as she simulated the act of spirit possession, thrusting her shoulders back and throwing her head back while shouting a salutation to Yansã.

Interviews with the artists in Azulay's documentary further reinforced their identification with Candomblé, which was at the time beginning to attract new followers, including former practitioners of Umbanda, a more syncretic religion that had emerged earlier in the century among lower-middle class, predominantly white urban sectors of Rio and São Paulo. In a long interview with Bethânia, shot in front of her dressing room mirror, Azulay asks her if she practices Umbanda. In response, Bethânia looks up, stares directly into the mirror, disavows any affiliation with Umbanda, and proclaims, "I am ketu," a common designation for nagô Candomblé houses in Bahia, owing to their historic connections to Kétou, a Yoruba-speaking kingdom located in present-day Benin. She further affirms her devotion to Mãe Menininha, whose framed portrait rests in front of her mirror. The exchange was significant in the way it indicated the growing prestige of Candomblé houses regarded as more "purely African" and the concomitant decline in the prestige of Umbanda among the urban middle class.[126] In the concert performances, recordings, and film, the Doces Bárbaros articulated a vision of Candomblé that highlighted its fidelity to West African tradition while also presenting it as a modern alternative spiritual and cultural practice.

The Brazilian counterculture played a key role in the process of consolidating the modern idea of baianidade as it reinforced ideas about Bahia as a place of cultural alterity, freedom, and leisure during the most repressive phase of military rule. Although local authorities harassed and arrested hippies, people with positions of influence within the tourist industry, such as the editors and writers of Viver Bahia, perceived a benefit in encouraging alternative tourism for its symbolic value in promoting the image of Bahia as an exotic place of adventure for middle-class youth. Many alternative tourists of the early 1970s would become conventional travelers with money to spend in the decades to come. The countercultural fascination with Bahia would be absorbed into the ever-evolving discourse of baianidade that promoted the region as a welcoming space of cultural difference. Baianidade is neither a product of underdevelopment and cultural isolation nor a mere invention of cynical elites. It is instead a modern discourse of regional identity and auto-exaltation forged by political elites, cultural brokers, Candomblé dignitaries, and artists, especially musicians.

The connection between the Brazilian counterculture and Candomblé was fraught with ambiguities. There was no particular affinity between hippies and practitioners of Candomblé, a religion based on hierarchy, discipline, and reverence for elders, qualities not typically associated with

countercultural youth. Candomblé and other manifestations of Afro-Bahian culture created an attractive atmosphere for youth in search of new experiences with cultures perceived as non-Western, much in the same way, as the previously cited *Veja* article noted, an Orientalist vogue for India grew among European youth of the time. In some cases, this attraction was sincere and committed, and Candomblé expanded significantly, together with Asian religions and adaptations of Amazonian shamanism like Santo Daime, among middle-class Brazilians of the center-south cities in the 1970s.[127]

Conservative critics disparaged this fascination for non-Western religion. Antonio Carlos Pacheco e Silva's denunciation of the hippie movement (discussed in Chapter 1) included a passage in which he lamented that young Brazilians "seek out charlatans, deceivers, healers, and others of the lowest class, practitioners of medicinal magic, in a regression to barbarian primitivism of African and indigenous savage tribes in order to enhance the sensationalism of their exhibitions and presentations."[128] Pro-regime reactionaries were not, however, alone in lamenting this turn to non-Western spiritual practices. Some left-wing intellectuals devoted to a materialist view of history regarded this turn as a symptom of political and social alienation. The sociologist Luciano Martins, for example, complained that middle-class youth increasingly sought "irrational or magical solutions" to their problems and "increasingly appeal[ed] to macumba."[129]

The Doces Bárbaros synthesized the confluence of symbols and discourses that aligned Candomblé with the counterculture under the sign of baianidade. In retrospect, their national tour and recordings might also be understood as a liminal experience, marking the end of a cultural period. As greater opportunities for civil society activism became available to young Brazilians during *distenção*, the hippie counterculture waned. In the late 1970s, new social and political movements began to challenge the regime, including a modern black movement that advocated race-based activism and contested the idea that Brazil was a "racial democracy." In Bahia, an emergent cultural phenomenon, described as a process of "re-Africanization," challenged the dominant paradigm based on mixture and hybridity.[130] Afro-Bahian carnival groups, or *blocos afro*, used music and performance to promote black pride and denounce racial inequality. Meanwhile, prominent Candomblé leaders, most notably Mãe Stella of Ilê Axé Opô Afonjá, a sister temple to Menininha's Gantois, affirmed the Africanness of their religion and disavowed the syncretic alignment of *orixás* and Catholic saints.[131] The *grupo baiano*, especially Gil and Veloso, championed affirmations of black

identity and incorporated these ideas into their own musical projects in the late 1970s and beyond.[132]

The period of the early 1970s was a watershed in the modern history of baianidade, when state and local governments invested heavily in the tourist economy. These efforts coincided in sometimes surprising ways with a youth counterculture seeking alternatives, whether ephemeral or lasting, to life under authoritarian rule in modern industrial cities. Even as local authorities harassed these visitors, state officials promoted an image of Bahia that was aligned with countercultural ideas of personal liberation. The countercultural fascination with Bahia would in turn have a decisive and lasting impact on the region's reputation and visibility as an alluring destination.

4 ⇒ Black Rio

> Why must blacks have to be the last stronghold of nationality and Brazilian musical purity? Could it be a reaction against the fact that they are leaving the slums? Against inevitable competition in the labor market?
> —DOM FILÓ, *Veja*, November 1976

In an analysis of Afro-Brazilian university students in Rio de Janeiro, historian J. Michael Turner described a profound transformation that he witnessed over a period of five years in the early 1970s. When he began his research in 1971, he found that these students, who were either part of the black middle class or aspired to join it, identified with "white cultural norms" and generally avoided cultural manifestations regarded as "black" or "African," which they associated with poverty.[1] They considered markers of black pride, such as afro hairstyles, dashikis, and head wraps, to be unattractive and even demeaning. These students also subscribed to the idea that their country was largely free of racism, despite the fact that it was rare for nonwhites to enter the university.[2]

Unlike their counterparts in the United States and South Africa, who had established segregationist regimes, Brazilian elites had since the early twentieth century endorsed racial and cultural mixing among the lower classes of society with the idea that the population would "whiten" over time. Starting in the 1930s, elite intellectuals, most famously Gilberto Freyre, celebrated Brazil's identity as a *mestiço* nation that was becoming, if not necessarily whiter, at least browner. By the time the generals took power in the 1960s, Freyre was promoting the idea that Brazil was a racial democracy.[3]

While some of the students that Turner interviewed questioned whether Brazil was a racial democracy, most argued that incidents of prejudice and discrimination were motivated by class, not race. With a "certain nationalistic pride," students compared Brazil favorably to the United States, with its history of racial violence and segregation. African Americans like

Turner were, in his words, "treated as survivors of a war."[4] These opinions reflected the dominant view of race relations in Brazil, promoted by prominent opinion makers as well as by the military government. Indeed, the idea that Brazil was a "racial democracy" had become a quasi-official state ideology. The *Doutrina Básica*, or "basic doctrine," published by the Escola Superior de Guerra, the national war college, directly referenced the work of Freyre in highlighting the "fusion of races" and the "abolition of class and race differences" in Brazilian society.[5] Left-wing activists and intellectuals were more likely to acknowledge racial inequality but tended to believe that the solution was a class-based social revolution that would unite exploited workers of all colors and ethnicities. The few academics and activists who took a critical view of race relations in Brazil were censored, persecuted, and sometimes driven into exile. Abdias do Nascimento, the most prominent Afro-Brazilian activist of the twentieth century, spent the better part of the dictatorship in the United States and Nigeria, which provided him opportunities to denounce what he called the "myth of racial democracy" to international audiences.[6]

For most Brazilian opinion makers, the civil rights and black power movements of the United States did not raise questions about Brazil's own history of racial inequality and violence. Instead, these movements seemed to reinforce the idea that Brazil provided a salutary counterpoint to racial strife in the United States. One small but illustrative example is from *O Pasquim*, which, as we have seen, regularly lampooned the regime but also used humor to reinforce dominant cultural values. In 1972, its New York correspondent, Paulo Francis, sent in a photo of Angela Davis, the African American activist and scholar who had been arrested and jailed for her alleged involvement in a courtroom shooting. Under the heading "The Difference," Francis quipped: "And to think that in Brazil Angela Davis would be Miss Renascença."[7] A social club for Rio's Afro-Brazilian middle class, Clube Renascença was at the time best known for its annual beauty contest, or *concurso de miss*. These contests invariably favored light-skinned women—the so-called *mulatas*. After Davis was released from jail, *O Pasquim* reprised the joke, now featuring a photo of a smiling Angela Davis under a thought bubble: "Now that I am free, I'm going to compete in the Miss Renascença contest."[8] Although it was a piece of light humor, taking up a small corner of print, it conveyed in concise terms how many Brazilian intellectuals engaged in racial comparisons. If Angela Davis were Brazilian, Francis implied, she would not be a persecuted black militant; she would be a *mulata* beauty queen at a petit bourgeois social club in Rio's north zone. The idea that a black

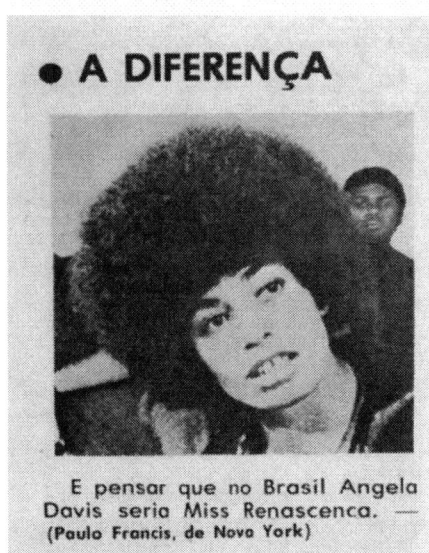

Commentary on Angela Davis by Paulo Francis, in O *Pasquim* 132 (January 11–17, 1972) and 154 (June 13–19, 1972).

movement could emerge in Brazil was simply unthinkable for most opinion makers. The few activists who had attempted intermittently to mobilize Afro-Brazilians along racial lines were frustrated by weak group identification and a complex array of personal identities based largely on color and phenotype. Dark-skinned *pretos* and light-skinned *mulatos* or *morenos* tended not to see themselves in the same "racial" group. There was a widespread belief that *mulatos* were better situated than *negros* in Brazilian society, what Carl Degler has called the "mulatto escape hatch."[9] Subsequent empirical research showed, however, that *pardos*, the official census term for mixed-race "brown" people, fared no better than dark-skinned *negros* in terms of education and employment.[10]

When Turner returned in 1976, he noted a dramatic transformation of attitudes, beliefs, and modes of self-representation among Afro-Brazilian students, including those who were lighter skinned. He observed men and women with afro hairstyles, "hennaed red and of large circumference," even as the hairstyle had started to wane in popularity in the United States.[11] They

talked about "black consciousness," denounced racial democracy as an insidious ideology, and identified with the liberation struggles of black people around the world. The black power movement, with its emphasis on racial solidarity, psychological liberation, and cultural nationalism, provided a particularly potent set of narratives and symbols.[12] The independence of Lusophone African countries in 1975, after a protracted liberation struggle against Portuguese colonial rule, was also inspiring to Afro-Brazilian students.[13] The Brazilian military regime became, somewhat surprisingly, the first Western government to recognize the new Marxist government of Angola, which paved the way for political, commercial, and educational exchanges.[14]

These students viewed cherished symbols of national culture with skepticism and embraced the diasporic aesthetics of the Black Atlantic, which Paul Gilroy famously characterized as "a counterculture of modernity."[15] This chapter explores how the diasporic turn among Afro-Brazilians related to counterculture more narrowly defined in relation to social dissent and artistic production during the dictatorship. Soul music, which had been part of the Brazilian soundscape since the late 1960s, had become the focal point for a mass cultural movement among Afro-Brazilian youth, who gathered on weekends across Rio's working-class north zone to dance to records by the likes of James Brown, Isaac Hayes, Marvin Gaye, and the Jackson Five. Soul culture quickly spread to other major cities with sizable Afro-Brazilian populations, such as São Paulo, Belo Horizonte, Salvador, and Porto Alegre. At a time when it was nearly impossible to organize a black political movement, young Afro-Brazilians turned to cultural expression to forge new collective identities.

The importation of soul music and style was not unique to urban Brazil. In the 1960s and 1970s, soul music attracted urban black youth with cosmopolitan sensibilities throughout Africa and the African Diaspora. In recalling his own experience in post-independence Mali, Manthia Diawara has described the impact of African American music for his cohort of youth in Bamako who forged secular and cosmopolitan identities that were at odds with a postcolonial socialist state opposed to American influence, on one hand, and traditional Islamic authorities opposed more broadly to contemporary Western culture, on the other.[16] These *bamakoise* youth had "embraced rock and roll as a liberation movement, adopted the consumer habits of an international youth culture, and developed a rebellious attitude towards all forms of established authority." He noted the special significance of James Brown as a symbol of "freedom and existential subjectivity

that linked independence to the universal youth movement of the 1960s."[17] Malian youth who embraced the dress and hairstyles of African Americans were accused of neocolonialism, and some were even sent to reeducation camps.[18] Diawara writes: "We wore shirts decorated with peace signs and flowers; we smoked marijuana [kampe]; we supported black power, the Black Panthers, and the Black Muslims in America; we were against the war in Vietnam and apartheid in South Africa."[19]

In 1976, Rio's north zone soul music scene gained heightened visibility and notoriety due to a series of press reports, starting with a long article by Lena Frias for the *Jornal do Brasil*. Written as an exposé, Frias described a hidden "parallel city" with "its own culture," which she called "Black Rio." By using the English word *black*, Frias sought to highlight the movement's debt to soul music, black power rhetoric, and expressions of racial affirmation commonly associated with African Americans in the post–civil rights era. Simultaneously fascinated and alarmed, Frias emphasized the radical alterity of Black Rio in relation to the rest of the city, especially the middle- and upper-class neighborhoods of the south zone, as well as to symbols of national culture, such as samba music: "The *blacks* know everything about soul, historical details, record release dates, North American groups and singers, to the extent that they are ignorant of Brazilian culture."[20]

As suggested by the article's subtitle—"The (imported) pride of being black in Brazil"—Frias regarded the movement and the attitudes it inspired as foreign and inauthentic. Subsequent journalistic reports about Black Rio focused on the commodification of soul music. The black youth who attended *bailes soul* and consumed these products were generally represented as tools of the culture industry, dominated by foreign interests. Writing for *Manchete*, Tarlis Batista commented that "the adherence to musical formulas produced in assembly line abroad doesn't suggest much beyond mere conformism of simple people who are unprepared to resist the bombardment of fads from the media."[21] It was an argument that recalls what Robert Stam and Ella Shohat have suggestively called "hypodermic needle cultural theories, whereby the culture industry 'injects' passive consumers."[22] Music critic Roberto Moura stridently denounced soul music as an "insidious, neocolonialist publicity campaign that aims to create subjects who will consume the excess of what is produced abroad."[23] For Moura, soul enthusiasts were devoid of agency and thought in their obedient consumption of products. Even Afro-Brazilian intellectuals joined the chorus of critics who belittled the Black Rio phenomenon. Lélia Gonzalez, a university professor and black leader, argued that Black Rio was simply another product of mass culture

that was devoid political significance: "We are subject to strong pressure from the American promotional machine that imposes soul music."[24]

The dismissal of Black Rio is remarkably similar to ways in which leftist critics regarded the hippie counterculture of the early 1970s, which they regarded as alienated, politically inconsequential, and beholden to cultural products and styles from the United States. We have seen, for example, how Luciano Martins disparaged the counterculture as a symptom of political malaise and disillusionment provoked by authoritarian rule. The counterculture was, for him, a mere "assortment of idiosyncratic behaviors" passing as "recipes for personal liberation." In a word, the counterculture was an expression of "alienation" among youth living under authoritarian rule.[25]

The Brazilian counterculture, like similar movements elsewhere in Latin America, the United States, and Europe, has mostly been studied in relation to predominantly white middle-class youth. Indeed, the majority of Brazilian youth who participated in the counterculture, especially during its peak in the early 1970s, were from the urban middle class. In Rio, the urban spaces most identified with the counterculture—Ipanema, Jardim Botânico, and Santa Teresa—were middle- and upper-class neighborhoods. I would like to propose that we understand Black Rio and associated manifestations of soul culture in urban Brazil as a black counterculture that emerged in the mid-1970s as the hippie counterculture was in decline. The Black Rio scene, with its emphasis on personal subjectivity, corporeal expression, and the consumption of styles and products from the United States, had much in common with the counterculture of the Brazilian middle class. In both cases, a combination of motivating factors was in play. On one hand, there was disillusionment with the Left's revolutionary project and profound dissatisfaction with life under authoritarian rule. On the other hand, both movements were linked to the growth of the middle class, the expansion of the Brazilian university system, and the development of consumer markets oriented toward youth leisure and style. In the case of Black Rio, the additional pressures of racial discrimination and prejudice were decisive factors in inspiring young Afro-Brazilians to embrace the symbols and discourses of black pride.

≈ The Early History of Soul in Brazil

Lena Frias's sensationalistic characterization of Black Rio as a "secret" or "parallel" city largely ignored a longer history of soul music in Brazil, which was neither secret nor alien to middle-class residents of the south zone.

The Black Rio scene emerged from two parallel developments in the production and consumption of Brazilian popular music beginning in the 1960s. The first involved Brazilian musicians who performed original songs in Portuguese that were inspired by African American R&B and soul music. These musicians reached a wide, multiracial audience through recordings, radio, televised music programs, and festival performances. The second revolved around weekly dances, or *bailes*, featuring recorded music from the United States played on turntables and amplified by production teams known as *equipes*. Airline employees and friends who traveled to the United States were often enlisted to bring back the latest releases.[26] It was a sound-system culture similar to the kind that gave rise to reggae in Jamaica and hip-hop in the United States. Soul culture largely revolved around the *bailes*, which favored recorded music from the United States over Brazilian live performers.[27]

Brazilian soul was one chapter in a long history of musical dialogue between Brazil and the United States. Given the economic, political, and cultural power of the United States, this encounter was uneven, as Brazilians were much more likely to appropriate musical styles than the reverse.[28] One notable exception was bossa nova, which combined the rhythmic elements of samba with jazz harmonies and well-wrought lyrics of recognized poetic value. Rio's bossa nova scene was predominantly white but also included several black artists, such as guitarist Bola Sete and vocalist Agostinho dos Santos, both of whom performed at the famous 1962 bossa nova showcase at Carnegie Hall in New York. Some samba-jazz artists connected to the bossa nova scene experimented with the blues scale as a mode of improvisation.[29] When R&B and soul music were making early incursions in Brazil, the United States was experiencing a bossa nova vogue, which would have a lasting impact on jazz music. At that time, R&B and soul were received in Brazil as part of a larger rock 'n' roll scene among urban working- and middle-class youth. For Brazilians, the "Americanness" of these musical genres initially had more salience than their "blackness."

Tim Maia, Brazil's most celebrated soul singer, began his career as a performer of rock 'n' roll, known in Brazil as *iê-iê-iê*. In the late 1950s, he formed a band with Roberto Carlos and Erasmo Carlos, two white crooners from his lower-middle-class neighborhood of Tijuca on Rio's near north side. The group performed on *Clube do Rock*, a televised music showcase hosted by Carlos Imperial, who introduced Roberto Carlos as the "Brazilian Elvis Presley" and Tim Maia as the "Brazilian Little Richard."[30] With the emergence of bossa nova in the late 1950s, the trio of north zone rockers attempted to learn the new style, which demanded considerable technical ability as well

as a cultural sensibility associated with university-educated youth from the south zone. Lacking in both, these young northsiders failed to break into the bossa nova scene and retreated to the iê-iê-iê circuit.[31]

In the 1960s, Maia's former bandmates would go on to become leading teen idols of the Jovem Guarda, a cohort of Brazilian rockers. The iê-iê-iê of the Jovem Guarda was heavily indebted to a romantic song tradition going back to colonial-era modinhas and evidenced little connection to the genre's origins in postwar African American popular music.[32] A chubby mulato, Maia had little opportunity to succeed in iê-iê-iê, which privileged telegenic white heartthrobs. He left for the United States, settling in Tarrytown, New York, where he lived between 1959 and 1963. Maia joined a racially integrated doo-wop quartet, The Ideals, and began experimenting with fusions of bossa nova and R&B. The group recorded a demo with Milton Banana, a leading Brazilian drummer, who had come to New York in 1962 for the concert at Carnegie Hall.[33] Maia might have settled permanently in the United States, like several Brazilian musicians of his generation, had he not been jailed for marijuana possession in Daytona Beach, Florida, and eventually sent back to Brazil.

Tim Maia struggled for several years in a pop music scene divided between MPB (Música Popular Brasileira), an eclectic, post–bossa nova category defined primarily by its association with the national song tradition, and Brazilian iê-iê-iê, which attracted legions of young fans but was also disparaged by artists and intellectuals as imported, inauthentic, and politically alienated. With the tropicalist insurgency of 1967–68, these divisions were largely overcome, as rock, soul, and other pop genres were incorporated into the field of Brazilian popular music. Roberto Carlos invited Maia on to his wildly popular television show, Jovem Guarda, but his experiments with soul music had little appeal for the teen fans of iê-iê-iê.[34] Ironically, Maia's first big break was a duet with Elis Regina, who had been an ardent defender of MPB and a fierce critic of rock in the mid-1960s.[35] Their recording of Maia's bilingual ballad "These Are the Songs," which featured his rich baritone vibrato, led to a record contract and a successful string of albums in the early 1970s that essentially invented a Brazilian language for soul music.

Maia's first national hit, "Padre Cícero," was composed for a TV Globo soap opera, Irmãos Coragem (Brothers courage), set in the northeastern backlands. Mixing soul vocal stylings with elements of forró, a northeastern dance music, Maia's song memorialized a renegade priest known for his healing powers who gained thousands of followers in the early twentieth century. As McCann quips, Maia portrayed Padre Cícero as "soul brother

Tim Maia, 1972. Photo by Antonio Guerreiro. Courtesy of the National Archive, Rio de Janeiro.

number one—a poor man from the harsh backlands who became a hero to his people."[36] Yet Maia never made reference to the themes of black pride or racial protest that were common in soul music. His songs mostly dealt with romantic love, betrayal, and reconciliation or his epicurean pleasures, as in "Eu quero chocolate" (I want chocolate), a popular jingle originally commissioned by the Brazilian Association for Cacao Producers.[37]

In the meantime, other black performers who experimented with rock, soul, and R&B gained visibility through televised music showcases and festivals. In the late 1960s, Wilson Simonal attracted a mass audience with a style of soul-inflected samba involving a flashy dance style known as *sambalanço*, or samba-swing. He was known as the king of *pilhantragem*, a word that suggests a raffish, devil-may-care attitude. Simonal was one of the first Brazilians to reference black struggles for civil rights in "Tributo a Martin Luther King" (1967), cowritten with bossa nova artist Ronaldo Bôscoli. The song was ostensibly about the African American civil rights leader, but the lyrics make no direct reference to King. Instead, it features exhortations to black people in general to join the struggle against racism: "For every black man there is another one coming / to fight with blood or not / with a song you can also fight, brother." With explicit references to racial strife, violent struggle, and cultural protest, the song is remarkably strident for its time and place. It was initially barred by censors but eventually approved, probably because it could be read as a protest against racism in the United States without any implications for Brazil. Furthermore, Simonal had cultivated a public persona as a jovial black entertainer, who steered clear of political protest.[38] In 1971, allegations surfaced that Simonal had enlisted two DOPS agents to kidnap and extort money from his former accountant, and his reputation as a regime collaborator destroyed his career.

Jorge Ben (who later changed his surname to Benjor) created a sui generis fusion of samba, blues, and R&B with songs about everyday life in the working-class favelas and suburbs of Rio. In the late 1960s, Ben had been an inspiration to the tropicalists, who admired his ability to traverse the divisions between MPB and rock with his soulful pop sambas that appealed across social classes. In 1969, he began working with the Trio Mocotó, a São Paulo–based session band that helped him to developed his signature "samba-rock" sound, which was heavily influenced by soul music. In songs like "Charles Anjo 45" and "Take It Easy My Brother, Charles," Ben celebrated black urban outlaws who were persecuted by the police but embraced by their communities in the favelas. His love song "Crioula," from 1969, sang praises for "a beautiful black lady," described as a "faithful representative of

Brazil," at a time when musical paeans to feminine beauty generally praised white or brown (morena, mulata) women. These songs prefigured Jorge Ben's more explicit statements of black pride in the early 1970s in songs such as "Negro é Lindo" (1971), a plea for respect and recognition: "Black is beautiful / black is love / black is friend / black is child of God."

Jorge Ben later composed songs that celebrated two mythologized figures of Afro-Brazilian history. His song of resistance and redemption, "Zumbi" (1974), pays tribute to the famous leader of Palmares, a runaway slave community, or quilombo, that survived for the better part of the seventeenth century in northeast Brazil. After describing a slave auction and scenes of forced labor on plantations of sugar, coffee, and cotton under the watchful eyes of white masters, Ben heralds the arrival of the quilombo leader: "I want to see when Zumbi arrives." The name of Zumbi is invoked in the present tense as if to suggest his relevance and symbolic importance for contemporary Afro-Brazilians: "Zumbi is the master of war / he makes demands / when he arrives / he's in charge." In 1976, Ben scored a massive hit with "Xica da Silva," a rousing soul samba commissioned by Carlos Diegues to be the theme song for an eponymously titled film about a female slave in colonial-era Minas Gerais who gained her freedom and amassed considerable wealth as the wife of a Portuguese diamond contractor.[39] The film and the song appealed to Brazilian audiences because they reinforced cherished ideas about the power of sexuality, and specifically interracial sex, to overcome social barriers.[40]

The Brazilian soul phenomenon gained national attention in 1970 at the Fifth International Festival of Song (FIC), televised by TV Globo, from Maracanãzinho Stadium in Rio. FIC was an international song competition that rivaled a similar televised festival for Brazilian popular music only, sponsored by the TV Record in São Paulo. In the late 1960s, FIC was a prestigious showcase for some of Brazil's most acclaimed artists, such as Tom Jobim and Chico Buarque, who won first prize for their song "Sabiá" in 1968. The 1970 festival was a breakthrough event for a group of Brazilian soul musicians, suggesting that the style had gained visibility and acceptance among Rio's cultural elite. A postfestival report heralded the arrival of soul music in Brazil, calling it the "cry of lament and protest of American blacks," implying that it was another imported style with origins in foreign social struggles that Brazilians could appreciate from a neutral distance.[41]

Dressed in long, colorful tunics and sporting afro hairstyles, the jazz pianist Dom Salvador and his group performed the song "Abolição 1860–1980," for which they received fifth place. Dom Salvador's instrumental group would subsequently record the album Som, Sangue, e Raça (1971), a milestone

in Brazilian instrumental music that combined elements of samba, soul, and jazz with arrangements that brought to mind Miles Davis's jazz fusion experiments of the same period.[42] Erlon Chaves and his band, Veneno, performed Jorge Ben's song "Eu também quero mocotó" (I also want mocotó). *Mocotó* is a traditional Brazilian dish made of cow hooves and other discarded parts. As urban slang, it referred to the exposed thighs of young women who wore miniskirts. Chaves was later arrested and jailed for his provocative dance routine, which featured two blond women who lavished him with kisses.[43] Following the festival, the song's title circulated as a slogan of irreverence toward established authority. In November, *O Pasquim* featured a reproduction of Pedro Américo's painting *Independência ou Morte* (1888), which depicts the moment that Dom Pedro I declared Brazilian independence in 1822. In the *O Pasquim* spoof, an exclamation bubble appears over the head of Pedro I as he brandishes his sword and exclaims, "I want mocotó!!" A general was so outraged with the parody of this national symbol that he ordered the arrest of *O Pasquim*'s editor, together with leading writers and cartoonists, which brought an end to the paper's early "Dionysian period." Elena Shtromberg has noted the irony of this incident given that Dom Pedro I was the first to establish freedom of the press in 1821, a fact that was not lost on the military government, which later issued a decree prohibiting any mention of the original abolition of censorship.[44]

The biggest sensation of the festival was Toni Tornado, a young black singer who, like Tim Maia, had spent time in New York in the 1960s. With few employment opportunities, he survived by working in the illegal drug trade and, like Maia, was eventually arrested and deported back to Brazil. He was able to find work in Rio at a local nightclub, where he met two white composers, Antonio Adolfo and Tibério Gaspar, who recruited him to perform at FIC in 1970. Their song "BR-3" refers to a stretch of highway connecting Rio de Janeiro to Belo Horizonte, which suggested a subtle analogy between the hazardous road, strewn with fatalities, and the violence of authoritarian rule. Adolfo and Gaspar had sought out Tornado for his soul style, which was in vogue at the festival that year.[45] For fans of James Brown, Curtis Mayfield, and Marvin Gaye, there is little in "BR-3" that would be recognizable as soul music. Tornado described "BR-3" as a "soul waltz," a designation that suggests the song's distance from the genre's origins in African American R&B and gospel.[46] The impact of Tornado's performance, televised around the country, and its identification as soul music were based largely on his bold affirmation of black power style. He wore a large afro, a canary yellow shirt left open to reveal a large radiant sun design painted on

his bare chest, and matching pants tucked into knee-high boots. Tornado's performance earned him first prize at the festival and a recording contract. He was personally congratulated by the president, General Emílio Médici, but he also attracted the attention of the secret police, which accused him of trying to start a chapter of the Black Panther Party and harassed him for his relationship to Arlete Salles, a white actress.[47]

The following year, at the FIC 1971, Tornado performed with Elis Regina, the superstar who had launched the career of Tim Maia. They sang in duet "Black Is Beautiful," a curious ballad featured on her album Ela, released that same year. It was written by Marcos and Paulo Sérgio Valle, fair-haired brothers from Rio's south zone who were best known for pop renditions of bossa nova, not for songs of political protest or social critique. The lyrics were in Portuguese, except for the refrain, which references the well-known slogan of black pride in the United States. Narrated from a white woman's perspective, the song's protagonist expresses disgust with all of the "horrible white men" she sees and brashly asserts: "I want a man of color / a black god from the Congo or from here / who will mix with my European blood." The song is anomalous in describing white female desire for a black man, a reversal of a significant strand of Brazilian popular songs about the sexual desire of white men for black- and brown-skinned women.[48] The song resignified the slogan "Black Is Beautiful," with its particular history in the civil rights–era United States, as a way to affirm Brazilian-style *mestiçagem*. While the song was transgressive in portraying white female desire for a black partner, it also endorsed the Brazilian national discourse that proposed mixture as a solution to racial tensions. In the early 1970s, Elis Regina frequently performed "Black Is Beautiful," which audiences often requested during her shows. With Tornado, however, the innocuous paean to interracial sex suddenly seemed menacing, especially as he performed the song with his fists clenched in a black power salute, a gesture that infuriated the authorities in attendance. As soon as he left the stage in Maracanãzinho, police agents handcuffed him and brought him in for interrogation.[49] Tornado would be hauled in on nine occasions for questioning by DOPS agents during this period.[50]

Luiz Carlos Maciel related another incident from the festival that suggests that the authorities were particularly concerned about the public gestures and verbal expressions related to black power. In an effort to make FIC more attractive to fans of international rock, its organizers invited the Latin rock group Santana to perform in 1971. Ever since their famous performance of "Soul Sacrifice" at the Woodstock festival in August 1969, Santana had been

a top draw for music festivals around the world. As the band took the stage in Rio, a group of forty policemen surrounded the band's leader, Carlos Santana, and one agent warned him: "We don't care about the hippie movement [*desbunde*]. We just don't want you to raise your arms to make signs that you shouldn't," as he clenched his fist to make the sign of black power.[51]

There is also some evidence that the regime attempted to censor references to black consciousness and racism in popular music in the early 1970s. The vast majority of censored songs, now collected in the National Archives, were banned for openly criticizing or satirizing the regime, but some were prohibited for violating traditional social conventions and racial etiquette. One such song, titled "Integração Racial" (Racial integration), by obscure artists Aldo and Paulo Roberto, protested: "I'm a black man of color / I have blood and love / but everyone is trying to destroy us." The song was summarily proscribed for violating a regulation that forbade any mention of racial discrimination.[52] Yet other songs that made reference to racial discrimination were approved, such as Toni Tornado's "Sou Negro" (I'm black), featured on his first album (1970): "You always treat me with disdain / I know that I'm black / but nobody will laugh at me." Jorge Ben's anthem of black resistance, "Zumbi," was never subjected to scrutiny, while his "Menina-mulher de pele preta" (Black-skinned girl-woman), an innocuous love song, sparked an internal debate among censors, some of whom appear to have been troubled by the song's explicit reference to skin color.[53]

In the United States, soul music had profound social and political implications for African Americans, especially after the assassination of Martin Luther King Jr. in 1968 and the rise of the black power movement. In this context, soul music took up themes of racial pride, self-reliance, and solidarity with international black struggles.[54] In contrast, soul music was largely disconnected from notions of black identity, pride, and empowerment when it first began to circulate in Brazil. It was just another international pop style that could be consumed as a passing fad. Some commentators associated soul with the African American civil rights struggles ("the cry of lament and protest of American blacks") but did not consider its implications for the Brazilian context. Regime censors and secret police, however, appeared to have been acutely aware of how soul music related to a larger movement of racial protest and black empowerment. Although mild expressions of black pride were acceptable, defiant gestures of black power were considered off-limits by the regime.

☙ Bailes Soul and the Rise of Black Rio

The emergence of Brazilian soul coincided with a parallel movement around *bailes* that featured imported dance music from the United States, especially rock, R&B, and soul hits. The earliest *bailes* date to the late 1960s, coinciding with the tropicalist movement and the ascension of hard-line forces in the military regime, marked by heavy government censorship and a dramatic increase in cultural imports, especially in the realm of popular music.[55] The earliest soul dances were held in Rio's north zone but were initially restricted to small gatherings. A white radio DJ in Rio de Janeiro, Newton Duarte, known as "Big Boy," was an early promoter of soul music on the Rádio Mundial AM station. Big Boy's programs were famously heterogeneous, featuring a mix of rock, including styles like heavy metal and psychedelic, and "black" music like soul and R&B. In the late 1960s, he began to produce a weekly dance party and later teamed up with Ademir Lemos, a white DJ who sported an afro hairstyle, to create the Baile da Pesada (Heavy Dance), a weekly event at the Canecão, a fashionable south zone club.[56] By the early 1970s, when Tim Maia and Toni Tornado were scoring hits as soul singers, the Baile da Pesada was attracting blacks and whites from all over the city.

After losing their weekly slot at Canecão, Ademir Lemos and Big Boy moved the Baile da Pesada to the north zone, where dozens of large venues, including samba schools, could accommodate them. With the move to the north zone, they lost most of their white, middle-class clientele but picked up increasing numbers of Afro-Brazilian working-class youth. In the early 1970s, they lost their monopoly on soul dances with the formation of new *equipes* with names like Soul Grand Prix, Soul Power, Dynamic Soul, Cash Box, and Boot Power, which suggest the cosmopolitan affinities and aspirations of these groups and the cultural scene they served. As rock music, both national and imported, strayed from its origins as dance music and became more oriented toward contemplative listening, the DJs began to exclusively play soul music expressly for dancing.[57] These emergent *equipes* were generally owned and operated by young Afro-Brazilian entrepreneurs, who recognized in the *bailes* a lucrative entertainment market.

An early entrepreneur in the north zone soul scene was Dom Filó (Asfilófio de Oliveira Filho), a middle-class Afro-Brazilian with a university degree in engineering. An enterprising young man with cosmopolitan tastes, he earned money while pursuing his studies by buying and reselling Lee blue jeans and Lancaster cologne.[58] In 1972, Filó joined the board of the Clube Renascença, the social club for middle-class Afro-Brazilians that figured

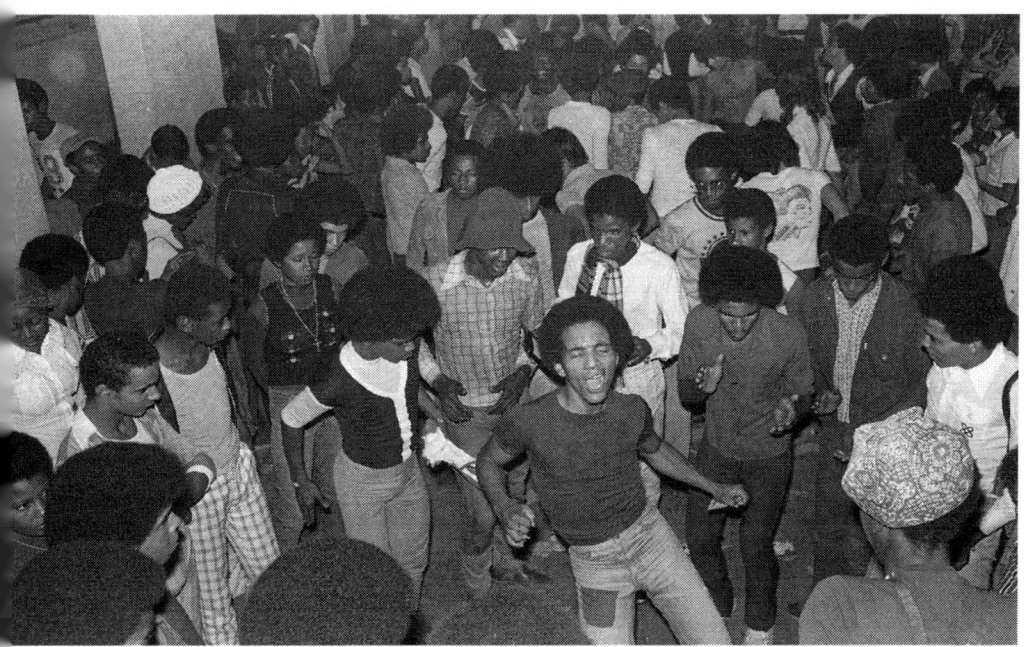

Baile soul, Rio de Janeiro, 1976. Almir Veiga/Acervo CPDoc JB.

into the Angela Davis joke in *O Pasquim* cited at the beginning of this chapter. Founded in 1951, Renascença provided a welcoming social space for Afro-Brazilians who had been excluded from predominantly white clubs in Rio. According to its statute, the club was to "promote and stimulate unity and the spirit of solidarity among members and their families without any prejudices."[59] The club's beauty contests launched the careers of aspiring models and actresses such as Aizita Nascimento, Dirce Machado, and Vera Lúcia Couto dos Santos. These contests reinforced the core social values of the club, which sought to exalt the beauty of black and *mulata* women while promoting conventional ideas about femininity and gender roles.

Sonia Maria Giacomini has divided the history of the Clube Renascença into three phases. During the first phase in the 1950s, the club was restricted to middle-class families and emphasized monogamous and endogamous relations between Afro-Brazilian men and women. In the 1960s, with the increasing popularity of the beauty contest, the club began to attract white, middle-class men. According to some members interviewed by Giacomini, many of these men attended the Saturday evening samba dances in order to pursue affairs with unaccompanied black and *mulata* women. During this time, roughly from the mid-1960s to the early 1970s, Renascença was known

as the *clube das mulatas*. The club's identity shifted from its traditional emphasis on the black middle-class family toward an identity that promoted racial integration under the sign of "Brazilianness."[60] During a third phase, which Giacomini calls "Black Is Beautiful," leaders sought to restore racial endogamy but rejected the class exclusivity of the early phase.[61] The insurgents, like Dom Filó, who transformed the club in the mid-1970s, embraced the diasporic aesthetics and politics of soul music and pivoted away from cherished symbols of Brazilian national culture, especially samba. During this phase, the figure of the young, sexualized, well-dressed black man replaced the *mulata* as the emblematic figure of Renascença.[62] The assertion of black masculinity, a central feature of black power movements in the United States, became a dominant value in the Brazilian soul scene.

In 1974, Dom Filó and his associates launched a weekly *baile* called the Noite do Shaft, or Shaft Night, a reference to the 1971 blaxploitation film by Gordon Parks, featuring a sound track by Isaac Hayes. Fearless and virile New York detective John Shaft projected an image of black masculine power and confidence that Filó and his associates admired. The Noite do Shaft was modeled after the *bailes* of Mister Funk Santos, a north zone DJ who played soul exclusively. With support from the local office of the Brazil-Germany Cultural Institute, Filó began an aggressive outreach program to youth from the surrounding favelas. In marked contrast to the organizers of Renascença's samba dances, the producers of the weekly soul dance were committed to making their event accessible to working-class blacks.

The Noite do Shaft also attracted emergent groups of black activists and intellectuals who sought opportunities to reach out and have an impact on Afro-Brazilian youth. At that time, there were two principal groups in Rio de Janeiro: Sociedade pelo Intercâmbio Brasil e África (Society for the Brazil and Africa Exchange, or SINBA), which was inspired by African liberation movements and advocated social revolution, and the Instituto de Pesquisa das Culturas Negras (Institute for the Research of Black Cultures, or IPCN), which identified more with the African American civil rights struggle for advancement within a capitalist system. The members of SINBA and IPCN were known, respectively, as *africanistas* and *americanistas*, although there was some overlap between the two groups in spite of their differences.[63] SINBA criticized the IPCN for trying to emulate the black elite of the United States instead of connecting the black struggle with larger revolutionary goals. Their heroes were revolutionary leaders such as Samora Machel and Eduardo Mondlane of Mozambique, Agostinho Neto of Angola, and Amilcar Cabral of Guinea-Bissau. SINBA's Africanist orientation, however, did not

prevent its members from attending *bailes* and defending soul culture in the press.⁶⁴

IPCN activists were inspired less by revolutionary movements in Africa than by African American culture and politics. One of its founders, Carlos Alberto Medeiros, has recalled that his discovery in late 1969 of *Ebony* magazine, available at some of the newsstands in Rio's commercial center, was a turning point in the development of his own racial consciousness. He began using an afro hairstyle and tried to persuade others to follow by showing them photos from *Ebony* when he went out on weekends.⁶⁵ In 1974, Medeiros met Filó and soon began working with him to use the Noite do Shaft as a platform to promote black consciousness. They were part of a much longer lineage, dating back to the late nineteenth century, of Afro-Brazilian intellectuals who found inspiration in black struggles for civil rights in the United States. IPCN members would meet on Saturday afternoons to debate texts and again on Sundays to dance and socialize at the Clube Renascença.⁶⁶ Around the same time, Medeiros and Filó met Jimmy Lee, an African American basketball player who had come to pursue a career in Brazil. Lee would later arrange for the Inter-American Foundation to purchase a building in downtown Rio to house the IPCN.⁶⁷ They came to regard soul music as a force for mobilizing Afro-Brazilian youth at a time when samba, especially the *samba-enredos* of carnival, tended to reproduce the discourse of racial democracy. Medeiros has recalled that while soul fans were singing along to James Brown's "I'm Black and I'm Proud," one of the leading samba schools, Salgueiro, recorded a song, "Batuque no Morro Velho" (1974), that romanticized slavery and began with the chorus "Oh, oh, oh, how I long for massuh's plantation."⁶⁸ His characterization of samba as conciliatory and submissive was not entirely fair, as young sambistas such as Martinho da Vila, Leci Brandão, and Nei Lopes, as well as older musicians such as Candeia, sought to reclaim samba as an expression of black identity. It did, however, capture the dominant ethos of carnival sambas, which had since the 1930s generally reinforced the discourse of cultural nationalism and racial democracy.

The Noite do Shaft evolved into a weekly multimedia event combining sound, image, and corporeal movement that rivaled the expressive audacity of the countercultural "happenings" and participatory art experiments of the time. It was famous for its slide shows, which projected images of international black celebrities interspersed with close-up shots of people who frequented the dance.⁶⁹ Although different in intent, these multimedia shows from Noite do Shaft recall the experimental "super-sensorial"

environments featuring slide projections and musical sound tracks created by Hélio Oiticica and Neville D'Almeida in the early 1970s. The event's producers also projected selected scenes from Shaft, Black Caesar, Super Fly, Claudine, and, most important, Wattstax, a documentary about a black music festival at the Los Angeles Coliseum in 1972 that featured speeches and performances by leading African American leaders and celebrities.[70] In one scene, often cited by Brazilian soul enthusiasts as particularly moving, Jesse Jackson exhorted the audience to recite with him "I Am—Somebody," a civil rights poem written in the 1950s by the Reverend William H. Borders. Lena Frias noted the film's significance for Black Rio, "a city whose inhabitants call themselves *black* or *brown*, whose hymn is a song by James Brown . . . whose bible is Wattstax . . . whose slogan is *I am somebody*, whose model is the American black."[71] In July 1976, the IPCN held a screening of Wattstax at the Museu de Arte Moderna in downtown Rio, an event that brought hundreds of working-class black soul enthusiasts to a predominantly white, middle-class space.[72]

With the success of Noite do Shaft, Dom Filó and his associates created Soul Grand Prix, a successful *equipe* that produced *bailes* in social clubs, samba schools, and private venues throughout the city. In 1976, André Midani, then president of WEA (later constituted as the Warner Music Group), invited Soul Grand Prix to compile a set from their dance parties, the first in a string of successful records.[73] For the second Soul Grand Prix compilation, Dom Filó invited a group of local musicians to record an instrumental track under the direction of saxophonist Oberdan Magalhães, a veteran of Dom Salvador's group, Abolição. With the success of this track on Rio's dance floors, Magalhães went on to form Banda Black Rio, Brazil's most celebrated soul band, which forged an innovative sound that combined elements of samba and soul. In 1978, the group performed and recorded with Caetano Veloso, whose musical project the Bicho Baile Show was inspired by the Black Rio scene.

By the mid-1970s, the soul music and dance scene in Rio was largely perceived as the exclusive domain of black, working-class youth, despite its early history in the predominantly white rock 'n' roll movement. In her 1976 exposé of Black Rio, Lena Frias was emphatic about asserting difference: "Today in metropolitan Rio, soul is synonymous with black, as rock is synonymous with white." Frias and her interlocutors highlighted the differences between the "white" rock scene and the "black" soul scene. They claimed, for example, that soul aficionados largely avoided the consumption of drugs, a stigmatized leisure activity historically associated with poor

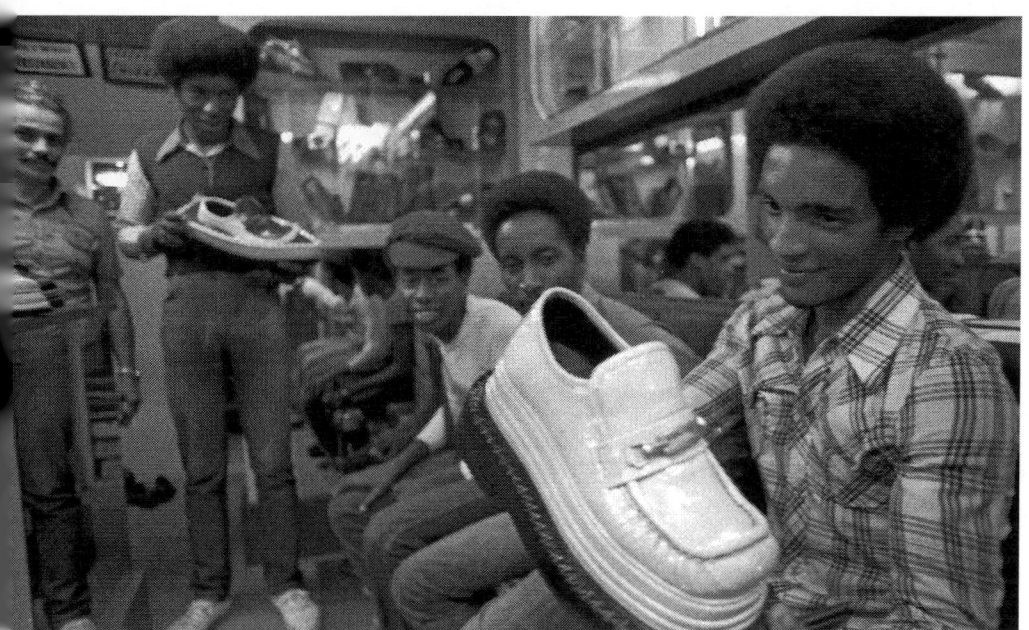

Shoe store in Madureira, Rio de Janeiro, 1976. Almir Veiga/Acervo CPDoc JB.

blacks. The defenders of soul music were eager to portray it as a wholesome and respectable activity, although police reports from the period suggest that marijuana consumption was common at the weekly *bailes*.[74] Frias registered a measure of hostility toward white youth, who were described in her article as *cocotas*, something akin to "playboys." This translated into a rejection of rock culture generally, which one soul enthusiast disparaged as "cocota, white, drogueiro." There were, however, whites who embraced soul and found the Black Rio scene congenial and welcoming. Frias interviewed one working-class white guy who told her "sou *white*, mas sou *black*," using the English words to identify himself as racially *white*, but culturally *black* given his affinity to soul music.

As with the hippie counterculture, the Black Rio scene generated its own repertoire of styles, expressed in clothing, shoes, accessories, and hairstyles. The most visible symbol of allegiance to soul music was the afro, referred to in Brazil as "estilo *black power*." Soul style had a particularly dramatic effect on masculine fashion as men began to wear flamboyant shirts, jackets, hats, and hairstyles similar to those worn by women.[75] The most important fashion item was a pair of platform shoes, or *pisantes*. The Black Rio scene gave rise to a lucrative cottage industry to manufacture custom, made-to-order

shoes using multiple soles, sometimes as many as seven, to create a rise. Frias visited one store in Madureira, a large commercial district in the north zone, which sold on average 500 pairs per week to young soul dancers.[76] In contrast to hippie style, male soul aficionados dressed elegantly with slim, straight-legged trousers, dress shirts, and an assortment of hats, from fedoras to outsized poor-boy caps. Among the unique accoutrements of mid-1970s Black Rio style were handcrafted, full-bent wood pipes and ornately carved canes, giving their users the appearance of debonair men of leisure.

The Black Rio scene provided welcoming spaces for young Afro-Brazilians who were barred and harassed in some parts of the city, especially the south zone. Although Lena Frias was skeptical of Black Rio, she was acutely sensitive to forms of discrimination and harassment suffered by the black youth she interviewed. Throughout her article, she interspersed descriptions of the dances with poignant vignettes about black youth in the public sphere, where they were barred from nightclubs, treated with suspicion at stores, and constantly harassed by the police. One informant told her of a harrowing experience in which police extorted money with the threat of summary execution. She interviewed several young soul enthusiasts for whom the weekly *bailes* provided a comfortable space for social interaction, somewhat akin to "liberated zones" of relative freedom, like Ipanema beach, where hippies congregated. One young woman explained: "At a soul party I feel very happy, free. Not because of the music, but for having a lot of blacks together."[77] Carlos Alberto Medeiros noted that the *bailes* provided important opportunities for young, working-class blacks to congregate in "their space," which was especially important for people often treated as inferiors.[78]

⇒ Policing Black Rio

Although the *bailes soul* provided comfortable spaces for social interaction among black youth, they were not entirely free from police surveillance and harassment. Paulina Alberto uncovered a rich trove of memos, newspaper clippings, and official directives produced by the Departamento Geral de Investigações Especiais, a political intelligence unit, which reveal that the secret police infiltrated soul dances, interrogated organizers, and followed media coverage, all in an effort to assess the movement's threat to national security. Police agents feared that Black Rio would promote racial discord and undermine the regime's efforts to maintain social order and project an image of harmony and tranquility in Brazil.[79] Early secret police reports on soul dances combined alarmist rhetoric with elements of paranoid fan-

tasy. One report from February 1975, filed under the title "Black Power," reported that "a group of black youth with higher than average intelligence" was coming together to "create in Brazil a climate of racial struggle between whites and blacks." The report detailed the goals of this shadowy group, which included "kidnapping the children of white industrialists," "creating a neighborhood only for blacks," and "fomenting aversion between whites and blacks."[80] A follow-up secret investigation of a soul dance at the Portela Samba School reported difficulties in determining the identities of the event's organizers because they belonged to a "closed circle" and were known only by "code names," as if they belonged to a clandestine guerrilla cell.

The secret police regularly infiltrated soul dances, wrote up long reports that carefully documented the use of black power rhetoric and symbols at these events, and occasionally interrogated *equipe* producers as suspected agitators. Frias's exposé on Black Rio in the *Jornal do Brasil* spurred the secret police to take more aggressive action in interrogating producers and participants.[81] Dom Filó and his cousin were arrested by regime agents on suspicion that they were allied with clandestine leftist organizations, a dubious charge given that armed groups had been wiped out by the regime by the time they had started producing soul dances.[82] One report worried that the *bailes* could serve as incubators for a black political movement, which was indeed the hope of some black intellectuals like Medeiros and his colleagues of the IPCN. This agent, steeped in the discourse of racial democracy, fretted that the soul movement would introduce racism where none existed: "Could the exclusive appeal of the music and the uniformity in clothing and shoes styles lead to the formation of a political group oriented toward racial prejudice?" The agent went on to praise Gilberto Freyre, an ardent supporter of the military regime, for showing that "there was always harmony among Brazilians, regardless of race and religion."[83]

Even some of the key figures of the Brazilian soul movement endorsed this view, at least in their public pronouncements and performances. The singer Gerson King, who modeled his vocal style, dance moves, and stage persona after James Brown, told the *Jornal de Música* that "the *blacks* from here shouldn't idolize the Americans because they have a series of problems that we don't have, especially racism that even makes it difficult to find work. In fact, the *blacks* only want to have fun and dance, nothing more."[84] He certainly was not the only Brazilian soul singer who sought to avoid offending people. In citing a similar remark by a soul DJ, McCann has observed that the rhetoric of racial democracy maintained power among many soul enthusiasts even as they embraced black pride. In the context of authoritar-

ian rule, these kinds of public statements are ambiguous: they can be read as an attempt to conceal black militancy from repressive authorities or as a sincere affirmation of a national ideal.[85] Gerson King's signature song, "Mandamentos black" (Black commandments), made explicit his view of Brazilian soul as a leisure activity: "Take charge of your mind, brother / and come to the powerful conclusion that *blacks* don't want to offend anybody, brother / what we want is to dance!" In "Mandamentos black," there is a tension between, on one hand, his vocal performance modeled after belters like James Brown and his exhortation to unite fellow "brothers" and, on the other, his assurance that soul music did not seek to "offend anybody." It was a far cry from "Say It Loud, I'm Black and I'm Proud," Brown's 1968 anthem of racial pride that inspired and mobilized African Americans during a period of crisis and violence.[86] For activists who regarded soul culture as a catalyst for raising consciousness and organizing a black political movement, "Mandamentos Black" was hardly a rallying cry, given its insistence on fun, as if to say, "There's no trouble here, we're just dancing."

It is important, however, to understand "Mandamentos black" within its context of a time when leading conservative critics were attacking Black Rio. Writing under the pseudonym "Ibrahim De Leve" for *O Globo*, the influential social columnist and television host Ibrahim Sued identified Gerson King and Toni Tornado as leaders of "a group in Brazil's music scene that is trying to launch the '*black power*' movement in Brazil." The goal of the movement, Sued argued, was "to launch racism in this country as it exists in the *States*."[87] In an editorial written for the *Diário de Pernambuco*, the primary architect of racial democracy discourse, Gilberto Freyre, also weighed in on the matter of Black Rio. Freyre's dislike for African American music extended back to the 1920s, when, as a student at Columbia University in New York, he had disparaged jazz as "barbarous" and "horrid."[88] Sounding some of the same alarmist notes as Sued and other conservative critics, Freyre wrote in conspiratorial tones about unnamed "Americans of color" who were coming "to convince Brazilians, also of color, that their African songs and dances should be ones of melancholy and revolt . . . and not, as is today[,] . . . sambas that are almost all happy and fraternal."[89] Freyre went on to charge that these Americans have come to "introduce into a Brazil that is growing fully, fraternally brown [*moreno*] . . . the myth of negritude." He further clarified that this brand of negritude was "not of Senghor's type, of the just valorization of black or African values," but rather it was of the kind designed to foment "civil war." This distinction points to an important dimension of modern Brazilian racial discourse, which celebrated manifestations of black culture

as an essential component of nationality as long as they were "happy and fraternal."

The shrill editorials by Freyre and Sued, two influential opinion makers who had the ear of the military government, suggest the precarious position of soul artists, even when they disavowed racial protest. In fact, both writers insinuated that the authorities should take an active role in monitoring and suppressing the movement, since, in Sued's words, "it could involve matters of national security."[90] The earlier experiences of Erlon Chaves and Toni Tornado, who had been arrested and interrogated by the secret police in the early 1970s after their performances at FIC, served as reminders of the perils of performing gestures of black power. Even Gerson King, who publicly asserted that soul was apolitical, was arrested and interrogated for three hours by the federal police.[91] The nationalist reaction to soul music must also be understood in relation to Brazil's strained relations with the United States in the latter half of the 1970s, when the Carter administration pointedly criticized human rights violations of the military regime and sought to block nuclear technology transfer from West Germany. For conservative critics, soul music was an unwanted intrusion in the cultural realm. When James Brown performed in São Paulo in 1978, he disappointed some of the black activists who went to interview him. The Godfather of Soul himself claimed total ignorance about race relations in Brazil and flatly declared that he would discuss "no politics."[92] With this in mind, Gerson King's message of reconciliation in "Mandamentos black" can be read in Brazilian parlance as *jogo de cintura*, a sly and beguiling move to hide other motives.

The secret police were ultimately swayed by the media reports of left-wing journalists and came to see Black Rio as innocuous entertainment designed to promote consumption.[93] Left-wing nationalists and right-wing agents of the regime converged in their dismissal of Black Rio as impulsive consumption of imported mass culture that revealed profound social and cultural alienation among working-class Afro-Brazilian youth. One police report from 1976, for example, argued that Afro-Brazilians embraced soul due to "atavism," a social-scientific term used to describe a primitive and instinctual return to clan identification.[94] Yet the same report also criticized the local soul culture for imitating Americans, "in part out of emulation, in part out of snobbery, but always aiming to make a profit," an observation that contradicts the charge of "atavism." Far from atavistic, the attitudes and behavior of young black soul enthusiasts in Rio suggest that they were cultivating cosmopolitan and entrepreneurial sensibilities, hardly reducible to ancestral allegiances.

☙ Black Rio and the Politics of Authenticity

The Right and the Left have often converged in their critique of movements that are based on identity politics. While the Right frets about how these movements threaten national unity and security, the Left has often regarded them as narcissistic distractions from the class struggle.[95] A similar dynamic attended the critiques of Black Rio. While conservative observers were concerned that the movement was promoting a black militancy that could have a destabilizing effect on Brazilian society, left-wing observers criticized the movement for its commercialism, its obsession with style, and its apparent disinterest in political mobilization.[96] Music journalist Tarik de Souza dismissed Black Rio as "10 percent soul and 90 percent planned marketing."[97] Tarlis Batista ridiculed soul enthusiasts who, in her words, "barely knew the meaning of the expressions repeated by everyone." She concluded by asking rhetorically: "Could it be alienation?"[98] In invoking "alienation," Batista framed her critique of Black Rio within a familiar left-wing discourse of national liberation.[99] The concept of alienation served nationalist intellectuals in countries free from colonial rule but dominated economically, politically, and culturally by an imperial power in alliance with national elites. In this context, a symptom of alienation would be cultural inauthenticity—the production and consumption of cultural products divorced from "national reality." Brazilian nationalists of the early 1960s, for example, regarded the consumption of pop cultural products from the United States, such as rock 'n' roll, as a sign of alienation and vigorously defended cultural forms understood to be authentically national. After Tropicália, rock music gained acceptance as a global phenomenon of youth culture that could be adapted and Brazilianized. By the 1970s, even the most nationalist and traditionalist critics had accepted the use of the electric guitar and acknowledged rock as part of the Brazilian soundscape.

Dom Filó pointed out the hypocrisy of criticizing blacks for dressing in lively colors, dancing soul, and revering James Brown at a time when it was acceptable for white youth to wear blue jeans, consume rock, and revere Mick Jagger. He denounced the unique burden of representation assigned to blacks as the guardians of "deep" Brazilian culture, as represented by music and dance genres such as samba. Nationalist critics, who were mostly middle- and upper-class whites, expected black people to be faithful defenders of Brazilian tradition. In an article published in *Veja*, he pointedly asked: "Why must blacks from the north zone accept white people from the south zone . . . telling them what is authentic and proper to black Brazilians?"[100]

He further suggested that anxiety around the authenticity of soul was related to black social mobility, as more young Afro-Brazilians left the morro, or hillside slums, to compete against whites in the labor market. In the same article, the powerful music executive André Midani argued a similar point: "When poor blacks have the misfortune of leaving the favela and playing something other than samba, they must confront a white press that accuses them of losing their blackness and tells them that they must go back to playing samba." The rejection of soul, Midani suggested, was tantamount to confining blacks in the favela and denying them access to other cultural and social networks.

White journalists were not, however, the only critics of Black Rio. Leading figures from the world of samba, particularly those who were deeply invested in reclaiming the genre as a vehicle for promoting black identity, also criticized soul music as a betrayal of tradition. The samba composer and singer Candeia was particularly assertive in his defense of Afro-Brazilian tradition. In 1976, he founded the Escola de Samba Quilombo, an alternative samba school founded with the express intention of reclaiming samba culture from the moneyed interests that had gained control of the largest and most successful samba schools. For Candeia, samba was still the most suitable musical form for expressing black identity in Brazil, despite its appropriation by political and cultural elites. His composition "Sou mais samba" (I am more samba) starts with the refrain "I'm not African, nor North American / to the sound of my tambourine / I am more Brazilian samba." Candeia confidently predicted that soul could be vanquished by the powerful force of Afro-Brazilian religion, denoted here as macumba: "To get rid of so-called soul / all we need is a bit of macumba." The following stanza boldly predicted that Black Rio was merely a passing fad and that soon everyone would eventually return to samba: "The blacks today are the sambistas of tomorrow." Dom Filó has claimed that Candeia wrote the song as a marketing ploy to generate media attention and told him that it would benefit both of them.[101]

By 1980, the heyday of Black Rio had passed, but soul culture continued to thrive and gain new adherents. In that year, Nei Lopes, a composer, singer, and organic intellectual of samba, recorded another song denouncing soul. In contrast to Candeia's confident dismissal of soul, Lopes's song, "Goiabada Cascão," was about nostalgia for a culture in decline. Written with Wilson Moreira, the song invoked homemade guava paste containing pieces of the rind and sold in a wooden box (in contrast to industrially produced canned guava paste) as a metaphor for folk tradition. The

gradual disappearance of this folk delicacy was emblematic of other forms of cultural decline and loss. In the first stanza, he lamented the fashion for American-style fast food in Brazilian cities: "Today it's only grilled ham and cheese, only *milkshakes*, all fake food." Lopes posited an analogy between food and music. As artisanal guava paste was disappearing, so was the traditional *partido-alto* style of samba. Just as sandwiches and milkshakes replaced a proper Brazilian-style lunch, soul music, identified as the "*black sound*," was pushing out samba: "*Partido-alto* samba with a knife on a plate and hand claps / you can't find it now, but how it was good! / today it's just disco, only the *black* sound, it's all imitation / there are no more boxes of goiabada cascão." Soul enthusiasts rejected samba for its close association with dominant discourses of Brazilian nationalism and for its status as a tourist attraction, while samba musicians, such as Candeia and Nei Lopes, were wary of soul music as an imported fad that betrayed cultural tradition. Giacomini's informants from the Clube Renascença also indicated that the partisans of samba and soul were deeply divided, and relatively few went to both the *roda de samba* on Saturday and the Noites do Shaft on Sunday.[102]

Yet there is also evidence that soul and samba coexisted. As modern Afro-Diasporic music and dance forms, soul and samba shared expressive affinities. The *Veja* article, for example, sought to make this point in a vignette about a dancer known as "Delegado," who was the *mestre-sala*, or flag bearer, of Mangueira, the venerable samba school of Rio de Janeiro. Found at a soul dance, Delegado explained his talent on the dance floor, declaring that "it's just the same as samba." Indeed, the mutual disdain that had divided partisans of samba and soul in the mid-1970s began to wane by the end of the decade.

≈ Black Rio/Black Politics

By the late 1970s, many of the Afro-Brazilian intellectuals who had rejected soul as an imported fad from the United States had come to appreciate the movement's larger political significance. Lélia Gonzalez, who criticized soul culture in Lena Frias's exposé from 1976, later embraced it as a manifestation of collective identity.[103] Gonzalez was a cultural mediator who circulated in several milieus in Rio de Janeiro, including the university, the black activist circles, the soul scene, and the south zone counterculture. Around the time she embraced soul as a vital manifestation of Afro-Brazilian identity, she began offering open seminars on black culture at the Escola de Artes Visuais (EAV), an art school housed in the Italianate mansion of Parque Lage in the

Jardim Botânico neighborhood (discussed in Chapter 1). In a 1979 interview, she admitted, "I thought that Black Rio was alienated . . . [and that] these blacks just want to imitate American blacks." She later came to understand the movement as a response to "a search for lost identity," as black youth were increasingly alienated from the samba schools.[104] J. Michael Turner has recalled that Lélia Gonzalez came to regard soul music and dance as a vital aspect of her political identity in the late 1970s.[105] Gonzalez recognized the role of soul culture in fomenting black political mobilization, especially as the dances provided activists with a platform to reach out to black youth. Soul was, in her words, "one of the cradles of the black movement in Rio."[106] When a group of black activists from São Paulo and Rio de Janeiro founded the Movimento Negro Unificado in 1978, the soul dances served as recruiting grounds for the organization. Several of the soul *equipes* were signatories to its founding manifesto.[107] Black Rio and similar cultural manifestations in other cities were, as Michael Hanchard notes, harbingers for Afro-Brazilian political mobilization in the waning years of the military dictatorship.[108]

Yet soul culture was also about leisure and style. Even the activists who were most enthusiastic about the political potential of soul were well aware of its limitations. McCann reminds us that for some black youth, attending a soul dance "could be a way to try on a sexy weekend identity of black militancy in a circumscribed environment before returning to the workaday world and its charade of racial democracy."[109] In this regard, the soul enthusiasts from Rio's working-class north zone were not so different from middle-class "situational hippies" (discussed in Chapter 1) whose relationship with the counterculture revolved primarily around consumption and leisure. The arrival of disco music in the late 1970s further diminished the role of black cultural politics at dances.[110]

The Black Rio movement and similar cultural scenes revolving around soul music and dance in other cities bring into focus some of the defining characteristics of the Brazilian counterculture. Black Rio emerged during a time when forms of political mobilization had been severely curtailed by the military regime, which was especially sensitive to forms of racial protest. Like other countercultural movements of the period, the soul movement was more about transgressing social conventions than about political organizing. It was a movement heavily focused on the management of appearance and the display of embodied competencies, especially through dance. Black Rio emerged at a time when opportunities for education and class ascension for young Afro-Brazilians were improving, albeit at a much slower rate than for whites. The soul phenomenon was related to a larger context of rising

expectations among urban Afro-Brazilian youth. Gilberto Gil's homage to Black Rio, "Refavela" (1977), captured this dynamic in describing black youth who "descend from the hills" (that is, leave the favelas) to enjoy the "effervescent ambiance of a scintillating city." Yet as more Afro-Brazilians "descended from the hills" to study at the university and compete in the labor market for professional jobs, they ran up against racial barriers. As a result, more university-educated and middle-class Afro-Brazilians turned to political and cultural organizations that emphasized black identity.[111] In retrospect, the mid-1970s may be understood as a key turning point for young Afro-Brazilians with a degree of social mobility, such as those interviewed by Turner. Authoritarian modernization had created new opportunities for marginalized groups, but also new contexts for racial discrimination and exclusion. As civil society activism reemerged during the second half of the decade, Afro-Brazilians would take a leading role among new social movements seeking to reinvent a post-dictatorial society. And for much of the 1970s, soul music provided the sound track.

5 ⇒ Masculinity Left to Be Desired

> I used to live with the illusion that being a man was enough
> that the masculine world would give me everything I wanted.
> —GILBERTO GIL, "Super-homem, a canção" (1979)

In January 1972, only days after his return from exile in London, Caetano Veloso performed a series of concerts at the Teatro João Caetano in downtown Rio de Janeiro. *Veja* magazine, which dedicated a cover story to Veloso's triumphant return to Brazil, gave special attention to Veloso's sartorial style: "Applauded, exalted, and idolized, the Caetano Veloso of 1972 wore low slung sand-colored pants, an unbuttoned, short cut Lee jacket, leaving his navel exposed."[1] Photos from the concert show him without the jacket, wearing just a frilly halter-top that accentuated his body. With long, curly hair and lithe torso, Veloso dramatized his femininity by imitating the campy, hypersexualized movements and gestures of Carmen Miranda as he sang "O que é que a baiana tem?" (What does the Bahian woman have?), the classic samba by Dorival Caymmi.

Veloso has written that his provocative performance was a "double commentary." On one hand, it commented on the reception of Brazilian culture abroad, with reference to Miranda's experience in Hollywood as well as his own experience of exile in London. On the other, he also conceived of the performance as a uniquely Brazilian contribution to "the cause of sexual liberation."[2] By then Carmen Miranda was an international gay icon, and his performance conveyed a measure of homoeroticism.[3] Veloso's performance reached an apex when he was joined onstage by Gilberto Gil, who had also just returned from exile. Although both men publicly identified as married heterosexual men, they both cultivated to varying degrees images of androgyny and homosexuality. On stage, they exchanged prolonged hugs, kisses on the lips, and other gestures of affection.

There is little evidence that Veloso's performance scandalized the audience; the *Veja* report only made a passing reference to his imitation of

Carmen Miranda and interpreted it as a part of a broader synthesis of Brazilian popular music. Yet secret police files reveal that at least one member of the audience was disturbed by what he saw at the Teatro João Caetano. In a report about the concert, a DOPS agent, Paulo Monteiro, identified Veloso as a member of "a group of left-wing composers connected to a subversive scheme" who had "collaborated in a campaign of defamation against Brazil through his compositions and in interviews with the European press." Monteiro expressed deepest concern with Veloso's purported homosexuality and its challenge to social conventions: "His shows degenerate into a revolt against prevailing customs in society, publicly rejecting codified laws, flaunting among us a liberal attitude toward homosexuality, which is so fashionable in England. In Caetano Veloso's shows, he makes hand gestures and swivels his hips in public leaving to be desired his masculinity. As he performed with Gilberto Gil, he came up and nibbled his neck like a female in search of a male, stopping short of kissing him on the lips. During their presentation at the Teatro João Caetano in Rio de Janeiro, Caetano Veloso received a rose from Gilberto Gil and in return gave him a kiss on the mouth."[4] Monteiro imagined that Veloso developed a "liberal attitude toward homosexuality" while in exile in England, where it was "fashionable" (*em voga*) to be gay. Far from being a disposition or orientation, homosexuality was for the DOPS agent a deviant behavior that was alien to Brazil. Many Brazilians who were exiled to Western Europe and the United States did, in fact, find more tolerant attitudes toward homosexuality, which in turn informed their own ideas about gender and sexuality. Yet, as Veloso observed, Brazilians were inventing their own strategies and attitudes toward sexual liberation that were not dependent on foreign models.

While the regime's aversion to homosexuality and robust assertion of traditional masculinity has been well documented, Monteiro's report provides a rare glimpse into the way agents of the regime associated homosexuality with subversion. In Monteiro's report, Veloso's "liberal attitude toward homosexuality" appears to be related to his involvement in a "subversive scheme." His reaction to Veloso's performance is consistent with what Benjamin Cowan has characterized as "moral-sexual panic" among regime ideologues and their conservative supporters in the Catholic Church and civil society organizations. The rise of what Cowan calls "moralizing anticommunism" or "authoritarian moralism" suggests that the regime and its supporters regarded the expansion of sexual freedoms as a potential threat to the national security state.[5]

Monteiro's remark that Veloso was "leaving to be desired his masculinity" (*deixando a desejar sua masculinidade*) reveals an unintended but suggestive ambiguity. The DOPS agent meant to impugn Veloso's masculinity, implying that it was deficient or inadequate, but he inadvertently suggested that his performance revealed an androgynous masculine body "to be desired" by an adoring audience. Indeed, judging from press reports from that time, Veloso attracted admirers of both sexes, who were captivated by his evident musical and poetic talent but also by his gender-bending performances. The *Veja* article, titled "Caetano no templo de caetanismo" (Caetano in the temple of Caetanism), portrayed Veloso as a kind of demigod, but also as a generational icon who influenced the attitudes, behaviors, and styles of his audience: "Heralded like a god during his entrance, Caetano Veloso left the stage receiving the kind of ovation dedicated not to divinities, but to artists, and above all, to people who are beloved."[6]

In an essay from 1972, Silviano Santiago characterized Veloso as a "superstar," a designation also used on the cover of the *Veja* magazine. According to Santiago, superstars are distinguished from mere stars in their ability to captivate audiences both on and off the stage. For superstars, there is no distinction between a stage performance and everyday life, as they are always a spectacle.[7] Brazilian superstars arguably had a greater impact in this regard than their American and British counterparts, who often led rather cloistered lives. In contrast, artists like Caetano Veloso and Gal Costa appeared frequently in public, most notably on the beach, where they interacted with friends and fans alike with a degree of intimacy that was uncommon elsewhere. During the same period, alternative press outlets such as *O Pasquim* and *Rolling Stone* featured long interviews with Veloso and other artists identified with the counterculture in which they talked about a broad range of topics that had nothing to do with music.[8] As Santiago noted, Veloso and other artists had a significant impact on everyday behavior, not through the articulation of ideas, but rather through behavior, style, and advice on everyday life.[9] That Veloso inspired both adulation and identification among audience members likely contributed to Monteiro's alarm at the concert. His report, albeit of minor significance in the operation of the security state, revealed the particular anxieties and concerns pertaining to gender and sexuality among agents of the regime. In this regard, it provides a good starting point for a final chapter about the Brazilian counterculture and broader transformations in gender roles and sexual mores during the period of authoritarian rule. This chapter will focus on challenges to the

patriarchal authoritarian moralism of the regime, with particular attention to the significance of the counterculture in reimagining masculinity and opening up space for gay rights activism.

⁓ Challenging Authoritarian Patriarchy

In her study on the modern Brazilian feminist movement, Sonia Alvarez has characterized the state as the "ultimate patriarch."[10] The U.S.-backed military regime that came to power in 1964 saw the struggle against communism as part of a larger mission to safeguard Christian civilization, traditional morality, and conventional family values. In this effort, women were enlisted as "natural" defenders of family, morality, and social order. At the same time, the regime presided over a dramatic expansion of the university system, which had a particularly notable impact on women. Female attendance at Brazilian universities increased fivefold between 1969 and 1975, although the system remained highly elitist.[11] Women began to question and challenge the attitudes, values, and practices that sustained a patriarchal order, including "bourgeois marriage," which they regarded as a rigid structure that promoted gender inequality. Valeria Manzano has documented a similar social transformation in Argentina, where a modern discourse of "love and responsibility" allowed for the increasing acceptance of premarital sex within urban middle-class society.[12] The increasing availability of oral contraceptives facilitated a growing challenge to the hypocrisy of traditional sexual mores, which allowed young men to pursue active, uncommitted sexual lives, while middle-class women were expected to remain chaste until marriage. Liberated female sexuality produced anxiety among regime officials and their conservative supporters, for whom, as Victoria Langland has observed, "birth control pills could appear as explosive as Molotov cocktails."[13] By the mid-1970s, second-wave feminist organizations and journals had emerged among middle-class women in the major cities. For the most part, these organizations were rooted in the student movement and tended to be oriented toward a Marxist critique of society.[14] Of all the social movements that emerged during the second half of the dictatorship, the feminist movement was the most active in the wider struggle against the military regime.

The assertion of traditional masculinity and patriarchy was central to the dominant ideology within the regime. Indeed, an attack on military masculinity served as a pretext for the regime to enact the fifth institutional act, following a series of speeches, delivered on the floor of the national

congress, which severely criticized military violence. One left-wing deputy, Marcio Moreira Alves, urged women with intimate connections to military officers to intervene directly in order to curtail authoritarian violence. Proposing the so-called Operation Lysistrata, he called on military wives and girlfriends to withhold affection from "those who revile the Nation."[15] Historians agree that hard-line officers used the speeches as a pretext for removing opposition congressmen, but the episode revealed a broader context of sexual anxiety in which an attack on military masculinity was intolerable. When a subsequent attempt to strip Alves of his parliamentary immunity failed to garner sufficient votes in congress, the regime acted swiftly in declaring AI-5, which suspended congress.[16]

Young women participated in large numbers in the student movement and constituted a significant segment of the armed opposition.[17] At the same time, the figure of the armed *femme fatale* circulated in the Brazilian media. Women who participated in armed operations were described in sensationalistic press reports with monikers like "Bela do terror" (the beauty of terror) and "Loura dos Assaltos" (the blonde of the holdups).[18] Print advertisements pictured gun-toting models in fashionable outfits as they pulled off daring capers. Joaquim Pedro de Andrade's cinematic 1969 adaptation of *Macunaíma*, the modernist classic by Mário de Andrade, represented the mythic indigenous forest goddess, Ci, as an urban guerrilla who slaughters regime agents on the streets of São Paulo. She dies when attempting to set a time bomb at a local bank, while her lover, the lazy Macunaíma, lies around in a hammock at home.

By the late 1960s, assertive, independent, and sexually liberated women were increasingly ubiquitous in popular culture. Unlike the rock countercultures elsewhere in Latin America, the Brazilian scene featured prominent female artists, such as tropicalist icon Gal Costa, the lead singer of Os Mutantes, Rita Lee, and Baby Consuelo of Novos Baianos. Although still dominated by men, Brazilian rock was hardly a "fraternity of long-haired boys," as Valeria Manzano has characterized the milieu of Argentinian rockers.[19] The television and film actress Leila Diniz was particularly notorious for her blunt public statements about her sexual adventures. In a November 1969 interview for *O Pasquim*, she scandalized the public with frank observations and personal opinions, punctuated with abundant profanity (replaced with asterisks to pass censors), about sex. In one segment, she asserted that one "could really love one person and go to bed with another" and added that her belief was based on personal experience.[20] She captured the new ethos of personal liberation, especially for women, in declaring in the same

interview that she had no regrets about things she had done, only about things she had not done due to societal prejudices and personal neuroses. That edition of O Pasquim sold over 117,000 copies, an all-time record for the paper. Cassette copies of the recorded interview, which was considerably longer than the printed version, circulated in Rio's south zone. Brazilians were fascinated with her matter-of-fact declaration of sexual independence in a jovial, almost raffish manner, which contrasted with the more serious tone of organized feminists.[21] Diniz was roundly denounced in the media, with one television host calling her a "prostitute" for her liberal use of profanity and her assertion of sexual freedom.[22] The Médici regime passed a new law in January 1970, popularly known as the "Leila Diniz Decree," which forbade the publication of anything deemed to be "contrary to morals and good customs" and established guidelines for reviewing and censoring material.[23] TV Globo subsequently refused to cast Diniz, allegedly telling her that "there were no roles for whores" in their upcoming telenovelas.[24] While pregnant with her first and only child in 1971, she further scandalized the public by frequenting the beach near the Ipanema Pier (see Chapter 1), wearing only a bikini at a time when pregnant women wore maternity swimwear designed to cover their bellies and hips. Diniz died tragically in a plane crash in 1972 but remained a vivid symbol of sexual liberation and female agency throughout the period of the dictatorship.

The military regime and its conservative supporters associated the sexual liberation of women and the challenge to traditional masculinity with communist subversion. A broad range of civil society organizations, some with international affiliations, actively supported the regime's efforts to defend traditional gender roles and control female sexuality.[25] Some of these moralizing anticommunists, like the ultraconservative journalist Gustavo Corção and Dom Sigaud, the bishop of Diamantina, enjoyed considerable influence in the military government, especially among officers at the Escola Superior de Guerra (ESG), the premier military college in Brazil. As Benjamin Cowan observes, "Young men's 'deviant' sexuality, 'free love,' and countercultural expressions of sexual 'liberation' became, in the discourse of the ESG, pathologized sources and symptoms of Brazil's vulnerability to communist 'penetration' and 'subversive' warfare."[26] These intellectuals were unaware of or chose to ignore the fact that most communist regimes also defended traditional gender roles and suppressed, sometimes violently, homosexuals. ESG intellectuals as well as agents of the security state perceived Brazilian youth to be weak and irrational and therefore vulnerable to subversives who used techniques of "seduction" and "enticement" to attract

followers.[27] Anxiety over the seductive power of sexual liberation and other countercultural practices helps to explain why seemingly innocuous performances, such as Veloso's campy parody of Carmen Miranda, so disturbed agents and supporters of the regime.

Authoritarian moralists also found fervid adherents within the scientific community. Psychiatrist and conservative author Antonio Carlos Pacheco e Silva (discussed in Chapter 1) railed against "the most sordid promiscuity" among the hippies, who "openly promote free love" and "don't accept conjugal or sexual fidelity."[28] For Silva, the sexual promiscuity of the hippies undermined what he called "civilization," by which he meant the values and mores of traditional Christian societies of the West. He argued that "peoples who have achieved the highest degree of civilization and social stability were those who were most concerned about sexual morality, seeking to protect sex from all aberrations by combatting promiscuity and bad habits, by respecting chastity, virginity, modesty, decency, conjugal fidelity, and normal sex."[29] By "normal sex," Silva meant procreative sexual relations between married men and women. Although Silva was most preoccupied with the strict control of female sexuality, he also blamed the sexual revolution for tolerating and even promoting what he saw as deviant sexual behavior: "Even in relation to sexual perversions, such as homosexuality, which was considered degrading and shameful in the past, is today accepted and tolerated by society, which does nothing to combat it as the aberration of nature that it is."[30] It is worth recalling here that Silva was not a marginal right-wing crank; he was an esteemed professor of psychiatry at the University of São Paulo who had served as president of the Brazilian Association of Psychiatry in the late 1960s. For the military regime and its conservative supporters in civil society, female sexual liberation and increasing tolerance for homosexuality represented dangerous social transformations that weakened society and left it vulnerable to political subversion.

⇌ Homosexuality and the Brazilian Left

One might expect these sorts of attitudes from ardent supporters of the regime, but one also finds homophobic or, perhaps more accurately, homoderisive attitudes among the opposition. By "homoderisive," I refer specifically to forms of ridicule and scorn, sometimes imbued with humor, that stigmatized gay people without the moral panic of conservatives. Most members of the clandestine Left considered homosexuality to be degenerate behavior that was not compatible with revolutionary action. James Green

has identified five ideological dispositions shared widely among Brazilian leftists that shaped the discourse of "revolutionary morality" in relation to homosexuality. First, homosexuality was widely regarded in leftist circles as bourgeois behavior that was completely alien to the working classes that militants sought to mobilize. Homosexuality was also pathologized as aberrant behavior, an idea widely shared by leading psychiatrists of the time. A third attitude, informed by the Catholic Church, simply regarded homosexuality as immoral and unnatural. As anti-imperialists, many Brazilian leftists regarded homosexuality as a foreign imposition, much in the way that the DOPS agent denounced Caetano Veloso's putative homosexuality as a fad acquired while living in England. Finally, many leftists rejected homosexuality because it supposedly feminized men and undermined revolutionary masculinity.[31] In many respects, the revolutionary Left and the regime held similar views of homosexuality as immoral, foreign, and enfeebling.

The association between homosexuality and effeminacy is based on hierarchically defined gender categories that assign men an "active" role as penetrators and women a "passive" role as penetrated during sex. The distinction between *atividade* and *passividade*, as Richard Parker has noted, "implies a kind of symbolic domination" within the Brazilian culture of gender.[32] Traditional notions of activity and passivity in sex were transferred to male homosexual encounters in which the "real men," or *bofes*, would penetrate the effeminate men, known as *bichas*. As long as a *bofe* maintained his active role as the one who penetrated his partner, he could safeguard a public identity as a "real" or "straight" man. In contrast, most *bichas* suffered abuse and discrimination at the hands of family members, sexual partners, and the police. What Green calls the "bofe/bicha dyad" structured same-sex erotic encounters among males for most of Brazilian history.[33]

Homophobic and homoderisive attitudes were not limited to armed militants and orthodox communists. Gay men were subject to harassment on a daily basis in environments in which one might expect a high level of acceptance. In a letter from 1970 to Gilberto Gil, then still in London, Hélio Oiticica described an unpleasant experience at a midnight session to see the American road movie *Easy Rider*, a key point of reference for the international counterculture. Oiticica, who refers to himself as a *boneca*, or "doll" (that is, a gay man), in the letter to Gil, was accompanied by musician Jards Macalé, filmmaker Antonio Fontoura, and journalists Nelson Motta and Mônica Silveira: "They invited me the other day to watch a midnight session of *Easy Rider* in Copacabana; very well, when this *boneca* went in to watch the film, with the theater filled [with Macalé, Fontoura, Motta, and Silveira],

the whole house yelled 'bicha, bicha, bicha'; look how tacky and provincial; of course nobody knew who I was, unlike Nelson, for they all went 'Nelsinho' (high voice), 'grab my dick,' etc. I had never seen so much idiocy and besides this everyone laughed at who knows what during the first part of the film."[34] To Oiticica, who had lived for nearly a year in London and would soon depart for New York where he would stay for most of the decade, the homophobia of the audience in Copacabana was a sign of provincialism, which was further reinforced by what seemed to him to be misplaced laughter during the first part of the film.

Homoderisive attitudes were even common among intellectual circles with greater connection to the counterculture. O Pasquim, the satiric paper (discussed in Chapter 1) that took a leading role in lampooning the regime and subverting traditional social conventions, also delighted in poking fun at gays. The editorials, cartoons, and photos often revealed an exuberant chauvinism revolving around, in Green's words, "beach life, beer, and beautiful women."[35] While O Pasquim lampooned moralizing conservatism promoted by the regime and published sympathetic portraits of gay and transgender icons, it also tended to reinforce masculinist ideologies that ridiculed homosexuals, especially those regarded as effeminate bichas.

Already in issue seven from August 1969, O Pasquim had published a cartoon that effectively pathologized homosexuality. Just weeks after the first successful landing on the moon, the journal featured a cartoon by Jaguar showing a group of NASA scientists in lab coats who watch with bewildered expressions as the American astronauts Neil Armstrong and Michael Collins return to Earth hand in hand with the announcement, "We are engaged." Wearing spacesuits with removable codpieces, they have bleary eyes and postcoital grins, as if they had spent the entire mission having sex. Whether intentional or not, the cartoon even reinforced the traditional bicha/bofe dyad in which one partner would perform a "feminine" role and be sexually penetrated, while the other would play an active, "masculine" role. Wearing a triangular codpiece that suggested the contours of a vagina, Armstrong was feminized, while his partner's codpiece outlined the rounded bulge of a penis. The caption reads: "It is not known for certain the consequences of contact between the moon's surface and the human organism."[36] Although expressed as humor, the cartoon was not much different from Silva's "scientific" characterization of homosexuality as "an aberration of nature." In this case, homosexuality was portrayed as a contaminant from outer space that could infect the entire planet.

O Pasquim was also responsible for popularizing the slang word bicha,

which, like its English-language equivalent, "fag," is generally used as a derogatory term. It gained notoriety in July 1970, when the editor in chief, Tarso de Castro, published an ironic attack on Nelson Rodrigues, a famous playwright, novelist, and journalist, who was well known for his moralizing conservatism and his support for the regime. Under the title "Bicha," Castro declared dozens of Brazilian celebrities of both genders, including the entire editorial team of O Pasquim, decorated soccer stars, popular artists, revered poets, long-deceased authors, and famous socialites, to be *bichas*. By the end of the text, Castro declared that all Brazilians together with the entire planet are *bichas*. The text ends with a punch line that ridicules the conservative moralist: "The only *macho* in the world is Nelson Rodrigues."[37] The excessive use of *bicha* to describe just about everyone emptied the term of its meaning. A year later, however, O Pasquim hit the newsstands with the sensationalist headline "TODO PAULISTA É BICHA." In miniscule print between "all paulistas" and "are fags," the qualifier "who don't like women" appears. In this case, the humor was much more ambiguous. As in Castro's article, the use of *bicha* in this context is absurd, but given the paper's notorious Rio-centric parochialism, or *bairrismo*, the derogatory charge of the term maintained its force.[38]

In 1971 the paper featured a sympathetic article about the famous cross-dresser Rogéria, who regarded her stage performances as occasions to affirm her humanity and homosexuality while fighting against discrimination. That same year, O Pasquim published a long interview with Madame Satã, or Madam Satan, an Afro-Brazilian man, then already seventy, who was famous for his street-fighting prowess on the streets of Lapa, Rio's bohemian district, during the 1930s and 1940s. Born João Francisco dos Santos (1900–1976), he came as a young boy from the impoverished backlands of Pernambuco to Rio, where he became a *malandro*, or street rogue, and discovered his preference for sex with other men. He identified as a *bicha*, who enjoyed anal penetration, yet defied the stereotype of feminine passivity by proving himself as a fearless, knife-wielding fighter. He gained notoriety in 1928 when he shot and killed a policeman who had repeatedly insulted him with the epithet *veado*, or "faggot." While the journalists of O Pasquim were generally dismissive of homosexuals, they were fascinated by Madame Satã, given his legendary status as a *malandro* of Lapa.[39]

Broad sectors of the Brazilian Left, from armed revolutionaries to bohemian intellectuals, regarded homosexuality with disdain, if not hostility. While exceptional figures like Rogéria and Madame Satã gained some measure of respect, either as exotic celebrities or as figures of marginality,

most gay and transgender men suffered routine humiliations. By the early 1970s, cultural and ideological transformations led to the formation of new social and political identities that would challenge the sexual hierarchies of patriarchal Brazil.

≈ Gay *Desbunde*

While the military coup of 1964 initially had little impact on gay social life in the major urban centers, the promulgation of AI-5 initiated a period of persecution and intimidation as spaces of gay social life were subject to raids and the leading gay journal, *O Snob*, was forced to shut down.[40] Persecution subsided by 1972 and gay social life flourished, especially in Rio and São Paulo. Regime authorities were disturbed by public displays of same-sex desire but generally ignored the bars, clubs, and other semiprivate spaces of gay sociability. Around this same time, a new ethos and identity emerged among urban middle- and upper-class men who rejected sexual hierarchies proper to the *bicha/bofe* model. These shifts in sexual identity were closely linked to the decline of traditional rural society, rapid urbanization and industrialization, and the rise of an urban, cosmopolitan bourgeoisie.[41]

As Peter Fry has observed, these men, identified as *entendidos* (people who are "in the know" or "understood"), defended an ideology of "equality and symmetry."[42] Many of these men were influenced by the rise of gay rights in the United States, which conceived of homosexuality as a collective social identity and eschewed binary active/passive sexual roles. By the early 1970s, the term circulated in popular culture. The inside cover of Caetano Veloso's album *Araçá Azul* (1972), for example, proclaimed that it was a "disco para entendidos," which underlined the album's experimental quality that appealed to those who "understood" avant-garde music. At the same time, the designation suggested Veloso's affinity with the gay counterculture, which was reinforced by the album cover featuring Ivan Cardoso's beachside photo of the artist reflected in a mirror wearing nothing but a skimpy swimsuit. This shift in middle-class urban conceptions of homosexuality may be understood as an early instance of what Dennis Altman has called the "internationalization of gay identities" based on models developed in the industrialized West.[43] For *entendidos*, sexual identity was based on same-sex desire, not on particular roles played during sexual encounters that were coded as masculine or feminine. Fry recognized the political expediency of a dualist classification system, in which people identified as masculine/feminine or heterosexual/homosexual, yet also wondered "if dualist classification systems are at the

expense of the magic of creativity and whether it's possible to imagine a society that rejects such classifications."[44] Fry anticipated subsequent debates between LGBT activists and scholars, who assert the political value of stabile gay and lesbian identities, and queer theorists, who emphasize fluid and multiple expressions of sexuality that elude unitary definitions.[45]

Writer Caio Fernando Abreu captured this emergent ethos in a short story, "Terça-feira gorda" (Fat Tuesday), published in the collection *Morangos Mofados* (1982). The story tells of two men who meet at a masked ball during the height of carnival revelry and immediately feel mutual sexual attraction. In a first-person voice, the narrator describes this blissful and guileless encounter of two desiring bodies engaged in what Fry might call the "magic of creativity" beyond classifications: "He didn't seem like a *bicha* or anything: only a body that happened to belong to a man who liked another body, mine, that happened to also belong to a man. I held out my open hand and passed it over his face and said something. What? He asked. You are sexy, I said. I was only a body that happened to belong to a man liking another body, his, which happened to also belong to a man." It is not an encounter between a manly *bofe* and an effeminate *bicha*, nor is it even an encounter between two people who necessarily identify as gay men. The narrator experiences this encounter as an erotic exchange between two bodies that just happen to be male. Yet the two lovers of Abreu's story are harassed at the carnival ball, suggesting that this simple attraction between two male bodies offends and threatens others. The two lovers leave the ball and head for the beach, where they consummate their mutual desire under a full moon. This utopian encounter of two desiring bodies, unburdened by social conventions and fixed sexual identities, is interrupted by a group of young men who viciously attack the couple. The narrator flees as his lover gets pummeled in the sand. Abreu's story captures the sublime beauty of desiring bodies beyond categories and classifications, but also shows how these bodies are policed and punished, implying the need for political struggle based on an affirmative "gay" identity.

By the mid-1970s, homosexual activists and intellectuals began to organize discussion groups and advocacy organizations, which preferred the increasingly popular English-language term "gay" over *entendido*, a term that suggested a measure of closeted secrecy.[46] João Silvério Trevisan, who formed a group in São Paulo in 1976, had lived for the previous three years in Berkeley and San Francisco, where he circulated in gay, feminist, leftist, and hippie circles. He was, in his words, "a leftist who was homosexual and believed in the power of marijuana to get in touch with one's inner self."[47]

When he returned to Brazil, his leftist friends thought he had become "Americanized" and criticized his political investments in gay rights, which they regarded as a "lesser struggle."[48] In recounting the failure of an early attempt to organize a gay movement, Trevisan has remembered that would-be activists did not see the point of discussing their own "deviant sexuality" at a time when many leftists regarded homosexuality as a symptom of bourgeois decadence.[49] Gay activists were divided on whether to focus exclusively on gay liberation or to seek tactical alliances with leftists, many of whom had ties to the PCB (Brazilian Communist Party), which historically disparaged homosexuality.[50]

The articulation of group identity based on sexual orientation among urban middle-class gays was further advanced with the launching of monthly publications in 1976–77 such as *Gente Gay*, *Entender*, and *Mundo Gay: O Jornal dos Entendidos*, which featured articles, interviews, short stories, and entertainment information oriented toward a gay male audience. Journalist Celso Cury also signed a weekly column in the São Paulo edition of *Última Hora* that focused on gay social life in São Paulo and Rio as well as international gay movements. Cury became a cause célèbre of Brazil's nascent gay rights movement when the government tried to prosecute him for promoting "encounters among abnormal people," a charge that was eventually dropped.[51] Launched in April 1978, the most successful of these journals, *Lampião da Esquina* (Streetlamp on the corner), was distributed nationally with an initial print run of 10,000. In referring to Lampião, a famous bandit who marauded the rural northeast in the 1920s and 1930s, the journal's title conveyed both defiance and rugged masculinity. The editors made a concerted effort to reach out to other emergent social movements organized by feminists, lesbians, Afro-Brazilians, and environmentalists, as well as to the resurgent labor movement. *Lampião da Esquina* also featured a large section dedicated to letters from readers, which provided a forum to share diverse experiences, perspectives, and critiques.[52] Soon after *Lampião da Esquina* appeared, a group of gay men in São Paulo founded Somos: Grupo de Afirmação Homosexual (We Are: Group of Homosexual Affirmation), Brazil's most prominent gay liberation organization. With the emergence of gay activist organizations throughout the country, the regime attempted to crack down on *Lampião da Esquina*, whose editors were subjected to a police investigation for "offending morality and good customs," a common designation for perceived behavioral transgressions. According to one editor, Antonio Chrysóstomo, the government and conservative civilian groups accused the paper of "inciting homosexuality among people."[53] As we saw with the DOPS agent who wor-

ried about the impact of Caetano Veloso's androgynous performance, the regime and its conservative civilian allies feared that young, impressionable people could be somehow enticed to homosexuality.

João Silvério Trevisan characterized this political and cultural effervescence as the *desbum guei*, or gay *desbunde*, a term that suggests a distinctly gay counterculture that would inform the work of key artists of the period. The links between the youth counterculture and the urban gay scene are most evident in the story of Dzi Croquettes, an all-male performance group founded by Wagner Ribeiro, a leather craftsman who owned a boutique in the bohemian neighborhood of Santa Teresa. In 1972, Ribeiro convened a group of friends at a bar in the Galeria Alaska, a commercial space in downtown Rio then known for gay cruising, to propose the formation of an all-male performance group. Their name referenced *croquete*, the deep-fried nosh usually filled with meat, which is sometimes used as a colloquialism for "penis" in Brazil.[54] Ribeiro recruited Lennie Dale, an exceptionally talented Broadway dancer and singer who had moved to Brazil in 1960 and had worked with some of the leading performers of Brazilian popular music, most notably with Elis Regina. By all accounts, Dale was an exacting taskmaster who brought a high level of expertise and professionalism to the group of younger Brazilian men.

The 2010 documentary *Dzi Croquettes*, directed by Tatina Issa and Raphael Alvarez, reveals a strong affinity between the group and the international counterculture. In its early years, the group lived together in Wagner Ribeiro's house in Santa Teresa. Later, when the group moved to São Paulo, its members maintained a communal lifestyle. One member described the origins of the group: "Eight guys—dancers, painters, musicians—who all were self-marginalized from the traditional theater sought ways to communicate. At some point, we began to pursue an underground life [*curtir uma vida underground*] in its deepest sense."[55] Several members of the group who were interviewed for the documentary remembered Ribeiro's motto "Só o amor constrói" (Only love builds) as a guiding ethos of their community. In a conversation with another member of the group who argued that the regime could only be defeated through armed struggle, Ribeiro argued that change could be realized through art, not arms. Period footage from the mid-1970s shows Wagner Ribeiro greeting an audience at the beginning of a show: "Boa noite para os brasileiros. *Good evening* for those who speak English. *Bon soir* for those who speak or think that they speak French, because there is a difference." Finally, lifting his hand to flash a peace sign, Ribeiro exclaims: "And peace and love to my beloved hippies if there are any here among you."

One segment of their show paid tribute to the Brazilian "underground," which initiated a hilarious, nonsensical exploration of the word's meaning, ending with a literal punch line: "é o metrô" (it's the subway).

Although sometimes described as an avant-garde performance group, Dzi Croquettes attracted a mass audience in Rio and São Paulo and later in Paris. The group developed a show that was heavily indebted to the aesthetics of Brazilian carnival, especially the tradition of cross-dressing, which dates back to the early twentieth century, as well as to the lowbrow cabaret performances typical of the Teatro de Revista in downtown Rio. Dzi Croquettes mixed corporeal and sartorial markers of both femininity and masculinity to mobilize an aesthetics of "gender fucking," which undermined binary gender and sex roles.[56] The men performed in dresses and wore eyeliner, lipstick, mascara, false eyelashes, and glitter, yet also sported hairy legs, beards, sideburns, and moustaches. One of their most famous acts featured the men in miniscule thongs as they danced to a disco version of Strauss's "Sunrise" fanfare to *Also sprach Zarathustra* while simulating the flutter of butterfly wings with silk fabric. In delivering their lines, they alternated between high- and low-pitched voices. Although the group was dressed in drag, the performances of Dzi Croquettes were not coded explicitly as gay or even transsexual. Above all, they aspired to confound and transcend gender categories. In one scene from the documentary, three members of the group try to explain their identity to the audience using both English and Portuguese, which further contributes to the polymorphous character of their performances: "Not ladies, not even gentlemen. Sorry people. We are not men. You got the wrong show, we're not men. We're not women either [Não somos mulheres, também não]. Exactly, if you're looking for a girlie girlie show we're not women either. It's another story. We are people." One of their best-known lines from the opening sequence of their act was "We are not men, nor are we women. We are people computed just like you."[57]

Rosemary Lobert, who lived for an extended period with the group, has observed that its members rejected identification with gay rights, insisting instead on gender and sex ambiguity. In one interview given to the *Folha de São Paulo*, they declared: "The Dzi Croquettes are not representatives of gay power, nor of the androgynes, nor of men, nor of women, nor of whites, nor of blacks, but of all of them. Either we represent all or we represent nothing."[58] Nevertheless, Dzi Croquettes gave impetus to an emergent gay movement by subverting traditional gender categories that rigidly defined femininity and masculinity. Through camp humor and extravagant gender-bending performances, Dzi Croquettes initiated important discussions

about sexual liberation among a wide audience at a time when the regime and its conservative allies sought to reinforce traditional ideas about gender and sexuality.

Around the time that Dzi Croquettes emerged, a musical group with a similar approach to gendered performance formed under the name Secos & Molhados. The band was formed in São Paulo by guitarist and composer João Ricardo, who recruited an additional guitarist, Gerson Conrad. Together they provided backing vocals to Ney Matogrosso, a lead vocalist with an extraordinary countertenor voice often mistaken for that of a female singer. Matogrosso was inspired by Caetano Veloso, whose gender-bending performance he had seen in 1972. The son of a military officer, Matogrosso had a contentious relationship with his father, who expected him to either pursue a military career or choose a conventional profession. Instead, Matogrosso left home as a teen, embraced the hippie movement, and pursued an itinerant lifestyle, settling first in Santa Teresa, the same neighborhood in Rio where Dzi Croquettes formed. In his words, "I think that 1970 marked the final step in breaking with everything. It was my *desbunde*."[59] For the next several years, he made a living as so many other hippies did by selling handcrafted jewelry and leather accessories on the street. In recalling his life from this period, Matogrosso touched on common themes in hippie life narratives: "I didn't want to participate in society and consciously marginalized myself. I opted to be marginal; it wasn't due to life circumstances. I decided to live my own truth and this made me extremely happy. I didn't feel the need for anything else. Everything I had fit into a handbag that I made: two pairs of pants and a half dozen shirts. I didn't have a refrigerator, television, nothing, and I was very happy."[60] During this time, Matogrosso also consumed large quantities of marijuana and engaged in ritual use of LSD to facilitate exercises of self-discovery.[61] His use of LSD also provided insights into his conflict with his father, for whom he began to feel empathy and pity, instead of anger and resentment.[62] In short, his experiences with LSD helped him to develop alternative perspectives on everyday life.

Secos & Molhados are often compared to the glam rock artists of the 1970s, such as David Bowie, T. Rex, Kiss, and the New York Dolls, who were noted for their outlandish clothes, flamboyant hairstyles, heavy use of stage makeup, and camp performance styles that flaunted androgyny and sexual ambiguity. According to a fan book published in 1974 at the height of the group's popularity, their androgynous style was conceived as "an aggressive attitude toward widespread machismo and against taboos surrounding behavior and ways of being that imprison people—something

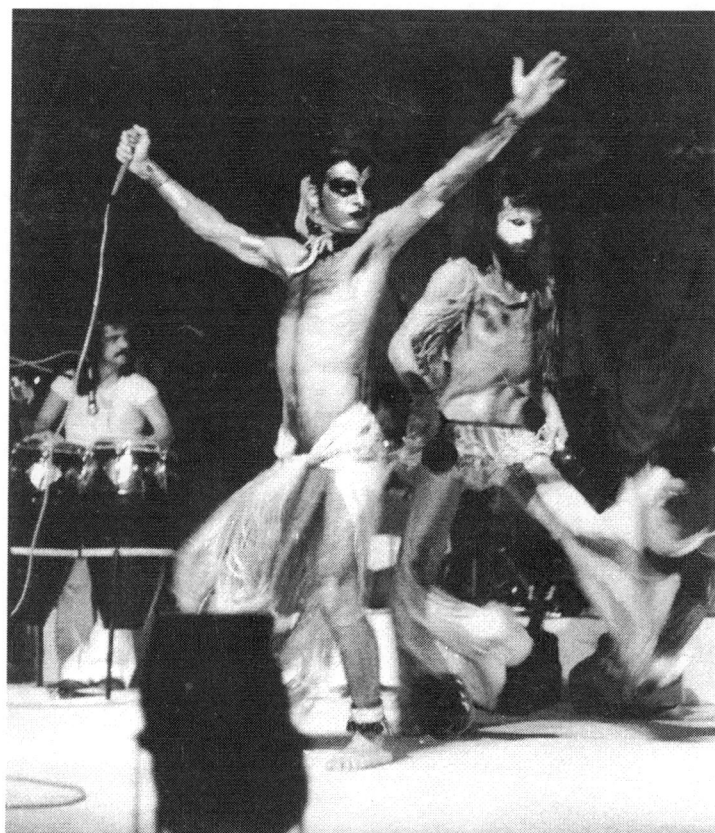

Ney Matogrosso and João Ricardo of Secos & Molhados, 1974. Luis Gleiser/ Acervo CPDoc JB.

like 'desbunde.'"[63] Yet the group's stage aesthetic was quite distinct from the glittery look of British and American glam rockers. Starting with a thick layer of white base and black makeup around the eyes, they painted their faces to look like masks. Matogrosso typically wore a small feathered headdress, a large bonetooth necklace, fur armbands, billowing silk pants, and a raffia skirt. Matogrosso was often described as the "David Bowie of Brazil," but his stage persona in the 1970s was different from the British rock star's. While Bowie's style tended toward high-fashion, space-age artifice, Matogrosso presented himself as a pseudo-primitive "natural man," which revealed affinities with his recent past as an itinerant Brazilian hippie.

Released in September 1973, the group's debut album, *Secos & Molhados*, quickly achieved mass success, selling over a million copies in the first year. Over the next two years, the group toured throughout Brazil, performed in several cities in Mexico, and made frequent television appearances, most notably on TV Globo's hugely successful program *Fantástico*. Matogrosso's

extraordinary voice and superb songwriting and the group's outlandish stage presence had wide appeal, attracting the usual adolescent and young adult fans, but also delighting young children and seniors. Inspired by the inventive eclecticism of the tropicalists, their first album featured a wide range of musical styles, including folk rock, blues, and traditional Brazilian song forms.[64] It combined elements of playful humor, whimsy, moral outrage, social critique, and political protest. Several of the songs were based on canonical poems, such as Manuel Bandeira's "Rondó do Capitão" (1940), Cassiano Ricardo's "As Andorinhas" (1971) and "Prece Cósmica" (1973), and Vinicius de Moraes's "Rosa de Hiroshima" (1946), a haunting indictment of the nuclear attacks on Japan. The group created a lively rock 'n' roll number with "Mulher Barriguda," a poem about the perils of raising a child in poverty by Afro-Brazilian poet-activist Solano Trinidade. Other songs addressed the repressive atmosphere under military rule, such as "Primavera nos dentes," a poem by João Ricardo's father, the Portuguese poet and journalist João Apolinário, which speaks of the necessity to constantly invent new strategies to assert individual freedom even under the most repressive conditions. The title of the poem comes from the final lines, which suggest individual tenacity in the face of violence: "And surrounded by the tempest, mutilated / teeth clenching on to spring."

Secos & Molhados has also been called "the first Brazilian LP to come out of the closet," due to Matogrosso's feminine voice and androgynous appearance.[65] While the songs made no overt reference to homosexuality, critics identified one track, titled "O vira" (The turn), written by João Ricardo, as an anthem of surreptitious gay revelry. Combining guitar-driven rock with a traditional Portuguese couple's dance, the *vira*, the song was popular among children, as it invoked a magical nocturnal dance in the middle of the forest attended by fireflies, owls, fairies, and *sacis*, one-legged trickster figures in Brazilian folklore. The chorus made a sly, but widely recognized, reference to nocturnal gay cruising in which "men turn into werewolves." Reporting on the astonishing success of the group, *Veja* noted that "O vira has become the banner for some sectors of national Gay Power."[66] In performing the song, Matogrosso would prance and sashay across the stage, swiveling his hips suggestively. Although some audiences delighted in Matogrosso's highly sexualized performances, he also was booed off the stage and attacked in the press.[67] Secos & Molhados rejected any direct connection to social or political movements, including the emergent gay liberation.[68] Their disengagement from organized movements was consistent with other post-1968 countercultural manifestations in Brazil. Like Caetano Veloso, Gilberto Gil,

and other artists of the period, they were wary of guiding their audiences or leading a movement, which they associated with unhealthy messianic impulses. They also believed that identification with a specific movement, such as gay liberation, would ultimately limit their range of action and influence.

Following the acrimonious dissolution of Secos & Molhados in 1974, Ney Matogrosso launched a highly successful solo career that continued to develop an aesthetics of gender fucking based on a simultaneous assertion of masculinity and femininity. His first solo album, *Água do Céu* (1975), is best known for its first track, "Homem de Neandertal" (Neanderthal man), which also served as the basis for his stage performance while touring to promote the album. The song opens with nearly two minutes of birdsong, monkey calls, thunder, rattles, and horn calls, before Matogrosso intones, "I am a Neanderthal man!," ending in an otherworldly scream. The Neanderthal man of the song seems to be in some ways like the ideal hippie: "I live by my own means / I live in feathers in touch with my feelings." The album cover, created by Rubens Gerchman, features a photo of Matogrosso, bare chested, with black horse-mane armbands and headgear, a tortoise-shell mask, and curved rams' horns rising over his shoulders. With his lips and eyes painted black, he stares intensely into the distance and thrusts forward his hairy torso. The inner foldout of the album cover includes a series of Gerchman's photos of Matogrosso in a variety of poses, including some in which he appears to be stalking prey. Against a background heavily saturated with light, Matogrosso seems to move through the mists of time, at once ancient and modern. He is ambiguously gendered, combining corporeal signs of femininity with the robust virility of a cave man. His embrace of the "primitive" resonated with countercultural identifications with "barbarians," such as the Doces Bárbaros (discussed in Chapter 3), as well as modernist celebrations of indigenous cannibals in the *antropofagia* movement of the 1920s.

Matogrosso further developed a stage persona and repertoire that reinforced an androgynous aesthetic and simultaneously affirmed manliness and femininity. In 1981, he recorded "Homem com H" (Man with an m), a satire of hypermasculinity composed by Antônio Barros, a northeastern musician who played triangle in Luiz Gonzaga's *forró* band. The song's protagonist proudly asserts his manliness, claiming to have heard his mother from the womb praying to God for a *cabra macho para danar* (a hell-raising he-man), followed by the proud declaration, "Here I am, mommy / a man with an m." As Steve Butterman has observed, "The repeated declarations of virility mock the very notions of *machismo* in a universe where the insecure

male is compelled to constantly assert his virility and his heterosexuality to earn the title of a 'real man.'"[69] The original 1974 recording of the song on the Copacabana label by the group Hydra was already a campy send-up of machismo. The high-pitched vocal histrionics of Simbas (Nivaldo Alves Horas), a rock singer who had performed with Rita Lee's band, Tutti Frutti, reinforced the song's satirical edge. The popular DJ Big Boy (discussed in Chapter 4) played it constantly on his programs in Rio and São Paulo, but the song only achieved mass success with Matogrosso's rendition seven years later.[70] With his countertenor voice, makeup, stage costume, and seductive hip swivels, Matogrosso's 1981 performance of the song on the TV show *Fantástico* brought the satire of machismo to a mass audience.[71]

In the late 1970s, Matogrosso began to publicly affirm his homosexuality in interviews given to the press. In a 1978 interview for the Brazilian version of the magazine *Interview*, he declared his identity as a gay man but also noted the risks in doing so: "I'm left exposed, even risking taking a bullet in the head because some macho guy doesn't like fags.... For me it's a mission to put an end to this idea that homosexuals are sad, suffering, and must hide themselves away."[72] As the most visible Brazilian artist to publicly affirm his homosexuality, Matogrosso played a key role in provoking public debates about gender and sexuality in Brazil.[73] Matogrosso has, for example, pointedly rejected the traditional active/passive, or *bofe/bicha*, binary in stating that "my kind of homosexual relationship is about total equality."[74] In denouncing sexual hierarchies and insisting on equality, Matogrosso aligned himself with the *entendidos*, those gay males who, like their counterparts in the United States and Western Europe, asserted gay identity based on sexual orientation, not sexual roles.

Yet Matogrosso disavowed any affinity or connection to the gay movement in Brazil.[75] His attitude toward identitarian movements was typical of the politics of personal liberation associated with the *desbunde*. In a long interview with the editors of *Lampião da Esquina*, Matogrosso acknowledged that his popularity as an openly gay artist had engaged in "existential politics" by helping others in affirming their sexuality, but he also claimed that he was not interested in "carrying a banner" for the gay rights cause.[76] The lead quote summed up Matogrosso's approach to gay liberation, which was clearly informed by a countercultural sensibility: "Liberation? Everyone take care of themselves." Matogrosso has associated gay movements with an "American mentality" that "forms ghettos" and sets boundaries on one's own sexuality.[77] Some Brazilian intellectuals, such as Silviano Santiago, have recently echoed this critique by calling for subtle or "wily" (*astucioso*)

forms of subversion that disavow a position of marginality and instead affirm homosexuality through everyday public and private behavior.[78]

One of the paradoxes of the gay *desbunde* is that some of its most recognized cultural icons of the 1970s, such as Dzi Croquettes, Ney Matogrosso, and Caetano Veloso, resisted any association with organized movements for gay rights that depended on a strong, unambiguous sexual identity. Instead, they asserted sexual ambiguity and the unbounded play of erotic desire. In disavowing a fixed sexual identity, they are aligned with queer theorists who have drawn attention to the limitations and pitfalls of defining identity in the way that it excludes or limits other aspects of the self. From the perspective of LGBT Studies and social movement activists, the refusal to affirm identity is naive, given the persistence of homophobic attitudes and attacks. As Braga-Pinto points out, ambiguity and indefinition run the risk of "reinforcing hegemonic heterosexuality" by assuring that homosexuality remains closeted and invisible in the public sphere.[79] The AIDS crisis of the 1980s and beyond, which took the life of Caio Fernando Abreu in 1996, gave further impetus to social movements that sought to mobilize gay communities. In this context, the "gay *desbunde*" of the 1970s seemed anachronistic in its disavowal of identity politics, which flourished in the years following the end of military rule in 1985.

⇒ Toward a New Masculinity

Countercultural challenges to traditional configurations of gender and sexuality also informed new ideas about masculinity among men who identified as heterosexual. Novel forms of body management, especially the use of long hair, and unisex sartorial styles among men, were external signs of attitudinal and behavioral transformations. With reference to the United States, Theodore Roszak had observed that "one of the most remarkable aspects of the counterculture is its cultivation of a feminine softness among its males."[80] Likewise, in some social circles of urban Brazil, it was not only acceptable but even fashionable to cultivate one's "feminine side" in contrast to the traditional *macho*. The new masculinity did not, of course, disrupt patriarchal power or subvert gender roles. During this time, men continued to dominate the labor market and many women remained confined to the domestic sphere. Nevertheless, new ideas about masculinity signaled changes in the ways that some men thought about their roles in families, their relationships with female partners, and their attitudes toward women in the workplace, homosexuality, and male friendship.

Caetano Veloso epitomized the new masculinity as a heterosexual married man who wore long hair and unisex clothing, spoke proudly of his feminine qualities, and openly expressed affection toward other men. He composed and recorded several songs that expressed his desire for other men, such as "Menino do Rio" (Boy from Rio), featured on the album *Cinema Transcendental* (1979). The song portrays a young surfer whom Veloso befriended on Ipanema beach. With a "dragon tattoo on his arm" and an "open body in space," the surfer is an "eternal flirt" who serves as a kind of male muse to the artist, who declares: "When I see you I desire your desire."[81] Recorded first by Veloso, the song achieved commercial success only after it was recorded by Baby Consuelo, the female vocalist of the Novos Baianos, which effectively stripped the song of its homoerotic charge.[82]

In a similar vein, Gilberto Gil recorded "Tradição" (Tradition), a song about his admiration for another man without the explicit eroticism of Veloso's song. Featured on the album *Realce* (1979), "Tradição" evokes the Salvador of his early adolescence in the 1950s when he took notice of a young girl from the working-class neighborhood of Barbalho. Immediately, however, the object of his gaze shifts to "the boy that was her boyfriend." Gil has claimed that the girl from Barbalho was his "object of sexual desire" and her boyfriend was his "object of cultural desire."[83] He admires the way he jumps on the streetcar (at the time still a mode of public transportation in Salvador), his open shirt, his contraband American jeans, and his way of smiling and singing. Gil's admiration for the older boy is primarily related to his modern style of dress, his sparkling self-confidence, and his happy-go-lucky demeanor, but it also suggests a latent eroticism. By the end of the song, the girl from Barbalho is all but forgotten, while the beautiful images of her boyfriend remain etched in his memory.

Gilberto Gil also composed and recorded songs that explored androgyny as a poetic motif and as an aspect of his own identity.[84] Another song from the album *Realce*, "Logunedé," pays homage to his *orixá*, a Yoruba deity who has feminine and masculine attributes, inherited respectively from the mother, Oxum, and the father, Oxóssi. These attributes conform to near-universal stereotypes about gender differences. From Oxum, the goddess of fresh water, Logunedé received qualities of sweetness, tenderness, and beauty; from Oxossí, the king of the forest, the androgynous *orixá* acquired the "cunning of a hunter / the patience of a fisherman." Gil's song reinforced affinities, real and imagined, between Candomblé and the counterculture, as discussed in Chapter 3. Candomblé houses are widely regarded as welcoming spaces for homosexuals, especially men, who are known as *adés*,

and cultural memes derived from the religion circulate in urban gay communities.[85] Although "Logunedé" made no reference to homosexuality, its celebration of androgyny linked the mythopoetic world of Candomblé to emergent models of feminized masculinity.

Another song from this same album, "Super-homem, a canção" (Superman, the song), was more explicit in advocating alternative masculinities that embraced femininity. Recorded soon after the release of the international blockbuster film *Superman, the Film*, Gil's song became an anthem for gays, bisexuals, and heterosexual men allied with feminist causes who rejected traditional models of masculinity. In the song, Gil proclaims that he had "lived the illusion that being a man would suffice" but then came to the realization that his "woman portion," which had been repressed, was in fact his "best portion." There are obvious pitfalls in essentializing one's feminine side, or "woman portion," as if it were a stable, self-evident quality and not a contingent and variable social construction.[86] What does it mean to embrace one's "feminine side," after all? The song also seems to suggest that the embrace of femininity is little more than an exercise in male self-improvement and redemption, as revealed in the final stanza: "Superman might come to restore us to glory / like a god changing the course of history / thanks to women." Despite these problems, "Super-homem, a canção" ironically subverted the comic-book and cinematic images of the male superhero who relies on his power and strength, while also suggesting new ways of being male that privilege qualities typically associated with women.[87]

These recordings coincided with the beginning of the *abertura*, the period of gradual "opening" leading up to formal redemocratization in 1985. In August 1979, the Brazilian congress passed a sweeping amnesty law, which paved the way for the return of political exiles and the release of political prisoners, while also absolving the regime and its security forces of its crimes committed in the name of national security. The most prominent face of amnesty was Fernando Gabeira, a journalist who in the late 1960s had left his job with the *Jornal do Brasil* to join the armed struggle against the dictatorship. A member of the MR-8, he played a minor role in the 1969 kidnapping of U.S. ambassador Charles Elbrick, who was released in exchange for a group of imprisoned guerrillas who were safely transported out of the country. Arrested later that year, he was ransomed and sent into exile as the result of a subsequent kidnapping. He lived briefly in Chile before the military coup of 1973 forced him to flee to Europe. Gabeira spent most of the decade in Sweden, where he worked as a hotel doorman and subway

train operator. There he came into contact with feminist, environmentalist, and antiracist activists. Gabeira's disillusionment with the armed struggle and his contact with leftist social movements in Europe inspired a process of self-critique, which he would later parlay into a successful literary and political career.[88]

Returning to Brazil soon after the passage of the amnesty law, Gabeira immediately gained fame and notoriety with the publication of a memoir, *O que é isso, companheiro?* (What is this, comrade?), a riveting story about his experience as an urban guerrilla, the Elbrick kidnapping, his ordeal in prison, and his exile. Published in September 1979, the book remained at or near the top of the best-seller list for well over a year, received the prestigious Jabuti Prize for autobiography and memoir, and was translated into French and German. Nearly twenty years later, Gabeira's memoir would inspire a successful, albeit controversial, film directed by Bruno Barreto, which reached a substantial English-speaking audience as *Four Days in September* (1997). Gabeira and his memoir became closely associated with political amnesty and, subsequently, the phase of *abertura*. Over the years, he has drawn criticism for inflating the significance of his role in the kidnapping, disparaging the patient efforts of the left-wing opposition, and belittling the armed struggle as youthful folly.[89] There is also a tendency in Gabeira's writings from the early 1980s to imagine that inspiration for new social movements around feminism, gay rights, black consciousness, and environmentalism would come from returning exiles, while ignoring the history of homegrown organizations engaged in such struggles.[90] More recently, the memoir has drawn criticism precisely for its conciliatory narrative and endorsement of an amnesty law that shielded torturers from prosecution.[91]

Among the most controversial aspects of Gabeira's writing and his public persona during the period of *abertura* was his vigorous critique of machismo in Brazilian society, including within the ranks of the left-wing opposition. As a former guerrilla who had been imprisoned, tortured, and exiled for most of the decade, Gabeira enjoyed considerable prestige and visibility when he returned to Brazil in 1979. He used his notoriety to advance a new agenda for the Brazilian Left that pointedly criticized armed insurgency as a path to power and promoted democracy against all forms of authoritarian rule, including socialist regimes like Cuba, which he visited during his period of exile.[92] He advocated environmentalism and a "politics of the body" aligned with feminist and gay movements. Fernando Gabeira did not identify as a gay man, but, like Caetano Veloso, he cultivated a slightly effeminate and androgynous public persona, which corresponded to his

political critique of sexism and machismo in Brazilian society, not the least among fellow leftists.

In the summer of 1980, months after the publication of his blockbuster memoir, he caused a sensation when he began to frequent Ipanema beach wearing a crocheted *tanga*, a skimpy female bikini bottom, in a unisex gesture enacted years earlier by Luiz Carlos Maciel. Gabeira's scrawny figure clad in a *tanga* belonging to his niece became one of the emblematic images of the post-amnesty *abertura* and a symbol of a new masculinity. Fellow ex-guerrilla Alfredo Sirkis characterized Gabeira's beach performance as a "megascandal of the amnesty" since it fueled speculation that this "heroic guerrilla fighter" was a gay man.[93] Gabeira's success as an author and notoriety as a public intellectual were enhanced by his embrace of the *desbunde* at a time when a newly invigorated civil society sustained intense debates within the Left.[94] While his penchant for self-promotion and political transformation rankled former comrades in the armed struggle as well as fellow left-wing intellectuals, Gabeira's role in *abertura* politics was vital in provoking discussions around a range of social issues pertinent to the construction of democracy.

While none received the same level of attention as Gabeira, other former guerrillas went through similar transformations. Bahian artist, anthropologist, and historian Renato da Silveira has provided a revealing personal narrative about his own process. In the early 1970s, Silveira was affiliated with a Bahian cell of the MR-8. Although he never participated in any armed actions, his links to the organization were significant enough to land him in jail for several long stints in the notorious Lemos Brito penitentiary in Salvador. While imprisoned, he dedicated himself to reading and reflection, focusing primarily on the classic literature of international and Brazilian Marxism. An encounter with the work of anthropologists Melville Herskovits and Claude Lévi-Strauss and art historian Pierre Francastel moved him to question the Eurocentric and evolutionist logic of his ideological formation. He initiated a lifelong relationship as an artist, anthropologist, and historian with the Afro-Brazilian religion of Candomblé, a powerful institution of healing, creativity, and knowledge. Upon his release, he explored the *desbunde*:

> I experimented with acid, started to smoke pot in the interval between my last two prison terms at the end of 1972. I expanded my reading habits and started to dance again (a practice that I had abandoned at age 20 when I became an intellectual), I learned yoga, and explored the states of contemplation in Zen Buddhism. Aldous Huxley and Carlos Castañeda helped me to legitimize intellectually

this marvelous opening of the doors of perception. And every week, I read the "Underground" column of Luiz Carlos Maciel in O Pasquim. My wife Aninha, whom I married in 74, had a lasting influence on me. She was a yoga instructor and descendent of Brazilian Indians, from whom she inherited a particularly affectionate way to speak of nature. She awakened in me my "feminine side," a delicate sensibility that always existed in me, but had been rejected by chauvinist defenses [carapace machista] as something dangerous.[95]

Silveira's trajectory, from a committed Marxist and member of an armed movement to a reader of Maciel's "Underground," devotee of Zen Buddhism and Candomblé, and man in touch with his "feminine side," is emblematic of profound generational shifts among middle-class Brazilian men in the 1970s. His personal narrative corresponds to a larger transformation in the construction of masculinity that was directly inspired by countercultural discourses and practices. While Brazil remains a profoundly machista and homophobic society with high rates of violence against gay and transgender people, it also hosts the world's largest gay pride parade, sustains an array of vibrant LGBT organizations, and became in 2013 the second nation in Latin America, after Argentina, to sanction gay marriage. These achievements in gender equality and sexual liberation followed years of cultural intervention and grassroots activism going back to the 1970s, when the "gay desbunde," to remember Trevisan's term, challenged the authoritarian moralism of the regime as well as entrenched patriarchal values in Brazilian culture.

Epilogue

In "Os sobreviventes" (The survivors), a short story by Caio Fernando Abreu, a couple takes stock of a decade while chain smoking and sipping on vodka. To the sound of Angela Ro Ro, a lesbian torch singer who was popular in the late 1970s, the couple reflect on their past struggles, their shifting sexualities, and their intellectual passions. They are survivors of the long period of military rule who nurtured utopian dreams and indulged their passions and senses, but they have now been left disillusioned just as the country is returning to democratic rule.[1] Published in 1982, it was featured in a collection of stories, *Morangos Mofados* (Moldy strawberries), a title that denotes a process of decay and rot that serves as a metaphor for generational failures. Loosely structured as a dialogue between a man and a woman, the narrative voice oscillates between first and third person, as they try to come to terms with their own failed love affair, which was heavily mediated by their mutual interests in film, music, and literature. The woman observes that "too much culture kills our bodies" and reveals that she finds pleasure only through masturbation. At some point in the past, both had opted to pursue same-sex relations as part of their quest for pleasure and freedom.

Sexual experimentation was only one facet of their decade-long adventure, as the woman remarks: "I've read everything, man, I've tried macrobiotics psychoanalysis drugs acupuncture suicide dance swimming jogging astrology skating Marxism Candomblé gay nightclub ecology, I'm left with this knot in my chest, now what do I do?"[2] The reader is first struck by the sheer heterogeneity of experiences, from drug consumption to exercise, from macrobiotics to psychoanalysis, from Marxism to Candomblé, from acupuncture to astrology, and from gay revelry to ecology. Somewhere in the middle, a suicidal episode figures into her life history as a potential ending, only to be succeeded by a life-affirming exploration of dance. The absence of punctuation suggests an overlapping and conflation of experiences, rather than an ordered succession of personal projects. The protagonists had tried everything but were left feeling empty and unfulfilled. Abreu's

story registers a distinctly post-utopian perspective that contrasts with the revolutionary vision of the sixties as well as the countercultural euphoria of the early seventies.

The waning of countercultural ideas and practices in Brazil was, as elsewhere, mourned by those most deeply invested in them. Luiz Carlos Maciel described the postwar period as a succession of seasons, beginning with the "winter of the West," a period in which youth began to question the values and assumptions of "Western" culture, technology, and capitalist growth. The sixties represented the "spring of revolution," led by young protagonists who aimed to seize power through either mass protest or armed insurrection. With the failure of these political projects came what Maciel calls the "summer of the counterculture," as people explored forms of personal liberation and bodily pleasure. For Maciel, the 1980s represented the beginning of a long, seemingly interminable "autumn of alienation," with the demise of socialism and the triumph of neoliberal, global capitalism.[3] The achievements of the sexual revolution were threatened by the global health crisis of AIDS, which conservatives used to promote the return to traditional values. The use of drugs for both recreational and "mind-expanding" pursuits lost some of its hopeful innocence with the rise of violence associated with heavily armed narco-trafficking gangs and the state-sponsored militarization of efforts to control the production, sale, and export of drugs. Recent works, such as José Padilha's 2008 film *Tropa de Elite* (Elite squad), have criticized middle-class consumption of marijuana and other drugs for fueling the violence by sustaining demand. Gone are the high-minded "nobles" and the innocent "angels" analyzed by Gilberto Velho in the early 1970s who associated drug consumption with mind expansion and pleasure.

The slow deflation of utopian energies coincided somewhat paradoxically with a political process of *abertura*, a gradual opening of civil society. Dominant forces within the military regime, chastened by economic failures at home, international pressure to cease repression, and a broad range of grassroots political and social movements calling for democratization, initiated a gradual transition. The amnesty law of 1979 seemed to most Brazilians to be an expedient solution to hasten a smooth transition to civilian rule, although it subsequently came under fire for creating cover for agents of the regime who directed or carried out state violence, especially the torture of political prisoners. Flawed as it was, the amnesty law enabled political exiles to return to Brazil and gave further impetus to a variety of social movements that had begun to mobilize during the second half of the 1970s. For some artists associated with the counterculture, the period of *abertura* created condi-

tions for a new utopianism. In *Panfletos da nova era* (Pamphlets of a new era), a collection of essays published in 1980, Jorge Mautner prophesied that Brazil would emerge from the period of dictatorship to become "one of the irradiating focal points of a new culture," a socially democratic force for global unity, powered by renewable energy sources and fueled by a "technological agrarian revolution."[4]

It is difficult to measure the impact of countercultural experiences on these new social movements. Among neighborhood associations, rural workers' groups, ecclesiastical base communities, environmentalist groups, and the new labor movement, the counterculture was not a point of reference. The impact of the counterculture was more evident among predominantly middle-class, identity-based organizations, such as black, feminist, and gay movements, which were more invested in cultural and behavioral transformations that would have an impact on everyday life. I do not wish to suggest that these new social movements evolved organically from the counterculture, which was in many instances disengaged from political action, a common critique among leftists. Instead, the counterculture inspired the development of an "alternative Left," which placed value on the subjective dimension of politics based on everyday experience.

French philosopher and psychoanalyst Félix Guattari described this reconceptualization of politics as a "molecular revolution," a term he proposed to account for micropolitical movements and practices. Guattari regarded Brazil, then experiencing an explosion of civil society activism in the waning years of the dictatorship, as a kind of laboratory for molecular revolution. In 1982, he traveled throughout the country with Suely Rolnik, a Brazilian psychoanalyst and cultural critic, meeting with activists and intellectuals from the feminist, gay, and black movements, as well as the emergent Worker's Party under the leadership of Luiz Inácio Lula da Silva. In one interview, Guattari explained: "I don't believe in revolutionary transformation, whatever the regime may be, if there is not also a cultural revolution, a kind of mutation among people, without which we lapse into the reproduction of an earlier society. It is the whole range of possibilities of specific practices of change in the way of life, with their creative potential, that constitutes what I call molecular revolution, which is a condition for social transformation. And there is nothing utopian or idealistic in this."[5] Although Guattari makes no reference to countercultural experiences from the post-1968 period, his evocation of personal transformation, or "mutation among people," describes what was at the center of many of these movements.

Guattari was particularly fascinated with the Worker's Party, which he

championed as a new model for grassroots mass mobilization that brought together industrial workers, leftist intellectuals, and social movement activists. The Worker's Party, then in its early phase, represented a new political experiment in democratic socialism that rejected the Soviet and Chinese models followed, respectively, by the Brazilian Communist Party (PCB) and the Communist Party of Brazil (PcdoB). The Worker's Party was notable for accommodating a wide range of so-called tendencies that advocated various ideological positions and strategies. One tendency, Liberdade e Luta (Liberty and Struggle), known by its lyrical acronym "Libelu," whose members were known for their countercultural orientation, combined Trotskyist politics with sexual liberation, gender equality, and marijuana use.

Countercultural ideas and practices reached a wider population in the form of alternative lifestyle, which took a variety of forms. Among the most dedicated were those who joined surviving hippie communes, such as the one in Arembepe, or founded new ones, typically in the mountainous interior or on remote beaches of the northeast. Some intentional communities developed around new-age religions such as Santo Daime and União do Vegetal (Union of the Plant), which are based on the ritual use of the psychoactive plant ayahuasca. For the vast majority of Brazilians, however, alternative living involved what Sam Binkley has called, in reference to the United States, "lifestyle consumption" among urban middle-class people who led conventional lives. Binkley describes a process of collective "loosening," as some of the leisure activities and sartorial styles previously associated with countercultural hippies were adopted and modified by members of mainstream society.[6] Support for the legalization of marijuana as a product with both recreational and therapeutic values has grown in Brazil since the 1980s. The expansion of organic farming, macrobiotic diets, vegetarianism, and veganism spurred a growing market for "natural" restaurants and food stores. Interest in homeopathy, herbalism, and various forms of non-Western medicine also expanded throughout the 1980s and beyond. Founded in 1977, the Instituto Aurora Espiritual (Spiritual Dawn Institute) of Rio de Janeiro took a leading role in promoting alternative lifestyles by offering seminars, lectures, and personal consultations and distributing a catalog of addresses for related organizations and businesses such as organic food stores, vegetarian restaurants, yoga centers, and spiritual centers throughout Brazil. The return to democratic rule also gave impetus to new experiments in alternative education, including pedagogical methods developed by Paulo Freire, which were oriented toward social justice, and other holistic, student-centered approaches to learning.

Fernando Gabeira, the former urban guerrilla, became a leading advocate for alternative politics upon his return to Brazil after years of exile in Sweden, where he had lived in an urban commune. In 1986, he helped to found the Partido Verde, a green party dedicated to environmentalism, sustainable development, social justice, and nonviolence. This period witnessed several high-profile environmental struggles against the destruction of the Amazon rainforest, the construction of a nuclear energy plant in Angra dos Reis, a coastal town south of Rio de Janeiro, and the infamous levels of industrial pollution in Cubatão, a peripheral suburb of São Paulo. The environmentalist movement contested the growth-oriented authoritarian modernization of the military regime, but also the traditional developmentalism of the nationalist Left.[7] By the mid-1980s, environmentalism had gained adherents among activists, artists, and intellectuals committed to alternative left-wing politics oriented in large part by social movements. Gabeira and his colleagues were not the pioneers of the environmentalist cause, and some critics regarded the Partido Verde as excessively festive and countercultural.[8] Early leaders of the Partido Verde, such as Gabeira, also supported the legalization of marijuana, the legalization of abortion, and gay rights.

Gabeira was also cognizant of the limitations of what he called *vida alternativa*, or "alternative living." In a short pocket book on the topic, published in 1985 and intended for a broad audience, he admitted the difficulties in creating an alternative society separated from the capitalist system and consumer society.[9] Indeed, as we have seen, the circulation of countercultural, and later alternative, values depended to a large extent on cultural consumption. He lamented that much of what passed for "alternative living" was largely confined to middle- and upper-class citizens. He began to consider these limitations while visiting an ashram in India, which he described as "a Paradise for well-fed blondes" from Europe and the United States, who were oblivious to the "real India" of entrenched poverty and social inequality.[10] He noticed a similar dynamic in Brazil, where alternative lifestyle practices and spiritual quests were largely the domain of affluent and educated urbanites. It is worth recalling here Alex Polari's critique of the counterculture, quoted in Chapter 1, that it never became "rigorously political" and remained "limited to the middle class."[11] The challenge for Gabeira was to reject elitism and create the conditions for a new society in which these "alternative" practices, values, and institutions could be accessible to all people.[12]

In other ways, the legacy of the counterculture is very much alive in contemporary Brazil. When Lula, the leader of the Worker's Party, ran for

president in 2002 after three previous unsuccessful attempts, his publicists reinvented their candidate as "Lulinha Paz e Amor" (Little Lula Peace and Love). This timeworn slogan of the counterculture was employed to assuage the fears of voters concerned about his past as a labor leader and socialist firebrand. Once elected, Lula appointed the tropicalist Gilberto Gil as minister of culture, despite the fact that the artist belonged to the Green Party and had never been affiliated with the Worker's Party. Gil appointed a cabinet composed largely of fellow Bahians, many of whom had been affiliated with the counterculture. Gil's tenure as minister of culture was transformational in projecting Brazilian culture globally while democratizing cultural policy by funding previously marginalized cultural initiatives outside of the Rio–São Paulo axis. Nearly all of the musicians discussed in this book continue to perform and record, some with notable success. In 2014, for example, Gil and Veloso embarked on an international tour celebrating fifty years of collaboration. Ney Matogrosso continues to pack large venues throughout Brazil. In 2016, the Novos Baianos reunited for a series of concerts, and the Black Rio phenomenon was the subject of a retrospective exhibit that attracted soul aficionados.

As Brazilians reflect on the legacy of the military dictatorship, most attention has rightly focused on the victims of state violence who were disappeared, tortured, and incarcerated for extended periods. In 2011, the Brazilian congress established a National Truth Commission to investigate human rights abuses carried out by the dictatorship, an effort that had long been stymied by the 1979 amnesty law, which favored reconciliation over justice, forgetting over remembering.[13] In relation to this belated process of truth-seeking and accountability, such a focus on victims is obviously appropriate and necessary. As Brazil "turns to memory," to use Rebecca Atencio's phrase, it is also important to remember the experiences of those Brazilians who largely avoided confrontation with the military regime but instead were inspired to embark on quests of self-critique and personal transformation. To be sure, many of these experiences were ephemeral and inconsequential, but others would have a profound and lasting impact on how people lived their daily lives, interacted with others, and engaged in political life. In the context of authoritarian rule, countercultural ideas and practices provided alternative ways of living, expressing personal identity, and perceiving the world for thousands of young Brazilians.

Notes

INTRODUCTION

1 Almeida and Weis, "Carro zero e pau-de-arara," 327–28.
2 Sorensen, *A Turbulent Decade Remembered*, 8.
3 Carlos Alberto Messeder Pereira, *Retrato de época*, 92.
4 Buarque de Hollanda, *26 poetas hoje*, 18. Unless noted otherwise, all translations from Portuguese to English are by the author.
5 Benjamin, "Left Melancholy," 306.
6 Buarque de Hollanda, *26 poetas hoje*, 217.
7 Yinger, "Contraculture and Subculture," 629.
8 Ibid., 634–35.
9 Braunstein and Doyle, *Imagine Nation*, 7.
10 Goffman and Joy, *Counterculture through the Ages*, 29.
11 Eco, *Apocalypse Postponed*, 120.
12 Ibid., 124.
13 Roszak, *The Making of a Counter Culture*, 2.
14 Suri, *Power and Protest*, 88.
15 Ibid., 104.
16 Roszak, *The Making of a Counter Culture*, xv.
17 Ibid., 42.
18 Cited in Miller, *The Hippies and American Values*, xxiii.
19 DeKoven, *Utopia Limited*, 28.
20 Frank, *The Conquest of Cool*, 31.
21 Heath and Potter, *Nation of Rebels*, 62.
22 Ibid., 96.
23 Ibid., 103.
24 Roszak, *The Making of a Counter Culture*, 70.
25 Suri, "The Rise and Fall of an International Counterculture," 46–47.
26 Grandin, *The Last Colonial Massacre*, 15.
27 Zolov, "Expanding Our Conceptual Horizons," 48.
28 Ibid., 55.
29 Ibid., 72.
30 Zolov, *Refried Elvis*, 106–7.
31 Ibid., 27.
32 Ibid., 132.

33 Zolov, "Showcasing the 'Land of Tomorrow,'" 183–84.
34 Zolov, Refried Elvis, 132–34.
35 Pacini Hernandez, Fernández L'Hoeste, and Zolov, Rockin' las Américas, 1.
36 Ibid., 8.
37 Zolov, Refried Elvis, 192–93.
38 Ibid., 214–15.
39 Ibid., 221; Zolov, "La Onda Chicana," 38–41.
40 Markarian, "To the Beat of 'The Walrus,'" 373.
41 Ibid., 379.
42 Manzano, "'Rock Nacional,'" 399.
43 Manzano, The Age of Youth in Argentina, 132.
44 Ibid., 150.
45 Pacini Hernandez and Garofalo, "Between Rock and a Hard Place," 46–47. Due to Cuba's geographical proximity to the United States, Cubans were able to discreetly tune in to stations based in Miami and other southern cities.
46 Moore, Music and Revolution, 150.
47 Ibid., 151.
48 Barr-Melej, "Siloísmo and the Self in Allende's Chile," 751–52.
49 Ibid., 766.
50 Ibid., 777–78.
51 Schwarz, Misplaced Ideas, 20–21.
52 Zolov, Refried Elvis, 111.
53 Ridenti, Em busca do povo brasileiro, 55–57.
54 Schwarz, Misplaced Ideas, 135.
55 Langland, Speaking of Flowers, 80.
56 Ibid., 88–89.
57 As Langland notes, the March of the Family with God for Liberty had actually been planned before the coup as an event to call for military intervention to depose João Goulart and stave off the threat of communism. Instead, it turned into a victory march in support of the new regime. See Speaking of Flowers, 89–90.
58 Fico, Reinventando o otimismo, 43–45.
59 Buarque de Hollanda, Impressões da viagem, 31–35.
60 Ridenti, O fantasma da revolução brasileira, 122–23.
61 Napolitano, "A MPB sob suspeita," 105.
62 Ross, May '68 and Its Afterlives, 103.
63 Langland, Speaking of Flowers, 127.
64 Langland has shown how the friends and colleagues of Edson Luis dramatized his death by transporting his body to the state legislature, where the public could bear witness and the press could take photographs. In addition to preventing the authorities from absconding with the body, their actions spurred a mass protest movement against the regime. See Speaking of Flowers, 112–14.
65 Ibid., 10.
66 Ventura, 1968: O ano que não terminou.

67 Perrone, *Seven Faces*, 25.
68 Dunn, *Brutality Garden*, 148–49; Sussekind, "Chorus, Contraries, Masses," 31.
69 Frederico Coelho, *Eu, brasileiro, confesso*, 24.
70 Ibid., 128.
71 Dunn, *Brutality Garden*, 129.
72 Ibid., 161.
73 Ibid., 134.
74 Napolitano, "A MPB sob suspeita," 120–21.
75 Almeida and Weis, "Carro zero e pau-de-arara," 320–21.
76 Skidmore, *The Politics of Military Rule in Brazil*, 138.
77 Ortiz, *A Moderna Tradição Brasileira*, 121–29.
78 One major exception to this pattern was China, which saw its enrollments plummet during the Cultural Revolution of the 1960s. See Suri, *Power and Protest*, 269–71.
79 Durham, "O sistema federal de ensino superior," 8.
80 Avelar, *The Untimely Present*, 41.
81 Fico, *Reinventando o otimismo*, 147.
82 Ibid., 18.
83 Ibid., 116.
84 See advertisement for Philips television in *Veja*, November 19, 1969, 20–21.
85 Fico, *Reinventando o otimismo*, 148–49.
86 Beal, *Brazil under Construction*, 100.
87 Brandão and Duarte, *Movimentos culturais de juventude*, 85.
88 Avelar, *The Untimely Present*, 43.
89 Gaspari, Buarque de Hollanda, and Ventura, *70/80: Cultura em trânsito*, 41.
90 Ibid., 44.
91 Calirman, *Brazilian Art under Dictatorship*, 18–19.
92 Napolitano, "Coração Civil," 11–12.
93 Ibid., 35–36.
94 Ibid., 187.
95 Carlini, "A história da maconha no Brasil," 315; MacRae and Simões, *Rodas de Fumo*, 19–22.
96 Arquivo Público do Estado do Rio de Janeiro, DOPS 214–221, Deuteronomio Rocha dos Santos, February 5, 1975; relatório 002, Hollywood Rock, January 18 and 25, 1975. See also Mário Magalhães and Sergio Torres, "Documento revela que o festival de rock de 1975 foi vigiado," *Folha de São Paulo*, June 2, 2000.
97 Kaminski, "Por entre a neblina," 160–61.
98 The French anticommunist writer Suzanne Labin argued that Maoist China produced opium and heroin to corrupt and weaken military forces in the West. Her 1968 book *Hippies, Drugs, and Promiscuity* informed conservative Brazilian psychiatrist Antonio Carlos Pacheco e Silva, who argued that drug use in Brazil was "one of the most common strategies to weaken the morale, corrode the character, undermine the combative spirit, and destroy the civic and patriotic sentiments of all those who rise up and struggle against

the Marxist credo." See Pacheco e Silva, *Hippies, drogas, sexo, poluição*, 61. For Labin's influence on Pacheco e Silva, see Cowan, *Securing Sex*, 107–8.
99 Velho, *Nobres e anjos*, 69.
100 Ibid., 107.
101 Ibid., 117.
102 Farber, "The Intoxicated State/Illegal Nation," 19.
103 Ibid., 28.
104 Risério, "Duas ou três coisas sobre a contracultura no Brasil," 28.
105 Velho, *Nobres e anjos*, 112.
106 Ibid., 143.
107 Ibid., 198.
108 Ibid., 101.
109 Ibid., 106–8.
110 Ricardo Noblat, "Falando de Política, Sexo e Vida," *Playboy*, March 1980, http://bvgf.fgf.org.br/portugues/vida/entrevistas/playboy.html (accessed January 14, 2012).
111 Manzano, *The Age of Youth in Argentina*, 99.
112 Langland, "Birth Control Pills and Molotov Cocktails," 309–10.
113 Kehl, "As duas décadas dos anos 70," 34. See also Napolitano, "Coração Civil," 34.
114 Guattari and Rolnik, *Molecular Revolution in Brazil*, 37.
115 Luciano Martins, "Magia, droga e antiintelectualismo," *Opinião*, June 3–10, 1973, 19.
116 Luciano Martins, A *"Geração AI-5" e Maio de 68*, 14.
117 Ibid., 18.
118 Ibid., 44.
119 Martins cited slang words like *barato* (literally "cheap," colloquially "good"), *bode* (literally "goat," colloquially "a bad trip"), *jóia* (literally "jewel," colloquially "good"), and *pinel* (the name of a psychiatric hospital in Rio, used to describe someone as "crazy"). Ibid., 70–71.
120 Ibid., 102.
121 A Spanish-language translation of this book, *El nacimiento de una contracultura*, was first published by Editorial Kairós of Barcelona in 1970. This translation was part of a series that also included a translation of Norman Brown's *Life against Death* and Luiz Carlos Bresser Pereira's *Tecnoburocracia e Contestação*, an analysis of the student movement as a revolt against technocratic society.
122 Claudio Novaes Pinto Coelho, "A contracultura," 39–41.
123 Dias, *Anos 70*, 75.
124 Skidmore, *The Politics of Military Rule in Brazil*, 172–73.
125 Maria Paula Nascimento, Araújo, *A utopia fragmentada*, 109.

CHAPTER 1

1 Pereira and Buarque de Hollanda, *Patrulhas Ideológicas*, 243.
2 Polari, *Em busca do tesouro*, 122.

3 Larsen and Rolnik, "A Conversation on Lygia Clark's *Structuring the Self*."
4 Lesser, *A Discontented Diaspora*, 11.
5 Sirkis, "Os paradoxos de 1968," 112.
6 Risério, "Duas ou três coisas sobre a contracultura no Brasil," 26.
7 Interview with José Celso Martinez Correia by Fabio Maleronka Ferron and Sergio Cohn for Produção Cultural no Brasil, http://www.producaocultural.org.br/wp-content/uploads/livroremix/zecelso.pdf (accessed on September 11, 2013).
8 Ridenti, *O fantasma da revolução brasileira*, 272.
9 Sirkis, *Os carbonários*, 298.
10 Green, "'Who Is the Macho Who Wants to Kill Me?,'" 438–39.
11 Ibid., 460.
12 Frederico Coelho, *Eu, brasileiro, confesso*, 222.
13 Ibid., 249.
14 Santiago, *Uma literatura nos trópicos*, 142.
15 Ibid., 123–24.
16 Lopes, *Novo dicionário bantu do Brasil*, 91.
17 Veloso, *Verdade Tropical*, 472. See interview with Hamilton Almeida, "Quem é o Caretano?," *Bondinho*, March 31–April 13, 1972, reprinted in Veloso, *Alegria, alegria*, 98–145.
18 Zolov, *Refried Elvis*, 27.
19 Risério, "Duas ou três coisas sobre a contracultura no Brasil," 25.
20 Morari, *Secos & Molhados*, 35.
21 Gil attended the free outdoor concert with a large group of Brazilian artists, including Caetano Veloso, Jards Macalé, Julio Bressane, Rogério Sganzerla, Glauber Rocha, and Helena Inês, among others. They saw artists such as Traffic, Fairport Convention, Joan Baez, and David Bowie. See Hamilton Almeida, "O sonho acabou, Gil está sabendo de tudo," *Bondinho*, February 1972, 18.
22 Joel Macedo, "Open Road," *Presença*, October 1971, 6–7.
23 "Onda de hippies em Ouro Preto," *Diário da Tarde*, July 4, 1974. Cited by Kaminski, "Por entre a neblina," 152.
24 Dias, *Anos 70*, 116–22.
25 Arquivo Público do Estado do Rio de Janeiro, Campo psico-social, Informe 0030, February 24, 1970.
26 "Hippies sem paz," *Veja*, March 4, 1970, 70.
27 "Imitação original," *Veja*, February 17, 1971, 26–27.
28 Zolov, *Refried Elvis*, 201.
29 Manzano, *The Age of Youth in Argentina*, 145–53; Manzano, "'Rock Nacional,'" 393.
30 Pacheco e Silva, *Hippies, drogas, sexo, poluição*, 3.
31 Ibid., 5–6.
32 Quoted in Braunstein and Doyle, *Imagine Nation*, 6.
33 Dias, *Anos 70*, 177. Benjamin Cowan interviewed a former official of the Escola Superior de Guerra (ESG), who affirmed that within military circles "the counterculture was not something to be controlled, but to be combated." See Cowan, *Securing Sex*, 119–20.

34 Arquivo Público do Estado do Rio de Janeiro, DOPS Informe 186: 11–8, "Atividades Suspeitas de 'Hipies'—Contato com Elemento Russo," Alladyr Ramos Braga, March 15, 1973.
35 Drummond de Andrade, *O Poder Ultra-Jovem*, 52–53.
36 Cohn, *Nuven Cigana*, 16.
37 Chevalier, *Areias escaldantes*, 18.
38 Velho, *Nobres e anjos*, 50–51.
39 Castro, *Ela é Carioca*, 298. The iconic American musical *Hair*, to which Castro refers, was translated and staged in Brazil for the first time at the Teatro Aquarius of São Paulo in October 1969 under the direction of Ademar Guerra after a long negotiation with the censors. The Brazilian version of *Hair* created by Renata Palottini ran for eight months and was seen by 170,000 spectators. The rock opera launched the career of Sonia Braga, who went on to international fame as a film star in the 1970s and 1980s. See Feijó, "*Hair* 40 anos depois"; and Dias, *Anos 70*, 89. On one regime censor's "remarkably nuanced" response to the Brazilian production of *Hair*, see Cowan, *Securing Sex*, 211–12.
40 José Simão, "As dunas da Gal," June 30, 2005. Published on official web site of Gal Costa, www.galcosta.com.br/sec_textos_list.php?page=1&id=23&id_type=3 (accessed June 1, 2013).
41 Dunn, "Waly Salomão: Polyphonic Poet," 253.
42 Green, *Beyond Carnival*, 251.
43 Velho, *Nobres e anjos*, 145.
44 Maciel, *As quatro estações*, 168. Silviano Santiago has noted that Maciel's gesture, although fleeting, revealed an "experimental lifestyle that transforms an intolerable and intolerant national reality that limits his horizons." Santiago, *O cosmopolitismo do pobre*, 206.
45 Cohn, *Nuven Cigana*, 81.
46 Velho, *Nobres e anjos*, 142–49. According to Velho, smoking marijuana was only about *curtição*, or ludic pleasure, for most of these adolescents. It had none of the political implications that it had for the older group of artists and intellectuals.
47 Opened in 1966, Modern Sound was famous for its extensive selection and for getting new releases in a timely fashion. In his column "Geleia Geral" (September 29, 1971), for example, Torquato Neto informed his readers: "Whoever wants to can go to Modern Sound and buy the new (and very heavy) LP by John Lennon and Plastic Ono Band. It was released a week ago in the States and the first copies to arrive here are almost gone." See Neto, *Os últimos dias de Pauperia*, 83. Modern Sound closed in 2010.
48 Velho noted one incident in particular when a group of *hippies do museu* appeared at the Lanchonete Balada, which provoked a tense reaction from the local adolescents in the surfing scene. See *Nobres e anjos*, 143.
49 Exhibition catalog for "O Jardim da Oposição, 1975–1979," curated by Heloísa Buarque de Hollanda and Hélio Eichbauer, Escola de Artes Visuais, June 19–August 30, 2009, 19.
50 Ibid., 80.

51 Teixeira, *Krig-ha, bandolo!*, 57.
52 Seixas and Essinger, *O Baú do Raul Revirado*, 82–83.
53 For an insightful reading of "Ouro de tolo," see Harvey, "Transando com Deus e o Lobisomem," 153–59.
54 Carlos Drummond de Andrade commented on this vogue for UFO sightings in the poem "Falta um disco," which opens with the memorable line "Love, / I am sad because / I am the only Brazilian alive / who has never seen a flying saucer." See *O Poder Ultra-Jovem*, 1972.
55 Teixeira, *Krig-ha, bandolo!*, 55–56.
56 Buarque de Hollanda, *Impressões de viagem*, 69.
57 For an exhaustive examination of *música cafona* in Brazil during the period of military rule, see Paulo César de Araújo, *Eu não sou cachorro, não*.
58 Teixeira, *Krig-ha, bandolo!*, 200–201.
59 Almeida and Weis, "Carro zero e pau-de-arara," 350–51.
60 Kucinski, *Jornalistas e revolucionários*, 5–6. Maria Paula Nascimento Araújo suggests a slightly different taxonomy, dividing the alternative press into three types: leftist journals, countercultural magazines, and social movement publications. See *A utopia fragmentada*, 21.
61 Maria Paula Nascimento Araújo, *A utopia fragmentada*, 29.
62 Chinem, *Imprensa Alternativa*, 41–42.
63 Andréa Cristina de Barros Queiroz, "O Pasquim," 220.
64 José Luiz Braga, *O Pasquim e os anos 70*, 28.
65 Ibid., 26. This quote originally appeared in *Folhetim*, December 30, 1979.
66 Mino Carta, "Um paulista vê Ipanema," *O Pasquim* 141, March 14–20, 1972, 4–5. Cited in Andréa Cristina de Barros Queiroz, "O Pasquim," 225.
67 José Luiz Braga, *O Pasquim e os anos 70*, 16.
68 José Luiz Braga has divided the history of *O Pasquim* into distinct periods. The "Dionysian" phase, up through issue 80 (January 1971), was followed by what he calls the "long passage" in which the journal struggled with censorship, financial threats, and the need to institutionalize after the initial period of euphoria. With the end of censorship, the paper entered its "liberal" phase as it participated with greater force and frequency in efforts to restore democracy and free expression. In the late 1970s, *O Pasquim* became a "jornal dos retornados," during which it focused attention on the political exiles who returned following the suspension of AI-5 in December 1978 and the establishment of a general amnesty in August 1979. See *O Pasquim e os anos 70*, 15–17.
69 Quoted in Chinem, *Imprensa Alternativa*, 44.
70 José Luiz Braga, *O Pasquim e os anos 70*, 35.
71 Andréa Cristina de Barros Queiroz, "O Pasquim," 232.
72 *O Pasquim* 314, July 4–10, 1975. Cited in ibid., 230.
73 *O Pasquim* 105, July 8–14, 1971.
74 Maciel, *Geração em Transe*, 167–68.
75 Maciel, *As quatro estações*, 154.
76 Maciel, *O sol da liberdade*, 78–79.
77 "Underground," *Bondinho*, February 17–March 1, 1972, 18–19.

78. Luiz Carlos Maciel, "Cultura de Verão," O Pasquim 21, November 13–19, 1969. Reprinted in Maciel, Negocio Seguinte, 31–33.
79. Luiz Carlos Maciel, "Você está na sua: Um manifesto hippie," O Pasquim 29, January 8–14, 1970. Reprinted in Maciel, Negocio Seguinte, 69–72.
80. Maciel has claimed that he received "an avalanche of letters, mostly from young people, that were sincere, gushing, and guileless." See Maciel, Negocio Seguinte, 75.
81. For a compendium of Maciel's articles for the "Underground" column, see Capellari, "O discurso da contracultura no Brasil," 233–37.
82. Maciel, Nova consciência, 137.
83. Versions of Rolling Stone magazine were published elsewhere in Latin America, most notably in Mexico under the Spanish title Piedra Rodante, which was edited by Manuel Aceves in 1971–72. Zolov, Refried Elvis, 221.
84. The Brazilian edition of Rolling Stone was relaunched as a full-color, glossy magazine similar to the American version in October 2006. The first issue featured a story about the earlier version from the early 1970s. See Antônio do Amaral Rocha, "A primeira versão," Rolling Stone, October 2006, http://rollingstone.com.br/edicao/1/a-primeira-versao (accessed January 10, 2013).
85. Roszak, The Making of a Counter Culture, 27.
86. Examples of Rhodia's tropicalist fashion can be found in Basualdo, Tropicália: A Revolution in Brazilian Culture, 184–87.
87. Dias, Anos 70, 112.
88. "Gal," O Pasquim 25, December 11–17, 1969, 15.
89. Langland, "Birth Control Pills and Molotov Cocktails," 326.
90. Manzano, "The Blue Jean Generation," 657.
91. In contrast, Manzano reports that locally made jeans, known as vaqueros, were regarded as vulgar, or mersa, by middle-class Argentine youth, who put a huge premium on "authentic" American jeans. See The Age of Youth in Argentina, 91–93.
92. The Ôi advertisement appeared in O Pasquim throughout 1970. For one example, see O Pasquim 48, May 21–28, 1970.
93. Almeida and Weis, "Carro zero e pau-de-arara," 375.
94. The report mentioned earlier in this chapter, pertaining to the arrest of hippies in Ipanema, also includes a paragraph about the closing of the Feira Hippie in the Praça General Osório, noting that the secretary of security shut it down because the vendors lacked proper authorization yet continued at the square, "upsetting public order." The report goes on to register the protests of the Association of Visual Artists of Guanabara, which produced a manifesto against the repressive action. Arquivo Público do Estado do Rio de Janeiro, Campo Psico-social, Informe 0030, February 24, 1970.
95. Frank, The Conquest of Cool, 26–28.
96. O Estado de São Paulo, March 17, 1968, 48, and Suplemento Feminino, 3.
97. O Estado de São Paulo, May 5, 1968, 11. Thanks to Victoria Langland for sharing with me these advertisements from O Estado de São Paulo.
98. O Pasquim 73, November 11–17, 1970, 20. The original publication of Pasquim

73 erroneously gave the publication year as 1969. It was either an editorial error or a sly commentary on time lost under the regime. The editors of *Pasquim* frequently inserted these kinds of subtle jokes.

99 Between 1971 and 1976, the number of university students in Brazil nearly doubled, from 561,397 to 1,044,472 matriculations. Durham, "O sistema federal de ensino superior," 8.
100 *O Pasquim* 61, August 20–26, 1970, 18.
101 *O Pasquim* 22, November 20–26, 1969, 19.
102 *A Tarde*, February 29, 1972.
103 *O Pasquim* 139, February 29–March 3, 1972, 16.
104 *Rolling Stone* 22, September 26, 1972, 16.
105 *Veja*, October 6, 1971, 51.
106 Kehl, "As duas décadas dos anos 70," 37. Luiz Galvão has also claimed that "advertisements never succeeded in making a long-haired guy buy something that he didn't really need." See *Geração Baseada*, 61.
107 Herbert Marcuse's critique of consumer capitalism, *One Dimensional Man* (1964), was translated and published in Brazil as *Ideologia da Sociedade Industrial* (Rio de Janeiro: Zahar, 1969). For a critical view of the reception of Marcuse in Brazil, see Loureiro, "Herbert Marcuse—Anticapitalismo e emancipação."
108 Frank, *The Conquest of Cool*, 120.
109 Helena Salem, "Ex-militante inspira personagens femininas," *O Estado de São Paulo*, May 1, 1997. Reprinted in Reis Filho et al., *Versões e ficções*, 61–69.
110 Polari has since become internationally renowned as the author of a book explaining the religion and the use of ayahuasca and its relation to Amazonian spiritual traditions. See Polari, *The Religion of Ayahuasca*.

CHAPTER 2

1 Oiticica, "General Scheme of the New Objectivity," 229.
2 Letter from Hélio Oiticica to Guy Brett dated April 2, 1968. Cited by Carlos Basualdo in *Tropicália: A Revolution in Brazilian Culture*, 360.
3 Oiticica, "Tropicália: The New Image," 311.
4 Buarque de Hollanda, *Impressões de viagem*, 66–67. The journalist Marisa Alvarez Lima popularized the term *marginália* in a feature story for *O Cruzeiro*, "Marginália: arte e cultura na idade da pedrada," published December 12, 1968, on the eve of the promulgation of AI-5. See Frederico Coelho, *Eu, brasileiro, confesso*, 170–71.
5 Ventura, "Vazio Cultural," 51.
6 Haroldo de Campos, *Metalinguagem*, 80–81.
7 Gonzalo Aguiar suggestively observes that Lúcio Costa had eliminated the street in his design of Brasília, just as the concretists had eliminated the verse in poetry and the figure in painting. See *Poesia concreta brasileira*, 83.
8 "Manifesto Neoconcreto," *Suplemento Dominical do Jornal do Brasil*, March 21–22, 1959. Excerpted in Ramirez and Olea, *Inverted Utopias*, 496–97.

9. Brito, "As ideologias construtivas no ambiente cultural brasileiro," 77.
10. Farias, "Apollo in the Tropics," 398.
11. Originally published in Livro-Obra (1968), "Nós somos os propositores" is archived on the website "O mundo de Lygia Clark," www.lygiaclark.org.br (accessed June 7, 2012).
12. Foster, The Return of the Real, 9.
13. Bürger, Theory of the Avant-Garde, 49.
14. Herkenhoff, "The Hand and the Glove," 328.
15. Gullar, Vanguarda e subdesenvolvimento, 35.
16. Asbury, "This Other Eden," 35. Sérgio B. Martins writes that Gullar's defection constituted a "formative shock" for Oiticica, who was compelled to establish his own voice and defend his own understanding of the avant-garde in the context of an increasingly polarized cultural field. See Sergio B. Martins, Constructing an Avant-Garde, 63.
17. Pedrosa, "Arte ambiental, arte pós-moderna," 357.
18. Salomão, Hélio Oiticica: Qual é o parangolé, 126.
19. Vianna, "'Não quero que a vida me faça de otário,'" 50–51.
20. Salomão, Hélio Oiticica: Qual é o parangolé, 39–40.
21. Ibid., 59–60.
22. Calirman, Brazilian Art under Dictatorship, 94–95; Shtromberg, Art Systems, 24.
23. Cara de Cavalo (Manoel Moreira) was a petty drug dealer and pimp who killed a famous police detective, Milton Le Cocq. He was hunted down by the Scuderie Le Cocq, a death squad of policemen formed to avenge the detective's death. Oiticica paid tribute to his friend in the work Caixa Bólide 18—Homenagem a Cara de Cavalo (1966).
24. Dunn, Brutality Garden, 143–44.
25. Figueiredo, Lygia Clark—Hélio Oiticica, 44–45.
26. Oiticica, "Tropicália," 240.
27. Dunn, "Mapping Tropicália," 33.
28. Dunn, "The Tropicalista Rebellion," 132.
29. Oiticica, "Brasil diarréia," 117–18.
30. Oiticica, "Tropicália," 241.
31. Oiticica, "The Plot of the Earth That Trembles," 254. Veloso, for his part, has affirmed that he and Oiticica were "companions on a mission." Brett and Figueiredo, Oiticica in London, 26.
32. See letter to Guy Brett in Oiticica, Hélio Oiticica, 135.
33. Oiticica, Aspiro ao grande labarinto, 120.
34. Salomão, Hélio Oiticica: Qual é o parangolé, 71–72. Irene Small references Mario Pedrosa's distinction between critical and positivist utopias proposed in a 1958 essay about the planned capital Brasília, which was an example of the latter. She writes: "Éden was a critical utopia: a temporary paradise that responded to the social and political failures that modernist projects such as Brasília have come to represent." See Small, Hélio Oiticica: Folding the Frame, 101.
35. Wisnik, "Public Space on the Run," 120–21.

36 Waly Salomão has written that *Éden* was "an extreme interpretation" of Marcuse's *Eros and Civilization*, a book given to him by Rogério Duarte. Salomão, *Hélio Oiticica: Qual é o parangolé*, 72.
37 Skrebowski, "Revolution in the Aesthetic Revolution," 70.
38 Oiticica, "Experiência Londrina: Subterrânea," January 27, 1970, Projeto Hélio Oiticica 0290.70.
39 Favaretto, *A invenção de Hélio Oiticica*, 188–89.
40 Oiticica, "The Possibilities of Creleisure," 136.
41 Letter dated March 31, 1969, from Hélio Oiticica to Caetano Veloso, accessed from online Archive of Programa Hélio Oiticica, organized by Itaú Cultural and Projeto Hélio Oiticica.
42 Oiticica, "Creleisure," 132.
43 Oiticica, "On the Discovery of Creleisure," 18.
44 "Bob Dylan e o 'environment' Ilha de Wight," letter dated September 1, 1969, Archive of Projeto Hélio Oiticica.
45 Inspired by tropicalist musicians and other artists like theater director Zé Celso Martinez Correa, he conceived of the *Barracão* as a kind of experimental theater in which the idea of creleisure would structure the everyday life of a group united by creative affinities. See Braga, "Conceitualismo e vivência," 274.
46 Gilse Campos, "Uma arte sem medo," *Jornal do Brasil*, January 20, 1969. Reprinted in César Oiticica Filho, *Hélio Oiticica*, 90.
47 "Norma Pereira Rêgo, "Mangueira e Londres na rota, Hélio propõe uma arte afetiva," *Última Hora*, January 31, 1970. Reprinted in César Oiticica Filho, *Hélio Oiticica*, 99.
48 Ferraz and Conduru, "Na trilha da *Navilouca*," 201.
49 "O som e a imagem de Gal," *Veja*, June 17, 1970.
50 I am grateful to Joanne Pottlitzer, the founder and director of TOLA, for these details about the concert.
51 Writing for *O Pasquim*, Jorge Mautner characterized the set as "an environment in which green, red, yellow, and purple lights flicker on and off like suns and stars of unknown galaxies." Jorge Mautner, "Gilberto Gil na Babilônia," *O Pasquim* 122, November 2–8, 1971, 2.
52 Figueiredo, *Lygia Clark—Hélio Oiticica*, 173.
53 Ibid., 137.
54 Larsen and Rolnik, "A Conversation on Lygia Clark's *Structuring the Self*."
55 Teresa Cristina, "Gal Costa dá um show a todo vapor," *Fatos e Fotos*, October 28, 1971.
56 Neto, *Os últimos dias de Paupéria*, 56.
57 Harvey, "Transando com Deus e o Lobisomem," 206–8.
58 Ibid., 196; Vargas, "Tinindo, trincando," 468–69.
59 Luiz Carlos Maciel concluded his *Rolling Stone* review of "Gal Fa-Tal" with this observation: "I can't help but saying something about Gal's body. She was really very sexy in this show. A beauty, a real marvel, totally worthy of all of the aroused passions." The cover of her follow-up LP, *India* (1974), played on this

carefully constructed image in its ostentatious display of a full-color photo that framed Gal's bikini-clad crotch.
60 Bueno, *Pássaro de fogo no terceiro mundo*, 18.
61 His reference to the "chorus of the contented" came from Sousândrade's "O Inferno de Wall Street" (Wall Street inferno), a part of a long epic poem, "O Guesa" (1871).
62 Remarking on the "magnificent tension of the spirit" in Europe, Nietzsche asserted that "with so tense a bow one can shoot for the more distant goals." *Beyond Good and Evil*, 3.
63 *Invenção* 5 (1966–67).
64 Dunn, *Brutality Garden*, 94.
65 Frederico Coelho, *Eu, brasileiro, confesso*, 259.
66 Neto, *Os últimos dias de Paupéria*, 143.
67 Stam, "On the Margins," 312.
68 Alex Viany, "Sganzerla ataca de bandido," *Tribuna de Imprensa*, December 5, 1968. Reprinted in Canuto, *Rogério Sganzerla*, 29.
69 The name "Quotidianas Kodaks" was appropriated from the title of journalistic chronicles published by Bahian symbolist poet Pedro Kilkerry in the early twentieth century. Cardoso likely picked up this reference from Augusto de Campos, who had published his collected works, *ReVisão de Kilkerry*, in 1970.
70 On the rise of Super 8 production in Mexico, see Lerner, "Superocheros."
71 See interview with Jorge Mautner in Pereira and Buarque de Hollanda, *Patrulhas Ideológicas*, 126. Mautner composed "Vampiro" in 1958, but it wasn't recorded until 1979, when Caetano Veloso included it on his album *Cinema Transcendental*.
72 Cardoso was inspired by a concrete poem by Affonso Ávila, "onde se vê isso, veja-se aquilo" (where you see this, see that instead), in creating this signboard. See Cardoso, *O mestre do terrir*, 95.
73 Campos, "Ivampirismo: O cinema em pânico," *Correio da manhã*, August 14, 1972. Reprinted in Cardoso and Lucchetti, *Ivampirismo: O cinema em pânico*, 37–38.
74 Neto, *Os últimos dias de Paupéria*, 118.
75 Ibid., 130.
76 Ibid., 160.
77 Ibid., 180–81.
78 Frederico Coelho, *Livro ou livro-me*, 13.
79 Ibid., 55–56.
80 Oiticica was especially critical of musician and writer Jorge Mautner, whose texts featured a heady mixture of classical philosophy, new-age utopianism, and popular culture. In one letter, dated June 3, 1971, to Salomão, he characterized Mautner's work as "boring subliterature (Greece, Naziism, Nietzsche, rock music baked all in the same cake)." Mautner had forged close relationships with Veloso and Gil in London, where they made the experimental film *O Demiurgo* (1970).

81 Hinderer Cruz, "Tropicamp."
82 After moving to New York in 1970, he would also reject conceptualism. In an oft-cited letter from 1972 to Brazilian critic Aracy Amaral, Oiticica wrote, "I detest conceptual art, I have nothing to do with conceptual art. On the contrary, my work is rather concrete as it is." See Braga, "Conceitualismo e vivência," 260–61.
83 Before leaving for New York, Oiticica created geometric layouts for the texts, but these designs were confiscated in a police raid on the home of Rogério Duarte in 1971 when they were mistaken for subversive material. Dunn, "Waly Salomão: Polyphonic Poet," 252.
84 Candido, "A literatura brasileira em 1972," 13.
85 Salomão, Me segura, 172–73.
86 Frederico Coelho, Livro ou livro-me, 80–81.
87 Antonio Cícero proposes the idea of *teatralização*—to make life into theater—as a strategy for avoiding what Salomão called the "horrible fixedness" of prescribed social identities in the context of a dictatorship. See "A falange de máscaras," 33.
88 Salomão, Me segura, 173.
89 Ibid., 61.
90 Dunn, "Waly Salomão: Polyphonic Poet," 251.
91 Ibid., 255.
92 Salomão, Me segura, 163.
93 Salomão's text, "Revendo Amigos (Volto pra curtir)," was published in *Verbo Encantado* in February 1972. It was a rebuttal to filmmaker Gustavo Dahl, who had written an article for *O Pasquim* that ridiculed Salomão as a poseur from Bahia who was hoping to repeat the success of Caetano Veloso. A good part of the text is dedicated to making the point that he should not be confused with anyone else, nor should his work be conflated with that of his friends. Cited in Frederico Coelho, Eu, brasileiro, confesso, 284–85.
94 Salomão, Me segura, 106.
95 Ibid., 110.
96 Ibid., 95.
97 Santiago, Uma literatura nos trópicos, 123–24.
98 Zular, "O que fazer com o que fazer?," 52.
99 Ibid., 50.
100 Salomão, Me segura, 140.
101 Ibid., 200.
102 Ibid., 202.
103 Ibid., 203.
104 Frederico Coelho, Livro ou livro-me, 81.
105 Jards Macalé worked closely with Salomão on his first two LPs, *Jards Macalé* (1973) and *Aprendendo a Nadar* (1974), which was dedicated to Lygia Clark and Hélio Oiticica. He later developed a parallel career as a film actor, starring in *Amuleto de Ogum* and *Tenda dos Milagres*, both directed by Nelson Pereira dos Santos.

106 Ferraz and Conduro, "Na trilha da Navilouca," 186.
107 Ibid., 188.
108 As Omar Khouri has noted, "Navilouca was a meeting of waters: from geometric rigor to an apparently careless informalism." See *Revistas na era pós-verso*, 25.
109 Neto, *Os últimos dias de Paupéria*, 253.
110 Waly Salomão later characterized Neto's suicide as a "terrible contradiction," in light of his call to "occupy space" and never give up. See Salomão, "Contradiscurso," 81–82. André Bueno has argued that Neto was another casualty of authoritarian rule: "Torquato Neto ended up transferring historical contradictions to his own body, resolving with his own body, with his own death, the impasse of his dissidence in the face of Brazil during the military dictatorship and conservative modernization with its procession of myths and lies." *Pássaro de fogo no terceiro mundo*, 22.
111 Dunn, "Waly Salomão: Polyphonic Poet," 252.
112 Ferraz and Conduro, "Na trilha da Navilouca," 190.
113 These inserts are exceedingly rare since they were not distributed with the copies of Navilouca. I found them with a pristine copy of Navilouca in the Kohler Art Library at the University of Wisconsin.
114 Buarque de Hollanda, *Impressões de viagem*, 76.
115 Rolnik, "The Body's Contagious Memory."
116 Oiticica, "Brasil diarréia," 119. In a letter to Caetano Veloso dated February 21, 1970, Oiticica explained his metaphor to describe the situation in Brazil: "This idea of diarrhea I like the best. It's more than *geléia geral*. It's like a roof that collapses and engulfs everything." Archive of Programa Hélio Oiticica.

CHAPTER 3

1 Historically, Salvador was known as "a cidade da Bahia" (the city of Bahia) and is still frequently referred to simply as "Bahia." This synecdochical usage obscures significant geographical and cultural differences between Salvador and the coastal environs, on one hand, and Bahia state's vast semiarid hinterland, or *sertão*, on the other. That being said, I will use "Salvador" and "Bahia" interchangeably throughout this chapter in accordance with cited sources and popular usage.
2 "A redescoberta do Brasil," *Veja*, October 6, 1971, 42. By way of contrast, the article reported that Rio de Janeiro, the country's most renowned destination for national and international visitors, had posted only a 9.2 percent increase in tourism during the same year.
3 MacCannell, *The Tourist*, 41.
4 "A redescoberta do Brasil," 47.
5 Hamilton, "The Present State," 358–59.
6 Angelina Bulcão Nascimento, *Trajetória da juventude brasileira*, 199.
7 Rubim et al., "Salvador nos anos 50 e 60," 36.

8 Höfling, "Staging Capoeira, Samba, *Maculelê*, and *Candomblé*," 107.
9 Zolov, *Refried Elvis*, 138–39.
10 "A redescoberta do Brasil," 49.
11 Franklin Machado, "Candomblé como 'underground,'" *Flor do Mal* 3, 1971, 15.
12 As Reginaldo Prandi has observed: "Traveling to Salvador and having the future read through the oracle of sixteen cowries by priestesses [mães-de-santo] for many became a must, a necessity filling an emptiness deriving from a modern and secularized lifestyle so emphatically built through social changes characterizing the industrialized cities of the Southeast." Prandi, "The Expansion of Black Religion in White Society," 10.
13 "Os alegres invasores da Bahia," *Veja*, February 16, 1972, 29.
14 Ibid., 29.
15 Ibid., 26.
16 "Povo da Bahia," *O Pasquim* 83, February 4–10, 1971, 10–11.
17 Dorival Caymmi, whose songs had done so much to attract visitors to the city, also complained that tourism was ruining the quality of life in Bahia. See "Os alegres invasores," 29.
18 Romo, *Brazil's Living Museum*, 152.
19 Höfling, "Staging Capoeira, Samba, *Maculelê*, and *Candomblé*," 98.
20 Lúcia Aquino de Queiroz, *Turismo na Bahia*, 71.
21 Ibid., 105–6.
22 Ibid., 118.
23 Sansone, *Blackness without Ethnicity*, 56.
24 Risério, *Caymmi: Uma utopia de lugar*, 155–83.
25 Osmundo S. de Araújo Pinho, "'A Bahia no fundamental.'"
26 Patricia de Santana Pinho, *Mama Africa*, 197.
27 This pamphlet, found in the archive of Bahiatursa, is titled "Turismo 71/74." See also Jocélio Teles dos Santos, *O poder da cultura*, 86–89.
28 Borges, "Recognition of Afro-Brazilian Symbols and Ideas," 70–72.
29 Freyre, *Bahia e Bahianos*, 29; Patricia de Santana Pinho, "Gilberto Freyre e a Baianidade," 237–38.
30 See Weinstein, "Racializing Regional Difference," 254–56; and Weinstein, *The Color of Modernity*, 302–5.
31 Matory, *Black Atlantic Religion*, 156.
32 Ickes, *African-Brazilian Identity*, 45.
33 Ibid., 13.
34 Landes, *City of Women*, 17; Cendrars, *Christmas at the Four Corners of the Earth*, 37.
35 McCann, *Hello Hello Brazil*, 50–51.
36 Matory, *Black Atlantic Religion*, 151; Prandi, *Segredos guardados*, 187–88. Prandi has assembled a useful database of Brazilian songs from the twentieth century that reference Afro-Brazilian religions. See http://www.fflch.usbr/sociologia/prandi/mpb-down.htm (accessed June 1, 2013).
37 Ickes, "Salvador's *Modernizador Cultural*," 445.
38 Risério, *Avant-garde na Bahia*, 35; Alberto, "Para Africano Ver," 88–89.

39 Jocélio Teles dos Santos, *O poder da cultura*, 66; Carvalho, *A nova onda baiana*, 40–42.
40 Stam, *Tropical Multiculturalism*, 205.
41 Augusto de Campos, *Balanço da bossa e outras bossas*, 153.
42 This interview is featured in the documentary *Uma noite em 67*, directed by Renato Terra and Ricardo Calil, 2010.
43 Galvão, *Anos 70: Novos e baianos*, 145; Harvey, "Transando com Deus e o Lobisomem."
44 Stam, "On the Margins," 315.
45 Ramos, *Cinema Marginal*, 112.
46 *Meteorango Kid* was only released after the director's father, Milton Oliveira, personally appealed to censors in Brasília. Given the film's focus on generational conflict, it is both ironic and revealing that the circulation of the film depended on paternal intercession. André Luiz Oliveira, *Louco por cinema*, 41.
47 Jairo Ferreira, *Cinema de Invenção*, 160.
48 Stam, "On the Margins," 319.
49 André Luiz Oliveira, *Louco por cinema*, 34.
50 Antonio Luiz Martins, *Mágicas mentiras*, 121–22.
51 Stam, "On the Margins," 319–20.
52 Antonio Luiz Martins, *Mágicas mentiras*, 114.
53 Galvão, *Geração Baseada*, 60. Leon Kaminski notes that Brazilian families attending the annual Festival de Inverno in Ouro Preto were similarly fascinated by hippies. See "Por entre a neblina," 142.
54 Epstein, *Along the Gringo Trail*, 10.
55 "Hippies para Gal Costa são lindo e maravilhosos," *A Tarde*, November 3, 1969.
56 "Hippies contra decôro public na Avenida Sete," *A Tarde*, November 4, 1969. This incident also showed up in a police report that alleges that the hippies under arrest had invaded a house. Arquivo Municipal da Cidade de Salvador, Delegacia de Jogos e Costumes, Occorrência 2606, September 14–November 24, 1969.
57 Some readers may recall Zygmunt Bauman's classic distinction between tourists, who are characterized by the ability to move and consume at will, and vagabonds, who are displaced, immobile, and powerless. Bauman's scheme does not fit this context, as many of the so-called *vagabundos* were not displaced, as were global migrants. See Bauman, *Globalization*, 92–93.
58 "Hippies abusaram e perderam o festival," *A Tarde*, November 8, 1969. A police report filed with the Delegacia de Jogos e Costumes indicated that the group included two *paulistas*, one *gaucho* (that is, from Rio Grande do Sul), one Argentine, one Colombian, and four Chileans. Arquivo Municipal da Cidade de Salvador, Delegacia de Jogos e Costumes, Occorrência 2619, September 14–November 24, 1969.
59 *Veja* published a short article about the aborted festival in Salvador and the first mass pilgrimage of hippies to Bahia: "With their eternal velvet pants, colored shirts, necklaces, and head bands, they didn't even have much to eat:

their best option was the fruit picked from orchards along the road." "Onde será a festa?," *Veja*, November 12, 1969, 41.
60 In mid-November 1969, for example, police arrested Luiz Galvão and Pepeu Gomes of the music group Novos Baianos and shaved their heads. Galvão, *Anos 70: Novos e baianos*, 81. Municipal authorities also pressured male city employees to keep their hair short. In February 1972, for example, the mayor's office (*prefeitura*) suspended without pay a taxi driver and a city bus fare collector who wore long hair and muttonchop sideburns. See "Prefeitura persegue motorist cabeludo," *Jornal da Bahia*, February 24, 1972, 3.
61 See "O hippicida," *Veja*, June 23, 1971, 26; and Galvão, *Anos 70: Novos e baianos*, 83.
62 "Advogados afirmam ser ilegal veto a hippies," *A Tarde*, November 15, 1969. Article 153, section 27, of the 1967 Constitution (including the October 1969 amendments to which this lawyer refers) guarantees the right of assembly without arms but retains the right of authorities to intervene "to maintain order."
63 Galvão, *Anos 70: Novos e baianos*, 77.
64 "Polícia prende 14 'hippies,'" *A Tarde*, February 20, 1970. The police report indicated that this group was composed of Argentine, Brazilian, and French citizens. Arquivo Municipal da Cidade de Salvador, Delegacia de Jogos e Costumes, Occorrência 319, December 11, 1969–April 9, 1970.
65 Arquivo Municipal da Cidade de Salvador, Delegacia de Jogos e Costumes, Occorrência 326–27, December 11, 1969–April 9, 1970. The report noted the following: "In accordance with received instructions, we turned over to the Federal Police all of the 'hippies' detained in this station and will do with new ones that arrive."
66 "Inspirados pelo Girassol eles vivem para o amor," *A Tarde*, January 27, 1970.
67 Kottak, *Assault on Paradise*, 94.
68 Ibid., 30.
69 Ibid., 92.
70 Ibid., 31.
71 Ibid., 92.
72 "Are-m' bepe," *Bondinho*, March 17–30, 1972, 26.
73 Josélia Aguiar, "Lembranças de Janis," *A Tarde*, September 1, 1995.
74 Renato César de Moraes, "Arembepe: O Festival de Ondestouque," *Rolling Stone*, July 18, 1972, 5.
75 One notable example is the short film *Céu sobre Àgua*, by the writer Zé Agrippino de Paula and his wife, dancer Maria Esther Stockler, which was filmed with a Super 8 camera over a period of six years (1972–78). Shot mostly in and around the waters of the Capivara River, a popular bathing spot for residents of the aldeia hippie, the film portrays Arembepe as a tropical Eden. Set to a sound track of sitar music by Ravi Shankar, the film conveys a sense of ludic sensuality and blissful harmony between humans and tropical nature in Arembepe.
76 "Are-m' bepe," *Bondinho*, March 17–30, 1972, 27.

77 "Arembepe: O sonho acabou (Só no próximo verão)," *Tribuna da Bahia*, March 6, 1972, 8.
78 Francisco Viana, "Jovens fazem em Arembepe uma colônia primitivista," *A Tarde*, February 7, 1972. During a visit to Arembepe in 1980, Kottak remarked similarly on the apparent malnutrition of transient hippies. See *Assault on Paradise*, 129.
79 Kottak, *Assault on Paradise*, 114.
80 Ibid., 107.
81 "Polícia estoura 'boca de fumo' com extensão até na Argentina," *A Tarde*, January 22, 1972.
82 MacRae and Simões, *Rodas de Fumo*, 20.
83 "Presos 30 'hippies,' dois com maconha e um com elixir paregórico," *Tribuna da Bahia*, February 10, 1972, 8.
84 "Mais de 100 hippies presos," *Tribuna da Bahia*, March 4, 1972. This article reported the arrest of several young women who were pregnant or had just given birth.
85 "De como os 'fantasmas' dos hippies e da maconha assustam a polícia," *Tribuna da Bahia*, March 18, 1972, 8.
86 "Arembepe: O sonho acabou (Só no próximo verão)," *Tribuna da Bahia*, March 6, 1972, 8.
87 "Polícia em ação: Adeus vida mansa em Arembepe," *Jornal da Bahia*, August 13–14, 1972.
88 Epstein, *Along the Gringo Trail*, 372.
89 Vilela et al., *Os baianos que rugem*, 76.
90 "Underground," *Bondinho*, February 17–March 1, 1972, 20.
91 Vilela et al., *Os baianos que rugem*, 118. Armindo Bião edited a facsimile edition of the complete collection of *Verbo Encantado* in 2013.
92 In his column for *Última Hora*, Torquato Neto heralded the arrival of *Verbo Encantado*, calling it a "brother to *Flor do Mal* and *Presença*," and with each new issue he urged his readers to check it out. By January 1972, *Verbo Encantado* appears to have attracted a substantial audience in Rio such that Neto could report to his readers that the journal was selling out in two or three days. See Neto, *Os últimos dias da Paupéria*, 167, 249.
93 Vilela et al. describe *Verbo Encantado* as "manifestly gay" (119), but the references to same-sex desire in the journal are relatively few. The longest commentary on gay life appeared in the section "Consultório Sentimental," an advice column signed by "Tashka," which dispensed advice to a young man from Bahia's interior. *Verbo Encantado*, December 25–31, 1971, 20.
94 In response to a reader's complaint that the journal was "confused," for example, the staff shot back: "We are everything, even confused. . . . If you can take it, great. If not, too bad." *Verbo Encantado*, December 4–10, 1971, 5.
95 The section featuring "Letters from Readers" provides evidence that readers from Rio and São Paulo indeed read the journal as a guide, often in preparation for travel to Bahia. See, for example, a letter from Sandra Lemos from

Rio: "*Verbo* has taught me everything. I now know about the beaches, the festivals, all about Bahia." *Verbo Encantado*, January 1–7, 1972, 23.
96 *Verbo Encantado*, November 27–December 3, 1971, 6.
97 *Verbo Encantado*, December 4–10, 1971, 3.
98 *Verbo Encantado*, November 27–December 3, 1971, 12–13.
99 *Verbo Encantado*, November 6–12, 1971, 19.
100 In "Trekinhos," I found advertisements for juice bars, diners, restaurants, *acarajé* vendors, bars, nightclubs, bookstores, clothing stores, fabric stores, beauty salons, private schools, insurance companies, photography studios, real estate agents, dentists, and accountants. All were disguised as candid advice from those in the know.
101 Armindo Bião has related this story on his blog "Armindo Bião, etc. et al.," http://armindobiao.blogspot.com/2011/08/de-como-revista-mensal-oficial-viver.html (accessed September 26, 2013).
102 *Viver Bahia*, October 1975, 18; Jocélio Teles dos Santos, *O poder da cultura*, 152–53. Russell Hamilton noted that Candomblé ceremonies billed as "authentic" would sometimes be staged in the hotel lobbies for the entertainment of guests. Hamilton, "The Present State," 366.
103 Jocélio Teles dos Santos, *O poder da cultura*, 131.
104 For example, see *Viver Bahia*, February 1974, 1.
105 *Viver Bahia*, November 1973, 2.
106 *Viver Bahia*, July 1974, 24.
107 Góes, *O país do carnaval elétrico*, 72–73.
108 Neto, *Os últimos dias de Paupéria*, 247. Originally published in *Última Hora*, January 1, 1972.
109 Neto, *Os últimos dias de Paupéria*, 263. Originally published in *Última Hora*, February 9, 1972.
110 Veloso, *Verdade Tropical*, 465.
111 Veloso has written that Mautner "only writes clichés with the originality of a Martian." See his liner notes to Mautner's first LP, *Para Iluminar a cidade* (1972), which was reprinted in Veloso, *Alegria, alegria*, 156. See also Perrone, *Brazil, Lyric, and the Americas*, 171–72.
112 Mautner, *Mitologia do Kaos*, 309. Mautner's essay "Cultura negra sem fronteiras" was written in 1973 and published in *Panfletos da nova era* (1980), which was later anthologized in the two-volume *Mitologia do Kaos*. See Dunn, "Jorge Mautner and Countercultural Utopia in Brazil," 173–85.
113 Jerry Cardoso, "Bomtner," *Bondinho*, March 1972. Reprinted in Jost and Cohn, *O Bondinho*, 175–76.
114 Nóbrega and Echeverria, *Mãe Menininha do Gantois*, 158.
115 Ibid., 174.
116 Menininha do Gantois famously posed for an advertisement for Olivetti typewriters. Silveira, "Pragmatismo e milagres de fé," 195. The Gantois temple and Menininha were also the focus of a year-end televised message in 1976 from the state government under Roberto Santos, governor of Bahia from

1975 to 1979, which ends with a voice-over announcement: "Government and people, united in their beliefs, anticipating a year of peace."
117 Tom Zé, one of the original members of the *grupo baiano* who had participated in Tropicália, had embarked on more experimental musical projects in the early 1970s and no longer collaborated with the rest of the group.
118 Jom Tob Azulay, *Doces Bárbaros*, DVD, Biscoito Fino, 2007.
119 Barros, "Doces Bárbaros," 123.
120 Nirlando Beirão, "Baiunos? Baianaves?," *Istoé*, August 10, 1977, 40.
121 Azulay's film features a backstage visit by members of the Novos Baianos in which Caetano Veloso tells them that the Doces Bárbaros were trying to imitate the Novos Baianos. Veloso repeated this claim decades later. See Monica Loureiro, "A volta dos Doces Bárbaros, 26 anos depois," www.cliquemusic.com (accessed September 16, 2013).
122 João Santana Filho, "Gil: O fumo não é deus nem é o diabo," *Boca do Inferno*, 1976. Reprinted in Risério, *Gilberto Gil: Expresso 2222*, 127–53.
123 "Os Baianos, de novo," *Veja*, June 30, 1976, 78. Gil wore a full-body white leotard emblazoned with a sparkling red *oxé*, the symbol of Xangô. Veloso wore a raffia crown embroidered with cowry shells and yellow satin pants, for Ibualama, a manifestation of the hunter Oxossí. Gal Costa wore a red skirt and beaded halter top, for Yansã, the *orixá* of wind and storms. Bethânia similarly dressed in white for Oxalá, the father of all *orixás*.
124 José Miguel Wisnik, "Caetano, Gal, Gil, Bethânia: Tudo de novo," *Movimento*, July 5, 1976. Reprinted in Risério, *Gilberto Gil: Expresso 2222*, 124–26.
125 *Afoxés* are Afro-Bahian parading carnival organizations most famously exemplified by the Filhos de Gandhi, a group that Gilberto Gil helped to revitalize in the mid-1970s after it went through a period of decline.
126 Brown, "Power, Invention, and the Politics of Race," 228–31.
127 Prandi, "Brasil com axé," 236.
128 Pacheco e Silva, *Hippies, drogas, sexo, poluição*, 61.
129 "Macumba" is a colloquial designation for Afro-Brazilian religions, sometimes used pejoratively as something akin to "black magic." As we have seen, however, the term has also been employed neutrally in songs such as "Batmacumba." Luciano Martins, A *"Geração AI-5" e Maio de 68*, 34.
130 Risério, *Carnaval Ijexá*, 17.
131 Matory, *Black Atlantic Religion*, 228.
132 In 1977, Gil recorded *Refavela*, in which he explicitly embraced an international black aesthetic inspired by soul music, reggae, and African pop. Veloso recorded and toured with the Banda Black Rio, Brazil's leading soul formation. That year, both artists traveled to Nigeria for the Second International Festival of Black Arts. The Bahian group, especially Veloso and Gil, took an early interest in *blocos afro* and strongly supported their work at a time when the local press criticized them for racial politics. Over the years, however, their perspectives have taken divergent paths as Veloso now defends an idea of nonracialism that privileges ambiguity and mixture,

while Gil has continued to affirm his own identity as an Afro-Brazilian, while speaking out in favor of affirmative action measures. See Armando Almeida, "A contracultura e a política que o Ilê Aiyê inaugura," 11.

CHAPTER 4

1 Turner, "Brown into Black," 73.
2 Hasenbalg, Discriminação e desigualdade raciais no Brasil, 192. Using data from six of the largest and wealthiest states, Hasenbalg shows that only 0.5 percent of the nonwhite population entered the university in 1973, compared with 7.5 percent of the white population.
3 Dávila, Hotel Trópico, 14.
4 Turner, "Brown into Black," 77.
5 Doutrina Básica, 39–40.
6 Abdias do Nascimento, Brazil: Mixture or Massacre?, 181–82; see also Dávila, Hotel Trópico, 232–36.
7 O Pasquim 132, January 11–17, 1972, 21.
8 O Pasquim 154, June 13–19, 1972, 22.
9 Degler, Neither Black nor White, 224–25.
10 Silva, "Updating the Cost of Not Being White in Brazil," 42–43. Silva concluded that the cost of not being white in Brazil was about 566 cruzeiros per month based on data from 1976.
11 Turner, "Brown into Black," 78.
12 Van Deburg, Black Camelot, 70–73.
13 Dzidzienyo, "The African Connection," 138–39; Turner, "Brown into Black," 84–85.
14 Dávila, Hotel Trópico, 190–91.
15 Gilroy, The Black Atlantic, 36. Gilroy's use of the term "counterculture" in this context draws on Zygmunt Bauman's theorization of the Left as a counterculture of modernity. See Bauman, "The Left as the Counter-Culture of Modernity," 92–93.
16 Diawara, "The 1960s in Bamako," 66.
17 Ibid., 63.
18 Ibid., 66.
19 Diawara, "The Song of the Griot," 16. May Joseph has described similar tensions between soul culture embraced by urban youth in Tanzania and the experiments with African socialism led by Julius Nyerere. Soul music and dance enacted a "politics of enjoyment" that expressed forms of cultural citizenship that were at odds with Ujamaa, a nationalist discourse of self-reliance. See Joseph, "Soul, Transnationalism, and Imaginings of Revolution," 130–31.
20 Lena Frias, "Black Rio: O orgulho (importado) de ser negro no Brasil," Jornal do Brasil, caderno B, July 17, 1976, 4–6. Throughout this chapter, I italicize English words, such as black, when they are used in the Brazilian sources.

I will use the unitalicized English word "black" to refer to people and movements typically identified as negro in Portuguese.

21 Tarlis Batista, "Os Blacks no embalo do soul," Manchete, September 11, 1976, 111.
22 Stam and Shohat, Race in Translation, 278.
23 Roberto M. Moura, "Carta aberta ao Black-Rio," O Pasquim, September 2–8, 1977. Cited in Alberto, "When Rio Was Black," 27.
24 Tarlis Batista, "Os Blacks no embalo do soul," Manchete, September 11, 1976, 113.
25 Luciano Martins, A "Geração AI-5" e Maio de 68, 19.
26 Vianna, O mundo do funk carioca, 26.
27 McCann, "Black Pau," 70.
28 Segal, Uneven Encounters, 87.
29 McCann, "Blues and Samba," 25.
30 Thayer, "Soul Searching," 94.
31 Motta, Vale tudo, 36–37.
32 McCann, "Black Pau," 72–73.
33 Thayer, "Soul Searching," 94.
34 Motta, Vale tudo, 66.
35 In 1966, for example, Elis Regina organized the March against Electric Guitars, which united a group of MPB artists who opposed the Jovem Guarda. One of the participants in the March against Electric Guitars was Gilberto Gil, who would soon thereafter lead the tropicalist movement. See documentary by Renato Terra and Ricardo Calil, Uma noite em 67, DVD (2010).
36 McCann, "Black Pau," 76.
37 Motta, Vale tudo, 97.
38 Gustavo Alves Alonso Ferreira, Simonal, 51–53.
39 The film was based on an actual historical figure, Chica da Silva, who, like many other black women born into slavery, used matrimonial strategies to secure manumission and ascend socially. In Diegues's film, the spelling of her name is altered, as the "Ch" becomes an "X," a change that slyly symbolized the hypersexualized representation of the heroine. See Furtado, Chica da Silva, 301–2.
40 See Randal Johnson, "Carnivalesque Celebration," 216–19. For some critics, the film was racist in its depictions of black female sexuality, while others praised it for its carnivalesque subversion of social roles. The left-wing journal Opinião dedicated several pages of the October 1, 1976, issue to Xica da Silva, with mostly negative reviews by Carlos Frederico, Carlos Hasenbalg, Beatriz Nascimento, Roberto DaMatta, and Antonio Calado.
41 "O 'soul' veio de BR-3 até o Rio," Tudo sobre o Festival Internacional da Canção, n.d., 23.
42 McCann, "Black Pau," 79–80.
43 Thayer, "Black Rio," 92.
44 Shtromberg, Art Systems, 55–57.
45 Homem de Melo, A era dos festivais, 380.

46 "O 'soul' veio de BR-3 até o Rio," *Tudo sobre o Festival Internacional da Canção*, n.d., 23.
47 Thayer, "Black Rio," 92–93.
48 The only other example that comes to mind is "Mulatinho Bamba" (Ary Barroso-Kid Pepe), recorded by white samba singer Carmen Miranda in 1935, which conveys female admiration for an elegant, brown-skinned samba dancer. Unlike the lyrics of "Black Is Beautiful," "Mulatinho Bamba" did not identify the female admirer as white, but in the voice of Miranda, who first recorded the song, such an association was implicit.
49 Alves, "O poder negro na pátria verde e amarela," 27–28.
50 Ibid., 32.
51 Maciel, *Nova consciência*, 169.
52 Arquivo Público do Estado do Rio de Janeiro, TN 23.16090, Departamento de Polícia Federal, Divisão de Censuras de Diversões Públicas, October 4, 1972.
53 Arquivo Público do Estado do Rio de Janeiro, Caixa 647, Departamento de Polícia Federal, Divisão de Censuras de Diversões Públicas, December 28, 1973.
54 D'Amico, "The Revolution Will Not Be Televised," 186–88.
55 Ventura, "Vazio Cultural," 49.
56 Thayer, "Black Rio," 90.
57 Bahiana, "Importação e assimilação: Rock, soul, discoteque," 59.
58 Sandra Almada, "O dom de ser negro," *Raça Brasil*, February 20, 2013.
59 Giacomini, *A alma da festa*, 28.
60 Ibid., 247–49.
61 Ibid., 209–10.
62 Ibid., 264.
63 Hanchard, *Orpheus and Power*, 88–89; Emanuelle Oliveira, *Writing Identity*, 33.
64 Alberto, "When Rio Was Black," 32.
65 Alberti and Pereira, *Histórias do movimento negro no Brasil*, 70–71.
66 Gonzalez and Hasenbalg, *Lugar de negro*, 34.
67 Ollie A. Johnson III, "Black Politics in Latin America," 67.
68 Alberti and Pereira, *Histórias do movimento negro no Brasil*, 85; Amilcar Araújo Pereira, "O 'Atlântico Negro,'" 252.
69 Giacomini, *A alma da festa*, 195–96.
70 Alberto, "When Rio Was Black," 15.
71 Frias, "Black Rio," 4.
72 Alberto, *Terms of Inclusion*, 276.
73 Ana Maria Bahiana, "Enlatando Black Rio," *Jornal de Música*, February 1977, 3–4. Bahiana reported that two small labels, Top Tape and Tapecar, were pioneers in collaborating with the soul *equipes* Soul Grand Prix and Dynamic Soul, respectively, to launch compilations.
74 One secret police report from 1975 reported that the soul dancers "made use of great quantities of marijuana." See Alberto, "When Rio Was Black," 10.
75 Giacomini, *A alma da festa*, 202.
76 Frias, "Black Rio," 5.
77 Ibid., 6.

78 Nelson Rodrigues Filho, "O soul: Ser D. João VI or Mr. John, eis a questão," *Artefato* 2, no. 10 (January 1979): 13.
79 Alberto, "When Rio Was Black," 9.
80 Arquivo Público do Estado do Rio de Janeiro, DGIE 232, 219-197, February 7, 1975.
81 Vianna, *O mundo do funk carioca*, 27–28; Alberto, "When Rio Was Black," 4.
82 Alberto, "When Rio Was Black," 14. For Dom Filó's account of this harrowing experience, see Pires, "Colorindo mémorias e redefinido olhares," 43.
83 Alberto, "When Rio Was Black," 22; Arquivo Público do Estado do Rio de Janeiro, DGIE 252, 10, July 22, 1976. The IPCN was also subject to surveillance for resisting the dominant narrative of racial democracy. See DGIE 296, 623–29, May 18, 1977, cited in Pires, "Colorindo mémorias e redefinindo olhares," 30–31.
84 Bahiana, "Enlatando Black Rio," 4.
85 McCann, "Black Pau," 85.
86 D'Amico, "The Revolution Will Not Be Televised," 190.
87 Ibrahim De Leve, "'Black Power no Brasil," *O Globo*, October 1, 1977. Cited by Alberto, "When Rio Was Black," 22. A journalist for *Última Hora* also denounced Gerson King but did not think he would have much of an impact in Brazil: "We don't believe he'll have any success since the black folks [crioulada] from here, in contrast to those (from the United States), don't have any problem fraternizing with whites and vice-versa." Luiz Augusto, "Na onda Black," *Última Hora*, November 1, 1977, 7.
88 Vianna, *The Mystery of Samba*, 61.
89 Cited in Turner, "Brown into Black"; Hanchard, *Orpheus and Power*, 115; and Alberto, "When Rio Was Black," 24.
90 Alberto, "When Rio Was Black," 24.
91 Flávia Oliveira, "Ditadura perseguiu até bailes black no Rio de Janeiro," *O Globo*, July 11, 2015.
92 "James Brown," *Jornegro* 1, no. 5 (November 1978).
93 Alberto, "When Rio Was Black," 29.
94 Arquivo Público do Estado do Rio de Janeiro, DGIE 252, October 5, 1976. See Alberto, "When Rio Was Black," 30.
95 Stam and Shohat, *Race in Translation*, 93–100.
96 Hanchard, *Orpheus and Power*, 114–16; Alberto, "When Rio Was Black," 27.
97 Tarik de Souza, "Soul: Sociologia e Mercado," *Jornal do Brasil*, August 27, 1976.
98 Batista, "Os Blacks no embalo do soul," 113.
99 In Marxist theory, capitalism produces alienation by instrumentalizing human activity through the exploitation of labor. Alienation describes the condition under industrial capitalism when workers lose control of their productive capacity in the service of capital accumulation. Anticolonial writers further theorized alienation as a psychological effect produced by colonialism sustained by forms of racial domination, especially white supremacy. As a necessary condition of liberation, colonized black and brown people needed to "free their minds" from specific forms of alienation such as racial self-hatred and the emulation of white ideals.

100 "Black Rio," *Veja*, November 1976, 156–58.
101 Pires, "Colorindo memórias e redefinindo olhares," 38.
102 Giacomini, *A alma da festa*, 219; "Black Rio," *Veja*, November 1976, 156–58.
103 Ratts and Rios, *Lélia Gonzalez*, 79–80.
104 Pereira and Buarque de Hollanda, *Patrulhas Ideológicas*, 208–9.
105 In a radio documentary produced by Sean Barlow for Afropop Worldwide (2009), Turner stated: "I can remember going out dancing with Lélia and dancing until seven o'clock in the morning. With her hennaed afro hair and these ringlets just shaking all over the place and these red high-heeled boots and other things that only Lélia could pull off. But Lélia loved to dance. She felt that by dancing, by expressing oneself culturally, one also expressed oneself politically." See http://soundcloud.com/afropop-worldwide/brazilian-soul (accessed October 26, 2013).
106 Gonzalez and Hasenbalg, *Lugar de Negro*, 32–33.
107 McCann, "Black Pau," 86.
108 Hanchard, *Orpheus and Power*, 115; Covin, *Unified Black Movement in Brazil*, 50–53.
109 McCann, "Black Pau," 86.
110 Ibid., 88.
111 Turner, "Brown into Black," 84; Alberto, *Terms of Inclusion*, 258.

CHAPTER 5

1 "Caetano no templo de caetanismo," *Veja*, January 19, 1972, 62.
2 Veloso, *Verdade Tropical*, 481.
3 Leu, *Brazilian Popular Music*, 32.
4 Arquivo Público do Estado do Rio de Janeiro, Continuação PB SP/SA 78, Secreto 268, January 10, 1972.
5 Cowan, "'Why Hasn't This Teacher Been Shot?,'" 408; Cowan, *Securing Sex*, 74.
6 "Caetano no templo de caetanismo," *Veja*, January 19, 1972, 63.
7 Santiago, *Uma literatura nos trópicos*, 148.
8 See, for example, the long interview with Caetano Veloso conducted by Jorge Mautner, "Caretano," *Rolling Stone* 7, May 2, 1972, 10–13.
9 Santiago, *Uma literatura nos trópicos*, 160–61.
10 Alvarez, *Engendering Democracy*, 33.
11 Ibid., 51. Of all Brazilians between the ages of eighteen and twenty-four, only 5.11 percent of women and 4.75 percent of men attended universities in 1980, compared to 2.84 percent and 3.65 percent in 1970.
12 Manzano, *The Age of Youth in Argentina*, 122.
13 Langland, "Birth Control Pills and Molotov Cocktails," 310.
14 Alvarez, *Engendering Democracy*, 84.
15 Langland, *Speaking of Flowers*, 159.
16 Ibid., 162–63.
17 Women accounted for 16 percent of those detained for participating in the clandestine opposition, most of whom belonged to the middle class. Ridenti, *O fantasma da revolução brasileira*, 205.

18 Langland, "Birth Control Pills and Molotov Cocktails," 329–34.
19 Manzano, *The Age of Youth in Argentina*, 155.
20 "Leila Diniz: &$£7," *O Pasquim* 22, November 20–26, 1969.
21 Joaquim Ferreira dos Santos, *Leila Diniz*, 149.
22 Ibid., 165.
23 Ibid., 172–73.
24 Castro, *Ela é Carioca*, 211.
25 Cowan documents a number of organizations, such as the Liga de Defesa Nacional (National Defense League), the Instituto de Pesquisas e Estudos Sociais (IPES, Institute for Social Research and Study), the Instituto Brasileiro de Ação Democrática (IBAD, Brazilian Institute for Democratic Action), Tradição, Família, e Propriedade (Tradition, Family, and Property), and Rearmamento Moral (Moral Rearmament). Cowan, "'Why Hasn't This Teacher Been Shot?,'" 406–8; Cowan, *Securing Sex*, 74.
26 Cowan, "Sex and the Security State," 463.
27 Ibid., 465.
28 Pacheco e Silva, *Hippies, drogas, sexo, poluição*, 7–8.
29 Ibid., 79.
30 Ibid., 80.
31 Green, "'Who Is the Macho Who Wants to Kill Me?,'" 450. See also Cowan, *Securing Sex*, 65–66.
32 Parker, *Beneath the Equator*, 30.
33 Green, *Beyond Carnival*, 187.
34 Hélio Oiticica, letter to Gilberto Gil, March 14, 1970, Archive of Programa Hélio Oiticica.
35 Green, *Beyond Carnival*, 264.
36 *O Pasquim* 7, August 1969.
37 Tarso de Castro, "Bicha," *O Pasquim* 54, July 2–8, 1970.
38 *O Pasquim* 105, July 8–14, 1971; Green, *Beyond Carnival*, 264–65.
39 Green, "O Pasquim e Madame Satã," 211.
40 Green, *Beyond Carnival*, 246.
41 Parker, *Beneath the Equator*, 36.
42 Fry, *Para ingles ver*, 93–94.
43 Altman, "Rupture or Continuity?," 77–78.
44 Fry, *Para ingles ver*, 109.
45 Lovaas, Elia, and Yep, "Shifting Ground(s)," 5–6.
46 Green, *Beyond Carnival*, 269.
47 Dias, *Anos 70*, 292.
48 Ibid., 295.
49 Trevisan, *Pedaço de mim*, 144.
50 Green, *Beyond Carnival*, 271.
51 Ibid., 301–2.
52 Simões Junior, *. . . E havia uma lampião na esquina*, 73–74.
53 "Ney Matogrosso sem bandeira—Liberação? Cada um cuide da sua," *Lampião da Esquina* 11 (April 1979): 7.

54 Trevisan, *Devassos no Paraíso*, 288; Lobert, *A palavra mágica*, 24. The members of Dzi Croquettes were only vaguely aware of The Cockettes, a San Francisco–based underground theater group from the early 1970s that also challenged gender norms.
55 Lobert, *A palavra mágica*, 22.
56 Whittle, "Gender Fucking or Fucking Gender?," 117; Trevisan, *Devassos no Paraíso*, 288.
57 Lobert, *A palavra mágica*, 48–49.
58 Quoted in ibid., 245.
59 Morari, *Secos & Molhados*, 33.
60 Vaz, *Ney Matogrosso*, 75.
61 Ibid., 73.
62 Ibid., 77.
63 Morari, *Secos & Molhados*, 11.
64 Ibid., 26. João Ricardo affirmed that "Caetano Veloso and Gilberto Gil were extremely important for the creation of Secos & Molhados. Tropicalism provided an opening for us to become what we are today."
65 Pedro Alexandre Sanches, "Homem-banda tenta reeditar Secos & Molhados," *Folha de São Paulo*, June 4, 1999. Cited in Trevisan, *Devassos no Paraíso*, 289.
66 "Fadas e bruxas," *Veja*, December 12, 1973, 106. See also Faour, *História Sexual da MPB*, 385.
67 In 1975, the music producer and television host Carlos Imperial launched a scathing attack in the newspaper *Última Hora* against what he saw as Matogrosso's "disgusting attitudes" on stage. Vaz, *Ney Matogrosso*, 87–88.
68 See, for example, Gerson Conrad's blunt disavowal of the "underground" and "gay power," in Morari, *Secos & Molhados*, 45.
69 Butterman, "Ney é gay, não é?," 558–60.
70 The 1974 recording of "Homem com H" with information about the song's history can be found on the site of DJ Mister Sam, who was a producer at Copacabana Discos at that time. See http://entretenimento.r7.com/blogs/mister-sam/2014/09/02/a-verdadeira-historia-da-musica-homem-com-h/ (accessed September 7, 2015).
71 Braga-Pinto, "Supermen and Chiquita Bacana's Daughters," 192–93; Butterman, "Ney é gay, não é," 559.
72 Interview with Vânia Toledo and Nelson Motta, "Ney fala sem make-up," *Interview* 5, May 1978. See Green and Polito, *Frescos trópicos*, 150–51.
73 Green, *Beyond Carnival*, 259.
74 Vaz, *Ney Matogrosso*, 185.
75 "Ney excita e gosta," *IstoÉ*, December 28, 1977, 12. In this interview he asserted: "People have a distorted view of homosexuality. They think it's an illness, something sad, causes suffering. It's none of that. Now I don't believe in organizing, in movements, in homosexual consciousness-raising."
76 "Ney Matogrosso sem bandeira—Liberação? Cada um cuide da sua," *Lampião da Esquina* 11 (April 1979): 5.
77 See interview with Matogrosso in Weinschelbaum, *Estação Brasil*, 68–69.

78 Santiago, *O cosmopolitismo do pobre*, 201–2.
79 Braga-Pinto, "Supermen and Chiquita Bacana's Daughters," 199.
80 Roszak, *The Making of a Counter Culture*, 74.
81 Monteiro, "Cross-Dressed Poetics," 64.
82 "Menino do Rio" inspired a 1982 film of the same name directed by Antonio Calmon, who transformed it into a heterosexual story about the star-crossed love between a surfer and an upper-class society girl.
83 Gil, *Todas as letras*, 145.
84 Perrone, *Masters of Contemporary Brazilian Song*, 111.
85 Matory, *Black Atlantic Religion*, 207.
86 Braga-Pinto, "Supermen and Chiquita Bacana's Daughters," 196.
87 Perrone, *Masters of Contemporary Brazilian Song*, 111; Monteiro, "Cross-Dressed Poetics," 95.
88 Pereira and Buarque de Hollanda, *Patrulhas Ideológicas*, 186–87.
89 Idelber Avelar has noted how Gabeira narrated his experience with the armed struggle as a "Batmanesque adventure" that erased politics by obscuring difficult questions about the complicity of middle-class Brazilians with the regime. See Avelar, *The Untimely Present*, 66.
90 Avelar, "Fernando Gabeira y la crítica da la masculinidad," 149.
91 Rebecca Atencio has called attention to the way that Gabeira's memoir enacts "reconciliation through memory" by humanizing members of the security forces and obscuring the grave human rights abuses of the regime. Atencio, *Memory's Turn*, 37.
92 Moraes Neto, *Dossiê Gabeira*, 137.
93 Sirkis, *Os carbonários*, 26.
94 Avelar, "Fernando Gabeira y la crítica da la masculinidad," 149.
95 Silveira, "La force et la douceur de la force," 14.

EPILOGUE

1 Arenas, "Estar entre o lixo e a esperança," 56.
2 Abreu, *Morangos Mofados*, 15.
3 Maciel, *As quatro estações*, 231.
4 Mautner, *Mitologia do Kaos*, 238.
5 Guattari and Rolnik, *Molecular Revolution in Brazil*, 261.
6 Binkley, *Getting Loose*, 4–5.
7 Jacobi, "Movimento ambientalista no Brasil."
8 Hochstetler and Keck, *Greening Brazil*, 91–92.
9 Gabeira, *Vida Alternativa*, 68–69.
10 Ibid., 70.
11 Polari, *Em busca do tesouro*, 122.
12 Gabeira, *Vida Alternativa*, 76–77.
13 Atencio, *Memory's Turn*, 123.

Bibliography

Abreu, Caio Fernando. *Morangos Mofados*. São Paulo: Brasiliense, 1982.
Aguiar, Gonzalo. *Poesia concreta brasileira: As vanguardas na encruzilhada modernista*. São Paulo: Edusp, 2005.
Alberti, Verena, and Amilcar Araújo Pereira, eds. *Histórias do movimento negro no Brasil*. Rio de Janeiro: Pallas, 2007.
Alberto, Paulina. "Para Africano Ver: African-Bahian Exchanges in the Reinvention of Brazil's Racial Democracy, 1961–63." *Luso-Brazilian Review* 45, no. 1 (June 2008): 78–117.
———. *Terms of Inclusion: Black Intellectuals in Twentieth-Century Brazil*. Chapel Hill: University of North Carolina Press, 2011.
———. "When Rio Was Black: Soul Music, National Culture, and the Politics of Racial Comparison in 1970s Brazil." *Hispanic American Historical Review* 89, no. 1 (2009): 3–39.
Almeida, Armando. "A contracultura e a política que o Ilê Aiyê inaugura: relações de poder na contemporaneidade." Ph.D. diss., Universidade Federal da Bahia, 2010.
Almeida, Maria Hermínia Tavares de, and Luiz Weis. "Carro zero e pau-de-arara: O cotidiano da oposição de classe média ao regime military." In *História da vida privada no Brasil: Contrastes da intimidade contemporânea*, edited by Fernado Novais and Lilia Moritz Schwartz, 320–409. São Paulo: Companhia das Letras, 1998.
Almeida, Maria Isabel Mendes de, and Santuza Cambraia Naves. *"Por que não?" Rupturas e continuidades da contracultura*. Rio de Janeiro: 7 Letras, 2007.
Altman, Dennis. "Rupture or Continuity? The Internationalization of Gay Identities." *Social Text* 48 (Autumn 1996): 77–94.
Alvarez, Sonia. *Engendering Democracy in Brazil: Women's Movements in Transition Politics*. Princeton: Princeton University Press, 1990.
Alves, Amanda Palomo. "O poder negro na pátria verde e amarela: Musicalidade, política e identidade em Tony Tornado (1970)." M.A. thesis, Universidade Estadual de Maringá, 2010.
Araújo, Maria Paula Nascimento. *A utopia fragmentada: As novas esquerdas no Brasil e no mundo na década de 1970*. Rio de Janeiro: Editora FGV, 2000.
Araújo, Paulo César de. *Eu não sou cachorro, não: Música popular cafona e ditadura military*. Rio de Janeiro: Editora Record, 2002.
Arenas, Fernando. "Estar entre o lixo e a esperança: *Morangos Mofados* de Caio Fernando Abreu." *Brasil/Brazil* 8 (1992): 53–67.

Asbury, Michael. "This Other Eden: Hélio Oiticica and Subterranean London." In *Oiticica in London*, edited by Guy Brett and Luciano Figueiredo, 34–39. London: Tate Publishing, 2007.

Atencio, Rebecca. *Memory's Turn: Reckoning with Dictatorship in Brazil*. Madison: University of Wisconsin Press, 2014.

Avelar, Idelber. "Fernando Gabeira y la crítica de la masculinidad: La fabricación de un mito." In *El lenguaje de las emociones: Afecto y cultura en América Latina*, edited by Mabel Moraña and Ignácio Sanchez Prado, 137–50. Frankfurt: Iberoamericana/Verveurt, 2012.

———. *The Untimely Present: Postdictatorial Latin American Fiction and the Task of Mourning*. Durham: Duke University Press, 1999.

Bahiana, Ana Maria. "Importação e assimilação: Rock, soul, discotheque. In *Anos 70: Ainda sob a tempestade*, edited by Adauto Novaes, 53–60. Rio de Janeiro: Aeroplano, 2005.

Barr-Melej, Patrick. "Siloísmo and the Self in Allende's Chile: Youth, 'Total Revolution,' and the Roots of the Humanist Movement." *Hispanic American Historical Review* 86, no. 4 (2006): 747–84.

Barros, Carlos. "Doces Bárbaros: Um estudo sobre construções de identidades baianas." M.A. thesis, Universidade Federal da Bahia, 2005.

Basualdo, Carlos, ed. *Tropicália: A Revolution in Brazilian Culture*. São Paulo: Cosac Naify, 2005.

Bauman, Zygmunt. *Globalization: The Human Consequences*. New York: Columbia University Press, 1998.

———. "The Left as the Counter-Culture of Modernity." *Telos* 70 (Winter 1986–87): 81–93.

Beal, Sophia. *Brazil under Construction: Fiction and Public Works*. New York: Palgrave Macmillan, 2013.

Benjamin, Walter. "Left Melancholy." In *The Weimar Republic Sourcebook*, edited by Anton Kaes, Martin Jay, and Edward Dimendberg, 304–6. Berkeley: University of California Press, 1994.

Bentes, Ivana. "Multitropicalism, Cinematic-Sensation, and Theoretical Devices." In *Tropicália: A Revolution in Brazilian Culture*, edited by Carlos Basualdo, 99–128. São Paulo: Cosac Naify, 2005.

Bião, Armindo. *Verbo Encantado*. Lauro de Freitas, BA: Solisluna Editora, 2013.

Binkley, Sam. *Getting Loose: Lifestyle Consumption in the 1970s*. Durham: Duke University Press, 2007.

Borges, Dain. "The Recognition of Afro-Brazilian Symbols and Ideas, 1890–1940." *Luso-Brazilian Review* 32, no. 2 (Winter 1995): 57–78.

Braga, José Luiz. *O Pasquim e os anos 70: Mais pra epa que pra oba*. Brasília: Editora UNB, 1991.

Braga, Paula. "Conceitualismo e vivência." In *Fios Soltos: A arte de Hélio Oiticica*, edited by Paula Braga, 259–87. São Paulo: Perspectiva, 2008.

Braga-Pinto, César. "Supermen and Chiquita Bacana's Daughters: Transgendered Voices in Brazilian Popular Music." In *Lusosex: Gender and Sexuality in the*

Portuguese-Speaking World, edited by Susan Canty Quinlan and Fernando Arenas, 187–207. Minneapolis: University of Minnesota Press, 2002.

Brandão, Antonio Carlos, and Milton Fernandes Duarte. *Movimentos culturais de juventude*. São Paulo: Moderna, 1990.

Brasil, Bruno. "Por um mundo livre e menos 'careta': a imprensa alternativa durante o regime military." *Anais da Biblioteca Nacional* 124 (2004): 8–20.

Braunstein, Peter, and Michael William Doyle, eds. *Imagine Nation: The American Counterculture of the 1960s and '70s*. New York: Routledge, 2002.

Brett, Guy. "Lygia Clark: In Search of the Body." *Art in America* 57 (July 1994): 57–108.

Brett, Guy, and Luciano Figueiredo, eds. *Oiticica in London*. London: Tate Publishing, 2007.

Brito, Ronaldo. "As ideologias construtivas no ambiente cultural brasileiro." In *Crítica de Arte no Brasil: Temáticas Contemporâneas*, edited by Glória Ferreira, 73–81. Rio de Janeiro: Funarte, 2006.

———. *Neoconcretismo: Vértice e ruptura do projeto construtivo brasileiro*. São Paulo: Cosac Naify, 1999.

Brown, Diana De G. "Power, Invention, and the Politics of Race: Umbanda Past and Future." In *Black Brazil: Culture, Identity, and Social Mobilization*, edited by Larry Crook and Randal Johnson, 213–36. Los Angeles: UCLA Latin America Center, 1999.

Buarque de Hollanda, Heloísa. *Impressões de viagem: CPC, vanguarda, desbunde: 1960/70*. Rio de Janeiro: Rocco, 1980.

———. *26 poetas hoje*. Rio de Janeiro: Aeroplano, 2001.

Bueno, André. *Pássaro de fogo no terceiro mundo: O poeta Torquato Neto e sua época*. Rio de Janeiro: 7 Letras, 2005.

Bürger, Peter. *Theory of the Avant-Garde*. Minneapolis: University of Minnesota Press, 1984.

Butterman, Steven F. "Ney é gay, não é? The Emergence and Performance of Queer Identities in Brazilian Popular Music (MPB) under Dictatorship." In *Music and Dictatorship in Europe and Latin America*, edited by Roberto Illiano and Massimiliano Sala, 549–72. Turnhout, Belgium: Brepols, 2009.

Calirman, Claudia. *Brazilian Art under Dictatorship: Antonio Manuel, Artur Barrio, and Cildo Meireles*. Durham: Duke University Press, 2012.

Campos, Augusto de. *Balanço da bossa e outras bossas*. São Paulo: Perspectiva, 1972.

Campos, Haroldo de. *Metalinguagem*. Petrópolis, RJ: Vozes, 1970.

Candido, Antonio. "A literatura brasileira em 1972." *Revista Iberoamericana* 43, nos. 98–99 (January–June 1977): 5–16.

Canuto, Roberta. *Rogério Sganzerla—Encontros*. Rio de Janeiro: Azougue Editorial, 2007.

Capellari, Marcos Alexandres. "O discurso da contracultura no Brasil: O *underground* através de Luiz Carlos Maciel (c. 1970)." Ph.D. diss., Universidade de São Paulo, 2007.

Cardoso, Ivan. *O mestre do terrir*. São Paulo: Remier, 2008.

Cardoso, Ivan, and R. F. Lucchetti, eds. *Ivampirismo: O cinema em pânico*. Rio de Janeiro: Editora Brasil-América, 1990.

Carlini, Elisaldo Araújo. "A história da maconha no Brasil." *Jornal Brasileiro de Psiquiatria* 55, no. 4 (2006): 314–17.

Carvalho, Maria do Socorro Silva. *A nova onda baiana: Cinema na Bahia 1958/1962*. Salvador: Edufba, 2003.

Castro, Ruy. *Ela é Carioca: Uma enciclopedia de Ipanema*. São Paulo: Companhia das Letras, 1999.

Cendrars, Blaise. *Christmas at the Four Corners of the Earth*. Rochester, N.Y.: Boa Editions, 1994.

Chevalier, Scarlet Moon de. *Areias escaldantes: Inventário de uma praia*. Rio de Janeiro: Rocco, 1999.

Chinem, Rivaldo. *Imprensa Alternativa: Jornalismo de oposição e inovação*. São Paulo: Editora Ática, 1995.

Cícero, Antonio. "A falange de máscaras de Waly Salomão." Preface to *Me segura qu'eu vou dar um troço*, by Waly Salomão. Rio de Janeiro: Aeroplano, 2003.

Coelho, Claudio Novaes Pinto. "A contracultura: O outro lado da modernização autoritária." In *Anos 70: Trajetórias*, edited by Antonio Risério, 39–44. São Paulo: Iluminuras/Itaú Cultural, 2006.

Coelho, Frederico. *Eu, brasileiro, confesso minha culpa e meu pecado: Cultura marginal no Brasil nas décadas de 1960 e 1970*. Rio de Janeiro: Civilização Brasileira, 2010.

———. *Livro ou livro-me: Os escritos babilônicos de Hélio Oiticica (1971–1978)*. Rio de Janeiro: Eduerj, 2010.

Cohn, Sergio, ed. *Nuvem Cigana: Poesia e delirio dos anos 70*. Rio de Janeiro: Azougue, 2007.

Covin, David. *The Unified Black Movement in Brazil, 1978–2002*. Jefferson, N.C.: McFarland, 2006.

Cowan, Benjamin. *Securing Sex: Morality and Repression in the Making of Cold War Brazil*. Chapel Hill: University of North Carolina Press, 2016.

———. "Sex and the Security State: Gender, Sexuality, and 'Subversion' at Brazil's Escola Superior de Guerra, 1964–1985." *Journal of the History of Sexuality* 16, no. 3 (July 2007): 459–81.

———. "'Why Hasn't This Teacher Been Shot?' Moral-Sexual Panic, the Repressive Right, and Brazil's National Security State." *Hispanic American Historical Review* 92, no. 3 (2012): 401–36.

D'Amico, Francesca. "The Revolution Will Not Be Televised, but It Will Be Recorded: Soul, Funk, and the Black Urban Experience, 1968–1979." In *The Global Sixties in Sound and Vision: Media, Counterculture, Revolt*, edited by Timothy Brown and Andrew Lison, 185–209. New York: Palgrave-Macmillan, 2014.

Dávila, Jerry. *Hotel Trópico: Brazil and the Challenge of African Decolonization, 1950–1980*. Durham: Duke University Press, 2010.

Degler, Carl. *Neither Black nor White: Slavery and Race Relations in Brazil and the United States*. Madison: University of Wisconsin Press, 1971.

DeKoven, Marianne. *Utopia Limited: The Sixties and the Emergence of the Postmodern*. Durham: Duke University Press, 2004.

Dias, Lucy. *Anos 70: Enquanto corria a barca*. São Paulo: Editora Senac, 2003.

Diawara, Manthia. "The 1960s in Bamako: Malick Sidibé and James Brown." *Black Renaissance Noir* 4, nos. 2–3 (Summer/Fall 2002): 59–83.
———. "The Song of the Griot." *Transition* 74 (1997): 16–30.
Doutrina Básica. Rio de Janeiro: Escola Superior de Guerra, 1979.
Drummond de Andrade, Carlos. *O Poder Ultra-Jovem e mais 79 em prosa e verso*. Rio de Janeiro: José Olympio, 1972.
Dunn, Christopher. *Brutality Garden: Tropicália and the Emergence of a Brazilian Counterculture*. Chapel Hill: University of North Carolina Press, 2001.
———. "*Desbunde* and Its Discontents: Counterculture and Authoritarian Modernization in Brazil, 1968–1974." *Americas* 70, no. 3 (January 2014): 429–58.
———. "Experience the Experimental: Avant-Garde, *Cultura Marginal*, and Counterculture in Brazil, 1968–72." *Luso-Brazilian Review* 50, no. 1 (Fall 2013): 229–52.
———. "Jorge Mautner and Countercultural Utopia in Brazil." In *The Utopian Impulse in Latin America*, edited by Kim Beauchesne and Alessandra Santos, 173–85. New York: Palgrave-Macmillan, 2011.
———. "Mapping Tropicália." In *The Global Sixties in Sound and Vision: Media, Counterculture, Revolt*, edited by Timothy Brown and Andrew Lison, 29–42. New York: Palgrave-Macmillan, 2014.
———. "The Tropicalista Rebellion: A Conversation with Caetano Veloso." *Transition* 70 (1996): 116–38.
———. "Waly Salomão: Polyphonic Poet." *Review: Literature and Arts of the Americas* 39, no. 2 (2006): 249–55.
Durham, Eunice Ribeiro. "O sistema federal de ensino superior: Problemas e alternativas." *Revista Brasileira de Ciências Sociais* 8, no. 23 (October 1993): 5–37.
Dzidzienyo, Anani. "The African Connection and the Afro-Brazilian Condition." In *Race, Class, and Power in Brazil*, edited by Pierre-Michel Fontaine, 135–53. Los Angeles: UCLA Center for Afro-American Studies, 1985.
Eco, Umberto. *Apocalypse Postponed*. Bloomington: Indiana University Press, 2000.
Epstein, Jack. *Along the Gringo Trail: A Budget Travel Guide to Latin America*. Berkeley: And/Or Press, 1977.
Faour, Rodrigo. *História Sexual da MPB: A evolução do amor e do sexo na canção brasileira*. Rio de Janeiro: Editora Record, 2006.
Farber, David. "The Intoxicated State/Illegal Nation: Drugs in the Sixties Counterculture." In *Imagine Nation: The American Counterculture of the 1960s and '70s*, edited by Peter Braunstein and Michael William Doyle, 17–40. New York: Routledge, 2002.
Farias, Agnaldo. "Apollo in the Tropics: Constructivist Art in Brazil." In *Brazil: Body and Soul*, edited by Edward J. Sullivan, 398–405. New York: Guggenheim Museum, 2002.
Favaretto, Celso. *A invenção de Hélio Oiticica*. São Paulo: Edusp, 1992.
Feijó, Martin Cezar. "Hair 40 anos depois—uma viagem pessoal." *Trama Interdisciplinar* 2, no. 1 (2011): 89–99.
Ferraz, Eucanaã, and Roberto Conduro. "Na trilha da Navilouca." *Sibila: Revista de Poesia e Cultura* 4, no. 7 (2004): 185–214.

Ferreira, Gustavo Alves Alonso. *Simonal: Quem não tem swing morre com a boca cheia de formiga*. Rio de Janeiro: Editora Record, 2011.
Ferreira, Jairo. *Cinema de Invenção*. São Paulo: Editora Limiar, 2000.
Fico, Carlos. *Reinventando o otimismo: ditadura, propaganda e imaginário no Brasil*. Rio de Janeiro: Editora FGV, 1997.
Figari, Carlos. *@s "outr@s" cariocas: Interpelações, experiências, e identidades homo-seróticas no Rio de Janeiro, séculos XVII ao XX*. Belo Horizonte: Editora UFMG, 2007.
Figueiredo, Luciano. "The Other Malady." *Third Text* 8, nos. 28–29 (1994): 105–16.
———, ed. *Lygia Clark—Hélio Oiticica: Cartas, 1964–74*. Rio de Janeiro: Editora UFRJ, 1998.
Filho, César Oiticica, ed. *Hélio Oiticica*. Rio de Janeiro: Projeto Hélio Oiticica, 1992.
Foster, Hal. *The Return of the Real: The Avant-Garde at the End of the Century*. Cambridge: MIT Press, 1996.
Frank, Thomas. *The Conquest of Cool: Business Culture, Counterculture, and the Rise of Hip Consumerism*. Chicago: University of Chicago Press, 1997.
Freire, Jurandir Costa. *Violência e Psicanálise*. Rio de Janeiro: Editora Graal, 1984.
Freyre, Gilberto. *Bahia e Bahianos*. Salvador: Empresa Gráfica da Bahia, 1990.
———. *Casa Grande e Senzala*. Rio de Janeiro: Editora José Olympio, 1952.
Fry, Peter. *Para ingles ver: Identidade e políitica na cultura brasileira*. Rio de Janeiro: Zahar Editores, 1982.
Furtado, Júnia Ferreira. *Chica da Silva: A Brazilian Slave of the Eighteenth Century*. Cambridge: Cambridge University Press, 2009.
Gabeira, Fernando. *Negócio Seguinte*. Rio de Janeiro: Codecri, 1982.
———. *Nova Consciência: jornalismo contracultural—1970/72*. Rio de Janeiro: Eldorado, 1973.
———. *O Crepúsculo do macho*. Rio de Janeiro: Codecri, 1980.
———. *O que é isso, companheiro?* Rio de Janeiro: Codecri, 1979.
———. *Vida Alternativa*. Porto Alegre: L&PM Editores, 1985.
Galvão, Luiz. *Anos 70: Novos e baianos*. Rio de Janeiro: Editora 34, 1997.
———. *Geração Baseada*. Rio de Janeiro: Editora Codecri, 1982.
Gaspari, Elio, Heloísa Buarque de Hollanda, and Zuenir Ventura. *70/80: Cultura em trânsito: Da repressão à abertura*. Rio de Janeiro: Aeroplano, 2000.
Giacomini, Sonia Maria. *A alma da festa: Família, etnicidade e projetos num clube social do Rio de Janeiro, o Renascença Clube*. Belo Horizonte: Editora UFMG, 2006.
Gil, Gilberto. *Todas as letras*. São Paulo: Companhia das Letras, 1996.
Gilroy, Paul. *The Black Atlantic: Modernity and Double Consciousness*. Cambridge: Harvard University Press, 1993.
Góes, Fred. *O país do carnaval elétrico*. Salvador: Corrupio, 1982.
Goffman, Ken, and Dan Joy. *Counterculture through the Ages: From Abraham to Acid House*. New York: Villard Books, 2004.
Gonçalves Dias, Cleber Augusto. "O surfe e a moderna tradição brasileira." *Movimento* 15, no. 4 (October–December 2009): 257–86.
Gonzalez, Lélia, and Carlos Hasenbalg. *Lugar de negro*. Rio de Janeiro: Marco Zero, 1982.
Gosse, Van. "A Movement of Movements: The Definition and Periodization of the

New Left." In *A Companion to Post-1945 America*, edited by Jean-Christophe Agnew and Roy Rosenzweig, 278–302. London: Blackwell, 2002.

Grandin, Greg. *The Last Colonial Massacre: Latin America in the Cold War*. Chicago: University of Chicago Press, 2004.

Green, James. *Beyond Carnival: Male Homosexuality in Twentieth-Century Brazil*. Chicago: University of Chicago Press, 2001.

———. "O Pasquim e Madame Satã, a 'rainha' negra da boemia brasileira." *Topoi* 4, no. 7 (July–December 2003): 201–21.

———. "'Who Is the Macho Who Wants to Kill Me?': Male Homosexuality, Revolutionary Masculinity, and the Brazilian Armed Struggle of the 1960s and 1970s." *Hispanic American Historical Review* 92, no. 3 (2012): 437–69.

Green, James, and Ronald Polito. *Frescos trópicos: Fontes sobre a homosexualidade masculina no Brasil (1870–1980)*. Rio de Janeiro: José Olympio, 2006.

Guattari, Félix, and Suely Rolnik. *Molecular Revolution in Brazil*. Los Angeles: Semiotext(e), 2008.

Gullar, José Ribamar Ferreira. *Vanguarda e subdesenvolvimento: Ensaios sobre arte*. Rio de Janeiro: Civilização Brasileira, 1969.

Hamilton, Russell G. "The Present State of African Cults in Bahia." *Journal of Social History* 3, no. 4 (Summer 1970): 357–73.

Hanchard, Michael. *Orpheus and Power: The Movimento Negro of Rio de Janeiro and São Paulo, 1945–1988*. Princeton: Princeton University Press, 1998.

Harvey, John. "Transando com Deus e o Lobisomem: Counterculture and Authoritarianism in *Brasil Grande*." Ph.D. diss., Tulane University, 2004.

Hasenbalg, Carlos. *Discriminação e desigualdade raciais no Brasil*. Rio de Janeiro: Graal, 1979.

Heath, Joseph, and Andrew Potter. *Nation of Rebels: Why Counterculture Became Consumer Culture*. New York: HarperCollins, 2004.

Herkenhoff, Paulo. "The Hand and the Glove." In *Inverted Utopias: Avant-Garde Art in Latin America*, edited by Mari Carmen Ramírez and Héctor Olea, 237–44. New Haven: Yale University Press, 2004.

Hinderer Cruz, Max Jorge. "Tropicamp: Some Notes on Hélio Oiticica's 1971 Text." *Afterall* 28 (Autumn/Winter 2011). http://www.afterall.org/journal/issue.28/tropicamp-pre-and-post-tropic-lia-at-once-some-contextual-notes-onhlio-oiticica-s-1971-te. Accessed March 28, 2014.

Hochstetler, Kathryn, and Margaret Keck. *Greening Brazil: Environmental Activism in State and Society*. Durham: Duke University Press, 2007.

Höfling, Ana Paula. "Staging Capoeira, Samba, *Maculelê*, and *Candomblé*: Viva Bahia's Choreographies of Afro-Brazilian Folklore for the Global Stage." In *Performing Brazil: Essays on Culture, Identity, and the Performing Arts*, edited by Severino Albuquerque and Kathryn Bishop-Sanchez, 98–125. Madison: University of Wisconsin Press, 2015.

Homem de Melo, Zuza. *A era dos festivais: Uma parabola*. Rio de Janeiro: Editora 34, 2003.

Ickes, Scott. *African-Brazilian Identity and Regional Identity in Bahia, Brazil*. Gainesville: University Press of Florida, 2013.

———. "Salvador's Modernizador Cultural: Odorico Tavares and the Aesthetics of Baianidade, 1945–1955." The Americas 69, no. 4 (April 2013): 437–66.
Jacobi, Pedro. "Movimento ambientalista no Brasil: Representação social e complexidade da articulação de práticas coletivas." In Patrimônio Ambiental Brasileiro, edited by Wagner Costa Ribeiro, 519–43. São Paulo: Edusp, 2003.
Johnson, Ollie A., III. "Black Politics in Latin America: An Analysis of National and Transnational Politics." In African American Perspectives on Political Science, edited by Wilbur Rich, 55–75. Philadelphia: Temple University Press, 2007.
Johnson, Randal. "Carnivalesque Celebration in Xica da Silva." In Brazilian Cinema, 2nd ed., edited by Randal Johnson and Robert Stam, 216–24. New York: Columbia University Press, 1995.
Joseph, May. "Soul, Transnationalism, and Imaginings of Revolution: Tanzanian Ujamaa and the Politics of Enjoyment." In Soul: Black Power, Politics, and Pleasure, edited by Monique Guillory and Richard C. Green, 126–38. New York: New York University Press, 1998.
Jost, Miguel, and Sergio Cohn, eds. O Bondinho. Rio de Janeiro: Azougue, 2008.
Kaminski, Leon Frederico. "Por entre a neblina: O Festival de Inverno de Ouro Preto (1967–1979)." M.A. thesis, Universidade Federal de Ouro Preto, 2012.
Kehl, Maria Rita. "As duas décadas dos anos 70." In Anos 70: Trajetórias, edited by Antonio Risério, 31–38. São Paulo: Iluminuras/Itaú Cultural, 2006.
Khouri, Omar. Revistas na era pós-verso: Revistas experimentais e edições autônomas de poemas no Brasil, dos anos 70 aos 90. São Paulo: Ateliê Editorial, 2004.
Kottak, Conrad Phillip. Assault on Paradise: Social Change in a Brazilian Village. New York: McGraw Hill–College, 1999.
Kucinski, Bernard. Jornalistas e revolucionários nos tempos da imprensa alternativa. São Paulo: Edusp, 2003.
Landes, Ruth. City of Women. Albuquerque: University of New Mexico Press, 1994.
Langland, Victoria. "Birth Control Pills and Molotov Cocktails: Reading Sex and Revolution in 1968 Brazil." In In from the Cold: Latin America's New Encounter with the Cold War, edited by Gilbert M. Joseph and Daniela Spenser, 308–49. Durham: Duke University Press, 2008.
———. Speaking of Flowers: Student Movements and the Making and Remembering of 1968 in Military Brazil. Durham: Duke University Press, 2013.
Larsen, Lars Bang, and Suely Rolnik. "A Conversation on Lygia Clark's Structuring the Self." Afterall Magazine 16 (Autumn/Winter 2007). http://www.afterall.org/journal/issue.15/lygia.clarks.structuring.self. Accessed February 22, 2015.
Lerner, Jesse. "Superocheros." Wide Angle 21, no. 3 (July 1999): 2–35.
Lesser, Jeffrey. A Discontented Diaspora: Japanese Brazilians and the Meanings of Ethnic Militancy, 1960–1980. Durham: Duke University Press, 2007.
Leu, Lorraine. Brazilian Popular Music: Caetano Veloso and the Regeneration of Tradition. Burlington, Vt.: Ashgate, 2006.
Lobert, Rosemary. A palavra mágica: A vida cotidiana do Dzi Croquettes. Campinas, SP: Editora Unicamp, 2010.
Lopes, Nei. Novo dicionário bantu do Brasil. Rio de Janeiro: Pallas, 2003.

Loureiro, Isabel. "Herbert Marcuse—Anticapitalismo e emancipação." Trans/form/ação 28, no. 2 (2005): 7–20.
Lovaas, Karen E., Joseph P. Elia, and Gust A. Yep. "Shifting Ground(s): Surveying the Contested Terrain of LGBT Studies and Queer Theory." In *LGBT Studies and Queer Theory: New Conflicts, Collaborations, and Contested Terrain*, edited by Karen E. Lovaas, Joseph P. Elia, and Gust A. Yep, 1–18. Binghamton, N.Y.: Haworth Press, 2006.
MacCannell, Dean. *The Tourist: A New Theory of the Leisure Class*. Berkeley: University of California Press, 1999.
Maciel, Luiz Carlos. *As quatro estações*. Rio de Janeiro: Editora Record, 2001.
———. *Geração em Transe: Memórias do tempo do tropicalismo*. Rio de Janeiro: Nova Fronteira, 1996.
———. *Negocio Seguinte*. Rio de Janeiro: Codecri, 1981.
———. *Nova consciência: Jornalismo contracultural, 1970/72*. Rio de Janeiro: Eldorado, 1973.
———. *O sol da liberdade*. Rio de Janeiro: Vieira e Lent, 2014.
MacRae, Edward, and Júlio Assis Simões. *Rodas de Fumo: O uso da maconha entre camadas medias urbanas*. Salvador: Edufba, 2000.
Manzano, Valeria. *The Age of Youth in Argentina: Culture, Politics, and Sexuality from Perón to Videla*. Chapel Hill: University of North Carolina Press, 2014.
———. "The Blue Jean Generation: Youth, Gender, and Sexuality in Buenos Aires, 1958–1975." *Journal of Social History* 42, no. 3 (Spring 2009): 657–76.
———. "'Rock Nacional' and Revolutionary Politics: The Making of a Youth Culture of Contestation in Argentina, 1966–1976. *Americas* 70, no. 3 (January 2014): 393–427.
Markarian, Vania. "To the Beat of 'The Walrus': Uruguayan Communists and Youth Culture in the Global Sixties." *Americas* 70, no. 3 (January 2014): 363–92.
Martins, Antonio Luiz. *Mágicas mentiras*. Salvador: Vento Leste, 2009.
Martins, Luciano. *A "Geração AI-5" e Maio de 68: Duas manifestações instransitivas*. São Paulo: Editora Argumento, 2004.
Martins, Sérgio B. *Constructing an Avant-Garde: Art in Brazil, 1949–1979*. Boston: MIT Press, 2013.
Matory, J. Lorand. *Black Atlantic Religion: Tradition, Transnationalism, and Matriarchy in the Afro-Brazilian Candomblé*. Princeton: Princeton University Press, 2005.
Mautner, Jorge. *Mitologia do Kaos*. Vol. 2. Rio de Janeiro: Editora Azougue, 2002.
McCann, Bryan. "Black Pau: Uncovering the History of Brazilian Soul." In *Rockin' Las Américas: The Global Politics of Rock in Latin/o America*, edited by Deborah Pacini Hernandez, Héctor Fernández L'Hoeste, and Eric Zolov, 68–90. Pittsburgh: University of Pittsburgh Press, 2004.
———. "Blues and Samba: Another Side of Bossa Nova History." *Luso-Brazilian Review* 44, no. 2 (2007): 21–49.
———. *Hello Hello Brazil: Popular Music and the Making of Modern Brazil*. Durham: Duke University Press, 2004.
Miller, Timothy. *The Hippies and American Values*. Knoxville: University of Tennessee Press, 1991.

Monteiro, Luciana. "Cross-Dressed Poetics: Lessons and Limits of Gender Transgressions in Brazilian Popular Music." M.A. thesis, University of Florida, 2007.

Moore, Robin. *Music and Revolution: Cultural Change in Socialist Cuba*. Berkeley: University of California Press, 2006.

Moraes Neto, Geneton. *Dossiê Gabeira: O filme que nunca foi feito*. Rio de Janeiro: Globo, 2009.

Morari, Antonio Carlos. *Secos & Molhados*. Rio de Janeiro: Nórdica, 1974.

Motta, Nelson. *Vale tudo: O som e a fúria de Tim Maia*. Rio de Janeiro: Objectiva, 2007.

Muggiati, Roberto. *Rock, o grito e o mito: A música pop como forma de comunicação e contracultura*. Petrópolis, Brasil: Vozes, 1973.

Napolitano, Marcos. "A MPB sob suspeita: A censura musical vista pela ótica dos serviços de vigilância política (1968–1981)." *Revista Brasileira de História* 24, no. 47 (2004): 103–26.

———. "Coração Civil: Arte, resistência e lutas culturais durante o regime militar brasileiro." Livre-Docência, University of São Paulo, 2011.

Nascimento, Abdias do. *Brazil: Mixture or Massacre? Essays in the Genocide of a Black People*. Dover, Mass.: Majority Press, 1989.

Nascimento, Angelina Bulcão. *Trajetória da juventude brasileira dos anos 50 ao final do século*. Salvador: Edufba, 2002.

Neto, Torquato. *Os últimos dias de Paupéria*. São Paulo: Editora Max Limonad, 1982.

Nietzsche, Friedrich. *Beyond Good and Evil: Prelude to a Philosophy of the Future*. New York: Vintage, 1989.

Nóbrega, Cida, and Regina Echeverria. *Mãe Menininha do Gantois*. Salvador: Corrupio, 2006.

Novaes, Adauto, ed. *Anos 70: Ainda sob a tempestade*. Rio de Janeiro: Aeroplano, 2005.

Oiticica, Hélio. *Aspiro ao grande labarinto*. Rio de Janeiro: Roccó, 1996.

———. "Brasil diarréia." In *Hélio Oiticica*, edited by César Oiticica Filho, 112–19. Rio de Janeiro: Azougue, 2009.

———. "Creleisure." In *Hélio Oiticica*, edited by César Oiticica Filho, 132–33. Rio de Janeiro: Projeto Hélio Oiticica, 1992.

———. "General Scheme of the New Objectivity." In *Tropicália: A Revolution in Brazilian Culture*, edited by Carlos Basualdo, 221–31. São Paulo: Cosac Naify, 2005.

———. "Notes on the Parangolé." In *Hélio Oiticica*, edited by César Oiticica Filho, 93–96. Rio de Janeiro: Projeto Hélio Oiticica, 1992.

———. "On the Discovery of Creleisure." *Art and Artists* 4, no. 1 (April 1969): 18–19.

———. "The Plot of the Earth That Trembles: The Avant-Garde Meaning of the Bahian Group." In *Tropicália: A Revolution in Brazilian Culture*, edited by Carlos Basualdo, 245–54. São Paulo: Cosac Naify, 2005.

———. "The Possibilities of Creleisure." In *Hélio Oiticica*, edited by César Oiticica Filho, 136–38. Rio de Janeiro: Projeto Hélio Oiticica, 1992.

———. "Tropicália." In *Tropicália: A Revolution in Brazilian Culture*, edited by Carlos Basualdo, 239–41. São Paulo: Cosac Naify, 2005.
———. "Tropicália: The New Image." In *Tropicália: A Revolution in Brazilian Culture*, edited by Carlos Basualdo, 310–12. São Paulo: Cosac Naify, 2005.
Oliveira, André Luiz. *Louco por cinema: Arte é pouco para um coração ardente*. Brasília: Fundação Cultural do DF, 1997.
Oliveira, Emanuelle. *Writing Identity: The Politics of Afro-Brazilian Literature*. West Lafayette, Ind.: Purdue University Press, 2007.
Ortiz, Renato. *A Moderna Tradição Brasileira*. São Paulo: Editora Brasiliense, 1988.
Pacheco e Silva, Antonio Carlos. *Hippies, drogas, sexo, poluição*. São Paulo: Martins, 1973.
Pacini Hernandez, Deborah, and Reebee Garofalo. "Between Rock and a Hard Place: Negotiating Rock in Revolutionary Cuba, 1960–1980. In *Rockin' las Américas: The Global Politics of Rock in Latin/o America*, edited by Deborah Pacini Hernandez, Héctor Fernández L'Hoeste, and Eric Zolov, 43–67. Pittsburgh: University of Pittsburgh Press, 2004.
Pacini Hernandez, Deborah, Héctor Fernándes L'Hoeste, and Eric Zolov, eds. *Rockin' las Americas: The Global Politics of Rock in Latin/o America*. Pittsburgh: University of Pittsburgh Press, 2004.
Parker, Richard. *Beneath the Equator: Cultures of Desire, Male Homosexuality, and Emerging Gay Communities in Brazil*. New York: Routledge, 1999.
———. *Bodies, Pleasures, and Passions: Sexual Culture in Contemporary Brazil*. Nashville: Vanderbilt University Press, 2009.
Pedrosa, Mário. "Arte ambiental, arte pós-moderna, Hélio Oiticica." In *Acadêmicos e modernos: Textos escolhidos III Mário Pedrosa*, edited by Otília Arantes, 355–60. São Paulo: Edusp, 1998.
Pereira, Amilcar Araújo. "O 'Atlântico Negro' e a constituição do movimento negro contemporâneo no Brasil." *Perseu* 1, no. 1 (2007): 236–63.
Pereira, Carlos Alberto Messeder. *Retrato de época: Poesia marginal anos 70*. Rio de Janeiro: Funarte, 1981.
———. *O que é contracultura*. São Paulo: Brasiliense, 1983.
Pereira, Carlos Alberto Messeder, and Heloísa Buarque de Hollanda. *Patrulhas Ideológicas: Arte e engajamento em debate*. São Paulo: Editora Brasiliense, 1980.
Perrone, Charles. *Brazil, Lyric, and the Americas*. Gainesville: University Press of Florida, 2010.
———. *Masters of Contemporary Brazilian Song, 1965–1985*. Austin: University of Texas Press, 1989.
———. *Seven Faces: Brazilian Poetry since Modernism*. Durham: Duke University Press, 1996.
Pinho, Osmundo S. de Araújo. "'A Bahia no fundamental': Notas para uma Interpretação do Discurso Ideológico da Baianidade." *Revista Brasileira de Ciências Sociais* 13, no. 36 (February 1998): 1–13.
Pinho, Patricia de Santana. "Gilberto Freyre e a Baianidade." In *Gilberto Freyre e os estudos latino-americanos*, edited by Joshua Lund and Malcolm McNee, 227–54. Pittsburgh: Instituto Internacional de Literatura Iberoamericana, 2006.

———. *Mama Africa: Reinventing Blackness in Bahia*. Durham: Duke University Press, 2010.
Pires, Thula Rafaela de Oliveira. "Colorindo memórias e redefinindo olhares: Ditadura militar e racismo no Rio de Janeiro." Rio de Janeiro: Comissão da Verdade do Rio, 2015.
Polari, Alex. *Em busca do tesouro*. Rio de Janeiro: Codecri, 1982.
———. *The Religion of Ayahuasca: The Teachings of the Church of Santo Daime*. Rochester, Vt.: Park Street Press, 2010.
Prandi, Reginaldo. "Brasil com axé: Candomblé e umbanda no mercado religioso." *Estudos Avançados* 18, no. 52 (2004): 223–38.
———. "The Expansion of Black Religion in White Society: Brazilian Popular Music and Legitimacy of Candomblé." Paper delivered at the 20th Congress of the Latin American Studies Association, Guadalajara, Mexico, 1997.
———. *Segredos guardados: Orixás na alma brasileira*. São Paulo: Companhia das Letras, 2005.
Queiroz, Andréa Cristina de Barros. "O Pasquim: Embates entre a cultura política autoritária e a contracultura." *Revista Eletrônica Cadernos de História* 6, no. 2 (December 2008): 218–35.
Queiroz, Lúcia Aquino de. *Turismo na Bahia: Estratégias para o desenvolvimento*. Salvador: Empresa Gráfica da Bahia, 2002.
Ramirez, Mari Carmen, and Héctor Olea, eds. *Inverted Utopias: Avant-Garde Art in Latin America*. New Haven: Yale University Press, 2004.
Ramos, Fernão. *Cinema Marginal (1968/1973): A representação em seu limite*. São Paulo: Brasiliense, 1987.
Rassinow, Doug. "'The Revolution Is about Our Lives': The New Left's Counterculture." In *Imagine Nation: The American Counterculture of the 1960s and '70s*, edited by Peter Braunstein and Michael William Doyle, 99–124. New York: Routledge, 2002.
Ratts, Alex, and Flávia Rios. *Lélia Gonzalez*. São Paulo: Selo Negro, 2010.
Reis Filho, Daniel Aarão, et al. *Versões e ficções: O sequestro da história*. São Paulo: Editora Fundação Perseu Abramo, 1997.
Ridenti, Marcelo. *Em busca do povo brasileiro: Artistas da revolução, do CPC à era da tv*. Rio de Janeiro: Editora Record, 2000.
———. *O fantasma da revolução brasileira*. São Paulo: Editora Unesp, 1993.
Risério, Antonio. *Avant-garde na Bahia*. São Paulo: Instituto Lina Bo e P.M. Bardi, 1995.
———. *Carnaval Ijexá*. Salvador: Corrupio, 1981.
———. *Caymmi: Uma utopia de lugar*. São Paulo: Perspectiva, 1993.
———. "Duas ou três coisas sobre a contracultura no Brasil." In *Anos 70: Trajetórias*, edited by Antonio Risério, 25–30. São Paulo: Iluminuras/Itaú Cultural, 2006.
———, ed. *Gilberto Gil: Expresso 2222*. Salvador: Corrupio, 1982.
Rolnik, Suely. "The Body's Contagious Memory: Lygia Clark's Return to the Museum." *Transversal* (2007). http://eipcp.net/transversal/0507/rolnik/en. Accessed February 22, 2015.

Romo, Anadelia A. *Brazil's Living Museum: Race, Reform, and Tradition in Bahia.* Chapel Hill: University of North Carolina Press, 2010.

Ross, Kristin. *May '68 and Its Afterlives.* Chicago: University of Chicago Press, 2002.

Roszak, Theodore. *The Making of a Counter Culture: Reflections on the Technocratic Society and Its Youthful Opposition.* Berkeley: University of California Press, 1969.

Rubim, Antonio Albino Canelas, Simone Coutinho, and Paulo Henrique Alcântara. "Salvador nos anos 50 e 60: encontros e desencontros com a cultura." *Revista de Urbanismo e Arquitetura* 3, no. 1 (1990): 30–38.

Salomão, Waly. "Contradiscurso: Do cultivo de uma dicção da diferença." In *Anos 70: Trajetórias*, edited by Antonio Risério, 77–88. São Paulo: Iluminuras/Itaú Cultural, 2006.

———. *Hélio Oiticica: Qual é o parangolé e outros escritos.* Rio de Janeiro: Rocco, 2003.

———. *Me segura qu'eu vou dar um troço.* 2nd ed. Rio de Janeiro: Aeroplano, 2003.

Sansone, Livio. *Blackness without Ethnicity: Constructing Race in Brazil.* New York: Palgrave, 2003.

Santiago, Silviano. *O cosmopolitismo do pobre: Crítica literária e crítica cultural.* Belo Horizonte: Editora UFMG, 2004.

———. *Uma literatura nos trópicos.* São Paulo: Perspectiva, 1978.

Santos, Joaquim Ferreira dos. *Leila Diniz.* São Paulo: Companhia das Letras, 2008.

Santos, Jocélio Teles dos. "A Mixed-Race Nation: Afro-Brazilians and Cultural Policy in Bahia, 1970–1990." In *Afro-Brazilian Culture and Politics*, edited by Henrick Kraay, 117–33. New York: M. E. Sharp, 1998.

———. *O poder da cultura e a cultura no poder: A disputa simbólica da herança cultural negra no Brasil.* Salvador: Edufba, 2005.

Schwarz, Roberto. *Misplaced Ideas: Essays on Brazilian Culture.* New York: Verso, 1992.

Segal, Micol. *Uneven Encounters: Making Race and Nation in Brazil and the United States.* Durham: Duke University Press, 2009.

Seixas, Kika, and Silvio Essinger. *O Baú do Raul Revirado.* Rio de Janeiro: Ediouro, 2005.

Shtromberg, Elena. *Art Systems: Brazil and the 1970s.* Austin: University of Texas Press, 2016.

Silva, Nelson do Valle. "Updating the Cost of Not Being White in Brazil." In *Race, Class, and Power in Brazil*, edited by Pierre-Michel Fontaine, 42–55. Los Angeles: UCLA Center for Afro-American Studies, 1985.

Silveira, Renato da. "La force et la douceur de la force: Structures et dynamisme afro-brésilien à Salvador de Bahia." Ph.D. diss., École des Hautes Études en Sciences Sociales, 1986.

———. "Pragmatismo e milagres de fé no Extremo Ocidente." In *Escravidão e Invenção da Liberdade: Estudos sobre o negro no Brasil*, edited by João Jose Reis, 166–97. São Paulo: Brasiliense, 1988.

Simões Junior, Almerindo Cardoso. *. . . E havia um lampião na esquina: Memórias, identidades e discursos homosexuais no Brasil no fim da ditadura (1978–1980).* Rio de Janeiro: Editora Multifoco, 2013.

Sirkis, Alfredo. *Os carbonários: Memórias da guerrilha perdida.* São Paulo: Global, 1980.

———. "Os paradoxos de 1968." In *Rebeldes e contestadores: Brasil, França e Alemanha*, edited by Marco Aurérlio Garcia and Maria Alice Vieira, 111–16. São Paulo: Fundação Perseu Abramo, 1999.

Skidmore, Thomas. *The Politics of Military Rule in Brazil, 1964–1985*. New York: Oxford University Press, 1988.

Skrebowski, Luke. "Revolution in the Aesthetic Revolution: Hélio Oiticica and the Concept of *Creleisure*." *Third Text* 26, no. 1 (January 2012): 65–78.

Small, Irene V. *Hélio Oiticica: Folding the Frame*. Chicago: University of Chicago Press, 2016.

Smith, Anne-Marie. *A Forced Agreement: Press Acquiescence to Censorship in Brazil*. Pittsburgh: Pittsburgh University Press, 1997.

Sorensen, Diana. *A Turbulent Decade Remembered: Scenes from the Latin American Sixties*. Palo Alto: Stanford University Press, 2007.

Stam, Robert. "On the Margins: Brazilian Avant-Garde Cinema." In *Brazilian Cinema*, edited by Randal Johnson and Robert Stam, 306–27. New York: Columbia University Press, 1995.

———. *Tropical Multiculturalism: A Comparative History of Race in Brazilian Cinema and Culture*. Durham: Duke University Press, 1997.

Stam, Robert, and Ella Shohat. *Race in Translation: Culture Wars around the Postcolonial Atlantic*. New York: New York University Press, 2012.

Suri, Jeremi. *Power and Protest: Global Revolution and the Rise of Détente*. Cambridge: Harvard University Press, 2003.

———. "The Rise and Fall of an International Counterculture, 1960–1975." *American Historical Review* 114, no. 1 (February 2009): 45–68.

Sussekind, Flora. "Chorus, Contraries, Masses: The Tropicalist Experience and Brazil in the Late Sixties." In *Tropicália: A Revolution in Brazilian Culture*, edited by Carlos Basualdo, 31–56. São Paulo: Cosac Naify, 2005.

Teixeira, Rosana da Câmara. *Krig-ha, bandolo! Cuidado, aí vem Raul Seixas*. Rio de Janeiro: 7 Letras, 2008.

Thayer, Allen. "Black Rio: Brazilian Soul and DJ Culture's Lost Chapter." *Wax Poetics* 16 (2006): 88–106.

———. "Soul Searching." *Wax Poetics* 36 (2009): 90–102.

Trevisan, João Silvério. *Devassos no Paraíso*. Rio de Janeiro: Editora Record, 2000.

———. *Pedaço de mim*. Rio de Janeiro: Editora Record, 2002.

Turner, J. Michael. "Brown into Black: Changing Racial Attitudes of Afro-Brazilian University Students." In *Race, Class, and Power in Brazil*, edited by Pierre-Michel Fontaine, 73–94. Los Angeles: UCLA Center for Afro-American Studies, 1985.

Van Deburg, William. *Black Camelot: African-American Culture Heroes in Their Times*. Chicago: University of Chicago Press, 1999.

Vargas, Herom. "Tinindo trincando: contracultura e rock no samba dos novos baianos." *Contemporânea: Communicação e cultura* 9, no. 3 (September–December 2011): 461–74.

Vaz, Denise Pires. *Ney Matogrosso: Um cara meio estranho*. Rio de Janeiro: Rio Fundo, 1992.

Velho, Gilberto. *Nobres e anjos: Um estudo de tóxicos e hierarquia*. Rio de Janeiro: Fundação Getúlio Vargas, 1998.
Veloso, Caetano. *Alegria, alegria*. Rio de Janeiro: Pedra Q Ronca, 1977.
———. *Verdade Tropical*. São Paulo: Companhia das Letras, 1997.
Ventura, Zuenir. *1968: O ano que não terminou*. Rio de Janeiro: Nova Fronteira, 1988.
———. "Vazio Cultural." In *70/80: Cultura em Trânsito: Da repressão à abertura*, edited by Elio Gaspari, Heloísa Buarque de Hollanda, and Zuenir Ventura, 40–51. Rio de Janeiro: Aeroplano, 2000.
Vianna, Hermano. *The Mystery of Samba: Popular Music and National Identity in Brazil*. Chapel Hill: University of North Carolina Press, 1999.
———. "'Não quero que a vida me faça de otário': Hélio Oiticica como mediador cultural entre o asfalto e o morro." In *Mediação, cultura e política*, edited by Gilberto Velho and Karina Kuschnir, 29–60. Rio de Janeiro: Aeroplano, 2001.
———. *O mundo do funk carioca*. Rio de Janeiro: Editora Zahar, 1988.
Vilela, Gileide, et al. *Os baianos que rugem: A imprensa alternativa na Bahia*. Salvador: Edufba, 1996.
Weinschelbaum, Violeta. *Estação Brasil: Conversas com músicos brasileiros*. Rio de Janeiro: Editora 34, 2006.
Weinstein, Barbara. *The Color of Modernity: São Paulo and the Making of Race and Nation in Brazil*. Durham: Duke University Press, 2015.
———. "Racializing Regional Difference: São Paulo versus Brazil, 1932." In *Race and Nation in Modern Latin America*, edited by Nancy P. Appelbaum, Anne S. Macpherson, and Karin Alejandra Rosemblatt, 237–62. Chapel Hill: University of North Carolina Press, 2003.
Whittle, Stephen. "Gender Fucking or Fucking Gender?" In *Queer Theory*, edited by Iain Morland and Annabelle Willox, 115–29. New York: Palgrave Macmillan, 2004.
Wisnik, Guilherme. "Public Space on the Run." *Third Text* 26, no. 1 (January 2012): 117–29.
Yinger, J. Milton. "Contraculture and Subculture." *American Sociological Review* 25, no. 5 (October 1960): 625–35.
Zolov, Eric. "Expanding Our Conceptual Horizons: The Shift from an Old to a New Left in Latin America." *Contracorriente* 5, no. 2 (Winter 2008): 47–73.
———. "La Onda Chicana: Mexico's Forgotten Rock Counterculture." In *Rockin' Las Américas: The Global Politics of Rock in Latin/o America*, edited by Deborah Pacini Hernandez, Héctor Fernández L'Hoeste, and Eric Zolov, 22–42. Pittsburgh: University of Pittsburgh Press, 2004.
———. *Refried Elvis: The Rise of the Mexican Counterculture*. Berkeley: University of California Press, 1999.
———. "Showcasing the 'Land of Tomorrow': Mexico and the 1968 Olympics." *Americas* 61, no. 2 (October 2004): 159–88.
Zular, Roberto. "O que fazer com o que fazer? Algumas questões sobre *Me segura qu'eu vou dar um troço* de Waly Salomão." *Literatura e Sociedade* 8 (2005): 46–59.

Index

1968: events in Brazil, 19–21; and political repression, 21–22, 24–25, 78; and emergence of counterculture, 41, 59, 68, 72

1972: as apex of Brazilian counterculture, 4, 36; works from, 25, 36, 40–41, 43, 48, 88, 91, 96, 103–104, 106, 177; summer of, 110–11, 126, 128, 135–36

Abreu, Caio Fernando, 186, 195, 201–2
Alberto, Paulina, 166
Alternative press, 55–56, 64, 102, 111, 130–31, 177
Alvim, Francisco, 2–3
Amnesty law, 197–99, 202, 206
Andrade, Mário de, 121, 179
Andrade, Oswald de, 79, 104, 139
Androgyny, 175, 177, 188–93, 196–98
Antropofagia, 60, 79, 139, 193
Araça azul, 185
Arembepe, 43–44, 125–29, 204, 223 (n. 75)
Authoritarianism, 1, 3, 14, 17, 32, 37, 53, 94, 140, 151, 176, 178–79
Authoritarian modernization, 2, 22–23, 55, 174, 205
Avándaro Rock Festival, 11, 46
Azulay, Jom Tob, 139–43

Bahia: and Tropicália, 20, 86, 220n1; as destination for hippies, 43–44, 108–13, 121–25, 135–36; and Brazil, 114–16; and counterculture, 117–21, 130–36; and Doces Bárbaros, 139, 142–43. *See also* Salvador
Bahiatursa, 111–13, 133

Baianidade, 112–15, 128, 143–45
Bailes, 152, 160–67
Banda Black Rio, 164
Beatles, The, 10–11, 40, 62
Ben, Jorge, 86, 155–59
Benjamin, Walter, 3, 90
Bethânia, Maria, 136–38, 142–43
Bião, Armindo, 130, 133
Big Boy (Newton Duarte), 160, 194
"Black Is Beautiful," 158, 229n48
Black Rio: description of, 150–51; dances of, 160–65; repression of, 166–69; and authenticity, 170–71; and politics, 172–74
Body: and counterculture, 1, 38; in artistic expression, 76, 78, 89, 101, 105–6, 220n110; in relation to gender and sexuality, 175–77, 186, 195–96, 198, 217n59
Bondinho, 41, 56, 64, 127, 136
Bossa nova, 25, 58, 62, 75, 86, 88, 93, 115–16, 152–53
Brazilian Communist Party (PCB), 16–17, 26, 29, 56, 187, 204
Brett, Guy, 72, 80
Brown, James, 149, 157, 163–64, 167–70
"BR-3," 157
Buarque, Chico, 87, 156
Butterman, Steven, 193

Campos, Augusto de, 75, 80, 95, 99, 103–4
Campos, Haroldo de, 75, 93, 95–96, 99, 103–4
Candeia, 163, 171–72

Candomblé: as symbol of Bahia, 108–10, 128, 132–34; and counterculture, 109–10, 136–37, 221n12; in popular music, 113–16; as represented by Doces Bárbaros, 137–44; and gender, 196–200

Cardoso, Ivan, 92–94, 96, 103–4, 185, 218n69

Carlos, Roberto, 10, 91, 99, 152–53

Castro, Tarso de, 57, 59, 63, 111, 184

Caymmi, Dorival, 115, 137, 175, 221n17

Censorship, 22–23, 25, 55, 78, 102, 118, 130, 132, 212n39; of *O Pasquim*, 57–58, 63, 157, 213n68; and racial protest, 147, 155, 159; and Leila Diniz, 179–80

Centros Populares de Cultura (CPC), 16, 77

Chacal (Ricardo de Carvalho Duarte), 3, 103–4, 220n113

Chaves, Erlon, 157, 169

Cinema marginal, 73, 118–19

Civil rights movement, 5, 9, 147, 155, 158–59, 162–64

Clark, Lygia, 76–79, 84–85, 105–6

Coelho, Frederico, 20, 39, 91, 219n93

Coelho, Paulo, 52–55

"Colégio de Aplicação," 117

Communism, 18, 27, 46–47, 120

Communist Party of Brazil (PCdoB), 17, 22, 204

Concrete art, 74–75

Concrete poetry, 2, 20, 75, 80, 85, 90, 95, 104

Constructivism, 21, 34, 73–79, 100, 102, 106

Costa, Gal: and -Fa-tal- show, 25, 83–89; as countercultural icon, 49, 51, 65, 74, 117, 123, 179, 217–18n59; and Doces Bárbaros, 136–37

Counterculture: Brazilian context of, 1, 14, 29, 32; and *poesia marginal*, 3–4; definition of, 5–6; and consumerism, 7–8, 65–71, 133, 173; in Latin America, 8–13, 39, 43; and rock music, 11–12, 27, 32, 50, 62, 132, 149, 158, 179; and Tropicália, 21; and lifestyle, 26, 29–30, 37, 40, 47, 56, 65–66, 71, 112–13, 188, 190, 204; and the Brazilian Left, 26, 30–31, 37–38; and drug use, 28–29; politics of, 36–37; in Rio de Janeiro, 47–50; and Gal Costa, 49, 88–89; in music of Raul Seixas, 52–55; and alternative press, 55–56; in work of Luiz Carlos Maciel, 59–62; and *cultura marginal*, 73–74; and Hélio Oiticica, 81–83, 107; and Waly Salomão, 86–87, 99; and Bahia, 109–11, 117, 128–29, 135–36, 144–45; and Candomblé, 110, 137–38, 196; in *Meteorango Kid*, 118–21; and the Doces Bárbaros, 137–40, 144; and Black Rio, 149, 151, 165, 173; and sexuality, 177–78, 185, 188

Cowan, Benjamin, 176, 180, 211 (n. 33)

Cuban Revolution, 8, 16

Cultura marginal, 34, 39, 73–74, 78–79, 83, 89, 99, 102–103

Curtição, 28, 39, 62, 70, 88, 100–101, 110, 118, 188. See also *Desbunde*

D'Almeida, Neville, 96, 164

Davis, Angela, 147–48, 161

"Dê um role," 88

Degler, Carl, 148

Deniz, Leila, 58, 179–80

Departmento de Ordem Política e Social (DOPS), 18, 27, 44–47, 54, 78, 155, 158, 176–77

Desbunde: meaning of term, 30, 38–40; and counterculture, 55, 71, 99, 127, 135, 188, 190–91, 195. See also Hippies

Desmadre, 9, 11, 39

Dias, Lucy, 32–33, 44

Diawara, Manthia, 149–50, 227n19

Distenção, 139, 144

Doces Bárbaros, 137–44

Dom & Ravel, 24, 91

Dom Filó (Asfilófio de Oliveira Silva), 146, 160–64, 167, 170–71

Dom Salvador (Salvador da Silva Filho), 156–57

Drummond de Andrade, Carlos, 47–48, 90, 213n54

Duarte, Rogério, 63, 95, 103, 219n83
Dzi Croquettes, 188–90, 195

Easy Rider, 69, 182
Éden, 80–83
Entendidos, 185–87, 194. *See also* Gays
Epstein, Jack, 122, 129
Escola de Artes Visuais (EAV), 51, 172
Escola Superior da Guerra (ESG), 44, 180

Feira Hippie, 45, 66–67
Feminism, 4, 33–34, 56, 58–59, 178–80, 187, 198, 203
Fernandes, Millôr, 58–59
Ferreira Gullar, 75–77
Fico, Carlos, 17, 23
Fifth Institutional Act (AI-5), 21–22, 25, 28, 30–31, 41, 55, 179, 185
Figueiredo, Luciano, 85, 94, 102–4
Flor do Mal, 63–64
Francis, Paulo, 147–48
Frank, Thomas, 6–7, 65, 67, 71
Freyre, Gilberto, 23–24, 29, 113–14, 136, 146–47, 167–69
Frias, Lena, 150–51, 164–67, 172
Fry, Peter, 185–86

Gabeira, Fernando, 197–99, 205, 234n89
Galvão, Luiz, 88, 117, 122, 124, 215n106
Gays, 33–34, 49–50, 136; in *O Pasquim*, 58–59; and Hélio Oiticica, 95–96; and regime, 175–77; and leftists, 181–83; and counterculture, 185–89, 192–95
"Geléia geral," 89–91
Gerchman, Rubens, 51, 79, 193
Giacomini, Sonia Maria, 161–62, 172
Gil, Gilberto: and Tropicália, 20–22, 116–17; and counterculture, 40–43, 47, 62, 211n21; and Hélio Oiticica, 73, 80–81, 84, 182; and Doces Bárbaros, 135, 137; arrest of, 139–42; and Black Rio, 173; and masculinity, 175–76, 196–97
Gilroy, Paul, 149

Gonzalez, Lélia, 150–51, 172–73, 231n105
Grandin, Greg, 8, 30
Green, James, 38–39, 49, 181–83
Green Party, 205
Guattari, Félix, 30, 203–4
Guimarães, Álvaro, 130

Hair, 49, 212 (n. 39)
Heliotapes, 96, 101
Hippies, 6, 86, 92–92, 204; in Latin America, 9–13, 32; in Brazil, 14–15, 26–27, 29–30, 38–39, 41–42, 44–45, 48–51; as international movement, 34, 43; and lifestyle, 37, 65–70; repression of, 46–47; and Hélio Oiticica, 72, 82–83; and Novos Baianos, 88; in Salvador, 109–10, 113, 117–19, 121–24; in Arembepe, 125–29; and Doces Bárbaros, 135–36, 139; and Candomblé, 142–44; compared to soul music scene, 151, 159, 165–66, 173; and sexuality, 181, 186, 188, 190–91. *See also* Desbunde
"Homem com H," 193–94, 233n70
Homosexuality: and counterculture, 38–39, 49–50, 184–85; and regime, 175–76, 180–81; and active/passive dyad, 182–83; and Brazilian Left, 182–83; and Ney Matogrosso, 194–95, 233n75; and Candomblé, 196–97. *See also* Gays

Ickes, Scott, 115
International Song Festival (FIC), 156–59
Ipanema: and counterculture, 47–49, 51, 53, 65–67, 95, 196, 199; pier of, 49–50, 95, 180; mythology of, 57–60. *See also* Feira Hippie
Institute for Research of Black Culture (IPCN), 162–64

Jaguar (Sérgio Jaguaribe), 57–58, 60–61, 183
Joplin, Janis, 27, 55, 119, 127
Jovem Guarda, 10, 153, 228n35

Kehl, Maria Rita, 30, 71
King, Gerson, 167–69, 190, 230 (n. 87)
Kottack, Conrad, 125, 128–29, 224 (n. 78)

Lampião da Esquina, 187, 194
Langland, Victoria, 19, 65, 178
La Onda, 9–10, 13, 39
La Onda Chicana, 11, 46
Lemos, Ademir, 160
"Let's Play That," 90
Lifestyle, 7, 10, 12, 26, 29, 37, 56, 65, 82, 112–13, 204
Lopes, Nei, 39, 163, 171–72
LSD, 5, 28–29, 38, 59, 128–29, 190

Macalé, Jards, 74, 86, 90, 101–2, 182, 219n105
Maciel, Luiz Carlos, 50, 71, 158, 202, 212n44; and *O Pasquim*, 59–62; and column "Underground," 63–64, 111, 200
Maconha, 27. *See also* Marijuana
Madame Satã, 184–85
Mãe Aninha, 130
Mãe Menininha, 137, 144, 225n116
Magalhães, Antonio Carlos, 111–13, 134
Maia, Tim, 152–57
"Maluco beleza," 54–55
"Mandamentos black," 168–69
Manzano, Valeria, 12, 30, 178–79
Marcuse, Herbert, 6–7, 59, 61, 71, 81
Marijuana, 5, 9, 28; and counterculture in Brazil, 28–29, 38, 44, 47, 59, 61–62, 86, 132, 186, 190; and beach life, 49–50; in *Meteorango Kid*, 120–21; criminalization of, 128–29, 139–40; Gilberto Gil's praise for, 141–41; and soul music scene, 153, 165
Martinez Corrêia, José Celso, 38, 50, 217n45
Martins, Antonio Luiz, 118
Martins, Luciano, 30–31, 144, 151
Masculinity: and soul dances, 162; in Caetano Veloso, 175–77, 196; and military regime, 179–80; and leftists,

182; performances of, 189–92; new constructions of, 198–200
Matogrosso, Ney: and *desbunde*, 40; and Secos & Molhados, 190–92; and gay identity, 193–94, 233n75
Mautner, Jorge, 63, 92, 136, 203, 225n111
McCann, Bryan, 153, 167, 173
Medeiros, Carlos Alberto, 163, 166–67
Médici, Emílio Garrastazu, 22–23, 112, 139, 180
Melodia, Luiz, 74, 86, 88–89
"Menino do Rio," 196, 234n82
Me segura qu'eu vou dar um troço (Salomão), 73, 96–102
"Metamorfose ambulante," 52
Meteorango Kid, 118–21
Mexico: and counterculture, 9–10, 13, 39, 109; rock music of, 11, 46
Miccolis, Leila, 4
Midani, André, 103, 164, 171
Milagre econômico, 22, 33, 53, 70
Miranda, Carmen, 115, 175–76, 181, 229n48
Monsiváis, Carlos, 11, 13
Movimento Negro Unificado (MNU), 173
Muggiati, Roberto, 32
Música Popular Brasileira (MPB), 10, 51, 153, 155
Mutantes, Os, 20, 116

Napolitano, Marcos, 18, 26
Nascimento, Abdias do, 147
Nascimento, Milton, 43
Navilouca, 102–7
Neo-concretism: formation of, 74–76; and participation, 77–78; and Tropicália, 84–85; in *Navilouca*, 102–5
Neto, Torquato, 72, 74, 87, 220n11; songs of, 89–90; and column "Geléia Geral," 89–92; in *Nosferato no Brasil*, 92–94
New Left, 5–6, 8–9, 26, 31, 33
Noite do Shaft, 162–64
Nosferato no Brasil, 92–94
Novos Baianos, 88, 117–18, 120, 139, 179, 196

Oiticica, Hélio, 20–21; on avant-garde, 72–73; and neo-concretism, 74–78; *Tropicália*, 79–80; *Éden*, 80–83; collaboration with Gal Costa, 83–84; dialogue with Waly Salomão, 95–96, 101, 219n83; in *Navilouca*, 106–7
Oliveira, André Luiz, 118–121
"Oração de Mãe Menininha," 137
"Oriente," 41–43
"Os mais doces bárbaros," 142
"O sonho acabou," 40–41
"Ouro de tolo," 53–54
"O Vira," 192

Pacheco e Silva, Antonio Carlos, 46, 144, 181, 209n98
Parangolés, 78, 80
Pasquim, O: and alternative journalism, 56–57, 130, 213n68; and Ipanema, 57; politics of, 58–59, 147–48; repression of, 63, 157; and sexuality, 179–80, 183–84
Patriarchy, 4, 8–9, 178–79, 195, 200
"Perola negra," 89
Poesia marginal, 1–4, 25, 50–51, 100, 104,
Polaris, Alex, 36, 71, 205
Porto da Barra, 122–23, 134–35

Queer, 96, 186, 195

Race: and national discourse, 23–23, 146–47, 162, 167; and counterculture, 29, 47, 117, 136; in Bahia, 110, 112–14; and black movement, 144, 148–49; and soul music, 150–52, 155, 158–59, 163–65, 168–69, 173–74
"Refavela," 174, 226n132
Regina, Elis, 153, 158, 188, 228n35
Renascença, 147, 160–63, 172
"Revendo amigos," 101–2
Rio de Janeiro: as center of counterculture, 26–27, 28–29, 45, 56, 58–59, 85–87, 89; countercultural spaces of, 47–52; hippie fair of, 66–67; in *Nosferato no Brasil*, 92–93; and Waly Salomão, 98–99, 101–2; as center of soul movement, 148–50, 160–66. *See also* Black Rio
Risério, Antonio, 28, 38, 112
Rocha, Glauber, 93, 111, 115
Rock music: in Latin America, 10–12, 32; and Tropicália, 20–21, 116, 170; festivals of, 27, 46; and Raul Seixas, 52–55; and Gal Costa, 83, 86–88; and Novos Baianos, 117–18; and soul music, 149, 152–55, 160, 164–65; female artists of, 179; and Secos & Molhados, 190–94
Rolling Stone, 64–65, 127, 131, 177, 214n83
Rolnik, Suely, 30, 36–37, 203
Roszak, Theodore, 6–7, 65, 108, 195

Salomão, Jorge, 91, 103–4
Salomão, Waly, 39, 49, 77, 81, 219n93, 220n110; and *cultura marginal*, 73–74; and Gal Costa, 85–89; dialogue with Hélio Oiticica, 95–96; and *Me segura*, 97–101; and *Navilouca*, 104–5
Salvador: tourism in, 108–10, 112–13; and hippies, 117–19, 121–22, 136–37; alternative press in, 130–33. Samba, 38, 78, 81, 87–88, 117; and soul music, 150, 152, 155–57, 160–64, 167–72
Santa Teresa, 51, 151, 188, 190
Santiago, Silviano, 1, 39, 100, 172, 194, 212n44
Schwarz, Roberto, 13, 16
Secos e Molhados, 190–93
Seixas, Raul, 52–55
Sexuality: and counterculture, 7–8, 29–30, 38–39, 89, 130–31, 136, 177–78, 189–90, 200–201; and gays, 49–50, 92, 95, 175–76, 185–87, 192, 194–96, 198–99; and women, 58–59, 66, 106, 178–80; and soul music, 158, 162, 173; repression of, 180–82
Sganzerla, Rogério, 92, 103
Silveira, Renato da, 199–200
Simonal, Wilson, 58, 155

Sirkis, Alfredo, 37–38, 199
Social class, 4, 23, 33, 36–37, 57–58, 178, 182, 202; and counterculture, 6–7, 11, 26–30, 44, 52–53, 65–69, 110, 118, 121, 127–28, 144, 200, 203–5; and Afro-Brazilians, 147–48, 151–52, 160–62, 169–70, 173–74
"Sociedade alternativa," 54
Soul music: dances of, 150–52, 160–63; Brazilian singers of, 153–57, 168–69; politics of, 158–59, 165–66, 172–74; repression of, 166–67; critique of, 169–71
Stam, Robert, 92, 116, 118–19, 150
Students: and global protests, 5–6, 9, 19; and expansion of Brazilian university system, 14–15, 23, 68–69, 215n99; and Brazilian Left, 16, 18; and counterculture, 111, 117, 128; Afro-Brazilian, 146, 148–49
Sued, Ibrahim, 168–69
Sufoco, 22, 26
Super 8, 92–93
"Super-homem, a canção," 175, 197
Suri, Jeremi, 5, 8

Tavares, Odorico, 115
Teatro Tereza Rachel, 51, 53, 85–87, 91
Tornado, Toni, 157–60, 168–69
Tourism: in Bahia, 108, 111–12; and hippies, 124, 127–28; promotion of, 133–35, 143
"Tradição," 196
Trevisan, João Silvério, 186–88, 200
Tropicália, 20–21, 65, 72–73, 85, 90, 116, 170
Tropicália (work by Hélio Oiticica), 79–81
"Tudo que você podia ser," 43
Turner, J. Michael, 146–49, 173–74, 231n105
TV Globo, 26, 55, 153, 156, 180, 191

Udigrudi. See Cinema marginal
Underground, 31, 34, 39, 43, 61, 70, 73, 86, 91–92, 94, 96, 99, 103, 109–10, 113, 117–18, 136–37, 188–89

"Underground" (column in *O Pasquim*), 63, 111, 200

Vagabundos, 113, 119, 121, 123. *See also* Hippies
"Vapor barato," 49, 86–87
Vargas, Getúlio, 23–24, 48, 114, 137
Vazio cultural, 25, 73
Velho, Gilberto, 28–29, 202
Veloso, Caetano: and Tropicália, 20–22, 78–79, 116–17; and *desbunde*, 36, 39, 41, 121, 132; and Hélio Oiticica, 72–73, 80–81, 95; and Lygia Clark, 84–85; and *Navilouca*, 103; and Doces Bárbaros, 135–39; and masculinity, 175–77, 181–82, 185, 188, 196, 198
Ventura, Zuenir, 19, 25, 73
Verbo Encantado, 64, 90, 99, 130–35, 224 (n. 92)
Viver Bahia, 133–35, 143

Wattstax, 164
Woodstock, 45–46, 127, 158
Workers Party, 203–4

"Xica da Silva," 156, 228n39, 228n40

Yinger, John Milton, 4, 6
Youth: and international counterculture, 4–8; in Latin America, 9–13; and protest in Brazil, 14, 16; and consumption, 23, 33, 65–70, 132–33; and Brazilian counterculture, 26–27, 31–32, 36, 40, 51–52, 113, 117, 140, 144, 170; and sexuality, 29–30, 178–79, 180; and travel, 43, 45, 86, 109–10, 135, 143–44; and national security in Brazil, 46–47; and alienation, 118–19; and Black Rio, 150–52, 162–64, 166–67, 173–74

Ziraldo (Ziraldo Alves Pinto), 57–58
Zolov, Eric, 8–9, 39, 46
"Zumbi," 156, 159

Made in the USA
Coppell, TX
08 May 2025

49132512R00159